A CULTURAL HISTORY
OF COLOR

VOLUME 6

A Cultural History of Color
General Editors: Carole P. Biggam and Kirsten Wolf

Volume 1
A Cultural History of Color in Antiquity
Edited by David Wharton

Volume 2
A Cultural History of Color in the Medieval Age
Edited by Carole P. Biggam and Kirsten Wolf

Volume 3
A Cultural History of Color in the Renaissance
Edited by Amy Buono and Sven Dupré

Volume 4
A Cultural History of Color in the Age of Enlightenment
Edited by Carole P. Biggam and Kirsten Wolf

Volume 5
A Cultural History of Color in the Age of Industry
Edited by Alexandra Loske

Volume 6
A Cultural History of Color in the Modern Age
Edited by Anders Steinvall and Sarah Street

A CULTURAL HISTORY OF COLOR

OF COLOR

IN THE MODERN AGE

VOLUME 6

Edited by Anders Steinvall and Sarah Street

BLOOMSBURY ACADEMIC

LONDON • NEW YORK • OXFORD • NEW DELHI • SYDNEY

BLOOMSBURY ACADEMIC
Bloomsbury Publishing Plc
50 Bedford Square, London, WC1B 3DP, UK
1385 Broadway, New York, NY 10018, USA
29 Earlsfort Terrace, Dublin 2, Ireland

BLOOMSBURY, BLOOMSBURY ACADEMIC and the Diana logo are
trademarks of Bloomsbury Publishing Plc

First published in Great Britain 2021
Hardback edition reprinted 2023
Paperback edition published 2024

Series cover design by Raven Design
Cover image: *City Lights in Seattle*, © Getty Images

A catalogue record for this book is available from the British Library.

A catalog record for this book is available from the Library of Congress.

ISBN: Pack, HB: 978-1-4742-7373-2
 Pack, PB: 978-1-3504-6035-5
 Volume, HB: 978-1-4742-7336-7
 Volume, PB: 978-1-3504-6034-8

Typeset by Integra Software Services Pvt. Ltd.
Printed and bound in Great Britain

CONTENTS

LIST OF ILLUSTRATIONS vii

SERIES PREFACE xii

EDITORS' ACKNOWLEDGMENTS xiii

Introduction 1
Anders Steinvall and Sarah Street

1. Philosophy and Science 21
 Jacob Browning and Zed Adams

2. Technology and Trade 39
 Stephen Westland and Qianqian Pan

3. Power and Identity 57
 Zena O'Connor

4. Religion and Ritual: The Modern Religio-Colorscape 79
 Urmila Mohan

5. Body and Clothing 97
 Tracy Cassidy

6. Language and Psychology 117
 Galina V. Paramei and David L. Bimler

7. Literature and the Performing Arts 135
 Nicholas Gaskill, Sarah Street, and Joshua Yumibe

8. Art 155
 Judith Mottram

9. Architecture and Interiors 173
 Juan Serra

10. Artifacts 197
 Kelly F. Wright

NOTES 219
BIBLIOGRAPHY 222
NOTES ON CONTRIBUTORS 248
INDEX 250

ILLUSTRATIONS

PLATES

0.1 Jim Lambie, *Zobop (Prismatic)*, 2016, exhibited at the Galleria d'Arte Moderna, Turin, 2018

0.2 Tracey Emin, *I Want My Time with You*, St. Pancras Station, London, 2018

0.3 Light painting mapping on Horzyca Theatre in Toruń, Poland, during the Bella Skyway Light Festival, 2015

1.1 The CIE 1931 Color Space is based on the mixture of three colored lights (represented as red, green, and blue at vertices). The location of hues is relative to one another, with wavelength information along the outer edge

1.2 The Land effect, full color

1.3 The Land effect, composed solely of red and gray wavelengths. The appearance of other colors, such as blues and yellows, is a product of our visual system and not in the image itself

2.1 The *blue marble* image of the earth released by NASA in 1972

2.2 Schematic representation of Maxwell's three-colour additive process

2.3 The first analogue-based COMIC recipe prediction computer, created by Davidson and Hemmendinger to enable optimization of color manufacturing

3.1 Gay and Lesbian Holocaust Memorial, Sydney, Australia

3.2 Logo color mapping study

3.3 Color-contrast strategy to improve environmental visual literacy

4.1 An Evangelical meeting place designed in tones of red and brown for the celebration of Lent, USA, 2010

4.2 Catholic priest at the fiftieth jubilee celebration for the king of Mankon, Cameroon, 2009

4.3 Initiates awaiting their turn at a toothfiling ceremony, Bali, 2016

5.1 Elements of a color trend prediction package

5.2 A more contemporary colored tattoo

6.1 The psychological structure of the eleven basic color terms

7.1 *Phantom of the Opera* (Rupert Julian, USA, 1925)

7.2 *The Adventures of Prince Achmed* (Lotte Reiniger, Germany, 1926)

7.3 *A Colour Box* (Len Lye, UK, 1935)

7.4 Jean Simmons as Kanchi in *Black Narcissus* (Michael Powell and Emeric Pressburger, UK, 1947)

8.1 Henri Matisse, *Plum Blossoms, Ochre Background,* Vence, 1948

8.2 Howard Hodgkin, *Morning,* 2015–16

9.1 Aldo Rossi's Quartier Schützenstrasse (Berlin, Germany, 1997)

9.2 Frank Gehry's Guggenheim Museum (Bilbao, Spain, 1997)

9.3 Neutelings Riedijk Architects' Netherlands Institute for Sound and Vision (Hilversum, The Netherlands, 2006)

9.4 UNStudio's (Ben van Berkel) "La Defense" Offices, Almere, The Netherlands (Amsterdam, 1999–2004)

10.1 An assortment of unmarked glass reflecting the palette of common glasswares of the 1920s and 1930s. Illustrated here are three shades of pink, a pair of iridescent plates with a pale pink base, a small pitcher and juicer in greens, a cobalt sugar bowl, and two mixing bowls in the most common colors of the day for kitchenwares—white and jadite

10.2 Mid-century glassware (from top left): amberina goblet, Vaseline hobnail water glass, large jar (possibly Blenko), Vaseline bowl, avocado relish dish, nostalgic barware

10.3 Plastic dinnerware, like its ceramic counterparts, reflected the times in which it was produced. The dinnerplate was the maker's attempt to update colonial revival themes popularized at mid-century with later colors. American Chemical was one of several component suppliers that decided to produce and market its own line of dinnerware direct to consumers. The turquoise saucer shows the rococo asymmetry of organic Modernism

10.4 Like other manufacturers, Dolphin made fondue pots in typical late 1960s "decorator" colors of red, yellow, orange, and avocado as well as stainless steel, which they touted as the same material used by architects Mies van der Rohe and Marcel Breuer. Detail from a Dolphin sales brochure

FIGURES

0.1 The use of the phrase *neon light* in Google Books by percentage, 1900–2008 11

0.2 Wrigley neon sign on the crowded Times Square, New York, 1940 13

1.1 Kanzisa Triangle: example of a "gestalt" where the viewer perceives whole objects—in this case overlapping triangles—instead of merely disconnected parts 25

1.2 The reflectance profiles of water, soil, and green vegetation. The curve represents the amount of light reflected at different wavelengths 32

2.1 Selected timeline of developments of dyestuffs and materials in the twentieth century 46

2.2 The *blue marble* image of the earth released by NASA in 1972 47

2.3 Timeline of developments in color photography in the twentieth century 52

3.1 Gay and Lesbian Holocaust Memorial, Sydney, Australia 59

3.2 Logo color mapping study 63

3.3 Color-contrast strategy to improve environmental visual literacy 65

3.4 Four posts from Instagram: @cinema.palettes 71

3.5 Emilio Pucci post from Instagram: @colour.design.palettes 73

3.6 Ricky Aloisio Instagram images: @aloisio.ricky 75

3.7 Hannah Mirbach Instagram images: @hannahmirbach 77

4.1 An Evangelical meeting place designed in tones of red and
 brown for the celebration of Lent, USA, 2010 82

4.2 Catholic priest at the fiftieth jubilee celebration for the king
 of Mankon, Cameroon, 2009 85

4.3 Initiates awaiting their turn at a toothfiling ceremony, Bali, 2016 92

4.4 A popular evil eye object, Greece, 2006 94

5.1 Example of an original flapper bodice, 1920s 100

5.2 Examples of folk art on everyday objects 105

5.3 A monotone tattoo 110

5.4 Example of the steampunk look 114

6.1 The psychological structure of the eleven basic color terms 122

6.2 Empirically estimated (predominant choices of) focal colors,
 defined in the Munsell system, for Italian *blu* (dark gray star)
 and *azzurro* (light gray star), obtained in Verona (Paramei et al.
 2014), compared to the focus for English *blue* (black five-pointed
 star) 124

7.1 *Phantom of the Opera* (Rupert Julian, USA, 1925) 141

7.2 *The Adventures of Prince Achmed* (Lotte Reiniger, Germany, 1926) 145

7.3 *A Colour Box* (Len Lye, UK, 1935) 145

7.4 Jean Simmons as Kanchi in *Black Narcissus* (Michael Powell
 and Emeric Pressburger, UK, 1947) 149

8.1 Henri Matisse, *Plum Blossoms, Ochre Background*, Vence, 1948 158

8.2 Howard Hodgkin, *Morning*, 2015–16 169

9.1 T.G. Rietveld's use of color at Schröder House (Utrecht, 1923) 177

9.2 Bruno Taut's Glass Pavilion in the Deutscher Werkbund exhibition
 (Cologne, 1914) 178

9.3 Richard Rogers and Renzo Piano's The National Center for Art
 and Culture Georges Pompidou (Paris, France, 1977) 183

9.4 Aldo Rossi's Quartier Schützenstrasse (Berlin, Germany, 1997) 185

9.5 Frank Gehry's Guggenheim Museum (Bilbao, Spain, 1997) 189

9.6 Neutelings Riedijk Architects' Netherlands Institute for Sound
 and Vision (Hilversum, The Netherlands, 2006) 190

9.7 UNStudio's (Ben van Berkel) "La Defense" Offices, Almere, The
 Netherlands (Amsterdam, 1999–2004) 192

10.1 Western Electric's advertisement "Because you love color"
 featured a bright red desk phone 211

10.2 The solid avocado refrigerator on the left and the patterned one
 in gold, orange, and avocado on the right were among the
 appliance colors "unleashed" on eager consumers in the late
 1960s and 1970s 213

10.3 Like other manufacturers, Dolphin made fondue pots in typical
 late 1960s "decorator" colors of red, yellow, orange, and avocado,
 as well as stainless steel, which they touted as the same material
 used by architects Mies van der Rohe and Marcel Breuer. Detail
 from a Dolphin sales brochure 214

TABLES

2.1 Major Importers of German Dyestuffs in 1913 43

2.2 Leading Dyestuff Producers in the Early Part of the Twentieth
 Century 44

SERIES PREFACE

A Cultural History of Color is a six-volume series examining the changing cultural understandings, interpretations, and utilizations of color throughout history. Each volume has the same structure and begins with a general overview of the major attitudes toward and uses of color in the historical period examined. The introduction is followed by contributions from experts, who investigate color under ten chapter headings that are identical in each of the volumes: philosophy and science; technology and trade; power and identity; religion and ritual; body and clothing; language and psychology; literature and the performing arts; art; architecture and interiors; and artifacts. Accordingly, the reader has the option of taking either a synchronic or a diachronic approach to the information provided. One volume can be read to gain a broad knowledge of color in a specific period or, alternatively, a theme or topic can be followed throughout history by reading the appropriate chapter in several volumes. The six volumes divide the history of color as follows:

Volume 1: A Cultural History of Color in Antiquity (*c.* 3000 BCE–500 CE)
Volume 2: A Cultural History of Color in the Medieval Age (500–1400)
Volume 3: A Cultural History of Color in the Renaissance (1400–1650)
Volume 4: A Cultural History of Color in the Age of Enlightenment (1650–1800)
Volume 5: A Cultural History of Color in the Age of Industry (1800–1920)
Volume 6: A Cultural History of Color in the Modern Age (1920–the present)

The general editors wish to dedicate the *Cultural History of Color* to the memory of their husbands who provided so much love and support: William Biggam (1944–2016) and Phillip Pulsiano (1955–2000).

General Editors, Carole Biggam and *Kirsten Wolf*

EDITORS' ACKNOWLEDGMENTS

We would like to thank Carole Biggam and Kirsten Wolf for giving us the opportunity to co-edit this book. It has been a pleasure to work with them and our wonderful contributors who have accompanied us on this stimulating, interdisciplinary encounter with color's fascinating recent history. We also thank Tristan Palmer and the editorial team at Bloomsbury for being so patient and meticulous in helping us to bring this project to completion.

Introduction

ANDERS STEINVALL AND SARAH STREET

This book demonstrates color's relationship to society in a range of different contexts. The modern age saw a number of developments that influenced how colors were used, interpreted, and disseminated. These include the spread of mass consumerism, the expansion of products produced with synthetic dyes, the application of new technologies that made color more easily reproducible, the impact of contemporary political regimes and shifting taste cultures. In this Introduction we outline some of these key themes that resonated throughout the post-1920 period and continue to draw attention to color's tendencies toward polyvalence and shifting meanings. We begin with a recent example that demonstrates how while some colors acquired new associations, the more entrenched cultural meanings of others could be invoked to exemplify particular ideas that are not always progressive.

COLOR, GENDER, AND POWER IN
THE HANDMAID'S TALE

In recent years the power of color as a marker of gender identity has been graphically expressed in the American television adaptation (MGM and Hulu, USA, 2017) of Margaret Atwood's *The Handmaid's Tale*, a novel first published in 1985. It describes a dystopian future in a fictional totalitarian regime called "Gilead" in America, when only a few women are fertile. They become slaves as the "property" of powerful Commanders with whom they are forced to have sexual intercourse, and any resulting children are raised by the man and his infertile wife. The handmaids are dressed in red cloaks and wear white bonnets that cover their hair. Atwood used red symbolically to emphasize how the women were defined by their fertility and blood associated with menstruation. She was also influenced by the red uniforms worn by prisoners in

Canadian camps during World War II, so they could be easily spotted against the snow if they escaped. In addition, she drew on Christian iconography of Mary Magdalene, a controversial figure often associated with prostitution and sexuality and who was consistently depicted wearing red clothes in classical paintings (*Imagine* 2017).

For the television adaptation great care was taken to obtain a specific shade of red that worked for the production's overall aesthetic look that represented a combination of classical and contemporary approaches to interpreting and reproducing color. Colin Watkinson, Director of Photography, explained that:

> Excellent production design from Julie Berghoff with a defined color palette combined with beautiful soft lighting and enough color contrast gave us a painterly effect reminiscent of Vermeer. Our use of vintage Canon K35 lenses set at an exposure of T2 or wider also enhanced our painterly look.
> ("The Symbolism of the Color Red in *The Handmaid's Tale*" 2017)

Costume designer Ane Crabtree also emphasized that:

> For *The Handmaid's Tale,* the color red was of the utmost importance, so we started there. I worked alone and side by side with Reed Morano to find the perfect shade that would emotionally exemplify a kind of visual life blood of our piece. We wanted the Handmaids, as they are the fertile women's tribe of the story, to flow down the streets of Gilead, leaving a long line of red in the midst of the gray of Gilead. Beyond this, the red is the color of a womb, of a wanton woman, a scarlet kind of mark upon a pious world of dark tones in the visual landscape, and also in a tiny intimate space.
> ("The Symbolism of the Color Red in *The Handmaid's Tale*" 2017)

The choice of shade was very important, and the designers needed to take into consideration the impact of red against skin tones, opting for a shade they observed in an industrial building and also influenced by the color of maple leaves that would contrast well with the blue worn by the Commanders' wives.

This example illustrates the complexities of color symbolism. In spite of what might seem an obvious equation of red with sexuality, in this case it also signifies the women's oppression rather than being expressive of an independent spirit or any powerful connotations one might otherwise ascribe to red. As philosopher Gilles Deleuze comments, filmmaker Jean-Luc Godard's famous remark when commenting on the amount of blood in his film *Pierrot le fou* (1965), "It's not blood, it's red," is also a bold attempt to separate color from rigid symbolic associations implying that "there are no longer any perfect and 'resolved' harmonies, but only dissonant tunings or irrational cuts" as images and sequences become independent of each other (Deleuze 1989: 182). In this case, Atwood's fiction animates the warped rationale of a totalitarian world with a profoundly unsettling chromatic sensibility, all the more so because, as

she famously recalled, her work of "fiction" was based on events that at one time or another had all occurred in the world. The popularity of the television series is also seen to be rooted in people's fears about the future—how incremental changes can cumulatively result in oppressive regimes—and in the wake of the "Me Too" protest movement against sexual harassment and violence. This graphic use of color thus shows how the "modern" world is not necessarily advanced in terms of political or ethical thinking.

The television series made a considerable impact, inspiring protesters in Texas, Argentina, and Ireland to dress in the distinctive red capes when they campaigned against anti-abortion laws. Protestors in other locations also wore the costumes in mass rallies in defence of women's rights. Atwood commented: "What the costume is really asking viewers is: do we want to live in a slave state?" (quoted in Beaumont and Holpuch 2018: 3). A very different appropriation of the "Handmaid look" was evident from a number of fashion designers' new collections for spring/summer 2018. The red signature color and distinctive shape of the handmaids' outfits were used in different ways by designers including Thornton Bregazzi and Vera Wang. These trod a somewhat uncomfortable line between connoting the oppression suggested by the allusion to Atwood's idea and an emphasis on catwalk modeling, sexuality, and the commercial viability of the fashions (Seth 2017).

ADVERTISING, CONSUMERISM, AND COLOR

Throughout the decades covered by this volume, the commercial use of color targeted consumers strategically. This strategy can be traced back to the first few years after World War I when the availability of colored merchandise more or less exploded. Marketing the notion of style was an important aspect of this development of consumerism. As Roland Marchand (1986) points out, manufacturers were able to obtain a better price for their products if they were colored and when this featured in advertising; utilitarian products were thus converted into objects of fashion. There is perhaps no better symbolic example of this than the development of color coating for cars. Henry Ford had famously stated in 1909 that "any customer can have a car painted any color that he wants so long as it is black" (Ford and Crowther 1922: 72). With Ford dominating the low end of the car market, 80 percent or so of cars were black in the USA. This changed however in the early 1920s when DuPont developed a new durable paint, which was first showcased on GM's True Blue Oakland in 1923 (Blaszczyk 2012: 119). The success was immediate—greater color choices among low-price cars was something customers had clearly been waiting for.

The printed press played an important role in promoting these stylish objects, through advertising and in lifestyle articles that advised readers on the array of new, colored products. This was the case in popular magazines as well as in

periodicals directed at the business community. A good example is an article, "Color in Industry," in the very first issue of *Fortune* magazine (1930), which highlighted the impact of recent developments in the use of color by comparing two homes, one from 1925 and one from 1928. The shift was illustrated by comparing the dark character of the 1925 home with the almost kaleidoscopic possibilities available for decorating the 1928 home. While this stark contrast served to make the point somewhat dramatically, there can be little doubt that the latter part of the 1920s represented "a color revolution" (Blaszczyk 2012) that was frequently commented upon in magazines.

More important for selling the idea of style and linking it to colored merchandise was advertising. With color itself in focus, one could have expected that a similar color revolution in representation would soon follow. Among the advertising companies, there was almost complete agreement on the eye-catching nature and effectiveness of colored advertisements (Eskilson 2002). However, although color advertisements and color photography had appeared in magazines as early as the end of the nineteenth century, there were still issues regarding the quality of color image reproduction, and color photographic technology was only in its infancy. In addition, there was also a substantial cost in color printing. For this reason, although expanding, color advertising in general and in magazines in particular did not quite keep up with the speed of the color revolution in merchandise. As Sally Stein notes:

> At the close of the twenties [...] we see an emerging dichotomy in the commercial graphics of magazine advertising. The use of unretouched black and white photographs increased very notably, but so did the use of four-color reproductions of commercial artwork. Since little of the new color imagery was photographic, the color advertising retained an air of unreality, especially in contrast to the increased use of unretouched black and white photographs. Conversely, this contrast between the obviously worked-up color image and the seemingly artless black and white photograph strengthened the reality effect of monochrome photographic imagery.
>
> (Stein 1991: 160)

This connection between monochromatic imagery and realism had a lingering cultural impact that spread from advertising into the general views of photographic images, the effect of which was still apparent in the 2000s.

Two systematic studies of advertising in print media (Pollay 1985; Feasley and Stuart 1987) illustrate the comparatively slow process of color advertising among the largest selling magazines in the United States. Both show that although there was a steady increase in the use of color in magazine advertising, a 50 percent threshold was not generally attained until the 1950s. A marked increase in color advertisements in the period 1930–50 noted in Pollay's study can be linked to improvements in color printing and the introduction of Kodachrome color

film in 1935, which revolutionized color photography. This technological development set the scene for picture magazines, such as the reinvented *Life* magazine (1936) and *Look* (1937). The strategies for these two magazines were different from the outset, however, with *Life* favoring black-and-white editorial content, "daring to look dull," initially using color photographs mainly for reproductions of fine art (Stein 1991: 269–77; Renn 2017) and for advertising, and *Look* more fully embracing the colorful sensational (Stein 1991). Over time, however, more and more color photographs entered editorial contents in most magazines and became associated with a number of diverse subjects for different magazines as editors developed strategies for the use of color (Timby 2015).

With further advancements in both printing and photographic technology, the 1950s saw a more extensive use of colored materials in magazines, which in turn led to an increase in sales. In her study of women's magazines, Janice Winship (1987) notes that as the number of advertisements and editorial pages increased during the 1950s, so did the proportion of color pages. As an example, she mentions the British weekly journal *Woman*, which in 1946 had twenty pages and sold a million copies, but in doubling the number of pages by 1951 the circulation increased to nearly 2.25 million. Nevertheless, color advertisements and editorial color images were primarily found in magazines and seldom in newspapers, due to production time and costs. In Britain, this began to change with newspaper groups' launch of color supplements such as the *Sunday Times Magazine*, the *Observer Magazine*, and the *Weekend Telegraph* in the early 1960s. These magazines, designed for a modern and younger audience, were frequently criticized for mixing serious content and photojournalism with glamorous, colorful (often oversaturated) advertisements that became associated with superficiality. Editorial content and color images frequently addressed topics such as lifestyle, gastronomy, and popular culture in ways that the daily newspapers rarely would. However, their increased use of color images and ambition to better integrate image and text were changes that affected the British press profoundly (Farmer 2018). Slowly, more and more color was seen in newspapers with *USA Today* accelerating the trend in the United States, and with some titles adjusting to the shift more slowly than others. *The New York Times*, for instance, only adopted color illustrations in the early 1990s (Glaberson 1993). Whether such hesitancy could be linked to a lingering association of color with glossy superficiality alone is debatable, but what is clear is that there was an active discussion of color images' suitability for serious contexts from World War II into the 2000s. The following comment by Martha Rosler is an instructive example of the worry some expressed regarding the impact of color:

> Over the past couple of decades, color has expanded into news photography from personal and commercial photography and produced powerful dislocations, since serious news had been so long identified with

black-and-white photography. [...] Highly saturated color film enhances the aestheticization of the image, producing eye-catchingly beautiful images of crime scenes, battlefields, slums and mean streets—rendering them the visual equal of green acres and luxury residences.

<div align="right">(Rosler 2004: 225)</div>

In order to counter the impact of such inherent aestheticism of documentary color photos Rosler recommends that they be carefully framed for the viewer to stay with the literalness of an image. To what extent her recommendation has been followed as color images have become more or less ubiquitous in news media is an open question and should perhaps give us reasons to reflect on these matters.

COLOR SYMBOLISM, GENDER, AND RACE

The gendered nature of this color revolution cannot be ignored. Much of the commercial advertising targeted women in particular, advising them on how to coordinate color for fashions and in the home. The phenomenon of the "color expert" came to prominence as forecasters were employed in what became an industry dedicated to harnessing color's inherent instability and with the ostensible goal of helping consumers to acquire "good taste." This involved a number of products including fabrics, shoes, paints, home furnishings, and domestic interior lighting designs, and forecasting also included garden horticulture. Particular stress was placed on how to maintain an individual personality in a modern world that was increasingly associated with mass consumption, anonymity, and the alienating effects of city living. Color was advocated in the popular press and by manufacturers as an important means of expressing an individual's personality within domestic environments. Particular schemes were created to reflect their owners' tastes, and using lighting was part of this aim. As Margaret Petty has demonstrated, colored lighting in American homes was marketed as a means of increasing "familial harmony and psychological wellbeing, more attractive and personalized interiors, the beautification of objects and inhabitants" (Petty 2017: 154). In the 1950s soft-toned incandescent lightbulbs were marketed as a means of influencing the ambience of a room, while in addition supporting dominant cultural beliefs about feminine beauty, blonde hairstyles, and fair complexions. Pink bulbs were promoted as part of a wider adoption, particularly in the United States, of pink as a "woman's color" that has subsequently become identified with the ubiquitous "princess culture" for young girls so aggressively marketed by Disney and other companies (Grisard 2017: 77–96). While these developments have been contested, the commercial dominance of color-coding for children remains entrenched, even to the extent of having separate sections in department stores: pink for girls and blue for boys. The potential for a color's meaning to perform

other functions is clear, however, as with pink ribbons used as a symbol of the fight against breast cancer, or pink as expressive of queer identities.

As well as reinforcing entrenched conceptions of femininity and gender, ideas about race and color that were prevalent from the nineteenth century persist in the modern age. As David Batchelor has argued, an inherently "chromophobic" Western culture seeks to control the power of color by desaturating it, draining it of its ability to shock, impress, and persuade. With this logic color is associated with "some 'foreign' body—usually the feminine, the oriental, the primitive, the infantile, the vulgar, the queer or the pathological" (Batchelor 2000: 22–3). On the other hand, such positions can be, and are, challenged, as with the assertion of "vivid color" as an expression of defiance or identity, as noted in chapter 7 in relation to Ousmane Sembène's film *Xala* (1975). The film's subversion of imperial color codes demonstrates how historic forms of power can be challenged through color to promote alternative associations. A recent example of the color green being adopted as a symbol of hope, change, and renewal is its use to commemorate the victims of a tragic high-rise, tower-block fire that occurred on June 14, 2017, in London. Seventy-two people died when Grenfell Tower, a 24-storey social housing block, caught fire, starting with a domestic incident in one of the flats that spread rapidly because the building's cladding was highly inflammable. A year after the fire and during the public inquiry into the disaster's causes, the remains of the tower were lit green and a banner in the shape of a large green heart erected. The green heart has become a symbol to memorialize the victims, at first used by schoolchildren in the area who decided to wear green to honor their friends who had died in the fire. In this case, and also with the Green movement, the color's universal connotations of natural growth and renewal (rather than death and decay with which green can also be associated) provide a symbolic means of uniting the communities affected by the disaster. In the twenty-first century, classic meanings attributed to colors continue to be relevant and powerful, in this case in a positive way. In this sense color is in a constant dialogue with the past and present; it can never stay still, its mutable forms as quixotic and pulsating as the city lights of Seattle on the cover of this volume.

EXPERIMENTATION, COLOR, AND NEW TECHNOLOGIES

These qualities have attracted artists to experiment with color, often working within and against the strictures of charts, forecasts, and budgets. The period covered by this book is identified with Modernism, and color was central to its development in art forms including painting, poster art, architecture, and film. In spite of tendencies in different periods to favor white buildings or to avoid using assertive palettes in popular films that might distract audiences

from following their character-driven plots, color was a very important generator of creative innovation, particularly as new forms of dissemination and reproduction became available. David Hockney's application of vivid color for his Los Angeles-themed paintings characterized by blue swimming pools and deeply saturated, acrylic paints, was further extended to his work with Polaroid photographs, color printers, and iPad images. As an artist Hockney has kept in step with technology, and color has been central to his fascination with exploiting new, technology-driven modes of expression. By using an iPad, for example, Yorkshire is vividly depicted in non-naturalistic color to convey the beauty of the landscape. Blue and purple trees exoticize the locale in a color palette that viewers at recent exhibitions can, quite literally, see being created through using the iPad's technical ability to visualize through playback. In this way, much as with examining an artist's preparatory sketches for a painting, it is possible to evaluate the impact of Hockney's color choices but with the additional, dynamic effect of seeing the movements of how the drawing was produced.

Experimentation with color, form, and technology has been a feature of twentieth- and twenty-first-century art. The Modernist movement's predilection for geometric imagery has resonated over the decades, with artists such as Bridget Riley using it to create particularly striking optical effects from the 1960s onwards. Color is central to this idea, inviting viewers to recognize how color is both physiological and cultural. In Riley's painting *Fall* (1963), for example, the colors on the canvas are black-and-white wavy lines. But when looked at for a few minutes, the painting begins to look different and with

> flashes of blues and reds. Neither the movement nor the colour exists *on the canvas*, but that is not the same as saying that they are not there. They are in your head, in the complex eye-brain system that gives you the experience of sight.
>
> (Follin 2017: 30; emphasis in the original)

Other artists have sought to explore color's dynamic mutability through patterns and shapes that one would have thought are designed to *contain* rather than *expand* meaning and sensorial impact. Lightworks are particularly effective in doing this in another example of how technology can animate forms, such as Liz West's light installation *Our Spectral Vision* (2016) that uses LEDs and dichroic glass to create rainbow colors so that the viewer's position affects the colors seen as the eyes interpret the different wavelengths of light. Scottish artist Jim Lambie uses colored vinyl tape, aluminum, album covers, plastic bags, paint, mirrors, and objects to explore their chromatic or material affinities, often in everyday settings. Lambie has installed several versions of *Zobop* in different locations since the work was first created in 1998, the principle being that it is a little different according to the layout and topography of the site. With *Zobop* (*Prismatic*), an installation in Turin's Galleria d'Arte Moderna,

2016, the visitor to the gallery can experience the effect of walking on different colored stripes, which again look different depending on where one is walking, standing, and looking (see Plate 0.1).

Color is indeed ubiquitous in the modern age. The mass reproducibility of art has been accelerated by multiple digital platforms. Digital technologies also enable colors to be manipulated by making them more saturated, lighter, or darker so that an image can exist in multiple chromatic configurations. Work that would have taken advanced professional expertise to complete can now be done by those with little or no technical ability. The effect of creating solarized color images in the film *The Girl on a Motorcycle* (1968), for example, was a highly specialized technical operation. For a few scenes cinematographer Jack Cardiff experimented with solarization, or the replacement of some colors by others to create a disorientating, hallucinogenic impact. In solarized images, detail can be seen but the color and lightness is reversed in selected parts of the image. Probably the best known use of the effect in still photography was by Man Ray. Solarization with moving images presented opportunities for expressivity while drawing attention to the arbitrary nature of color signification. The viewer is challenged to compare "real" images with their solarized counterparts as the expectation of associating objects with culturally accepted colors is playfully blocked. As Batchelor puts it, in relation to luminous colors that similarly subvert our sense of conventional chromatic representation, this can be thought of as "an escape of colour, this assertion of its autonomy and independence from the objects that lay claim to it" (2014: 49). At the time, solarization was quite difficult to achieve photographically, and Jack Cardiff made use of the then new technologies to obtain the desired effect. As he explained, this involved using both film and tape:

> I used many techniques, one of which was solarization—half-negative, half-positive; it had been used before in small doses, but I was able to use it thanks to a computer system devised by a brilliant backroom boy from Technicolor, Laurie Atkin. I shot the scenes straight, then they were taken to the BBC's telecine department late at night when BBC work had finished. There I had Atkin's magic box with dials on it and I could adjust the solarization to any part of the scene I desired on a tape which would then be transferred to film at Technicolor.

> (Cardiff 1996: 242–3)

This technique contributed to *The Girl on a Motorcycle*'s reputation as expressive of the psychedelic era of the 1960s, but now similar effects can easily be achieved using a computer.

Changing notions of expertise surrounding color is thus a feature of the modern age. If complex color effects can be produced by nonprofessionals one might expect more democratic cultures to have replaced ideas prevalent in the early twentieth century concerning top-down color education and the need for

people to be taught to develop a discriminating sense of "color consciousness." Yet color forecasting persists, we still use paint charts, and some professional roles have become very lucrative and powerful, for example, the film colorist responsible for manipulating images in digital postproduction. Even though color images can be reproduced more easily than ever before, there are often marked differences in how they look according to how they are being viewed, edited, and by whom. Print forms can still differ markedly from what can be seen on a computer screen and postcards available to buy in art gallery shops usually look different to the "real" paintings. Color remains a complex arena to regulate; it is increasingly difficult to insist on the primacy of an original over a copy as diverse ways to experience color opens the door to a multitude of available "versions" of films, paintings, buildings, or even clothing. Negotiating one's way through the infinite variety of images is indeed a complex task that requires understanding how they have been created and reproduced.

COLOR AND ARTIFICIAL LIGHT FROM NEON TO LED

For the rest of our Introduction, we explore further the multiple meanings suggested by our cover image, which we have chosen because of its iconic status as reflective of color's inherent mutability; how through light it brings color to the world. Arguably, in modern times, characterized by urbanism and consumerism, few concepts of color are so distinctly related to the period and its development as artificial colored light. Discovered at the very end of the nineteenth century and popularized in the 1920s, neon light epitomizes in many ways how visual impressions and artificial color have come to play an important role in modern society and popular culture, not only in advertising, its prototypical use, but also in architecture, art, literature, and film to mention but a few examples. The image of the glittering, flickering, multicolored cityscape of the modern metropolis by night is largely a consequence of the invention of the neon tube. The impact can be illustrated by the fact that although technology has developed and neon is no longer the main lighting source in today's city lightscape, the phrase *neon light* is still as frequently used as seventy-five years ago as evidenced in Figure 0.1, which shows the relative frequency of occurrence of the phrase *neon light* in Google Books, 1900–2008. Figure 0.1 gives an idea of the lingering impact of the colorful neon light in popular culture, while at the same time showing that it became part of an extended conversation in the 1930s.

As pointed out by Kirsten Moana Thompson (2018), colored light was used in advertisements well before the discovery of neon. Advertising signs based on hundreds and even thousands of color-coated incandescent light bulbs were exhibited before 1900 in places such as Berlin and New York. Colored light was also used extensively at World's Fairs, as early as 1901 at the Pan-American

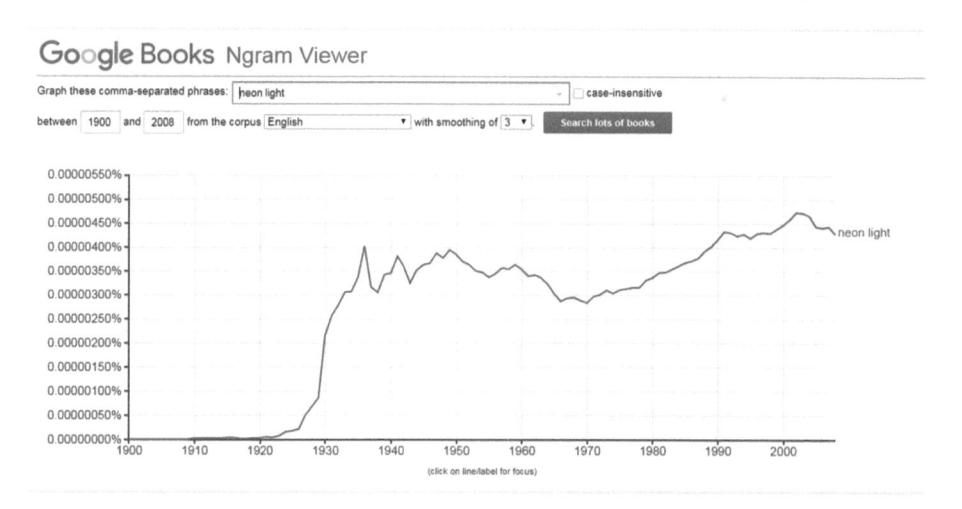

FIGURE 0.1 The use of the phrase *neon light* in Google Books by percentage, 1900–2008. Google Ngram Viewer: https://books.google.com/ngrams (accessed August 16, 2018). Public Domain.

Exposition in Buffalo, NY (Jakle 2001). However, it was with the invention of the neon tube that the use of artificial colored light spread more rapidly and to a broader public.

Neon, a noble gas, was discovered in 1898 by the British scientists William Ramsay and Morris Travers. In one experiment, they filled a test tube, a so-called Geissler tube, with the newly found gas and caused an electric discharge—the result was a very strong red light, "a blaze of crimson" in the words of Morris Travers (Ribbat 2013: 24). A way of controlling the strong red color of the neon gas when charged was developed into the neon tube by the French engineer and chemist Georges Claude. Thus, he created the tool that would lead to the neon revolution of the cities after World War I. However, it is not only neon that emits a strong colored light. All noble gases, helium (pink), argon (blue), krypton (pale green), and xenon (pale blue), emit colored light when electronically charged, as does mercury vapor (blue and green). Later development saw mercury mixed with argon/krypton and neon being particularly used, typically with different kinds of fluorescent coating of the tubes in order to increase the number of colors available (Morne 1998).

The first official exposition of a neon sign took place at a car salon in Paris in 1910. In 1914, Paris had more than 160 neon advertisements, but World War I slowed the development and it was only in the latter part of the 1920s that it took off in most parts of the world (Paris had more than 6,000 neon signs by 1927), with the 1930s being the heydays of neon light. A few numbers tell the story: the first neon sign in the United States was set up in Los Angeles

in 1923, and soon the technology spread all over the country. Ten years later, after the end of prohibition, "neon advertisements spread like wildfire, above all advertising beer" (Ribbat 2013: 35). Remarkably, more than 20,000 neon signs were put up in the small area of Manhattan and Brooklyn in 1934. In a similar fashion, if not as rapidly, colorful neon signs and advertisements started to illuminate and color the nights of many big and small cities all over the world: the development in Blackpool (UK), Mumbai, Tokyo, and Shanghai among others is described in the book *Cities of Light* (Isenstadt et al. 2015).

The impression of the colored light was overwhelming, as is evident in many accounts. Thompson quotes sign designer Mel Mossis's panegyric description of New York's lightscape in 1927:

> The gorgeous magentas and glowing purples created by red letters and blue borders, and the unusual illusions, blending the greens and oranges or blues and greens are indeed "highlights" in illuminating effectiveness. The transition is kaleidoscopic—from the monotonous "spotted" electric light to the smooth even rainbow hues, which are glorifying our electric thoroughfares.
>
> (Thompson 2018: 164)

What Mossis described was in fact Times Square and Broadway, the center of neon and billboard advertising in New York; electric light had turned Broadway into "the Great White Way" among locals, but the impact of neon signs changed it to "the Rainbow Ravine," an expression first coined by journalist Meyer Berger (Conrad 2011). At Times Square, the advertisements grew year by year to enormous proportions. One example is an advertisement for Wrigley's, known as the neon aquarium, set up in 1936 (Figure 0.2).

The advertisement, the largest in the world when designed (60 meters long, 25 meters high), combined 29,500 lightbulbs and over 300 meters of neon tubes in various colors: the fish were blue, orange, and yellow; the Spearman green (Ribbat 2013: 44). It was, however, not the colored light alone that generated interest. Three elements were seen as crucial in large-scale electric advertising: imagery, color, and movement (Thompson 2018). In the case of the abovementioned Wrigley sign, bubbles would rise from the bottom to the top of the "aquarium" and different text messages would be repeated in sequence. Thus, animated advertising in bright colors could be seen as entertainment. In fact, as Thompson points out, "electrical advertising was an important dimension in the ubiquitous visual presence of animated colour in public urban spaces" (2018: 165). In the late 1930s and early 1940s, new signs were spectacular with regard to color, size, design, and movement. And there was indeed an audience; according to Ribbat (2013: 46) as many as 1,100,000 people could be in the Times Square area every day in the 1930s. In a similar fashion, sophisticated

FIGURE 0.2 Wrigley neon sign on the crowded Times Square, New York, 1940. Courtesy of Getty Images.

colored-light advertising was set up in many of the big cities of the world: London (with Piccadilly Circus as a hotspot), Tokyo (Ginza), Chicago, Paris, Los Angeles, Shanghai, and Hong Kong are perhaps the best-known places, but the list can be made very long (Isenstadt et al. 2015).

The neon tube was not only applied in large-scale billboards. It also appealed to small-scale businesses. Neon tubes could be designed in very flexible ways, were available at a comparatively low price, and were much more efficient in transforming current into light than incandescent bulbs. All these factors taken together meant that neon signs appealed to a wide market. Hotels, shops, and restaurants could order individually designed signs with regard to shapes and color, as a craft developed in the 1930s. More than 5,000 glass blowers worked with neon advertising in the US during the 1930s (Ribbat 2013: 41). The colored artificial light was no longer the privilege of the citizens of big cities. Small shops and movie theaters in small towns, or motels and diners along any road could attract customers with highly visible, colorful, and unique neon signs.

The fascination with colored light is well documented in the writing of contemporary journalists and writers, and it generated associations. Christoph Ribbat suggests that "neon advertisements seemed to be signs of democratic

diversity" (2013: 47). According to William Brevda (2011), it was associated with glamour, taste, prosperity, and progress. Although Americans in general may have considered neon to be "a distinct improvement on the 'shabby earth,' a welcome intruder in the dust of the Great Depression" (Brevda 2011: 131), there were also those with a different opinion. One such voice was that of William Faulkner, to whom the colored neon light represented the dangers of escapism and should be opposed, evident in the novel *Sanctuary* (1931) and short stories such as "The Tall Men" (1942) and "Delta Autumn" (1942) (Brevda 2011). This dark representation of the other side of the colorful light would become more common, as the focus shifted from the fascination of the colorful spectacles to the reality surrounding them.

After World War II, the incidence of classic neon signs declined. Technological development meant that new, large signs made of plastic or Plexiglas used neon as fluorescent material that was only visible indirectly. There were also floodlit billboards where neon signs previously dominated. As a result, classic handmade neon signs with tubes visible became "associated with small-scale establishments on the slide" according to Ribbat (2013: 67), who suggests that they now stood for the rusting, declining city, and served as a reminder of the chasm between the social classes and their neighborhoods.

Two novels illustrating this state of affairs are Nelson Algren's *The Neon Wilderness* (1947) and John D. MacDonald's *The Neon Jungle* (1953). In the latter, "the trashy-looking colours of the neon lights, the mechanical buzzing, the faulty equipment—all seem to represent the exact metaphorical equivalent to these people" (Ribbat 2013: 72). It is also in this context we find the color of the neon light, bright red, becoming more distinctly associated with eroticism, sexuality, and prostitution, as establishments such as strip clubs and topless bars usually used neon red signs. Interestingly, the phrase *red-light district* was coined well before the discovery of the neon light—the *Oxford English Dictionary*'s first mention of red light with these associations is from 1880. The origin of the phrase and its association is obscure but the internet provides various theories. However, as we have already seen in the discussion of the costumes in *The Handmaid's Tale* in this Introduction, the color red has a long association with the womb and fertility. From there, the step is not far to sin, and this link has also existed for a long time in Western society, going at least as far back as the Bible and John's Book of Revelation, chapter 17 (the scarlet whore of Babylon). Thus, the preference for neon red for these signs was anything but a random choice. Kristina Davis (2017) observes how the ongoing gentrification of previous red-light districts, such as London's Soho, has turned the previously immoral red neon signs into art, expensive art, with an equivocal and yet safe meaning: "The signifier neon without its referent sex-work, is suggestive yet sanitized of sex-acts performance when exhibited in galleries throughout the Soho area" (Davis 2017: 20).

At this point, it might be appropriate to pause and consider the nature of color associations. As we have seen above, the colorful light of neon attracted various meanings during the modern period. Many writers talk about color metaphor, but strictly speaking this is not correct most of the time. Metaphor is based on similarity, but color, being a surface attribute, does not normally acquire meanings from its similarity with some other aspect but through its *closeness*. This is a metonymic process. Metonymy is a cognitive process "in which one conceptual entity, the vehicle, provides mental access to another conceptual entity, the target, within the same domain, or ICM" (Kövecses and Radden 1998: 39). For example, in our case red neon light has come to stand for eroticism and prostitution because red neon signs have been used in such quarters. In the above account, we have also seen how neon light (irrespective of color nuance) has developed various associations depending on societal or cultural developments in the contexts where neon-colored signs occurred. Seen in a more general perspective, the metonymic nature of color associations and symbolism makes them frequently vulnerable to change as the premise for an association may change from all sorts of societal or cultural factors. Depending on the degree of conventionalization, an association may survive such a change or "die." An example of this is how the colored neon light from traditional signs developed new associations in the 1950s, as technology developed. This also suggests that local culture can have a great impact on color associations as it is in these contexts that the contiguity will be perceived and conceptualized. The intricacies of color language and psychology are discussed in detail in chapter 6.

As Las Vegas boomed in the 1950s, neon signs in the more traditional mold experienced a kind of renaissance. Here, neon installations were bigger than ever. Casinos, hotels, and other buildings on the Strip and Freemont Street were clad with spectacular installations covering entire external walls, taking them into the street, as exemplified by "Vegas Vic" and "Vegas Vickie." To this day, Las Vegas is very strongly associated with colorful neon lights. The impressions of Las Vegas, and its special colorscape associated with large illuminated billboards, influenced architects Robert Venturi, Denise Scott Brown, and Steven Izenour, whose book *Learning from Las Vegas* ([1972] 1977) was a much-debated study among architects. The development of color in architecture and the roles of colored light in that context are discussed in greater detail in chapter 9 in this volume.

Others have been highly critical of what they experienced in Las Vegas in this respect. French philosopher Bruce Bégout's view of Las Vegas was that of a "grotesque farce." Behind the bright colors turning people in the street into the same blue green or violet as the lights, Bégout, writing in 2002, only saw a total absence of meaning (Ribbat 2013: 91).

The theme of emptiness in contrast to the colorful lights of advertising is something that has been picked up in a number of films. One such film is Ridley Scott's dystopian *Blade Runner* (1982). Set in future post-catastrophic Los Angeles (2019), the film uses the colored light of advertisements to great effect in the wet, dark, and polluted city. As pointed out by Milner, the presence of gigantic electronic advertisements reinforces a motif in the film: "commerce is everybody's goal here in Los Angeles" (Milner 2004: 268). Intriguingly, more traditional neon tubes, fitted lower and whose light affect the lighting of many scenes, are also used in the film but with a different symbolic value to some commentators. Ribbat considers them to be symbols of an "imperfect, authentic urban life that has survived despite genetic manipulation and the colonization of the universe" (2013: 118). Viewed this way, they help to communicate a link to past times and film history.

The absence of meaning in, or rather the inability to create meaning from, a chaotic neon cityscape is a theme in Sofia Coppola's film *Lost in Translation* (2003). Set in Tokyo, the film follows two Americans, an aging movie star Bob (played by Bill Murray) and a young philosophy student, Charlotte (played by Scarlett Johansson), both of whom suffer from insomnia, in their encounters with Japanese culture. The film uses the overwhelming neon advertising of the Japanese capital to good effect in which "the visual othering of Tokyo functions rhetorically to foster a general mood of alienation and dislocation" (Ott and Keeling 2011: 371). As Brian Ott and Diane Marie Keeling point out, Coppola uses the dazzling neon colors of the cityscape, oranges, yellows, and reds against a background of bluish hues, to dramatic effect in combination with up-tempo pop music to create a vibrant intensity that helps the viewer become absorbed by the moods of two lost protagonists. For this reason, some reviewers of the film see the city, Tokyo, as a third protagonist in the film, but also as a "metaphor for modern life, for the way in which we are alienated and dislocated by an endless array of signs—many of which are unfamiliar and indecipherable" (372).

Visual artists also experimented with the variety of arresting, chromatic sensations made possible by neon and fluorescent light. American artist Dan Flavin has produced some of the most celebrated work since the mid-1960s, exploiting the tendency of gaseous light to appear to volumize color. While most people would have encountered neon lighting as elongated tubes emitting white light from the ceilings of offices or industrial premises, neon and fluorescent artworks added color and manipulated shape in ways that transformed such everyday fixtures. Flavin's installations created sculptural forms from colored light emanating from structures such as in *a primary picture* (1964). This work created a rectangular frame made from tubes of yellow, red, and blue, set at right angles to each other. When a viewer looked at the frame from different angles and distances, the appearance of the frame would change, in particular the relationship between the colors and how the

light from each tube reflected on the wall. The void inside the frame also directed attention to its chromatic borders.

British artist Tracey Emin has used colored light, particularly neon, in a series of autobiographical statements written in her own distinctive handwriting. Like Flavin's work, this promotes new perceptions of commonplace industrial light forms. One of these, a 20-meter long pink sign that reads "I Want My Time with You," was erected in 2018 below the clock at London's St. Pancras station (see Plate 0.2). Emin had to avoid using brighter colors and the sign was made in LED rather than neon so that drivers would not be distracted as the trains entered the station. Yet the sign's prominent position in a crowded public space was far from unobtrusive: it was intended as "a great subliminal message to the rest of Europe" to be seen by incoming Eurostar train passengers (Emin quoted by Kennedy 2018). In this instance, the artwork transcends Emin's personal history, reaching outwards to convey a political message at a pivotal moment in Britain's relations with the rest of Europe.

Since the 1970s, technological development has led to further elaboration of city lightscapes. Gardner (2006) summarizes the most important technological advances for color lighting effects outdoors up to that point in time. His list includes color metal halide (which offers greater light output and greater color intensity than other sources), dichroic filters (which create multicolored fringe effects ["halos"]), dichroic color change projectors, and, most recently and most importantly, high output LEDs (which consume little energy, require almost no maintenance, have a long life, and are extremely versatile—they can be dimmed, be programmed for any color, and so on). This smorgasbord of opportunities for sophisticated advertising and light installations, which has developed since then, has created greater versatility in terms of control of color nuances, imagery, and movement, and the exploration of the improvements has led to certain parts of cities being even more colorful at night than during the daytime. Concerns about the impact of light installations in colorful combinations have opened up a discussion of light pollution, and indeed color pollution (Arrarte-Grau 2016). Such ideas were in fact expressed earlier in the wake of the neonization of cities, one example being Serge Chermayeff and Christopher Alexander, who argued that there was a crudeness, a "monotony of loudness," in contemporary urban landscapes:

> Neon lights are fast losing their significance in a profusion of signs of identical visual aspect and force, and, together with traffic lights, vanish from sight. Man has produced a paradox of "protective colouring." The things he wants to be seen most clearly are becoming invisible because there are so many of them.
>
> (Chermayeff and Alexander 1963: 60)

More than forty years later, Gardner (2006) expresses similar thoughts and identifies three distinct problems: arbitrary application of color effects, distortion

of the color of nature and natural materials, and finally over-bright color effects and light pollution. There can be little doubt that discussions regarding what is suitable color lighting will continue.

FESTIVALS OF LIGHT, COLOR, AND MUSIC

The increased availability of versatile color lighting tools has created a new kind of cultural event: the light festival. Historically linked to light shows at World Fairs, colorful light festivals have become common in many towns and cities around the world since the 1990s, especially during the dark months of the year. In such festivals, colorful light installations may adorn parts of the town or the city (buildings, parks, water) in unexpected and suggestive ways, specially designed objects may be exhibited, and "shows" presented in certain areas. Combining creative artistry, technological development, and entrepreneurships, these festivals are an important part of a cultural tourist industry in many cities and towns, a way of forging a distinct identity on the market (Zielinska-Dabkowska 2016). National and international newspapers regularly publish rankings of "the top ten light art festivals" in Europe or elsewhere, and the festivals' homepages often provide rich photographic material and films to attract visitors. Examples of such events in Europe are the annual *Fête des Lumières* in Lyon, the biannual *Luminale* in Frankfurt, and the triennial Ghent Light Festival to mention but a few of those that take place in the bigger cities of Europe. However, there are also a large number of recurring light festivals in less prominent places such as Alingsås in Sweden, Toruń in Poland, Oulu in Finland, and Westonbirt Arboretum in the UK (again a small random sample) where creative and colorful lighting installations are exhibited (see Plate 0.3 of the Bella Skyway Light Festival in Toruń). The number is increasing by the year as technology makes the equipment for advanced and original installations comparatively inexpensive and thus possible.

Some cities have established more or less permanent colorful light shows. Such shows are frequently coordinated with water fountains into events where water and color schemes interact in preprogrammed ways. Examples of such places are the Magic Fountain of Montjuïc in Barcelona and the Buckingham Fountain in Chicago, among many others; here various works of music can direct water flow and color into eye-catching shows. With the ongoing development of technology, the sophistication of these shows develops quickly and in some places, such as the Musical Gardens of Versailles, colorful musical fountains interact with color lasers, fog, and even fireworks to create extraordinary spectacles for eyes and ears. This is taken even further at *World of Color* at Disney California Adventure, in which, in addition to the previously mentioned possibilities, insubstantial mist screens are used for projecting sequences from some of Disney's best-known animations, and

programmable translucent Mickey Mouse Ears worn by spectators change colors through external signals. Thompson, analyzing the event, concludes that this development may have the result

> that "animation" can be understood not only as specific technical and material processes, but also as a perceptual and corporeal transformation in which movement, light and colour enlivens, indeed "animates" individual bodies even as it reifies us as part of the spectacle.
>
> (Thompson 2014)

A parallel development of synchronizing colored light with music can be found at music concerts and other big events, such as the Super Bowl or the Olympic Games, where colored lasers are used with great effect. The trend of combining music, especially rock music, with colorful laser shows started in the late 1960s and early 1970s, with the debut of Laserium in Los Angeles (Daukantas 2010). As technology has improved, developments have taken two parallel yet different directions: one being the use of advanced lighting equipment by music artists to produce sophisticated and colorful light shows to enhance the experience of their concerts, and the other being laser shows by laser artists featuring music chosen for its ability to enhance the experience of the audience. Pink Floyd pioneered the use of light effects to enhance their concert performances. In the 1980s the popular musicians worked with lighting director Mark Brinkman who developed their dynamic use of colored lasers. In recent years, the "Pink Floyd Laser Spectacular" shows present their remastered recordings with complex light shows involving color lasers, multiscreen video projections, and 3D images. As sophisticated, synchronized blends of music and color, the shows convey the aural and visual dynamism associated with a long tradition of experimentation with visual-music (Shaw-Miller 2013).

To sum up this section, we have seen that colored light has developed from initially being mainly a tool for advertising into a creative and central player in popular culture, occupying spaces in all sorts of cultural activities. It is clear that views differ with respect to its suitability as such a player. Some commentators have embraced it as an art form whereas others have seen it as superficial and artificial, creating an emptiness below the glittering colors, even accusing it of creating "pollution." Whether such comments stem from chromophobia (Batchelor 2000) is an open question. That colored light will continue to play a central and controversial role in the cultural sphere is beyond doubt.

CONCLUSION

In this introduction we have surveyed some of the key developments in color in the modern age that complement the material presented in the book's thematic chapters. While color has always been fundamentally related to cultural and societal change, the twentieth century witnessed crucial shifts in the wider

dissemination of color products. As we have argued, the "Color Revolution" of the 1920s enabled color to reach a broad constituency of consumers across the globe, as manufacturers were galvanized into producing goods that took advantage of the turn toward color advertising. We have highlighted how this impacted upon commerce, print media, artists, filmmakers, and in the very fabric of cities through the visual networks of modern communications. Our extended discussion of neon serves as a guide to some of the major changes in color design, technology, and social usages of color that have occurred since 1920. As the vibrant pulse of cityscape lighting beamed across cities all over the world, color became inextricably connected with ideas about what it is to be "modern." In the twenty-first century the possibilities for chromatic experimentation have been further dynamized by digital technologies. Once again, we can transform colors with new, intense shades such as *Quantum blue* and *Vantablack* being created by scientists. The spirit of magical alchemy that accompanied synthetic developments in color has entered a new phase as the modern age continues in its journey toward extending the reach, nature, and cultural experience of color.

Philosophy and Science

JACOB BROWNING AND ZED ADAMS

INTRODUCTION

The study of color expanded rapidly in the twentieth century. With this expansion came fragmentation, as philosophers, physicists, physiologists, psychologists, and others explored the subject in vastly different ways. This fragmentation was sometimes amicable, sometimes not. There are at least two ways in which the study of color became contentious. The first was with regard to *the definitional question*: what is color? The second was with *the location question*: are colors inside the head or out in the world? Neither question was settled by the end of the century, and fissures between competing views were amplified by differences in theoretical goals, resources, and methodologies.

In this chapter, we summarize the most prominent answers that color scientists and philosophers gave to the definitional and location questions in the twentieth century. We identify some of the different points at which their work intersected, as well as the most prominent schisms between them. One overarching theme of the chapter is the surprising proliferation of different views on color. Whereas some assume that progress in science must take the form of convergence, the twentieth-century history of color exhibited a marked divergence in views. This chapter leaves it an open question whether an ultimate unification of views is possible, or whether the only thing that ties together the study of "color" is the shared inheritance of a word.

COLOR SCIENCE AND THE PROBLEM OF DEFINING COLOR

In the first half of the twentieth century, color scientists wrestled both with how "color" should be defined as well as who should define it. This problem was motivated by the two most prominent competing theories of color vision of the nineteenth century, those of Hermann von Helmholtz and Ewald Hering. Helmholtz and Hering both held that progress in color science requires the introduction of a strict distinction between the objective and subjective aspects of color. On the objective side, there is the structure of the physical stimuli that cause color experiences (that is, wavelengths of light, which admit of continuous variation across the visible spectrum); on the subjective side, there is the qualitative character of color experiences (that is, how colors look, which can be divided into a small number of discrete categories). This distinction is crucial for understanding the role that the physiology and psychology of the perceiving subject play in color vision, but these distinctions do not, on their own, answer the definitional or location questions. The most heated debates in color science in the first half of the twentieth century were caught up in the ways that color scientists from different camps proposed to study the objective and subjective aspects of color.

Helmholtz's *trichromatic theory* was the dominant theory of color vision for the first half of the century. It was primarily supported by a discovery about the mixture of colored lights: varying the intensity of three appropriately chosen wavelengths of visible light suffices to produce stimuli that match all colors. Helmholtz's theory explains this discovery by positing three types of receptors in the human retina, each of which is maximally sensitive to a different point in the visual spectrum, and which were thought to produce red, green, and blue experiences, respectively. All other color experiences were held to be the result of a simultaneous stimulation of multiple receptors; for example, yellow was held to be the result of stimulating both the red and green receptors. Helmholtz took this physiological account of color vision to imply that colors are properties of *sensations* located inside our heads, and that their apparent location in the world is an illusion. His sensation-based account appealed not only to physiologists but also to physicists interested in the effects of mixing colored lights.

Hering's *opponent processing theory* was never as popular as Helmholtz's trichromatic theory, although it always had advocates. Hering's main criticism of Helmholtz was that his theory mischaracterized the phenomenology of color experience—our introspective awareness of what colors are like. Specifically, Hering observed that pure yellow appears unmixed—that is, as a *unique* hue— on a par with Helmholtz's three primary colors—rather than as mixed—that is, a *binary* hue—such as orange or purple. Hering also observed that it is impossible

to imagine a perceptual mixture of red with green or blue with yellow. Hering took these observations to show that there are four primary colors: red, green, blue, and yellow. He proposed his own competing physiological account of color vision to explain these observations. Hering's account posits three types of receptors, which can be positively or negatively stimulated, thereby producing one or the other side of an opposing pair of experiences: red/green, blue/yellow, or black/white. For example, the excitation of the receptor for experiencing red would thereby inhibit its ability to produce experiences of green. Hering also rejected Helmholtz's proposal to study colors as properties of sensations. Hering noted, "sensations mean in our language something that one perceives in or on one's body, but colors always appear outside of our body and especially outside our eyes" ([1905] 1964: 4). He proposed that color *perception*—that is, our everyday experience of colors as visual qualities of external objects—should be the central topic of color science.

For the first half of the century, Helmholtz and Hering each had their own dedicated groups of supporters, but neither could claim to offer a complete explanation of color vision.[1] The debate between Helmholtz's and Hering's supporters was in part a debate over which discipline is best positioned to study color: physiology or introspective psychology. The debate between these camps became increasingly contentious, with the best-recorded disagreement occurring within the Committee on Colorimetry (henceforth CoC), a group of about twenty American scientists in different fields developing multidisciplinary reports on the status of color science.[2]

The first CoC opens: "That the nomenclature and standards of color science are in an extremely unsatisfactory condition is manifest to practically all workers in the field" (Troland 1922: 530). After "protracted debate" the CoC settled on Helmholtz's position and defined color as "the general name for all sensations arising from the activity of the retina of the eye and its attached nervous mechanisms" (531–2).

This report and its definition were the starting point for the 1931 conference by the International Commission on Illumination (called by its French initials, the CIE). This conference provided the definitive international standards for measuring color, represented by the CIE 1931 color triangle (Plate 1.1). The CIE attempted to connect the subjective and objective aspects of color by proposing a one-to-one mapping of subjective qualitative experiences with objective physical stimuli. The qualitative character of color experience was defined in terms of hue, saturation, and brightness. The subjective aspects of color were arrived at by averaging the results from seventeen test subjects in color-matching experiments. The physical stimuli were defined in terms of relative intensities of red, green, and blue light sources. This benefited the field by introducing an "average observer" and "standard conditions" that provided shared reference points for laboratories and factories worldwide.

For introspective psychologists, however, the CoC and CIE grossly mischaracterized visual experience. The sensation-based picture treats color vision as a measuring device that detects the set of wavelengths produced by mixtures of lights in a narrowly circumscribed viewing situation. But this experimental setup is radically different from everyday color vision, in which the majority of colors we see are not lights but illumination-independent properties of the surfaces of objects. Many members of the CoC argued that color's definition should reflect our perception of it as a property of objects, not as an inner sensation.

For the next CoC report, the introspective psychologists pushed for the adoption of a perceptual definition more in line with Hering's position. For support, they drew upon the contemporaneous work of the (Hering-inspired) German "Gestalt school." This school held that in perceptual experience we encounter visual forms irreducible to their parts. They held our experience is not simply the aggregate of different sensations; we perceive complete scenes consisting in colored objects as part of a larger context (Figure 1.1).

The most influential gestalt color theorist during this period was the psychologist David Katz. His studies involved perceiving color in more natural circumstances: whereas physiologists' experiments often focused on a single colored light viewed in isolation, Katz investigated colors viewed against the backdrop of other colors, on shiny or matte objects, and seen across a variety of lighting conditions. He contended that the many ways we encounter colors—what he called their "modes of appearance" (Katz 1935: 7–27)—make important differences to our phenomenal experience of them.

Katz's work produced two major findings: first, that the colors of objects remain constant under different lighting conditions; and second, that perceivers can identify the color of the lighting independently of identifying the color of the objects in the scene. Both findings had been noticed before, but Katz's work made them central to what colors are. The former finding, *color constancy*, showed that even when the illumination color of a scene changes, the color of the objects in the scene does not appear to change. The latter, *perception of illumination*, suggested that our color experience of a scene generally contains two colors: the color of the object and the color of the illumination. These findings imply that we cannot treat color as identical to the local stimuli—that is, just the wavelengths emitted or reflected by an object—since the surrounding scene also plays an integral role.

When the CoC met a decade later to write an updated report, many members rejected the sensation-based account in favor of the perceptual account. But while Katz's version of the perceptual account provided a better description of color experience, it achieved this at the cost of increased complexity. As Katz notes, "objects on the one hand are blue, yellow, red, etc., and on the other hand sparkle, shine, glitter, etc." (1935: 33). Faced with specifications

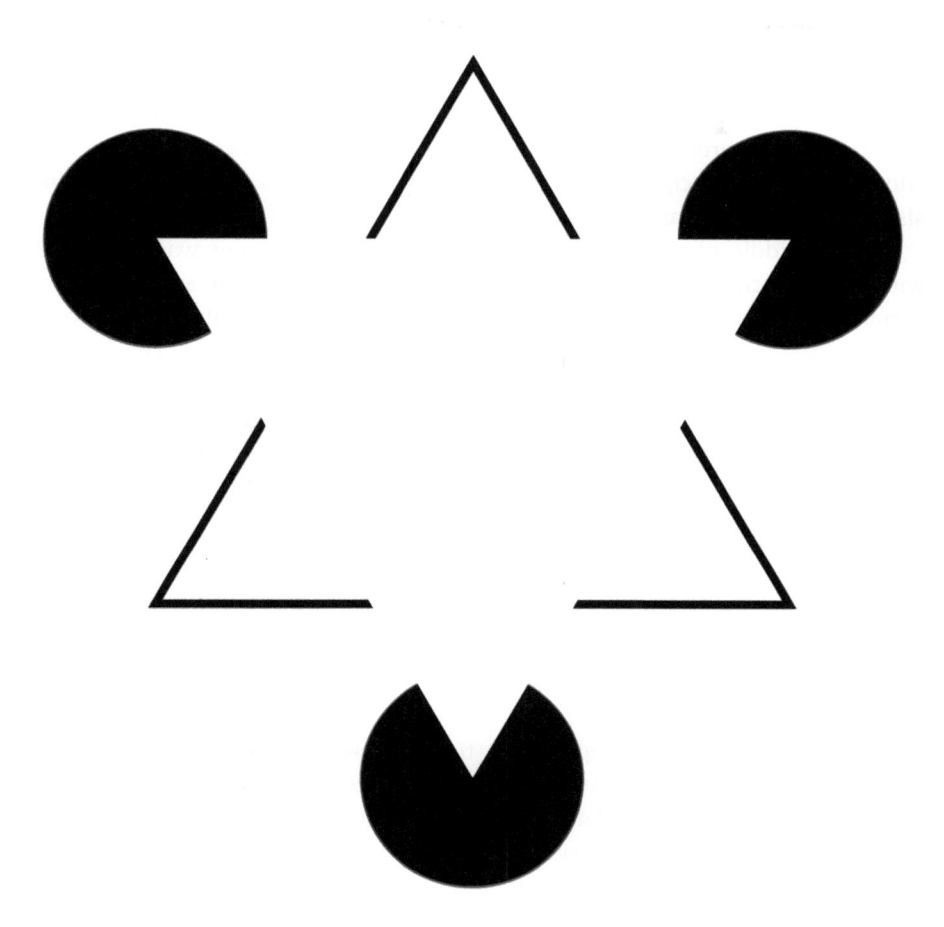

FIGURE 1.1 Kanzisa Triangle: example of a "gestalt" where the viewer perceives whole objects—in this case overlapping triangles—instead of merely disconnected parts. Public Domain.

of color far more complex than simply hue, saturation, and brightness, the chairman of the report, L. A. Jones, noted, "the Committee did not react favorably" (1953: 8). The committee debated these issues for several years with little progress; as Jones later recalled: "this discussion continued for more years than the chairman likes to remember, and a stalemate between the physical and psychological viewpoints seems to have been reached" (9). Jones finally proposed a psychophysical definition: "color consists of the characteristic of light [...] of which a human observer is aware through the visual sensations which arise from stimulation of the retina" (221). This psychophysical definition represented a notable attempt to tie together the diverging views: it acknowledged the role of

sensations in color vision but treated them as the means by which we perceive properties of external objects.

The final CoC report provided separate chapters for physics, psychophysics, sensation, and perception. This divided up the field of color in a way that allowed for each discipline to make their case for how to think of color—but also highlighted the gaps between them.

By the middle of the twentieth century, the study of color was splintered, with colorimetrists embracing the sensation-based definition and distancing themselves from concerns about color experience. Other committee reports, such as those by the Physical Society (1948), the Inter-Society Color Council (Newhall and Brennan 1949), and the CIE (1970), also acknowledged terminological problems associated with the word "color" and similarly proposed drawing stark contrasts between the different ways in which it is defined. As one prominent introduction to color noted:

> It has become customary to divide the subject of color into three broad fields called "physical, psychophysical, and psychological." [...] The word "color" has at one time or another been assigned to one or more of these categories by various writers or groups and in unmodified form has become almost completely ambiguous.
>
> (Evans 1974: 8)

Although these different approaches to color science coexisted, and were published alongside each other in committee reports, they often regarded one another as having debatable presuppositions, contentious definitions, and questionable scientific merit. The result was a series of parallel programs, each making room for the others while being suspicious of them as well. The unexpected result was that the more color was studied, the more difficult it became to talk about consistently.

PHILOSOPHY AND THE AUTONOMY OF COLOR

As color scientists divided the study of color into a number of distinct disciplines, many philosophers attempted to develop an account of color that would be independent of scientific debates altogether. These philosophers adopted a strategy defining color in terms of its qualitative character—what came to be called its *quale* (pl. *qualia*).[3] Qualia were taken to identify what is distinctive about the conscious experience of different colors: for example, red quale refers to the redness of red and green quale refers to the greenness of green. By defining color in terms of conscious experience, many philosophers held that it is possible to offer an understanding of color that is independent of science altogether.

The rise of this new sense of *qualia* was due in part to the emergence of introspective approaches in philosophy and psychology. The philosopher-cum-psychologist G.F. Stout introduced a generation of students to scientific

debates on color with his 1899 *Manual of Psychology*. Regarding color and other sensible qualities, Stout wrote:

> The sensible qualities perceived are by no means identical with the cause of sensation. The colour-sensation, for instance, is due to a vibratory motion of the particles of the luminiferous ether, giving rise to certain chemical or physical changes in the organ of vision, and to a certain modification of connected parts of the nervous system. But these conditions are not what a man sees when he perceives the colour red or blue.
>
> (Stout 1899: 118)

Stout argued that when we experience color we do not *see* wavelengths of light or their chemical or physical effects on the visual system.

Stout's idea that our experience of color is independent from the scientific study of light and vision was taken up by some of his advisees, chief among them Bertrand Russell, G.E. Moore, and C.D. Broad. Moore, in an influential passage, echoed Stout:

> Consider yellow, for example. We may try to define it, by describing its physical equivalent; we may state what kind of light-vibrations must stimulate the normal eye, in order that we may perceive it. But a moment's reflection is sufficient to shew that those light-vibrations are not themselves what we mean by yellow. *They* are not what we perceive.
>
> (1903: 62; emphasis in the original)

Moore takes this to show that colors are a paradigmatic example of a "simple, unanalyzable, indefinable" property of objects (90), and that visual experience of these indefinable properties makes possible a sort of knowledge that is irreplaceable by any other kind of knowledge. This view was later reiterated by Russell and Broad. For example, Russell wrote, "I know the colour perfectly and completely when I see it, and no further knowledge of it itself is even theoretically possible" (1912: 73–4; see also Broad 1923: 280). Taken together, these writings motivated the view that there is a kind of knowledge of color that is *autonomous* from all present and future scientific discoveries: the knowledge of color qualia. A.J. Ayer later provided a perfect encapsulation of the appeal of this view: "So far as anything can be, qualia are pre-theoretical" (1968: 335). In response to the conflicting scientific theories of color, these philosophers maintained that color is pre-theoretical: we know color simply by experiencing color qualia.

One cost of the idea of color qualia was that it raised a host of questions about what qualia are and how they fit into the world. Part of the difficulty was that definitions of qualia tended to be negative: qualia are *not* physical properties of objects, *not* definable in other terms, and so on. As E.A. Singer quipped early in the century, "If I am not mistaken, the best English into which we can render the Latin *quale* is not *what*, but what *not*!" (1917: 341).

Nevertheless, over the second half of the twentieth century, qualia came to play an increasingly prominent role in debates in the philosophy of consciousness, with color as the archetypal example invoked; as David Chalmers put it, "Among the many varieties of visual experience, color sensations stand out as the paradigm examples of conscious experience, due to their pure, seemingly ineffable qualitative nature" (1996: 6). Color's role in two of these debates will be highlighted here: in *the inverted spectrum thought experiment* and in *the knowledge argument*.

The inverted spectrum thought experiment concerns the possibility of color experience varying between persons in ways that are completely undetectable. At the beginning of the twentieth century, Henri Poincaré offered a vivid articulation of this thought experiment:[4]

> The sensations of others will be for us a world eternally closed. We have no means of verifying that the sensation I call red is the same as that which my neighbor calls red. Suppose that a cherry and a red poppy produce on me the sensation A and on him the sensation B and that, on the contrary, a leaf produces on me the sensation B and on him the sensation A. It is clear we shall never know anything about it; since I shall call red the sensation A and green the sensation B, while he will call the first green and the second red.
>
> (Poincaré 1907: 136)

Poincaré takes the possibility of undetectable variation to show that color experience is ineliminably private. Over the course of the twentieth century, the inverted spectrum scenario went on to be invoked in a variety of different philosophical contexts,[5] but central to all of them is the incommunicable nature of the qualitative aspects of color experience.

Perhaps the most influential invocation of the inverted spectrum was as a criticism of *functionalist* accounts of the mind, which rose to prominence in the 1960s and 1970s. Functionalism holds that mental states are constituted not by their intrinsic makeup but by the functional roles that they play in relating mental states to one another, as well as in linking sensory inputs to behavioral outputs. Critics of functionalism thus invoked the possibility of an inverted spectrum as a counterexample to the very idea of defining mental states in functional terms. Here is Ned Block's version of this criticism:

> If [the inverted spectrum] is true, then there is a mental state of you that is functionally identical to a mental state of me, even though the two states are qualitatively or phenomenally different. So the fundamental characterizations of mental states fail to capture their "qualitative" aspect.
>
> (Block 1980: 257–8)

Critics such as Block held that insofar as functionalism fails to capture the qualitative character of color experience it is fundamentally incomplete as a theory of the mind.

Color experience also featured prominently in the knowledge argument. This argument invokes the putative ineffability of color experience to support a different conclusion: that conscious experience essentially involves nonphysical properties. If this conclusion is true, it precludes the view that physical facts exhaust reality—the view known as *physicalism*. The most influential version of the knowledge argument was Frank Jackson's thought experiment involving an imaginary color scientist named Mary:

> Mary is a brilliant scientist who is [...] forced to investigate the world from a black and white room via a black and white television monitor. She specialises in the neurophysiology of vision and acquires, let us suppose, all the physical information there is to obtain about what goes on when we see ripe tomatoes, or the sky, and use terms like "red," "blue," and so on [...] What will happen when Mary is released from her black and white room or is given a color television monitor? Will she learn anything or not? It seems just obvious that she will learn something about the world and our visual experience of it. But then it is inescapable that her previous knowledge was incomplete. But she had all the physical information. Ergo there is more to have than that, and Physicalism is false.
>
> (1982: 130)

This thought experiment rests squarely upon the idea of the autonomy of color qualia: it takes for granted that Mary learns something from color experience that is completely independent of any possible physical knowledge.

The inverted spectrum and the knowledge argument demonstrate how intuitions about the qualitative character of color experience have played a pivotal role in larger philosophical debates about the mind and its place in the world. Given the stakes of these larger debates, many philosophers responded by arguing that the very idea of qualia is mistaken. One approach that some critics took was to argue that our inability to describe the qualitative character of color experiences is an artifact of the incomplete state of color science (for example, Perry 1912: 134). According to other critics of qualia, the problem was more fundamental: the very idea of qualia distorts the sort of knowledge that color experience makes possible. Advocates of qualia claim that a person who sees, for example, a red cherry and a green leaf comes to know something over-and-above how to visually discriminate these colors and how they relate to each other and other colors; they also grasp a further, directly apprehensible fact: the redness of red and the greenness of green. Many critics of qualia have argued that there simply is no such further fact. For example, Hans Reichenbach wrote:

> The structural relations between impressions have been distinguished from the specific *quale* of each of them; only the structural relations, it is said, are communicable; the quale is known only to ourselves. The fault of this conception, it seems to me, lies in the idea that we ourselves know more than

structural relations [...] The relation of sameness has been substantialized—turned into a certain substantial entity called the quale, a fallacy frequently occurring in logic.

(Reichenbach 1938: 253)

Reichenbach contended that the qualia view takes the perceptual discriminations and awareness of structural relations that color experience makes possible and mistakenly reifies them into a fact about our own private experience of colors. As a way of bringing out why there is no such knowledge, Reichenbach proposed the following thought experiment of his own:

Now imagine that [...] one day we see as usual, the next day with exchanged colors [that is, cherries come to appear to have the quale previously experienced when viewing leaves], the following day as the first day, etc. If this exchange affects our recollection images as well [that is, our memories of what qualia look like], we never should become aware of it. We should believe then in a constant quale of our impressions, whereas this quale in fact always changes. This shows that the quale is an untenable concept. Its tenable basis is nothing but the relation of sameness.

(Reichenbach 1938: 254)[6]

Reichenbach's point was not just that the qualia-switching person's perceptual discriminations and structural relations would be the same as someone whose qualia and memories of qualia stay constant. His point was that both people's thoughts about their qualia would be exactly the same. But if their thoughts about their qualia are the same, and their qualia are different, there's nothing for them to *know* about their color qualia just in virtue of having color experiences. Reichenbach concluded from this that since knowledge of color qualia is something we're supposed to be able to have just by virtue of experiencing a color, there is no such knowledge to be had.

Although many critics of qualia followed Reichenbach's lead, as the century progressed an even greater number of advocates of qualia emerged. By the century's end, the idea of qualia produced a multitude of philosophical debates that aimed to discern whether conscious experience really is autonomous, or if there might be some way to render subjective experience into something amenable to scientific investigation.

LATER DEVELOPMENTS IN COLOR SCIENCE

In the second half of the twentieth century, there were many impressive developments in color science. Notably, these developments did not depend upon the emergence of a single comprehensive approach that commanded universal assent among scientists. There was progress without consensus, and many deep disagreements persisted. In spite of this, new technologies played

a role in settling some old debates, but these developments also led to the emergence of new debates, which themselves had philosophical repercussions.

Progress on the Helmholtz-Hering debate began with the development of new electrophysiological and microspectrophotometric techniques for studying the biological mechanisms underlying color vision.[7] These techniques provided physiological support for both Helmholtz and Hering, but they also suggested a way beyond their debate. Helmholtz's theory was supported by experiments measuring the spectral sensitivities of individual cone cells. Researchers discovered three types of cones in the human retina that are sensitive to short, medium, and long wavelengths of light, respectively. The discovery of three types of receptors that are maximally sensitive to three different points in the visible spectrum aligned with Helmholtz's trichromatic theory. Hering's theory was supported by the discovery of opponent cells in the retinal pathway and further downstream in the lateral geniculate nucleus. These cells were excited by wavelengths of light from one part of the spectrum and inhibited by wavelengths of light from another part. The discovery of these cells aligned with Hering's theory of opponent processing.

In the 1950s and 1960s, Leo Hurvich and Dorothea Jameson used these developments to bring about a partial resolution to the Helmholtz-Hering debate. They first entered the debate by providing psychophysical evidence that supported Hering's theory of opponent processing. In their hue cancellation experiments, they showed that blue light can be combined with sufficiently intense yellow light in such a way that both hues are cancelled in a subject's experience; they found the same was possible with combinations of red and green light.[8] This supported Hering's idea that there are two chromatic opponent processing channels, and that these correspond to four phenomenologically primitive colors. They then went on to reconcile their discoveries with Helmholtz's theory by proposing a two-stage theory of color vision, according to which Helmholtz was right about the first stage, Hering about the second.[9] At the first stage, there are receptors that are responsive to three different wavelengths of light; at the second, there are cells that are excited or inhibited by the signals from the receptors. Hurvich and Jameson's work was notable not just for helping to resolve the Helmholtz-Hering debate but also for showing how work in psychophysics, physiology, and psychology could be profitably integrated into a multidisciplinary account of color vision.

During this same period a new approach to studying vision emerged, one that led to new disagreements in color science. The new approach was motivated, in part, by the development of a new technology: Edwin Land's invention of the Polaroid camera. In the late 1950s, while working to develop a process for instant color photography, Land first discovered that a full-color image could be produced using only red and green light. Intrigued, he then removed the green filter, leaving an image produced solely through a combination of red

and white light, and found that even this combination could still produce a full-color image, albeit a muted one (this is called the "Land effect"—see Plates 1.2 and 1.3). Land concluded from this that the color perceived at a location in space could not be reduced to the specific wavelengths of light emitted or reflected by that location.

Land rediscovered Katz's finding: color cannot be identified with the local stimulus. What was new was what Land did with this rediscovery. Land looked at it as an engineering problem: how could a three-color visual system, solely by absorbing wavelengths of light, perceive objects as having stable colors across changes in illumination? Land's influential answer was that the visual system solves this problem computationally. To support this answer, Land and John McCann wrote a computer program that tracked the constant colors in a scene by discounting the illumination conditions. The goal of Land's computer program was to determine the *reflectance profile* of a surface in a scene. A reflectance profile is the percentage of each wavelength of light that something is disposed to reflect, across the visible spectrum (Figure 1.2). The reflectance profile of a surface stays the same across changes in lighting, so even if one scene was darker than another, its reflectance profile nonetheless remains constant. Land and McCann's computer program ended up producing results that were functionally similar to those of human vision. The result of Land's work was to put color into the ambit of cognitive science, or "psychology by reverse-engineering" (Haugeland 1997: 1). A burgeoning number of computational scientists took on the challenge of developing simulations far more complex than Land's, and a whole new approach to studying color vision was born.

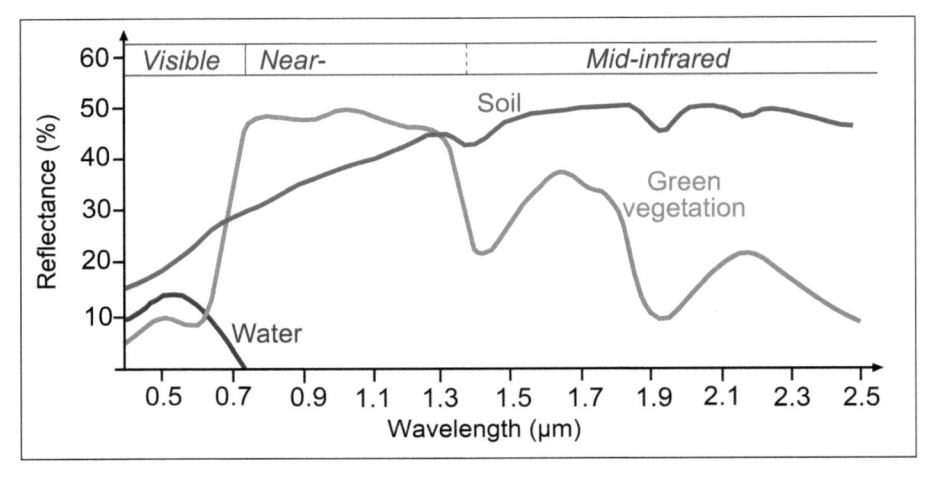

FIGURE 1.2 The reflectance profiles of water, soil, and green vegetation. The curve represents the amount of light reflected at different wavelengths. Courtesy of Seos initiative (creative commons).

Over this same period yet another approach to studying vision emerged from psychology. Beginning in the 1950s, J.J. Gibson proposed a novel account of perception and its objects, as part of developing an ecological approach that drew heavily from evolutionary considerations. Gibson argued that perceptual systems must be studied in real-world contexts rather than in artificially constrained laboratory conditions. He pointed out that these real-world contexts varied from species to species according to their specific evolutionary histories. Gibson took this to imply that it is mistaken to treat the inputs to perceptual systems in species-independent terms (such as wavelengths of light). Rather, Gibson proposed that the objects of perception should be characterized in action-oriented terms specific to the selection pressures of that specific species. Gibson referred to these species-specific objects of perception as "affordances" and included colors among the sorts of affordances that animals can perceive (1979: ch. 8).

While these different approaches each pulled in different directions, they all regarded color vision as more complex than just the selective absorption of wavelengths of light. In contrast to mid-century, late-century color scientists became increasingly comfortable with a pluralistic approach to studying color. For example, after summarizing a variety of philosophical, physical, physiological, and psychological accounts of color, Hurvich's 1981 color textbook simply concludes, "color is all of these things" (1981: 13). With the rise of neurological and computational approaches to color vision, however, it became increasingly common for color scientists to follow Land in locating color within various processes inside the head.[10] This tendency proved to be a provocative challenge to philosophers.

THE RISE OF EMPIRICALLY INFORMED WORK IN PHILOSOPHY

In the 1980s, a new generation of philosophers emerged who drew extensively upon recent advances in color science. C.L. Hardin was the most programmatic member of this new generation. His avowed goal was to "promulgate within the philosophical community the opinion that, henceforth, discussions about color proceeding in ignorance of visual science are intellectually irresponsible" (Hardin 1988: xvi).

The need to argue for the relevance of science for understanding color shows how pervasive the autonomy view had become. Ludwig Wittgenstein, in his *Remarks on Colour*, was the most prominent advocate of this view. He wrote, "phenomenological analysis (as e.g. Goethe would have it) is analysis of concepts and can neither agree with nor contradict physics" (1977: 16).[11] Wittgenstein investigated color as an example of a sort of knowledge that seemed both to be based upon experience yet revelatory of necessary truths.

For example, he puzzled over why it seems impossible to conceive of reddish-green hues or transparent whites. He took these reflections to reveal an insight into color that science could not provide.

In response, Hardin and other like-minded philosophers sought to show the relevance of color science for these questions, and more. Broadly speaking, this new generation of empirically informed philosophers fell into three camps: *computational objectivists*, *neurophysiological subjectivists*, and *ecological relationalists*. The debates between these camps often mirrored the debates between color scientists outlined in the last section.

The most prominent computational objectivist in this period was David Hilbert. His 1987 *Color and Color Perception: A Study in Anthropocentric Realism* is notable for several reasons. First, in opposition to how many computational color scientists interpreted the implications of their own work, Hilbert argued that the computational approach can explain how color vision tracks the distal properties of external objects.[12] To support this claim, Hilbert pointed out that computational accounts of color constancy (such as Land's) track the reflectance profiles of objects across changes in illumination conditions and lines of sight. Second, Hilbert proposed that it is possible for colors to be objective, physical properties of external objects while at the same time granting that they are "anthropocentric" in the sense that their similarity-and-difference relations seem arbitrary from the point of view of physics. To support this, Hilbert distinguished between the objectivity of a property (that is, whether it can be identified without reference to human experience), and the explanatory significance of that property (that is, whether it makes an ineliminable contribution to science). As Hilbert put it, "There are many objective properties of material properties that do not figure in the explanations of scientists" (1987: 10). For example, the present distance between Koko the Gorilla and the Empire State Building is an objective property that is extremely unlikely to figure prominently in any scientific explanations. Finally, Hilbert tied these considerations together into his own positive definition of color: colors are the reflectance profiles of objects, such that, "every difference in reflectance implies a difference in color" (99).

Hilbert's book drew philosophers' attention to computational approaches and introduced valuable distinctions to philosophical discussions about objectivity. But his positive account of color was not without its problems. The first is something Hilbert discussed at length: *metamerism*. Metamerism occurs when two objects with different reflectance profiles appear to be the same color; for example, a banana and a color photograph of a banana might appear to have the same color while nonetheless having very different reflectance profiles. This raises a problem for Hilbert's reflectance physicalism, insofar as it implies that two things can appear to be the same color to ordinary perceivers in ordinary circumstances and yet be different colors. A second problem for Hilbert's

identification of color with reflectance profiles is that there are many colors that do not involve reflection, such as the colors of lights, translucent volumes, the sky, afterimages, and so on.[13] An account that identifies colors with reflectance profiles seems to leave out these sorts of colors altogether.[14]

The most prominent neurophysiological subjectivist in this period was C.L. Hardin. His 1988 *Color for Philosophers* had two main goals: first, to familiarize philosophers with recent developments in color science, and, second, to marshal this science to establish a counterintuitive philosophical conclusion: that colors are illusions. Hardin argued that we should "be eliminativists with respect to color as a property of objects, but reductionists with respect to color experiences" (1988: 112). Through focusing on Hurvich and Jameson's work on opponent processing, he proposed that many aspects of color experience can be explained in neurophysiological terms.

In addition to reinvigorating debates about the reality (or lack thereof) of colors, Hardin made several other significant contributions to the philosophy of color. First, he attacked the long-standing assumption that color experiences are simple and unanalyzable. According to this assumption, the redness of red cannot be explained through comparing and contrasting it with other colors. Against this, Hardin proposed a more holistic picture of color. He drew attention to structural features of color experience, such as the distinction between unique and binary hues (that is, the distinction between unmixed colors like red and mixed colors like orange), and used these structural features to define the similarities and differences between colors. Second, he used these observations about structural features of color experience to introduce a new criterion for philosophical theories of color: is the theory able to explain why colors stand in these relations to one another? Hardin invoked this criterion as a criticism of objectivist views such as Hilbert's, since distinctions such as the unitary/binary distinction do not correspond to any known physical relationships between objects.

By contrast, in support of his own position, Hardin proposed that these structural relations can be explained by opponent processing. The problem Hardin identified here has come to be known as *the structure preservation problem*, and it has become much discussed. Finally, he attacked a view that many philosophers had come to think of as common sense: the view that the colors of objects are defined by how the objects are disposed to look to "normal" observers in "standard" conditions (that is, *dispositionalism* about color).[15] Against dispositionalism, he argued that neither "normal" observers nor "standard" conditions suffice to identify determinate colors for objects. With regard to "normal" observers, he drew upon psychophysical studies that revealed wide variation in what otherwise "normal" (that is, non-color-blind) observers identify as unique green. This variation makes it impossible to define the greenness of something in terms of *the* way it looks to "normal"

observers. Against "standard" conditions, Hardin pointed out that standard industry guidelines for colorimetry do not specify a single set of conditions for all objects; rather, they propose different sorts of viewing conditions for different sorts of objects, and they make it clear that the specification of these conditions depends much more on the interests of the viewer than on the nature of the object.

Hardin's book had a tremendous impact in philosophy. It raised issues that any subsequent philosophical theory of color must address, and also provoked a number of debates about Hardin's own eliminativism. One debate concerned how much the neurophysiological evidence actually explains. Although Hardin took opponent processing to explain the distinction between unique and binary hues, others were not convinced, and the question of whether neurophysiology can explain this and other structural features of color experience remains open. Further, his conclusion that color is an illusion raised the question of why color vision would have evolved in the first place.[16] Finally, Hardin's discussion of philosophical theories of color largely takes the form of dilemma: either colors must be reducible to physical properties or they cannot be in the world. The possibility that colors might be *sui generis* qualitative properties of objects that supervene on the physical properties of objects without being reducible to them is not discussed at length.[17]

The most prominent ecological relationalist in this period was Evan Thompson. In his *Colour Vision* (1994), he aimed to move beyond what he saw as a series of false dichotomies that pervade debates about color. Two such dichotomies he attacked were the mental/physical distinction (underlying the definitional question) and the inner/outer distinction (underlying the location question). Thompson argued that an adequate account of color must regard it as *both* mental and physical, inner and outer. Following Gibson, Thompson argued that color vision serves a variety of biological functions (against Hilbert's exclusive focus on tracking reflectance profiles), and that serving these functions plays as essential role in helping animals skillfully cope with the world (against Hardin's claim that color vision is pervasively illusory).

Rather than accept either horn of these dichotomies, Thompson proposed that colors are species-specific ways that organisms relate to their particular environmental niches. Thompson drew upon a considerable body of empirical work on different species' visual systems to reorient color debates around a new question: what makes a visual system a *color* visual system in the first place? To answer this, Thompson explored the many uses of color vision, which include "object detection, spatial segmentation, and object identification" as well as tracking the "hormonal and motivational state" of conspecifics (Thompson 1995: 176). From this, he concluded that color vision is "an adaptation for integrating a physically heterogeneous collection of distal stimuli into a small set of visually salient equivalence classes" (180).

A major challenge facing Thompson's account is showing how it is possible for it to move beyond the dichotomies structuring the color debate. For many, these dichotomies—especially the subjective/objective dichotomy—are so entrenched that any attempt to deny them seems atavistic. A related worry is whether thinking of colors as affordances provides us with a new way of thinking about colors that is not reducible to thinking of them as either physical properties in the world or psychological properties in the head.

Despite their differing views, Hilbert, Hardin, and Thompson were united in thinking that we can make progress on many traditional philosophical puzzles by drawing upon color science. For example, whereas Wittgenstein held that the difficulty of conceiving of a reddish-green hue rests upon our color concepts, it turns out that this difficulty might have more to do with our physiology than anything else: color scientists have devised ways of manipulating our visual system that produce experiences that have been described as reddish green.[18] In a similar way, the detectability or undetectability of an inverted spectrum might admit of empirical investigation: an inverted spectrum might always be detectable because our qualitative color space is asymmetric (because, for example, we are able to discriminate more shades of blue than of yellow). By the end of the century, it became common to invoke these sorts of empirically informed considerations in philosophical debates about color.

Since Hardin's seminal book came out, an increasing number of scientifically minded philosophers have become involved in the philosophy of color. Many books, articles, and edited collections have promoted this approach. In 1997, Alex Byrne and David Hilbert published a two-volume anthology, *Readings on Color*, with one volume devoted to the philosophy of color and the other to the science of color. The aim was to expose each community to the work of the other, and thereby bridge disciplinary divides. At the turn of the twenty-first century, it became increasingly common for philosophers and scientists to attend the same conferences, discuss the same topics, and be published alongside one another.[19]

CONCLUSION

In the middle of the twentieth century, Wilfrid Sellars (1963) claimed that a central challenge of philosophy is to combine two apparently conflicting images of the world: the *scientific* and *manifest* images. Many have taken color to be a vivid illustration of this problem: whereas science depicts a world in which electromagnetic radiation is selectively absorbed and reflected by objects, our conscious experience presents us with a world of colored objects. This can make it seem like the most fundamental problem in the philosophy of color is to explain whether these images can be fused into a single unified picture or whether the gap between them is too great to be bridged.

The history in this chapter puts a novel twist on Sellars's challenge. The story we have told is one of the fragmentation of the study of color: there was much greater variety of ways of studying color at the end of the twentieth century than there was at the beginning. As such, there simply is not such a thing as *the* scientific image of color, and it is not clear that there ever will be a single account. It could be that all we will have is a diverse set of approaches to studying a variety of visual phenomena that are grouped together by nothing more than the shared word "color." As such, the question of whether *the* scientific image of color can be reconciled with the manifest image of color is misplaced. (There is an additional question of whether there is such a thing as *the* manifest image of color.[20])

In conclusion, the twentieth century did not produce definitive answers to either the definitional or location questions. But it did yield a healthy awareness of the complexity of color phenomena as well as a new model for what the future study of color might look like. This new model is wholeheartedly interdisciplinary and eschews terminological disputes for more substantive disagreements about the nature of color vision, its various biological functions, and its relationships to other parts of our perceptual and cognitive lives.[21]

Technology and Trade

STEPHEN WESTLAND AND QIANQIAN PAN

INTRODUCTION

In this chapter, three important fields for twentieth-century developments in color technology are considered and briefly discussed. The first is the synthetic dye industry that had its origins in the eighteenth century but that saw many important innovations (such as the discovery of new types of dyes) in the twentieth century that enabled manufacturers to produce a wide range of colored materials with unparalleled light and wash fastness. The second development is the introduction of color imaging technology that gave us color photographs and moving images, which subsequently drove the development of the internet. The third development is the introduction of methods for specifying and measuring color, which led to the efficient production of color in a wide range of technologies, including clothing, food, automobiles, paints, and plastics, and provided methods that are used today for ensuring color fidelity in the digital world. Color measurement became increasingly important during the second half of the twentieth century as manufacturing and supply chains became ever more global. What these three areas of technological innovation have in common is their relationship with commerce and culture. It was changes in Europe's population during the early 1800s in particular that drove the innovations in chemistry and the efficient manufacture of raw materials required to process textiles that laid the foundations for the development of new materials and dyestuffs in the first half of the twentieth century. Meanwhile, the invention of consumer imaging devices would change the way that society viewed itself and reflected upon its history. The first instant camera (the Polaroid) transformed

how we think about images and arguably was the precursor for modern smartphone applications such as Instagram and Snapchat.

NEW TEXTILES, DYES, AND POLYMERS

The story of the chemical industry starts toward the end of the eighteenth century in a period when huge changes in population were taking place. For example, between 1750 and 1850 the population of England, Germany, and Spain more than doubled, and this growth in population put great pressure on the production of resources for construction and clothing. The growing synthetic dye and pigment industries (the first synthetic dye of commercial importance was mauveine that was discovered in 1856), in particular, increased the pressure to manufacture important chemical raw materials (Aftalion 2001). The discovery of coal-tar products (coal tar, discovered in 1665, is a thick dark liquid, which is a byproduct of the production of coke from coal) eventually transformed the dye and pigment industries (Holme 2006). However, methods to produce sulfuric acid (historically known as *oil of vitriol*) and sodium carbonate (an alkali known as *soda ash*) on an industrial scale were also particularly important for the synthesis of many dyes. Sulfuric acid, for example, was needed for the production of dyes and for the treatment of many metals. Even in 2001 sulfuric acid was still being produced in greater amounts than any other chemical other than water with a worldwide production of 165 million tonnes and with a value of approximately $8 billion (global production by 2016 has risen to 264 million tonnes with major production in Western Europe, Canada, Japan, South Korea, and Peru). Sodium carbonate, on the other hand, was important for the production of glass, paper, and soap and for cleaning and bleaching wool and cotton cloth. In the early eighteenth century, cotton linen was bleached by alkali treatment followed by repeated dipping in buttermilk and exposure to sunlight, a process that could take many months and used huge amounts of milk. Buttermilk was replaced by sulfuric acid in England in 1758 but this only increased the societal demand for oil of vitriol and soda ash. Therefore, finding ways to efficiently produce these and other important chemicals became an urgent task for society and many early innovations took place in the United Kingdom and in France.

Prior to this, in the period 1600–1800, chemistry had been mainly concerned with the alchemical search for the elixir that would transmute base metals into gold (Holme 2006) and therefore the need for efficient methods to make the chemicals required to meet the demands of a growing population could be said to have transformed industrial chemistry. In France, where there was a shortage of alkali, in part because of its strong glassmaking industry, the French Academy offered a prize for a process to convert common salt (sodium chloride) into sodium carbonate, and in 1791 Nicolas Leblanc filed a patent for what became

known as Leblanc's process. The Leblanc process transformed England's soda-ash industry in particular and led to the growth of the so-called soda factories in Liverpool, Newcastle, and Glasgow. Despite the economic benefits to England, there was a negative side to this success because hydrochloric acid was released into the air to return to the ground as acid rain. More than a century before the term "Green Chemistry" would be coined, there was concern about the societal and environmental impact of the soda process and in 1863 the Alkali Act required manufacturers to build towers that would absorb the gas. The Alkali Act went through several amendments and became the main legislative control of industrial pollution in the UK until it was repealed and replaced by the Environmental Protection Act of 1990 (McGrayne 2001). Meanwhile, whereas Europeans became major producers of these important raw materials, the United States tended to import alkalis and acids rather than manufacture them locally because American administrators favored free-trade agreements prior to the American Civil War (1861–5). The United States could import these materials for less than it would cost to manufacture them. For example, in 1870, the United States produced only 93,700 tonnes of sulfuric acid, ten times less than the UK on a per capita basis (Murman 2002). However, a change in the political environment in the United States and the subsequent emergence of large American chemical companies (DuPont in 1802, Colgate in 1806, and Proctor and Gamble in 1837) would gradually pull the center of the chemical industry across the Atlantic. In Europe, Germany became the major player in the production of sulfuric acid in the late nineteenth century and their production would exceed that of the UK by 1913 (Murman 2002).

The emergence of the dye industry, however, was very much focused on Europe, initially in England and France, and then later in Germany and Switzerland. In 1856 William Perkin discovered the synthetic colorant, mauveine, derived from coal tar. The production of mauveine by Perkin & Sons was the first industrial multistep synthesis of an organic chemical and the foundation of the modern chemical industry (Holme 2006). The discovery of mauveine was quickly followed by a red synthetic dye, *fuchsine* (1858), and shortly afterwards by *Hofmann violet*, *Perkin green*, and *Manchester brown*. This led to the introduction of specialist dye-manufacturing companies in England and France. The late nineteenth century saw the emergence of large synthetic dyestuff manufacturers in Germany (BASF in 1861, Bayer in 1863, and Hoechst in 1880) whilst Switzerland (Ciba in 1884, Geigy in 1860, and Sandoz in 1886) also started to produce synthetic dyes and developed a particular reputation for high-quality specialist colorants. By the end of the century the dominance of the UK and France gave way to Germany and the USA for the general chemical industry and to Switzerland and Germany for dyestuffs. Indeed, by the end of the century the UK became a net importer of synthetic dyes. When World War I broke out, the UK was importing 250 tonnes of alizarin, 100 tonnes of indigo,

and 1,200 tonnes of aniline dyes every month. By this time natural dyes had been virtually wiped out by synthetic products (Aftalion 2001). Innovations in dye synthesis and in dyeing methods during the next fifty years, however, would transform the coloration industry yet again.

Dyeing is normally considered to be a process carried out with dyes that are soluble in water and that have an affinity for the fiber (which means there is a tendency for the dye to react with the fiber and form a bond). Yet one of the oldest coloration methods was vat dyeing. Vat dyes are insoluble in water and cannot be used to dye fibers directly by conventional aqueous methods. However, chemical reduction of the dye using an alkali solution produces a colorless and soluble form of the dye (referred to as the *leuco form*), which can be applied to textiles; subsequent exposure to air (allowing the chemical process of oxidation) reforms the original insoluble (and importantly, colored) dye.

Vat dyes were originally obtained from natural materials. Indigo, for example, is used to produce blue colors and was derived from a plant (*Indigofera tinctoria*); there are records of its use in India since before the Greco-Roman era but it later made its way to ancient Rome and Greece where it was used to color luxury products such as silk. In Europe, indigo was traditionally extracted from woad (*Isatis tinctoria*) whilst *Tyrian purple* was extracted from molluscs. These natural vat dyes were expensive (indigo became known as "blue gold" because of its high trading value) and of variable quality (Clark et al. 1993). The first attempts to synthesize indigo were described by Adolf von Baeyer in 1878 and BASF developed a commercial process that was in use by 1897. In 1901 René Bohn, also of BASF, discovered the synthetic vat dye known as *Indanthrone blue*. The discovery of synthetic vat dyes allowed the natural sources to be replaced by synthetic equivalents that were less expensive and of a more consistent quality. Vat dyes, which were particularly useful for dyeing cotton, produced colored material that was very stable and did not fade with washing. In fact, the colors were so wash-fast that it was thought the fiber would perish before the dye and there were even concerns about their negative impact on trade and the growing fashion industry (Kay-Williams 2013). The most popular use of vat dyes today is to dye denim (and the iconic blue jeans) with synthetic indigo. However, the chemical synthesis of vat dyes on a wide scale required a further technical breakthrough. This was the development of a process to manufacture the chemical anthraquinone from naphthalene and benzene (which were coal-tar products). Anthraquinone is the starting chemical that is required for a number of different vat dyes. The first successful commercial production of anthraquinone was carried out by DuPont in the United States in 1919.

The Great Exhibition in 1851 had been a huge success for Britain but it did reveal that the UK lacked a systematic technical education in contrast with other European competitors. In 1852 the Society of Arts invited the various unions of the Mechanics' Institutes to a meeting to discuss technical education.

Shortly afterwards 90,000 members of these institutes became affiliated with the Society of Arts, which became dedicated to scientific development and examination. The Society of Dyers and Colourists (SDC) emerged as the UK's leading professional organization for technical expertise and education in color. The SDC's UK membership rose from a couple of hundred shortly after the inception of the society in 1884 to about fifteen hundred in the early 1920s as scientific and industrial life became an increasingly important feature of British society (Tordoff 1984).

The development of several new categories of dyestuff in the early part of the twentieth century led to a difficulty in categorizing and identifying the various new products. This led the SDC to produce a new index (or catalog) of dyestuffs that could make sense of the thousands of trade names and different scientific categories. The SDC produced their first edition of *The Color Index* in 1924 and it is still in widespread use nearly one hundred years later. By the early twentieth century the dominance of German dye manufacturers was such that practically every country imported German dyes (see Table 2.1), including major consumers in the Far East such as China and Japan (Morris and Travis 1992). In 1913 Germany produced 137,000 tonnes of valuable synthetic dyes compared to the UK's 5,000 tonnes (Murman 2002) and became the dominant manufacturer of synthetic dyestuffs (Table 2.2). It is clear that the synthetic dye industry and the chemical industry developed hand in hand and in response to socio-economic and population changes in the eighteenth and nineteenth centuries. The industry was subsequently changed somewhat with a rise in protectionism and import tariffs (following World War I), and the huge chemical corporation IG Farben was set up in Germany in 1925. Meanwhile, in the same year, the UK responded with the formation of Imperial Chemical Industries (ICI) by merging the four largest British chemicals firms, one of which was the British Dyestuffs Corporation.

Until about 1920, fibers from natural materials such as cotton, silk, wool, and linen were mainly dyed from aqueous solution. However, the development of manmade cellulose acetate (also known as *artificial silk*, and by the brand names

TABLE 2.1 Major Importers of German Dyestuffs in 1913.

Country	Export (tonnes)
United States	13,855
China	8,461
India	3,822
Japan	3,500

Source: Morris and Travis 1992.

TABLE 2.2 Leading Dyestuff Producers in the Early Part of the Twentieth Century.

Country (year of information)	Capacities (millions of pounds)
Germany (1913)	280
United States of America (1923)	94
United Kingdom (1920)	43
France (1923)	24
Switzerland (1920)	24
Japan (1919)	10
Italy (1922)	10

Source: Morris and Travis 1992.

Celanese and Rayon) created considerable technical challenges because this new fiber was hydrophobic (did not absorb water). Cellulose acetate is the acetate ester of cellulose (an organic material found in many plants that is used to produce paper) and was first experimented with in the 1860s. The first soluble forms of cellulose acetate were invented in 1903 by Eichergrün and Becker in Germany. By 1910 this material was being used to produce film for the motion picture industry and as a coating for some components in the aircraft industry. However, in 1913 the Dreyfus brothers managed to spin a continuous filament yarn that would have potential as a fiber. The British Cellulose and Chemical Manufacturing Company was set up in 1914 and a similar factory was set up in the United States. Originally these factories produced acetate dope (lacquer) for film and as a coating but increasingly yarn was produced that could be used to make garments.

Although vat dyes could be used on acetate fibers to some extent, the extreme alkaline conditions required to generate the soluble (colorless) form of the dye were damaging to the acetate fibers themselves. A scientific breakthrough in coloration occurred with the introduction of a further new class of dyes known as *disperse dyes*, which were also often produced from anthraquinone as the starting point. The British Dyestuffs Corporation developed ionamine disperse dyes in 1924, which were applied as a dispersion of particles in water (rather than in a solution) in a method that relied on new advances in theoretical chemistry. Not only could they be used to dye acetate fibers but also they would subsequently be used to dye the hydrophobic fiber polyester, which would be invented in the UK in 1941. In fact, today, disperse dyes are chiefly used to color polyester fibers.

Polyester is a polymer that contains an ester functional group. An ester is a chemical compound derived from an acid in which at least one hydroxyl (–OH) group is replaced by an alkoxy (–O–alkyl) group. Depending upon the copolymers, polyester can be represented as a number of different materials. It was W.H. Carothers (working at DuPont in the USA) who discovered that alcohols and carboxyl acids could be mixed to create fibers, but two British scientists (Whinfield and Dixon) patented polyethylene terephlatate in 1941, which became the basis of polyester and the brand name Terylene (first manufactured by ICI). World War II had made the supply of cotton difficult and by 1945 DuPont bought the rights to make polyester and started to produce it in a factory in Delaware. One advantage of polyester fibers is that they can be easily dyed using disperse dyes. When heated to about 100°C polyester expands and allows the dye molecules to enter (although note that in practice polyester is normally dyed at about 130°C in pressurized equipment). In the 1950s and 1960s fibers such as Terylene (in the UK) and Dacron (in the USA) were marketed as being strong and easy to wash and dry (they could be scrunched up and yet did not require ironing). Today, however, where there has been a societal movement toward natural fibers, polyester is considered to be a cheap fiber that is uncomfortable when worn next to human skin. Also, like many textile products, polyester is considered to have a negative effect on the environment (for example, fabric constructed from polyester/nylon blends can take up to forty years to decompose), though the recent development of microfibers is perhaps starting to change perceptions of the role of polyester in society.

The third major synthetic fiber was nylon, which was first used commercially in 1938 for the bristles in toothbrushes, quickly followed by its use in women's stockings (first shown at the 1938 New York World's Fair). Like polyester, nylon is also a polymer, but made from repeating units of diamines (–NH2) or diacids (–COOH). Carothers, who had been working on polyester at Du Pont, produced the first example of nylon, a variant known as nylon 6,6. Du Pont obtained a patent for nylon 6,6 in 1938 and quickly achieved a monopoly of production of the fiber. Nylon can be easily dyed using either acid dyes or disperse dyes. Although the popularity of synthetic fibers such as nylon and polyester has fallen since the 1970s, it is clear that they made a significant contribution to society in the twentieth century. Nylon, in particular, captured the public's imagination and influenced fashion in a way that few other fabrics would.

The 1950s saw the introduction of a new class of dyestuffs called *reactive dyes*. Reactive dyes, as their name suggests, chemically react and bond with the fiber. In fact, they had been investigated in the 1800s but were commercialized by Rattee and Stephens (working at ICI in the UK) in the early 1950s. Reactive dyes are most commonly used to color cotton and, occasionally, wool and can

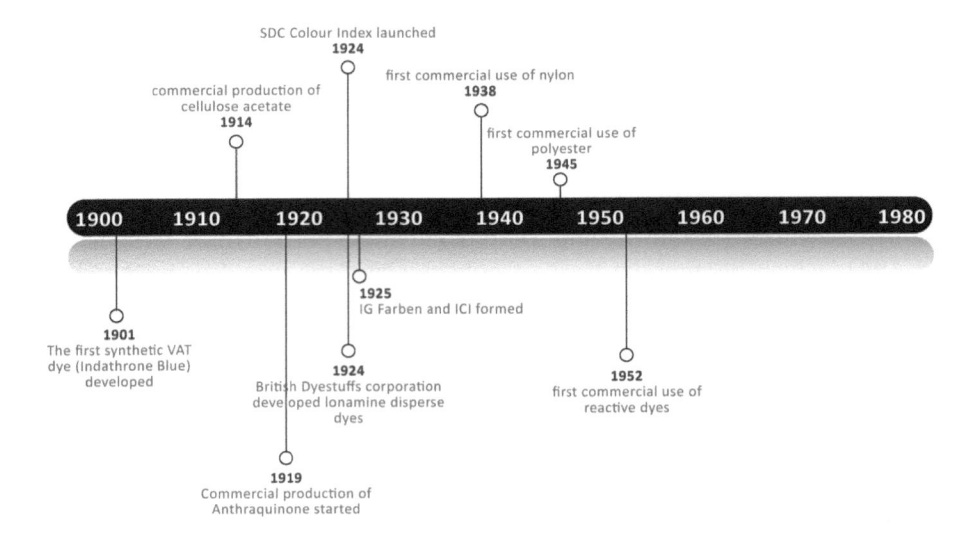

FIGURE 2.1 Selected timeline of developments of dyestuffs and materials in the twentieth century. Image by Stephen Westland and Qianqian Pan.

produce excellent wash fastness because of the chemical bond that they form with the fiber. A timeline for some of the events described in this section is shown in Figure 2.1.

PHOTOGRAPHY AND DIGITAL IMAGING

It is difficult to imagine any technological development in the twentieth century that changed everyday life more than the color image. In 1972 the crew of the Apollo 17 spacecraft took an image of the earth (formally named by NASA as AS17-148-22727 but known colloquially as the *blue marble*). Although not the first image of the earth to be produced, AS17-148-22727 was released at a time when there was huge concern about the environment and it became an icon for Earth's frailty, vulnerability, and isolation (see Plate 2.1 and Figure 2.2). Although it is hard to quantify the impact that this image had on society, interest in the environment grew substantially in the years following the release of this photograph (Wuebbles 2012).

The first publicly available photographic process was the daguerreotype (1839) which produced highly detailed and permanent gray photographs on silver-plated sheets of copper. Each image produced by the daguerreotype process was unique. They were very expensive, originally costing about 25 gold francs per plate, and were often kept in cases like jewelry. It has been suggested that the invention of the daguerreotype directly encouraged American cultural

FIGURE 2.2 The *blue marble* image of the earth released by NASA in 1972. Public Domain.

nationalism and an emerging definition of the American character (Rudisill 1971). Prior to the daguerreotype, Nicéphore Niépce had generated a permanent image taken from a camera, but the exposure took several days. By contrast, the daguerreotype required an exposure of only a minute or two. The daguerreotype did not create true color images but sometimes the plates were hand-colored using watercolors or pastels. Early cameras were produced in the 1800s but they only created achromatic images. Eastman Kodak was founded in 1888 with the Kodak No. 1 box camera and this was followed in 1900 by Kodak's iconic Brownie camera. A color photograph was produced in 1886 by Gabriel Lippmann using a phenomenon known as *interference* (Nareid 1988).

Although Lippmann would later win the Nobel Prize for Physics for his invention, the process was not practical for consumer use and it was James Clerk Maxwell's ideas that would essentially form the basis of color photography in the early twentieth century. Maxwell had suggested the idea of a projected color

image using three color primaries as early as 1855. In 1861, at a lecture given by Maxwell at the Royal Institution, a color image was projected that had been captured by Thomas Sutton (who developed the single-lens reflex camera the same year). The method used three separate black-and-white photographs taken and projected through red, green, and blue color filters to produce a temporary, but seemingly full color, image. Maxwell's method is, of course, based on the scientific principle of additive color mixing which allows a wide range of colors to be produced using three so-called primary lights (see Plate 2.2).

The problem with Maxwell's method, however, was that it was necessary to take three photographs (each through a colored filter); this was tedious and the camera (or the subject) could move between the shots, which resulted in blurring at best. Each of the three images were captured on a gel or emulsion containing silver halide particles that would react to light to leave particles of silver, recording a permanent image of where the light had fallen. Although some cameras were developed that could take three images at the same time, using an arrangement of mirrors, it was Louis Ducos du Hauron who proposed having an emulsion with three separate layers on top of each other so that the process could be exposed at once in any ordinary camera system. These so-called tripacks were sold to consumers and the development of celluloid (generated from cellulose acetate) was a key technological breakthrough in providing a strong but flexible base for the emulsion.

During the early 1930s, Agfa-Ansco in the USA produced roll-type film for snapshot cameras known as Colorol. This allowed consumers for the first time to buy film for their cameras and send the exposed negatives back to Agfa-Ansco for development into permanent color photographs. Unlike Maxwell's system the tripacks were based on subtractive color mixing using cyan (red absorbing), magenta (green absorbing), and yellow (blue absorbing) dyes on paper. The images were not perfect as light tended to scatter as it passed through the photographic layers, producing a slightly blurred image. In 1935, Kodak introduced their first tripack film and labeled it as Kodachrome. The refined Kodak color process used three layers of emulsion on a single base that captured the red, green, and blue wavelengths. The processing of the film was quite involved (requiring more than twenty-five individual stages), but the Kodak commercial model had been along the lines of "you press the button, we do the rest" ever since they released their box camera in 1888. Customers became accustomed to sending their finished rolls to Kodak who would return either prints or slides (transparencies). Eventually, in 1936, Agfa was able to simplify Kodak's development process by developing all three layers at one time. Color photography was still considered to be for special occasions, however, right through the 1950s and 1960s because of its high cost. Nevertheless, over time the cost of color photography gradually reduced until by the 1970s it had almost replaced black-and-white photography in all but the most artistic of situations.

In 1947 Edwin Land, founder of the Polaroid Corporation, announced the invention of the Polaroid photographic process. The idea behind this invention was that it would remove the requirement to send film to a third party to be developed. Instead, an "instant" photograph would be produced by the camera for the consumer. When Land demonstrated his camera he fired the shutter, pulled out the film, and ran it through a set of rollers before setting a timer for fifty seconds. He then peeled away the back sheet to reveal the image. Within a week his image was Picture of the Week in *Life* magazine. Arguably Land's invention did as much as any other to change our relationship with technology. The immediacy of the image produced was a forerunner of the modern digital era and the dominance of apps such as Snapchat and Instagram. With the early commercial Polaroid model (known as Model 95), the consumer was still required to time the development of the file; the film would be pulled out of the camera to activate a pod of reactive agent, the consumer would wait about sixty seconds, and the negative would then be peeled away to reveal the final color print (Buse 2010).

Approximately a quarter of a century later, various technological advances allowed Land to achieve his aim (which he called "absolute one-step photography") of having the camera automatically produce a white-bordered image that developed in front of the consumer. The so-called "One-Step" polaroid camera (the SX-70 was released in 1972) became the world's most highly sold camera in the 1980s, placing Polaroid second only to Kodak in terms of the world manufacture of consumer photographic equipment. Although speed and convenience were two important properties of the Polaroid system, it is worth noting that a third property was uniqueness. Whereas other photographic processes could produce multiple copies, the Polaroid system produced a single, unique, photographic record (Buse 2010). The elimination of the expert developer from the process placed control firmly with the consumer, yet the speed and convenience of the system may have acted to devalue photographs, which until then had acquired a special status in terms of appearing to preserve the past (Buse 2008).

Traditional consumer photographic processes, from the daguerreotype onwards, were based on chemistry, but a new digital process would decimate the industry toward the end of the century. The key technological breakthrough was the ability to capture a pattern of light electronically rather than chemically and to store this as digital information. Although Eastman Kodak are often thought to be the company that suffered most from the new digital technology it was, in fact, Steve Sasson (working at Kodak) who invented the first prototype digital camera in 1975. This prototype was almost as large as a desktop printer and took twenty seconds to capture one low-quality image. Kodak also produced the world's first megapixel digital camera in 1991, which had a 1.3 mega-pixel sensor and a Nikon F-3 body. However, in retrospect, it is clear that Kodak

made some poor decisions and perhaps focused too much on the professional side of digital imaging where they were attempting to create digital imaging workflows that matched the quality of film.

Over the next forty years the quality of digital imaging would improve each year and the cost would fall without necessarily reaching the standards of traditional film photography. It was probably the disruptive effect of the mobile phone industry merging camera technology with their handsets that destroyed the market for traditional film, despite traditional film maintaining a technical advantage in quality. Suddenly image quality was relatively unimportant and what dominated was what the consumers could do with their images and how they could share them in real time. As American photographer Chase Jarvis (2009) entitled his book on iPhone photography, *The Best Camera is the One That's With You.*

In the movie industry, images were originally captured using black-and-white film. Hand coloring as a postproduction process was often employed and, although time-consuming, was viable at a time when most movies were short (often ten minutes or less in length). For example, George Méliès employed twenty-one women to hand-color his film, *Le Voyage dans la Lune*, frame by frame in 1902. This process was mechanized somewhat (using stencils) with the introduction of Pathécolor (1903) but still relied upon a large labor force. A less labor-intensive method was to dip the film into a dyebath to perform tinting (where the frames would be colored with one particular shade) and toning (where only the densest, shadowy parts of the image would be colored). Although this method could be used to help create an atmosphere it was often used indiscriminately, and by the late 1920s about 80 percent of American movies used some form of tinting or toning.

The first commercially successful photographic color process for moving images was Kinemacolor, invented by George Albert Smith in the UK (1909). This was along the lines of Maxwell's system but used just two primary colors in an additive system. Alternative frames of film were captured through either a red or a green filter and when these were played back using a flywheel with red and green filters the result would be a reasonably good color image on screen. The Kinemacolor process was notably used for the documentary *Durbar at Delhi*, directed by Charles Urban, which portrayed the coronation of George V as the Emperor of India in 1912.

The second major color process in the movie industry was Technicolor (as detailed from an aesthetic perspective in Chapter Seven, this volume) and this dominated Hollywood from 1922 to 1952. In fact, the term Technicolor has been used to describe a number of different processes. The first Technicolor process (1917) was a two-color additive process somewhat similar to Kinemacolor. However, it was the second process (1922) that was so successful. This was based on subtractive color mixing. In subtractive color mixing the

primary colors cyan, magenta, and yellow are subtracted from white to generate a wide range of colors. In the second Technicolor process a beam splitter in the camera allowed two successive frames of a black-and-white film to be exposed, one through a red filter and one through a green filter. Until Kinemacolor, however, instead of using these two frames in an additive system, the two frames were toned to generate cyan and magenta transparencies and these were combined into a single frame print. Because the cyan and magenta frames were combined in a single print they could be used in cinemas with regular projectors equipped with a white light. *The Toll of the Sea* (1922) was the first movie for general release that used the Technicolor 2 process. Although successful there were technical difficulties with the Technicolor 2 process and of course the color reproduction was poor for some colors (especially yellow) because of the use of just two primaries. Technicolor made some improvements but then introduced a three-color process that became known as Technicolor 4. Red, green, and blue negative frames were generated and these were used to control cyan, magenta, and yellow primaries in the final print. The process produced beautiful movies but was expensive and required cumbersome and expensive Technicolor cameras that were capable of the requisite beam splitting.

Major Hollywood companies were not easily convinced to invest in the new technology and so Technicolor offered the process with good financial terms to a start-up company called Walt Disney. *Flowers and Trees* (1932) and *Three Little Pigs* (1933) were huge commercial successes for Walt Disney, winning Oscars. Warner Bros. then produced *The Adventures of Robin Hood* (1938) in Technicolor, which won three Academy Awards for aesthetic use of color. The color gamut of Technicolor was particularly evident in its use the following year in *The Wizard of Oz* (1939). In the 1940s Technicolor dominated the color film market despite the US government's attempts to break the monopoly with an anti-trust civil case against them.

The Agfacolor process was a similar three-color system that was used by the Germans to make propaganda movies during World War II. The patents were released after the war and the process was adopted widely and became Sovcolor in the USSR and Fujicolor in Japan. However, Eastman Kodak refined the process and renamed it Eastmancolor. This process produced less brilliant colors than Technicolor but was much simpler and did not require expensive cameras. Despite being arguably a technically inferior product, its low cost and ease of use meant that Eastmancolor came to dominate the movie market so that by the 1960s almost all mainstream movies were shot in color.

Although digital imaging was slow to permeate, in the movie industry the impact on traditional photography was dramatic and sudden, affecting many companies; none more so than Eastman Kodak. In 1962 Eastman Kodak employed over 75,000 people with sales exceeding $1 billion, reaching peak employment in 1999 with over 145,000 employees worldwide. However,

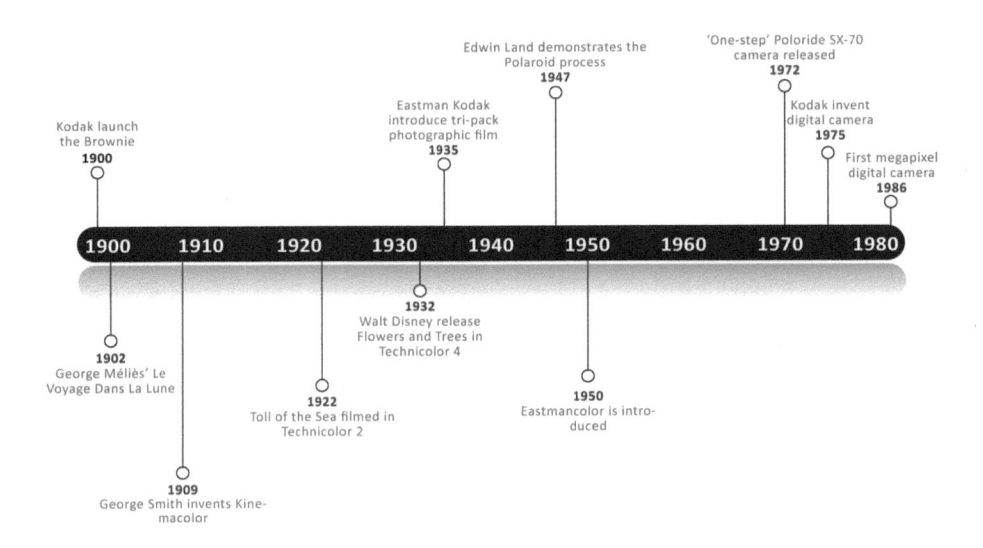

FIGURE 2.3 Timeline of developments in color photography in the twentieth century. Image by Stephen Westland and Qianqian Pan.

the company that invented photographic printing and the digital camera and dominated the photographic film industry filed for bankruptcy in 2012. The digital revolution did eventually affect the movie industry too. Movies started to be shot entirely in digital in the late 1990s and digital cinemas (where instead of shipping reels of film, movies are delivered to cinemas instantaneously through the internet) started to replace traditional cinema projection. Although distribution costs may be massively reduced, the digital projectors themselves are very expensive (around $100,000 each). One of the first well-known movies to be shot entirely in digital was *Star Wars Episode II: Attack of the Clones* (2002). Today 4K digital movie cameras can produce colored images of virtually equivalent quality as traditional film although some filmmakers still prefer 35mm film to achieve particular desired effects. A timeline for some of the events described in this section is shown in Figure 2.3.

COLOR MEASUREMENT

Color measurement has been a crucial enabling technology during the second half of the twentieth century. Not only did it allow manufacturing companies to efficiently and accurately produce colors that were demanded by consumers but it was also the basis on which digital color imaging came to dominate the internet and continues to do so today. It has been estimated that about 1.8 billion images are uploaded to the internet every day. A total of

300 million digital images are uploaded to Facebook alone every day. Different imaging devices use different technologies and different color primaries. The consequence of this is that without color management there would be huge variance in color appearance in images as they were transferred from one imaging device to another (for example, from screen to print or between two screens). It is arguable that consumers would not be interested in sharing digital images of their experiences if there was a substantive lack of color fidelity. The reason that color fidelity exists is that color management is embedded in the operating systems of our mobile phones, our tablets, and our computers and televisions. Color management is ubiquitous and yet the vast majority of consumers are unaware that it exists at all. When anyone looks at their phone, uses their smartphone, or goes to the cinema, they are almost certainly using color management even if they are unaware of this fact.

Color management relies upon color measurement, and a system for achieving this was published in 1931 by the International Commission on Illumination (Commission Internationale d'Éclairage, or CIE). In fact, the term *color measurement* is somewhat of a misnomer since it is arguable that the CIE does not strictly speaking *measure* color. The term *color* is usually employed to refer to the perceptual experience that we have under certain circumstances. It is difficult to communicate the true nature of our private experience to others, never mind measure this experience. However, the CIE system does allow the specification of color stimuli that relates to our visual experience. There were two important technological innovations that made the CIE system possible. The first of these was the understanding that color is something more than physics. In other words, just because two physical stimuli do not match does not mean that these two stimuli might not have identical color appearance. Physical objects can be characterized by their reflectance factors, which define the proportion of incident light reflected by the object at each wavelength in the visible spectrum. If two objects have identical reflectance factors at each wavelength then they will likely have identical color appearance if viewed by an observer under the same conditions. However, the objects may have identical color appearance even if their reflectance factors are very different. This is a phenomenon known as *metamerism*. Metamerism occurs because our visual systems are equipped with specialized receptors (known as *cones*) that have broadband spectral sensitivity. The human eye contains three classes of such receptors, each of which is maximally sensitive to a different part of the visible spectrum. In the 1920s it became evident that simply measuring the reflectance factors of an object would be insufficient to specify the color of the object; it was necessary to record the visual response to the physical stimulus. The problem was that the properties of the visual system were rather poorly understood in the early part of the twentieth century. In fact, the spectral sensitivities of the cones in humans were not measured accurately until the 1960s. Fortunately,

the notion of additive color mixing was established and it was understood that the human visual system was trichromatic.

The second important technological innovation was the notion that additive color mixing could be used to indirectly incorporate the human visual system into a measurement system. Jacob Le Blon (1667–1741) was a painter and engraver from Frankfurt who developed a commercial system for creating colored prints using three or four primaries. In Le Blon's system (1710), a set of three engraved metal plates would typically be used to print each of three primary inks. His method required that the target image that was to be reproduced had to be deconstructed into the three primary contributions. When overprinted the three or four (since black was sometimes added to the red, yellow, and blue primaries) contributions would produce a convincing color image print. Although creating the plates was time-consuming and highly skilled, once these plates were obtained it was possible to print multiple copies of the image. For the first time, consumers could have their own reproduction of famous fine art paintings. Le Blon's commercial venture ultimately failed because it was simply not cost-effective to create the printing plates. However, his ideas set the scene for subsequent developments in color printing and provided the basis for trichromatic techniques.

Thomas Young postulated the existence of three classes of sensor in the human eye (1802) and Hermann von Helmholtz developed the theory further by stating that the three types of cone photoreceptors could be classified as short-preferring (blue), middle-preferring (green), and long-preferring (red) (1850). Additive color mixing, which proved to be critical for the development of color photography, allows a color stimulus to be matched by the superimposition of light from three primaries. Although there is no one set of additive primaries and it is impossible to match all colors using just three primaries, it turns out that the largest color range (or gamut) can be produced using red, green, and blue primaries. The amounts of the three primaries that are used by a human to match a color are known as *tristimulus values*. The clever trick recognized by the CIE was that if these tristimulus values were determined for each individual wavelength in the visible spectrum then it would be possible to predict the tristimulus values that would be used if someone were to match any arbitrary color stimulus.

Human color vision varies from person to person, however, so it was necessary to measure the so-called color-matching functions (these being the tristimulus values that match each wavelength of light in the visible spectrum) for a group of people and then average these. Experiments were carried out by two scientists at approximately the same time in the late 1920s. William David Wright carried out a set of measurements at University College London and John Guild carried out a set of experiments at the National Physical Laboratory. Since both scientists used quite small groups of observers the data were combined to

create a single dataset known as the Standard Observer. The Standard Observer could be used to predict the tristimulus values for any physical color stimulus. The key achievement of the CIE system of colorimetry (1931) was to be able to predict whether two physical stimuli would be a match to an average observer. The CIE system is now nearly ninety years old but it still forms the basis of the international system for color specification today.

A revision to the CIE system was made in 1964 and various color spaces have since been published, most notably CIELAB in 1976. Until the introduction of general-purpose computers the necessary calculations were carried out by hand and were laborious and time-consuming. However, the introduction of computers in the 1960s enabled new opportunities for colorimetry to be used to optimize and control manufacturing processes in which color was a major component. One particularly important innovation was known as *color recipe prediction*, which was a computing system that allowed a manufacturer to predict which dyes or pigments to use (and at which concentrations or levels) to visually match a required color. This enabled manufacturers to find the best and most efficient ways to manufacture color that would either minimize costs and/or maximize other properties such as color fastness.

The COMIC (COlorant MIxture Computer) was introduced in 1958 by Davidson and Hemmendinger who had previously worked at General Aniline & Film (Davidson et al. 1963) and used an analog computer in order to make the color matches. Davidson and Hemmendinger launched a digital version of the system in 1967 (COMIC II). Over the next thirty years these systems became ever more sophisticated and by the 1980s they would routinely cost upwards of £100,000 per unit, but it was claimed that a dyehouse would break even on the investment (because of the savings in dyes, chemicals, and time) within a year (see Plate 2.3).

Color measurement is routinely used to control and communicate color and was an enabling factor in the evolution of global supply chains. It can be argued, however, that it was not until the emergence of the internet and mobile computing that the impact of the CIE system was fully recognized. The CIE system is now at the heart of the color-management systems that enable color fidelity in our television, computers, mobile devices, and cinema, and it has an impact on virtually the whole of the First World even if its importance is rarely recognized. The International Color Consortium (ICC) was formed in 1993 and the founding members were Adobe Systems Incorporated, Agfa Graphics, Apple Computer, Eastman Kodak, and Microsoft Corporation (ICC 2018). The purpose of the ICC is to promote the use and adoption of open, vendor-neutral, cross-platform color-management systems. Without the mutual cooperation of these companies through the ICC it is doubtful that the uptake of mobile devices, for example, would have been so rapid. Today there are as many mobile devices on the planet as there are people. Every two minutes humans take more digital

color images than ever existed in the previous 150 years (it is estimated that in excess of 700 billion digital images are uploaded to the internet every year). Color fidelity has been an important enabling technology in this growth and at the heart of modern color fidelity is the CIE system of color measurement.

CONCLUSION

This chapter has surveyed the key twentieth-century developments in the areas of producing and using color. Technological advancements in the way that color was produced and consumed were rapid in this period and had a wide impact on society. Indeed, as we have seen, some of the technological innovations were driven by societal changes. The field of textiles has been particularly important, including the introduction of synthetic textiles and the subsequent development of new classes of dyestuffs (for example, disperse dyes), the discovery of reactive dyes for cotton in the 1950s, and the impact of global supply chain management on the communication of color. It is impossible to consider the development of color in the twentieth century, however, by focusing on textile applications alone. We have argued that the introduction of low-cost durable plastics transformed the ways in which color was used in the workplace and in households. It is also necessary to be aware of the introduction of color photography and color television as technological advancements that had major impacts on society and culture. In the latter part of the century the introduction of computers and the invention of the internet were transformative and changed the way in which color is produced, distributed, and consumed by society.

Power and Identity

ZENA O'CONNOR

INTRODUCTION

The use of color as a form of code intended to convey meaning linked to identity, persona, presence, and power within a broader lexicon of visually based signifiers has a long tradition and dates back to preliterate cultures. This chapter explores the ways in which color has been used to signal, symbolize, and reinforce identity as well as to influence or even exert power in some manner. Ranging across a number of perspectives and sectors, color will be discussed in terms of its three attributes: hue, tonal value (lightness-darkness), and chroma (also referred to as saturation). These distinctions are important because color perception is complex and responses to color vary considerably depending on intensity or lack of chroma, and whether a hue is depicted in tints, shades, or varying degrees of lightness or darkness. In common parlance, references to color are often made in respect to the attribute of hue alone and variations in tonal value and chroma are accounted for by the use of color names such as *pink* or *turquoise* and by qualifiers such as *pale* or *vivid*, amongst others. A drawback of this practice is the differences in meaning and understanding of any given color name (Ostwald 1916; Munsell and Cleland 1921; Albers 1963; Itten 1973; Gage 2000). Examining color and its relation to power and identity is a wide-ranging endeavor and this discussion is limited by necessity to specific sectors: politics, branding, architecture, literature, cinema, fashion design, and social media. These have been chosen because of the prevalence of color in these sectors (in terms of visual imagery) and the impact and influence these sectors have in the modern age.

POLITICS

Color (predominantly in terms of hue alone) has played a key role in the visual imagery associated with cultural and political groups since preliterate times. Like the purple worn by emperors in ancient Rome and the blue woad of the early Britons in the first century CE, the practice of wearing color to distinguish political allegiance, status, and power continues today. Recent key examples include the black shirts worn by the paramilitary wing of Benito Mussolini's National Fascist Party (1923–43); the red nationalistic paraphernalia and dark charcoal/green "Mao" suits popular in China under Chairman Mao Tse-tung (1949–76); the red shirts worn by supporters of the United Front for Democracy against Dictatorship in Thailand (2008–2015); and the distinctive red plaid shirts worn by Basuki Tjahaja Purnama (known as Ahok) and his supporters during his 2017 governorship campaign in Jakarta, Indonesia.

From another perspective, color-coding was imposed as a particularly infamous form of identification and power-control by the Nazi administration in Germany. This arose primarily due to Adolf Hitler's stand against Jews and other minority groups from the 1930s onwards. Hitler's administration required all people of the Jewish faith to wear a yellow Star of David armband, and eventually this form of color-coding was used to assert and exercise power over a number of different minority groups during World War II. The official SS (*Schutzstaffel*, a Nazi paramilitary organization) chart of color-coding was designed in Dachau, the model camp for all other Nazi concentration camps. The color-coding system involved the manufacture of badges that were affixed to individual camp uniforms, and these varied slightly from camp to camp mainly due to differences in the printing process involved in manufacturing them. Whilst the specific rationale for each color code is somewhat elusive, the colors were chosen not just for differentiation and control purposes but to encourage existing political, social, and religious conflict (Kwiet 2017).

The Nazis enforced a system of color-coding for labor and concentration camp inmates, and this involved the use of badges generally in the form of a triangle pointing downwards: red for political prisoners, green for "professional criminals," blue for foreign forced laborers, purple for Jehovah's Witnesses, pink for sex offenders and homosexuals, black for "Asocials"—that is, alcoholics, the mentally ill, and drug addicts, brown for Roma gypsies, and yellow for people of Jewish faith (United States Holocaust Memorial Museum 2012).

After World War II, the pink triangle became a symbol of the gay and lesbian movement and an inverted format (triangle pointing upwards) often features in visual imagery, iconography, and memorial sculpture related to this social group. Many examples exist including the Gay and Lesbian Holocaust Memorial (GLHM) in Sydney, designed by Russell Rodrigo and Jennifer Gamble (2001) and the *Homomonument* designed by Karin Daan and installed in Amsterdam

FIGURE 3.1 Gay and Lesbian Holocaust Memorial, Sydney, Australia. Public Domain.

in 1987, both of which feature a pink triangle (GLHM n.d.; Homomonument 2013) (see Plate 3.1 and Figure 3.1).

Some politicians use color in a more subtle, strategic way. During the 2016 United States presidential campaign, Hillary Clinton used color to achieve three key aims: create unambiguous visual differentiation from her opponent; to assert a strong sense of statesman-like identity, power, and presence; and to convey symbolic associations relevant to American history. During her campaign, Clinton frequently wore the colors of the American flag (red, white, and blue) to reinforce her patriotism and dedication to the people of America. Clinton's strategic use of color is evident in each of the presidential debates. For the first debate, Clinton wore a saturated red pantsuit, this color has attentional advantage, ensuring that her presence stood out onstage and on camera. It is likely that Clinton also wore red due to its associations with winning and competitive advantage, hoping to harness these attributes to project a sense of power and confident success. These cultural associations were dominant, even though red is the color for the Republican Party, and blue for the Democrats. Clinton wore a navy and white pantsuit for the second presidential debate and this strong color contrast not only presented a persona but conveyed connotations associated with blue: dependability, stability, reliability.

For the third and final presidential debate, Clinton wore white, a color that contrasted with the darker background, enhancing her presence and prominence onstage and on camera. In addition, white is associated with purity, innocence, and virtue, and it is likely that Clinton hoped these connotations might help to mitigate the negative press that dogged her campaign. Aside from these color connotations, women's rights became a prominent issue during the 2016 US presidential campaign and Clinton frequently wore white to show her support for women in general and women's rights throughout America. The wearing of white by female politicians continued after the election of Donald Trump to the presidency of the United States mainly because his support of women's rights came into question during the campaign. Clinton wore white to Trump's inauguration ceremony, and when Trump gave his first address to a joint session of the United States Congress, the majority of the Democrat women senators and representatives wore white as a visually effective sign of support for women's rights.

The women's rights movement has used color as a key visual signifier since the emergence of the women's suffrage movement, which evolved into a widespread and transformational political force during the early twentieth century. In this context, it was Emmeline Pethick-Lawrence who initially championed the display of purple, white, and green by members of the Women's Social and Political Union (WSPU) at a Hyde Park, London, rally on June 21, 1908. Emmeline and Christabel Pankhurst applauded the success of these colors and adopted them as the colors of the WSPU movement, which campaigned for women's suffrage and sexual equality. Pethick-Lawrence provided the following beliefs about color symbolism as her rationale for adopting the three colors: "Purple […] stands for the royal blood that flows in the veins of every suffragette […] white stands for purity in private and public life […] green is the color of hope and the emblem of spring" (Pethick-Lawrence in Atkinson 2018: 91). Over time, purple, white, and green became synonymous with the women's movement, although the connotation of purity linked to white has since become problematic. Since the celebration of the first National Women's Day in the United States on February 28, 1909, purple, white, and green have featured in the signifiers and paraphernalia associated with International Women's Day (IWD), celebrated on March 8th each year (Crawford 1999; IWD 2017).

The color of politicians' neckties became an emotive topic in Australia from 2012 to 2015. At the time, Tony Abbot (Australian Leader of the Opposition and subsequently Prime Minister) and fellow Liberal ministers began wearing blue neckties. As a student, Tony Abbott won two Blues (sporting awards) for boxing while at Oxford University and it is possible that this influenced his decision to wear blue ties, a practice that was adopted by many of his Liberal colleagues. Or, perhaps Abbott was using the blue tie as a branding strategy to present a cohesive corporate image and create differentiation from

competing political groups. Despite this, color-coding can have downsides in the political arena as it can convey a lack of individualism and an uncreative herd mentality. At the time, Abbott and his fellow parliamentarians were in opposition to a female prime minister, Julia Gillard, and in late 2012, Gillard delivered her famous "Misogyny Speech" in reaction to the alleged sexism she was experiencing at the time. In this context, the wearing of blue neckties came to be seen as sexist and juvenile, and the ensuing debate led some politicians to abrogate responsibility for tie-color choice to their wives; a response that reinforced perceptions about chauvinism, and the blue-necktie brigade came to be seen as a misogynistic cohort within parliament. As a result, the color of neckties became a negative signifier of inflexibility and chauvinism rather than a positive, unifying signal of strength.

While color-coding can be an effective nonverbal signifier in politics, it can also become a misguided branding strategy depending on context. Strong, saturated colors and individual choice in the political arena can definitely help to convey strength of character, courage, and confidence—personal traits that are important and advantageous in politics. In addition, a range of different tie colors may indicate a political approach associated with diversity and this particular tactic may be more appropriate in a country such as Australia that prides itself on its cultural diversity.

BRANDING AND MARKETING

Color is a key element of corporate imagery and logo design, and is used to create and build corporate identity, branding, and market differentiation. In this context, brand colors are carefully selected to attract and engage attention relative to the target market and also to create a degree of differentiation from competitors, a difficult task in a visually cluttered environment. Over time, corporate and brand colors can become catalysts for recognition and recall, and among established and widely known brands, color alone can become a brand identifier that helps to reinforce market positioning. In a marketing context, color has the capacity to increase brand recognition by up to 80 percent (Olins 1989; Color Marketing Group [CMG] 2006; Hynes 2008; Kotler 2011).

A key aim of most brands is to reach a level of critical mass whereby brand colors and imagery are widely recognized examples of the power of color alone to assert identity, as with Coca-Cola red, Tiffany & Co. turquoise blue, and Cadbury purple. These brand colors are highly familiar and within the broader market prompt brand recognition and recall.

For one brand, this level of recognition and recall prompted by color alone was used to create a highly effective series of surreal print advertisements. At a time when cigarette advertising became highly regulated and brand names of cigarettes were banned, Silk Cut advertisements from the mid-1980s to the

1990s relied on a unique form of intertextuality. That is, their advertisements used brand color (purple) and visual imagery that had been drawn from earlier advertisements to create advertisements that were minimalistic and almost surreal to those unfamiliar with Silk Cut brand colors and previous advertisements. The range of advertisements, created by Paul Arden and Charles Saatchi of Saatchi and Saatchi, London, featured slashed purple silk or purple silk accompanied by scissors or a knife. The campaign was so effective that Silk Cut cigarettes became the highest selling brand in England during the 1990s, primarily due to the unique purple brand color (Squire 2009).

While color symbolism within logo design is common, it is not always stable and consistent, and this can become problematic for a brand. In addition, brand colors may be shared among disparate brands creating some cognitive dissonance among members of the target market. A case in point is the saturated red and yellow brand colors of fast food chains McDonald's and Hungry Jack's. These same colors feature in the imagery and logo design of the prestigious University of Cambridge and, while these brand colors are used to maintain brand identity for all three, the level of differentiation dominance is affected to a certain extent.

Cultural context plays an important role in the ways in which color supports brand identity, and wise marketers pay particular attention to color selection to ensure cohesion between brand identity and values, and color connotations. It is particularly important for global brands to select appropriate colors to avoid the potential for offence arising from the alignment of culturally sensitive colors with inappropriate brand identities or values. Underlying this issue is the knowledge that few examples of color symbolism occur on a universal basis and hence studies have been undertaken to investigate and examine the variations in cross-cultural color symbolism (Aslam 2006). In addition, marketers and brand designers usually conduct logo color mapping and analysis studies to avoid potential problems in appropriateness of color symbolism and duplication of color (O'Connor 2011) (see Plate 3.2 and Figure 3.2).

The lack of absolute stability in color symbolism and the constant evolution of color trends can prompt brands to change their associated colors to ensure that their corporate visual imagery remains relevant and effective. Many logos dating from the early twentieth century changed from black and white to color as printing technology evolved and color was introduced. A key example is IBM, which started as the Computing Tabulating Recording Company before evolving into the International Business Machines Company in 1924. In 1947, IBM launched a simple logo featuring "IBM" in black on white, and in 1956 graphic designer Paul Rand updated the logo to a version with thicker black strokes. In 1972 Rand changed this to thirteen-bar horizontal stripes and then eight-bar horizontal stripes in blue rather than black. The style of the logo and its color coupled with the size and dominance of the company prompted

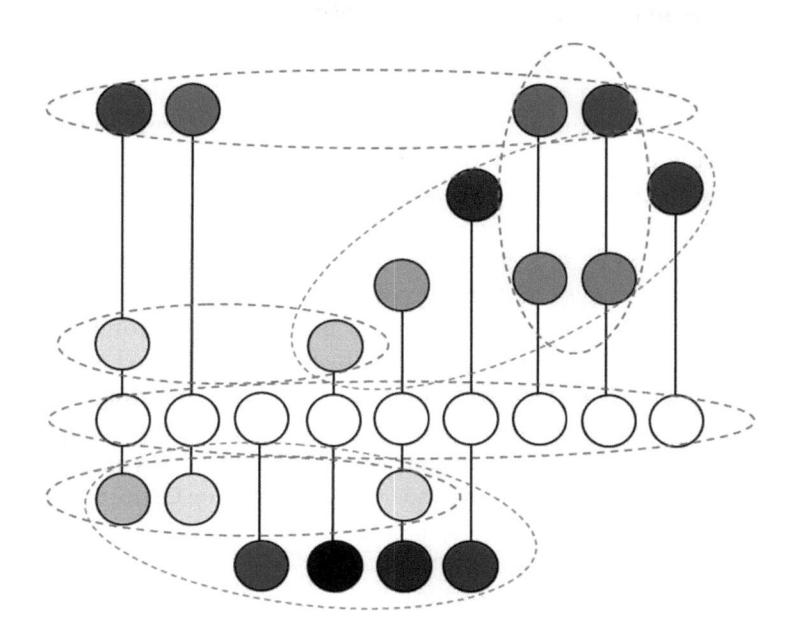

FIGURE 3.2 Logo color mapping study. Image by Zena O'Connor.

perceptions of stability and dependability. These helped IBM to build a strong identity in the marketplace, eventually becoming known as "the Big Blue." This association between the color blue and stability, reliability and dependability, prompted many other technology companies to follow suit and use blue in their logo designs.

A number of companies have changed their brand colors over the last twenty years to ensure visual imagery stays relevant and represents connotations appropriate to brand identity. Initially, most brand colors revolved around the primary hues of red, blue, and yellow in varying tonal and saturation levels. More recently, however, brands are using a wider range of hues as well as a variety of tonal and saturation levels such as the companies FedEx and Spotify. FedEx changed its name from Federal Express and its earlier logo design featured red, white, and blue due to its association with US-government agencies. The new logo was launched in 1994 and this featured a shorter name: "FedEx" in a range of colors to indicate different corporate identities within the organization. The new logo featured a purple "Fed" and variations of "Ex": orange for Express; green for Ground; yellow for Trade Networks; and red for Freight, with the most commonly known and familiar variation being purple and orange. The choice of secondary colors was inspired as these provide greater opportunities for unique brand identity and differentiation. Spotify is another company that

changed the color of its logo in 1995 from earthy green reminiscent of new growth (akin to Pantone "Greenery") to a slightly bluer, more neon green, the latter being seen as more contemporary. However, the color change prompted a reaction on social media, more because of a change from the familiar than a dislike of the new color in a typical case of criticism when customers identify strongly with an established brand color and resist change until they feel comfortable with the new brand color.

A relatively new and effective strategy in branding is the emergence of polychromy, or the use of multiple colors in corporate imagery, branding, and logo design to create identity and convey meaning. Polychromy is a nonverbal way of conveying notions associated with diversity and inclusivity as well as bold confidence. It is a suitable color scheme choice for global organizations and brands that aim to attract and engage a diverse target market across many different countries. Examples include the advertising for Havianas, Perrier, and Ray Ban sunglasses and branding and logo design for the Olympics organization, Google, Microsoft, Toys "R" Us, and Motorola.

Another strategy that has become effective on a large scale is the application of brand color in livery, architecture, and a range of applied design applications designed to further enhance brand identity. An example from the 1980s is the façade color of the Renault Distribution Centre in Swindon, UK. Designed by Foster + Partners, Renault's corporate identity color (yellow) is the predominant feature of the building's exoskeleton façade and Norman Foster noted at the time that the color was so distinctive and memorable that the building did not need to display the Renault logo. A more recent example is the façade color of the Allianz football stadium in Munich (2005). The façade of the building was designed by Swiss architects Herzog & de Meuron and changes color depending on which team is playing: red for Bayern Munich, blue for 1860 Munich, and white for the German National team. By changing color, the building acts like a branding beacon for football fans (Foster + Partners n.d.; Herzog & de Meuron n.d.).

ARCHITECTURE

In the field of architecture as well as urban design, color is now being used for strategic purposes, and when this is successful, the outcome can create landmark buildings, exceptional urban design, and elevate the status of those involved in the design process who use color to express their creativity. Aside from this, it is now recognized that color and color contrast can not only attract attention but encourage engagement in the built environment, support orientation and way-finding initiatives, and assist with the safe operation of daily activities, especially for the elderly and those with diminishing visual capacity. These positive outcomes are due to the roles that color and contrast play in terms

FIGURE 3.3 Color-contrast strategy to improve environmental visual literacy. Image by Zena O'Connor.

of human visual perception and the ways in which color and contrast improve environmental visual literacy (see Plate 3.3 and Figure 3.3).

The predominantly white, achromatic approach to color in architecture associated with Modernism, coupled with advances in construction techniques and materials, allowed some architects to use color specifically as a means to express their creativity and, in doing so, create differentiation and enhance their unique status in the field. Since the mid-twentieth century, it is often the architects who use color distinctively who have risen to prominence, albeit controversially at times. One of the most influential architects of the twentieth century, also referenced in Chapter Nine, in this volume, but noted here as a striking example of professional identity and color, Charles-Édouard Jeanneret (known as Le Corbusier) incorporated saturated color into the façades of a number of his buildings. For Le Corbusier, architecture lacked a sense of bold, individual expressionism. His use of saturated color coupled with sculptural form and functional aesthetics became characteristic of his architectural style, as evidenced in the apartment building Unite d'Habitation, France (1952) and the High Court of Justice building, Chandigarh, India (1955). Le Corbusier favored saturated red, yellow, blue, and green, and his use of these colors seemed groundbreaking at the time. This, in turn, helped to elevate Le Corbusier's status as a leading architect of the twentieth century, reinforced by his celebrated body of work and theoretical works.

Similarly, Pritzker Prize-winning Mexican architect Luis Barragán used large-scale saturated color and this became a distinctive key element of his signature style. Using color to evoke the "humble majesty" of colorful Mexican streets, Barragán imbued his buildings with a unique and extraordinary identity as evidenced in the Fuentes de los Amantes horse ranch (1966), the Towers of the Ciudad Satellite city (1966–8), and Casa Gilardi (1976). Vivid, saturated pinks, red, and oranges are a hallmark of Barragán's body of work and his approach to color has elevated his creative output and ensured that his buildings have a strong identity and presence in the landscape (Barragán 1980).

The link between color and architectural identity was highlighted by Pritzker Prize-winning English architect Norman Foster, who suggested that façade color was one of a number of design attributes that can help to reinforce a "caves or temples" identity with respect to individual buildings. Under Foster's approach, façade color can minimize a building's form and visual impact, lending a passive identity to the "cave" building and helping it to subtly meld into the landscape. Conversely, under Foster's "temple" approach, façade color can be used in a bold, disruptive, and expressive way to visually distinguish a building and set it apart from its surroundings, thereby creating a strong, powerful identity for the building relative to its surroundings (Foster 1976: 62).

Color has now become an accepted and desirable feature, often enabling a building to quickly achieve landmark status. Pritzker Prize-winning French architect Jean Nouvel often uses saturated color on an extraordinary scale and it is this design element that imbues his buildings with significant status irrespective of architectural style, as per Nouvel's Hotel Puerta America, Spain (2003), and Torre Agbar tower, Barcelona (2005). The Hotel features a rainbow across its façade in vivid, high-chroma colors, and the Torre Agbar features luminous LED windowpane devices built into the façade that generate a vivid array of colors at night. Many of Nouvel's buildings have achieved landmark status, and Nouvel himself has garnered celebrity status along with awards and distinctions.

Color in the urban landscape is recognized as one of many key visual elements that contributes to establishing a sense of place. In some locations it is often façade color that helps to establish the identity and character of a particular region, village, or city. This is particularly evident in locations such as the Cinque Terre region of Italy as well as cities such as Murano and Burano in Italy, Jaipur ("The Pink City") and Jodhpur ("The Blue City") in India, as well as towns and suburbs such as Bristol and Notting Hill in the UK. It is predominantly the hue and saturation of the façade color that imbues these locations with their unique identity and character (Rapoport 1982; Porter 1997).

Similarly, with respect to interior design, color and contrast are often used to create and reinforce identity of place and location within commercial, healthcare, and educational facilities. This is due to the key role that color

and contrast play in terms of enhancing and supporting environmental visual literacy, their capacity to attract or divert attention and to assist with orientation and wayfinding. Color is frequently used as a means of identifying key interior landmarks and locations by color-coding quiet work areas, collaborative work zones, service hubs, private meeting rooms, social areas, and so on. In this way, color is now frequently used as a powerful tool to influence behavior in a range of commercial, hospitality, and healthcare environments.

LITERATURE

As detailed in Chapter Seven, in this volume, color symbolism is frequently used to great effect in literature and cinema as a means of conveying concepts and themes, supporting narrative and character development as well as highlighting key situations or events. In literature, this device generally revolves around the dimension of hue and occasionally tonal value (but rarely color saturation/chroma), and the effectiveness of this device in literature and cinema is not always guaranteed. The following discussion concentrates on how power and identity is conveyed through color in literature and cinema.

In the modern era, one novel that stands out as a beacon of color symbolism is F. Scott Fitzgerald's *The Great Gatsby*. Published in 1925, Fitzgerald specifically used color symbolism to highlight the novel's themes and reinforce character development especially in terms of power and identity. Fitzgerald's novel has been described as one of the most colorful and visual works in literature and a quantitative analysis of color terms reveals that various colors and color-related terms are mentioned with barely restrained extravagance throughout the novel (Samkanashvili 2013).

The novel features two overriding themes and these are illustrated by a strong contrast between light-tone, clean, saturated colors and darker, muted, desaturated colors. One key theme involves the death of the American dream, and Schneider (1970) suggests that the overarching light-dark contrast represents the main conflict of the novel: "the foul dust that floated in the wake of his [Gatsby's] dreams [...] his incorruptible dream" (Fitzgerald 1925: 4). Fitzgerald built the novel around a hue contrast between clean, saturated colors symbolizing hope, wealth, and the American Dream, and desaturated colors signifying corruption and the sordid and somewhat disappointing reality and loss of hope that symbolizes the reverse. The colors of disappointment and loss of hope are represented by the valley of ashes (the "grey land" with its "grey cars" and "ash-grey men") that lies between the wealth of West Egg and New York (26).

Fitzgerald plays with color symbolism as it suits his purposes: yellow, gold, and silver are used to signify wealth and power while they also represent gaudiness, materialism, and eventual decline. Gatsby's yellow car in the end becomes the

"death car." In total, yellow, gold, golden, and silver are mentioned fifty times, while gray and black are cited twenty times. Green is also a significant color in the novel. With frequent mentions of the green light at the end of Daisy's dock, it becomes closely aligned with her identity as well as a symbol of hope and new growth: "Gatsby believed in the green light, the orgiastic future that year by year recedes before us." Traditionally, green is also the color of money, wealth, and power ("the fresh, green beast of the new world"), and the color is mentioned nineteen times in the novel (Fitzgerald 1925: 192).

Fitzgerald had an extraordinary capacity for crafting sentences that used color as a social signifier and to indicate social power and identity. White, for example, reinforces the affluence and indolence of people Gatsby sought to impress: "the white palaces of fashionable East Egg glittered along the water" and the chatter of Daisy and her friend Jordan Baker was "as cool as their white dresses" (Fitzgerald 1925: 8, 15). In the following passage, Fitzgerald takes an afternoon sky and imbues it with a visually rich identity that is distinctive and compelling: "The late afternoon sky bloomed in the window for a moment like the blue honey of the Mediterranean" (38). Similarly, Fitzgerald's reference to "yellow cocktail music" played by the orchestra as the lights grow brighter at Gatsby's party gives the reader a sense of the cheerful, lively ambience of the party (44).

Jack Kerouac was a twentieth-century writer who occasionally used references to color to convey a sense of power and identity. In his 1957 novel *On the Road*, Kerouac's narrator, Sal Paradise, refers to the creative, free-spirited, adventurous people whom he holds in high esteem. Kerouac builds this proclamation around a strong color contrast of yellow and blue that amplifies the unique and distinctive nature of these identities:

> The only people for me are the mad ones, the ones who are mad to live, mad to talk, mad to be saved, desirous of everything at the same time, the ones who never yawn or say a commonplace thing, but burn, burn, burn like fabulous yellow roman candles exploding like spiders across the stars and in the middle you see the blue centerlight pop and everybody goes "Awww!"
>
> (Kerouac 1957: 11)

More recently, English author Ian McGuire's *The North Water* (2016) imbues his narrative with a dark, moody ambience and identity that is impossible to ignore or escape. An example of literary realism, the novel is flooded with color references that have gloomy, negative connotations: "dark and darkness" as well as black, gray, charcoal, smoke, and shadow are mentioned numerous times and they are not offset by an equal proportion of light-hued color references. The dark characters and gloomy context depict the dying days of nineteenth-century whaling culture termed by critic David Evans (2016) as "subtle as a harpoon in the head." Unlike film noir and the painterly technique of chiaroscuro, which rely

on a strategic use of light-toned hues to relieve darker tones and highlight key information, *The North Water* lacks this device. The novel includes references to light-colored hues but more often than not, they reinforce the dark quality of the book: "white and harrowed sky"; "he feels lighter than he did a moment before [just after killing a man]"; and "the yellow moon is lodged like a bolus in the narrowed throat of the sky" (McGuire 2016: 8, 44). The gloomy, literary realism of the book may be difficult for See-Saw Films to translate into film.

CINEMA

In cinema color has frequently been used to achieve a range of strategic communication objectives involving power and identity, including variations in color, contrast, tonal value, and saturation to create mood and ambience and suggest symbolic color associations. Sergei Eisenstein's 1925 classic revolutionary film *Battleship Potemkin* (Sergei Eisenstein, USSR, 1925), for example, strikingly used color to symbolize identity and signal a call to action. In this black-and-white film, a white flag hoisted on the battleship was hand-colored red to serve as a visual symbol of propaganda for political purposes.

Similarly, in more recent cinema, color has been used selectively to convey themes of power and identity through chromatic contasts. A highly effective use of desaturated color is evident, for example, in Steven Spielberg's *Schindler's List* (Steven Spielberg, USA, 1993). The short opening scene of the Jewish Candle Prayer and credits is in color but the rest of the film is shot in black-and-white sepia film stock. Spielberg deploys strong light-dark contrasts and a major light-dark tonal value chord to depict the harsh realities of life in Nazi Germany and the horrors of the Holocaust. Against this monochromatic color aesthetic, the red of a young girl's coat is later singled out in a very moving scene. The red detail functions as a compelling symbol of her identity within an environment otherwise literally drained of humanity.

American Beauty (Sam Mendes, USA, 1999) is another film that uses red in a highly symbolic way. Saturated red features in every key scene signifying in different contexts vitality, passion, danger, and death. The film opens, for example, with Lester Burnham's wife Carolyn (Annette Bening) cutting "American Beauty" roses in her garden. This represents the act of literally cutting their life force, an effect that is also felt throughout the film by Kevin Spacey's character, Lester. Red also serves as an indicator of individuality, lust, and pent-up sexuality from a number of strong contrasts (light-dark, warm-cool, and blue-yellow/orange) that enrich the film's overall color palette and help to convey mood while also supporting narrative structure and development.

The contrasting colors of red and green play a key role in *Amélie* (Jean-Pierre Jeunet, France, 2001). This film features an intense red-green contrast that varies in saturation levels according to narrative context and emphasis. In

some scenes, for example, red and green are muted while in others the contrasts between the colors are enhanced and intensified. Using digital intermediate postproduction methods, reds and greens were particularly manipulated and their saturation increased in particular scenes. These saturated colors served to highlight and reinforce the identity and emotions of the central character, Amélie. Blue and gold feature as an auxiliary pair of contrasting colors, acting as a kind of visual foil to the dominance of red and green and as a signal of narrative change.

A subtle but highly effective use of color in relation to issues of identity is demonstrated in *L'Homme du Train* (*The Man on the Train*, Patrice Leconte, France, 2002). This film revolves around the relationship between two characters: a gangster and a teacher, played by Johnny Hallyday and Jean Rochefort, respectively. The stark contrast in the lives of these two men is enhanced throughout the film with a strong color contrast. A cool, grainy grayish-blue palette characterizes the gangster's appearances in the film, while a contrasting warm, golden palette is used to highlight the teacher's comfortable life and home. This warm-cool, blue-golden yellow contrast highlights the film's key themes, which focus on the similarities and differences in identity, social class, and power between the two main characters.

Digital manipulation of color has impacted on the design of many different color palettes for the contemporary screen. *O Brother, Where Art Thou?* (Joel and Ethan Coen, USA, 2000) was one of the first films to be entirely digitally color graded. The film's narrative is set in 1930s America during the Great Depression and color correction was used to give the film an overall sepia color tone. This was done to evoke the era of the Great Depression. As a result, the film features an idealized version of the dusty Mississippi Delta, and cinematographer Roger Deakins spent many weeks in postproduction adjusting the green colors of nature in the actual footage and desaturating these to achieve the sepia-toned aesthetic of the dust bowl era. Similarly, film director Wes Anderson is renowned for his highly controlled and effective use of color, which has enabled him to craft films that are highly recognizable and for evoking particular historical periods. In *Moonrise Kingdom* (Wes Anderson, USA, 2012), for example, the color palette features slightly tinted, faded versions of bright primary colors, particularly red and yellow plus green and blue. This color palette is reminiscent of a 1950s summer holiday and the handmade aesthetic of that era. The film is thus imbued with an aesthetic look that simultaneously represents nostalgia and the tender innocence of childhood and first love. Two pairs of contrasting colors feature extensively: red-green and blue-yellow/orange. They create strong visual identities for the two main characters and help to reinforce the disparity between them, their families and guardians.

Perhaps the most overtly successful use of color in recent cinema is *La La Land* (Damien Chazelle, USA, 2016). Damien Chazelle's film is a visual and

auditory feast; an unlikely romantic musical comedy-drama that focuses on the Hollywood dream. One of the strengths of the film is the way in which color and contrast play starring roles from the riveting opening scene through to the end. Saturated primary and secondary colors feature in the opening scene and recur throughout the film. These unadulterated, full-chroma colors hint at the artificial nature of Hollywood but also reflect the undiluted hope of young actors and musicians trying to make it in Tinseltown. Saturated colors flood the party scene and Hollywood sets as we wander through them with the main characters, Mia and Sebastian. Caravaggio-style strong light-dark contrast is used effectively but sparingly to highlight the connection between the lovers, and to draw attention to the haunting jazz piano melodies played by Sebastian. Night scenes are drenched with moody blues, perhaps a visual reference to the connection between blues and jazz. The bright, saturated color palette gradually fades into slightly more muted colors for the closing scenes as dreams struggle against reality and Tinseltown hopes face disappointment.

The analysis of color, saturation, and tonal value has a long history in film and this has recently expanded into social media. Accounts such as @cinema. palettes now devote entire Instagram feeds to the analysis and description of color in cinema, film, and television, highlighting the ways in which color creates differentiation in individual films as well as enabling directors to build a unique body of work as illustrated in Figure 3.4.

FIGURE 3.4 Four posts from Instagram: @cinema.palettes. Image by Zena O'Connor.

FASHION DESIGN

Changing color trends are a key element in fashion design in an industry that relies on seasonal changes to generate ongoing sales. In relation to the theme of this chapter, the fashion industry demonstrates a range of different approaches to questions of power and identity, albeit individual or corporate. As detailed more extensively in Chapter Five, in this volume, color forecasting in the industry came about when American milliners began to base their designs on information about color trends in England and Europe. This information was shared with button, thread, and footwear manufacturers to enable the production and marketing of color-cohesive fashion offerings to consumers. Eventually, a committee of textile and fashion manufacturers formalized the color forecasting process and the Textile Color Card Association (TCCA) was established in 1914. Meeting on a regular basis in New York, TCCA members produced biannual color forecasts for each new season and color forecasts were provided for different market segments (Rorke 1931).

Standardized seasonal colors for application across the textile, clothing, and footwear industries assisted manufacturers and marketers alike, and the Standard Color Reference of America became a widely used color reference. By the 1940s, the color forecasting expertise of the TCCA spread to the UK, Australia, New Zealand, Canada, the Middle East, and South America. The organization became known as the Color Association of the United States (CAUS) and fashion designers in most Western countries incorporated colors from seasonal color forecasting data into their output (CAUS 2009).

However, a handful of fashion designers eschew color forecasting information and rely on their own creative intuition for seasonal color choices. Designers that follow this approach are often seen as distinctive and unique, and this endows them with a reputation as less mainstream and more elite and exclusive. Two fashion design firms that follow this approach are Emilio Pucci (Italy) and Lilly Pulitzer (USA).

Emilio Pucci began designing in the 1950s and, aside from his design silhouettes, Pucci's fashions are characterized by abstract textile patterns in vivid colorways. Pucci's colorways are highly unique and distinctive, involving extended analogous color combinations but more often, split complementary or double complementary color combinations. Pucci's color combinations also feature relatively saturated colors intermixed with a limited number of tints plus white and black. This strident use of color has enabled the brand to establish and maintain a unique identity within the global fashion industry (Pucci 2017) as illustrated in Figure 3.5.

Similarly, Lilly Pulitzer fashion designs feature textile patterns and colors that are highly unique and distinctive. Like Pucci, Pulitzer uses a color palette that was initially established in the 1950s and it has changed little in sixty years.

FIGURE 3.5 Emilio Pucci post from Instagram: @colour.design.palettes. Image by Zena O'Connor.

The company's identity and powerful presence in the American resort-wear marketplace is primarily due to the unique color palette of saturated pink, orange/red, turquoise, yellow, and green in split or double complementary color combinations.

A similar color palette featured in the psychedelic colors associated with the 1960s hippie counterculture. This is a key example of a color palette being associated with a particular sociopolitical group and it simultaneously served as a badge of identity as well as a unique form of nonverbal communication, uniting members of this cultural group irrespective of age, gender, and geography. The psychedelic color palette involved polychromy in contrasting and often discordant colors designed to reflect the visual effects of psychedelic drugs. This particular color palette was depicted in fashion and graphic design as well as assorted paraphernalia of the counterculture. As a unique form of color-coding, psychedelic color served to reinforce identity and also exert power by debarring or excluding members of the prevailing "Establishment," who often struggled to read and interpret messages embedded in psychedelic-colored graphic design.

From another perspective, some prominent business people use a form of color-coding to establish and reinforce a unique identity revolving around their public persona. For example, Steve Jobs, cofounder of Apple Inc., was

famous for wearing black turtleneck sweaters and blue jeans on a daily basis, while Giorgio Armani is said to prefer navy trousers and either a white or navy crewneck shirt on all but formal occasions, and Facebook's Mark Zuckerberg invariably wears gray T-shirts. By crafting a unique color palette depicted in their fashion choices, the likes of Jobs and Zuckerberg have used color and a simple "uniform" to create a strong (albeit relatively casual) visual identity that serves as a distinctive approach in a suit-cluttered business environment.

SOCIAL MEDIA

In the modern era, it is impossible to ignore the impact and influence of social media, and this sphere has now become a dominant channel for expressions of power and identity across all sectors: social, cultural, political, and commercial. Social media includes a large range of platforms including Facebook, LinkedIn, personal and commercial blogs, Twitter, Tumblr, YouTube, Pinterest, and Snapchat.

However, social media platforms vary considerably in terms of focus, functionality, user profiles and preferences, as well as aesthetics. Instagram is currently a leading visually based platform in which visual imagery is primary and associated text is secondary. While Facebook is also a combination of visual imagery and text, Instagram has an estimated 600 million users and is being increasingly used for both personal and commercial purposes. It is for these reasons that Instagram will serve as the focus of this discussion on social media.

Given the visual nature of Instagram, many personal and commercial users have created accounts that feature particular visual design elements, and the design consistency of these elements becomes a key characteristic of their "feed" (the accumulated images of their Instagram account). By developing a unique feed, users are able to differentiate their account from other accounts by fashioning a unique online identity. A subgroup of these users specifically harnesses color and/or contrast to further reinforce their unique Instagram identity. By creating differentiated accounts, some users have managed to garner social media power and presence, and this has elevated them to prominence as style icons, "thought leaders," experts, or authorities in their particular field. For these users, the cohesive and unique visual aesthetic that they have created using color and contrast has resulted in growing numbers of followers and a level of prestige not enjoyed by other Instagram users. For many Instagram users, this has the capacity to be monetized and can translate directly into increased sales and profitability.

Aside from celebrity Instagram accounts, there are many Instagram users who have used color to create a unique and strong visual identity, which has helped them to attract a following and strong presence on social media. A handful of

these include @aloisio.ricky, @oliviathebaut, @signebay, @hannahmirbach, @shunksy.nyc, @colour.design.palettes, @cinema.palettes, @liamwon9, and @hol.fox.

New York-based Richard Aloisio's Instagram feed (@aloisio.ricky) features Aloisio wearing a variety of fashion designs and accessories. These images invariably feature contrasting, saturated colors coupled with white, gray, charcoal, or blue. There is no doubt that Instagram has helped to reinforce Aloisio's position and reputation as an art director and personal stylist, and his feed has attracted a strong following, garnered much publicity, and elevated Aloisio to the position of style icon on a global scale as evidenced in Figure 3.6.

FIGURE 3.6 Ricky Aloisio Instagram images: @aloisio.ricky. Image by Zena O'Connor.

Photographer and art director Olivia Thebaut (@oliviathebaut) is based in France and her Instagram feed is characterized by predominantly high key, major chord tonal hues in tints and shades of pink and orange contrasted with tints and shades of blues and greens. Thebaut's Instagram account has grown considerably; she now has a strong identity and powerful presence on social media, using Instagram as a distribution channel for her photography and art direction services.

The Instagram feed of Copenhagen-based visual stylist Signe Bay (@signebay) features low major tonal chord hues in a variety of grays enlivened with muted purple tints and shades. This unusual color palette ensures that Bay's Instagram feed is visually unique and has helped to establish and reinforce her identity on social media. Similarly, young Australia-based New Zealand designer Hannah Mirbach (@hannahmirbach) has crafted a strong presence and identity on Instagram built around a unique color palette and pared down design aesthetic. Mirbach's feed features a predominantly high key, major tonal chord in a relatively restricted color palette of white, tinted honey hues, and soft browns. This soft, stylish color palette stands out amongst the visual noise on Instagram and gives her a strong identity and presence on social media (Figure 3.7).

Tokyo-based photographer Liam Wong (@liamwon9) credits his Instagram feed with almost immediately establishing his social media identity and a strong, loyal following since posting his first images in December 2015. In a little over a year, Wong's unique, colored images have garnered him a considerable amount of publicity on a global scale. Wong's feed is characterized by a strong light-dark contrast featuring saturated, neon colors of turquoise, pinks, yellows, green, and blue. Similarly, Brooklyn-based, Japanese photographer Shunsuke Takino (@shunsky.nyc) uses strong light-dark contrast in his Cold Iron Brooklyn images. In these images, taken in his neighborhood at night in winter time, Takino expresses silence, coldness, and loneliness through his unique style. These images feature low key major tonal chord hues in partially desaturated blues and his love of more vivid, saturated hues peek through these darker hues from time to time. Demand for Takino's images has grown due to the unique colors and contrast that feature in his images, providing his feed with a strong and powerful online identity.

Finally, Los Angeles-based designer Holly Fox (@hol.fox) has applied her skills to sugar iced cookies, which feature mid-tone polychromy in contrasting colors. Fox's Instagram feed is characterized by similarity of tone and a soft gelato color palette. These colors have made her feed unique, enabling her to create a strong presence on social media, which has attracted publicity and helped her build her cookie distribution business.

FIGURE 3.7 Hannah Mirbach Instagram images: @hannahmirbach. Image by
Zena O'Connor.

CONCLUSION

The modern era is characterized by an ever-changing and almost invasive visual
culture. Despite this visually cluttered context, color still has the capacity to
attract and engage attention. As a result, color and contrast are often used
to strategically establish and reinforce identity within any given creative or

commercial endeavor. Color continues to be used to create differentiation and underpin the creation and enhancement of identity. For those who excel in this respect, color helps to build critical mass, elevate their creative output, and contribute to a relatively more powerful position within their selected sphere of influence. However, given the evolving nature of visual imagery and culture, color strategies cannot remain static but must respond to change and evolve accordingly to maintain differentiation. It is those who are masterful in this respect that maintain their status as powerful icons in their field.

Religion and Ritual: The Modern Religio-Colorscape

URMILA MOHAN

INTRODUCTION

Color is part of a religious repertoire of tools and techniques used in the material culture of worship spaces such as churches, temples, and mosques or object categories such as musical instruments, food, drink, and clothing. The history of religion in the modern world has been influenced by the simultaneous mobility of images, objects, and people between the West and the rest of the world thereby challenging identities previously bound by regional or national boundaries. How does color in modern religious practice cross these boundaries to objectify beliefs and identities and enable an experience of the otherworldly?

Modernity and globalization have created complex, shifting topographies or *scapes* (Appadurai 1996: 33), a concept that has been extended to the "religioscape" (Dwyer 2004: 196). Further, the modern nation as an imagined entity has always been mediated by constructed images (Asad 2003: 4) with humans using materials and practices to conceive and revitalize the numinous. If "it is not the presence of colour in a work that matters but the use of that colour" (Batchelor 2014: 17), then what does the use of color do to and through a particular religion in a modern context? Anthropological and art historical studies can aid in the study of the intersection of color and religion as a "religio-colorscape" wherein the relationships created help connect different people, places, and religions in an agentive manner.

This chapter discusses the role of color in religion through two related trajectories: the development of the study of the intersection of religion, ritual, and color as well as examples of how religions (both Western and non-Western) have used color in their modern practices of magic, spiritism, healing, and mysticism. The idea that religion must be studied through embodied means is one that has been emphasized in recent scholarship on material religion with the study of "bodily-and-material" cultures of religious practice (Mohan and Warnier 2017), focusing on how people are made as devotional subjects. Previously, the *Material Religion* journal stated that "the material study of religion concentrates on what bodies and things do, on the practices that put them to work, on the epistemological and aesthetic paradigms that organize the bodily experience of things" (Meyer et al. 2010: 209). In the case of bodily experiences and practices, a material culture and phenomenological lens may be combined to study color as an emotionally and sensorially compelling entity with people using colored materials and, in turn, being affected by them as matter, light, and sensation.

Religious belief may be studied as the generation of "feeling" both in sensory and emotional terms. Since the eighteenth century, the concept of aesthetics in the West has been one where disinterestedness and detachment have formed the basis for judgments of taste and quality (Morgan 1998: 26–7). Instead, color, whether deemed tasteful or tasteless according to prevailing trends, evokes a response in humans that is very much an engaged and interested one. This "felt-knowledge" of color is a useful context for a study of the religio-colorscape, where things, including colored objects, images, and bodies, can be understood as part of everyday practice, cultivated through embodied and situated ways of learning, making, and, doing. Further, the register of this efficacy may itself be a contingent one somewhere between the realms of the orthopraxic as well as the more flexible spaces of the everyday. An awareness of color as an entity made through performance and practice encourages us to appreciate its use in religion not just as conformance but as mimesis and the transformative possibility of contact and exchange.

COLOR AS RELIGIOUS PORTABILITY AND CHANGE

To discuss how modernity has influenced color in religion, one can briefly look back at how Christianity, for instance, has been instrumental in the formation of the modern subject. Debates that arose with the Reformation and Counter-Reformation movements in sixteenth- and seventeenth-century Europe exposed the schism between the "real" and the "symbolic." In the case of the transubstantiation of the Eucharist—the Catholic ceremony commemorating the Last Supper in which bread and wine are consecrated and consumed as the actual body and blood of Christ—the Reformation movement deemed the

Eucharist to be important but not literal, also setting the stage for a European empirical, modern self. Scholars such as J.P.S. Uberoi (1978: 28–9) argue that along with the ability to (re)present oneself through various media came the concept of a transcendental modern subject, separate from divine cosmology and intent. Modern man was the apex of culture, freed by a radical aesthetic purism to direct his own destiny. Later, in European Aesthetic movements in the twentieth century, art became a form of secular spiritualism and a means of celebrating Western creativity and progress. However, modernity and Modernism, despite predictions, did not result in uniform secularization in the twentieth century but a revitalization of faiths and a spread of beliefs in new forms.

Some religious practices in the West

Religious denominations of various kinds have grown far beyond their countries of origin, finding new ways to expand and energize their communities and congregations. Color in religion could be considered as moving and spreading through "portable practices" (Csordas 2009: 4) as well as transposable messages.

In the Christian worship calendar, color is traditionally materialized with churches decorating their altars in prescribed colors according to the season. The liturgical seasonal colors appear on altar cloths, on banners behind the altar, and on the surplice of the priest's robe. Red, green, blue, white, and black are the main colors in Anglicanism, Lutheranism, and Catholicism, the most liturgically oriented traditions. Other Christian groups use color as part of creative attempts to connect faith with new sensory experiences. For instance, the members of an Evangelical community in the United States use color in a multisensory, interactive "worship experience" at the time of Lent (Bielo 2011: 84). A photo of this event from February 2010 (see Plate 4.1 and Figure 4.1) depicts a meeting space set up with a red-brown theme to illustrate both the various Stations of the Cross as well as love (both for God and mankind) since it is the month of February when Valentine's day is celebrated. Other forms of Christianity in the United States use modern entertainment, media consumption, and capitalism to promote their faith. "Ark Encounter" in the state of Kentucky is an example of a creationist theme park designed to educate and entertain while imparting fundamentalist Christian values as well as generating sales (Bielo 2018). Every element of the visitor experience is designed to fit within an imagined world of biblical characters, including the earth tones of T-shirts meant to echo the colors of Noah's world. Such decisions are not superficial, and it is in making them that the staff and designers at the theme park learn to move between pleasing their Evangelical audience as well as their investors, and to work within the paradigm of religion as an immersive experience.

Among indigenous Christian communities, color has a history of being used in newer worship practices as well as being part of the revitalization of older

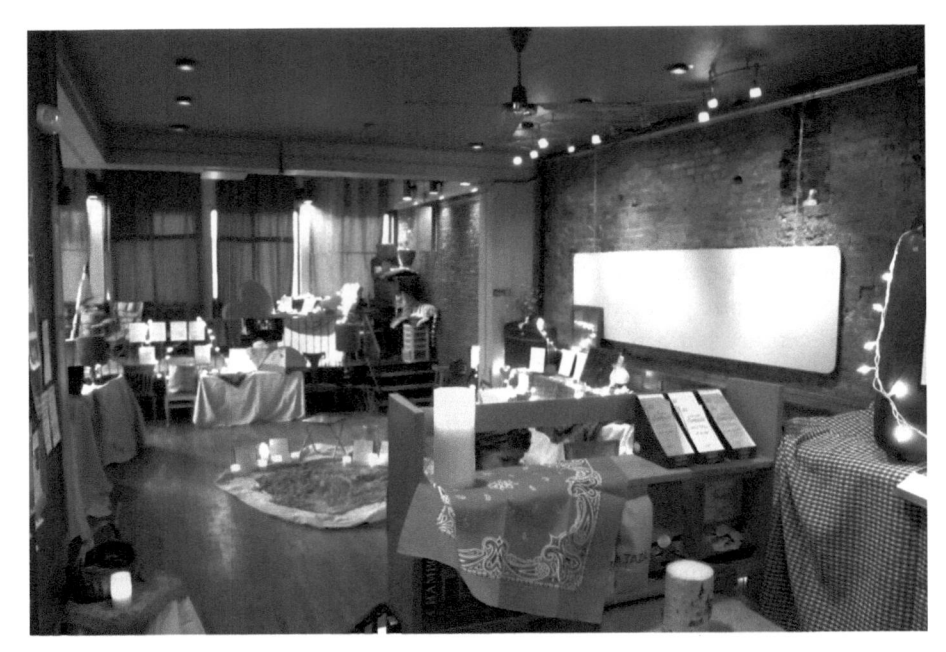

FIGURE 4.1 An Evangelical meeting place designed in tones of red and brown for the celebration of Lent, USA, 2010. Photograph by James Bielo.

rituals. For instance, among Alaskan peoples (such as the Sugpiaq and Yupik) Russian missionization from the late eighteenth century onward started as a tool of pacification but over the centuries has led to Alaskan cultures that integrate Eastern Orthodoxy into older practices of worship, gathering, feasting, and protection (Csoba DeHass 2007). Reminiscent of caroling, the practice of "starring," for instance, consists of people carrying large, brightly colored stars with an icon of the Nativity in the center through the village during the Russian Christmas. The star is constructed in such a way that when it is spun during the singing of hymns the icon in the center is still but the arms of the star blur into a sparkling pinwheel. Among the Yupik these practices may coexist with shamanic rituals where the power of the colors of objects, such as animal spirit masks, is linked with the material's source and mythology. Indeed, one of the traditional colors used and prized is red ocher, an iron oxide derived from a sacred mountain. Color on animal spirit masks is still believed to be one of the phenomena that successfully transforms the Yupik mask wearer into an animal spirit, and in some cases masks are believed to be fully empowered only after the paint is applied (Morrow 1984: 137).

Alongside more institutionalized forms of religion, color also became part of "secular spiritualism" in the modern West. Indeed, the French modernist artist Yves Klein (1928–62) could be described as somebody who used color

as a new spiritual form. For Klein color was an embodiment of a remote and original state of being to be revived as a kind of unspoilt earthly paradise, illustrated through his creation of abstract monochromes. Klein developed *International Klein Blue* (IKB) in collaboration with Edouard Adam, a Parisian art paint supplier. Klein's work on IKB can be appreciated both for the ability of the color's material properties to sensorially evoke the numinous as well as for the manner in which it references the artist's own religiosity.[1] Raised as a Roman Catholic, Klein described himself as somebody who would "defend and deliver" pure color in order to lead it to "triumph and glory" (Temkin 2008: 52). Klein's notes for an animated film storyboard made in 1954 are written in a biblical register, with references to the second generation of the Old Testament (Batchelor 2000: 77). On creating IKB, Klein made a pilgrimage to pay homage to St. Rita of Cascia, patron saint of lost causes, in a remote monastery in Italy cared for by cloistered Augustinian nuns. In 1961, he returned to offer her an *ex-voto* (a votive offering) that consisted of a transparent plastic box, divided into three compartments. The top compartment had three sections and each had been filled with paint pigment. In the first was rose (monopink), the second contained ultramarine blue (IKB), and the third contained gold leaf (monogold). Within the middle section of the box was a folded paper with the text of a hymn of thanksgiving to St. Rita written by Klein.

Around this time, Klein was exploring the more spiritual sides of his work through the performance of *Zones of Immaterial Pictorial Sensibility* (1959–62). This included the sale of empty spaces that Klein, in exchange for gold, relinquished to buyers via receipts that documented the ownership of immaterial zones. Since immaterial sensitivity was a spiritual quality according to Klein, the performance could culminate in a ritual in which Klein would throw half the gold into the Seine river in Paris and the purchasers could burn their receipts. In Yves Klein's notion of immaterial sensibility, art was not attached to any material object but was a way to see the world, something that the Mother Superior at the monastery of St. Rita of Cascia referred to as his faith. Klein's work on color and ritual could be analyzed as "immaterial religion" (Hughes 2015), with his particular sensitivity to the entanglement of votive offering, economic sacrifice, and the experiential dimensions of ritual. It would seem that Klein was returning to his Catholic roots (or perhaps he had never left them) when he made the ex-voto to St. Rita of Cascia and that the pictorial zones series was an attempt to imbue the material with spiritual value.

Religious clothing and color

Clothing is perhaps the most visible way to declare one's religious (and chromatic) affiliations. In a "'cultural phenomenology'" (Csordas 1994: 4) approach to the study of religion, the bodily experience of Catholic Charismatic Renewal members in global communities is studied as a source of faith and belonging.

As Catholic Charismatics formed churches in North America from the late 1960s onward, ritualization progressed from linguistic to somatic behaviors with members of the Charismatic culture enforcing norms such as types and colors of clothing (Csordas 1997). For instance, dress in one suburban North American parish is formally thematized as having a gender and religious status, and staff members wear a sash or jacket over their clothing or replace street clothing with a common color scheme.

In another example of sartorial identity, nearly a world away in an African community in Cameroon, the Catholic stole is transformed into an object that mediates between Christianity and ancestor worship. In 2009, the sacred king of Mankon celebrated his fiftieth jubilee as *Fon* of the kingdom, that is, keeper of sacred ancestral substance. Representatives of the main religions (Christianity and Islam) were also present. An image from this event (see Figure 4.2 and Plate 4.2) shows a Catholic priest with a stole covering his shoulders and chest, bearing the sign of Christ in purple. The stole may be familiar as a liturgical object to Christians in the West as an item worn to perform ceremonies such as the sacrament of penance or a benediction. But the fabric has been printed with the face of the king and messages of commemoration in English. For the priest, there does not seem to be a conflict between worshiping the cult of the ancestors and worshiping Christ; both are sacred and compatible especially when seen through the lens of material culture.

In the present day, Islamic dress can often be seen in the West, although in certain countries, such as France, the issue of veiling by Muslim women has become contentious. It is important to note that the veil's color and form depend on the sect of Islam, public versus private use, and urban versus rural spaces. Islamic dress asserts different ethnic, cultural, and sectarian identities, for instance, whether the wearer is Shia or Sunni. Garments include the white *haik* (a sheet that wraps around the body including much of the face) worn by Sunni women in North Africa and the black *chador* worn by Iranian women, as well as the *burka* (full-body covering) worn by Saudi and Afghan women. The color black is considered a symbol of mourning in Western countries but is a color of modesty in the Middle East (especially in ultra-conservative Wahhabi and Salafi groups) that has been subsequently adopted by Muslims in other parts of the world. West African Muslim women who started wearing black *niqabs* (face coverings) in the 1970s did so in part because veiling identified them with the spiritual authenticity and economic opportunities of Wahhabi Islam in the Middle East (Kobo 2012: 274). Around the same time, with the advent of the youth and student movement in Malaysia, urban, educated women in that country adopted conservative Islamic dress as part of a move against what they regarded as decadent secularism. Their headscarves and long black robes asserted their moral righteousness against consumer culture as well as supporting a form of nationalism (Schneider 2006: 215). Whereas in the early twentieth

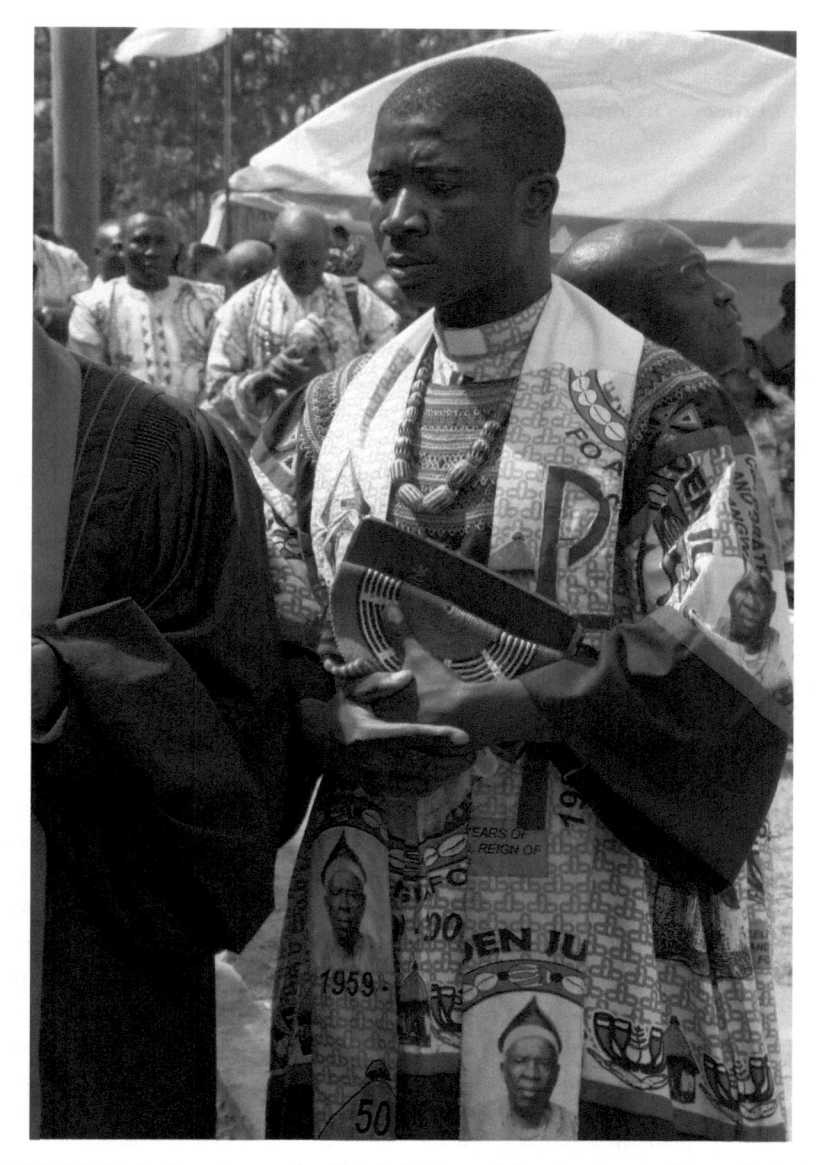

FIGURE 4.2 Catholic priest at the fiftieth jubilee celebration for the king of Mankon, Cameroon, 2009. Photograph by Manuela Zips-Mairitsch.

century Moroccan women wore white haik, black niqabs are increasingly visible in the country, indicating that the wearer is probably a follower of the Wahhabi or Salafi sect of Islam. Moroccan women very rarely wore black veils before the 1980s—a time period tied to the Iranian Revolution and wars in Afghanistan as well as the war between Iran and Iraq. Even today, many Moroccan women

prefer bright hues, patterns, and textures in their clothing while elderly women in rural areas literally use blankets with patterns (or images of Mickey Mouse, amongst others).[2] In another example, Muslim women in China wear Western-style wedding gowns, both marking a change from the red silk *qipao* (Chinese dress for women) popular in the 1920s, identifying with Western affluence, as well as modulating their dress to the wishes of local religious authorities by wearing gowns in shades of coral or pink instead of white (216).

The examples cited so far are adaptive moves toward certain religious and/or sectarian identities aided by global flows of ideas and materials. In the case of Hindu worship, color is a metaphysical entity that aids the mutually embodied, transformative sight exchange (*darsan*) between deity and devotee in the temple or between a guru and devotee. The incorporation of color in twentieth-century Hindu devotional encounters is further enhanced by the use of brightly colored devotional prints and photographs, often featuring attractively dressed Hindu deities. Here the impact of color in the temple practice of sewing clothing for deities and dressing them like royalty is enhanced when devotional printmakers and worshipers become agentive creators and consumers of color. In Hindu temples there is a well-established history of deity images being quickly adapted to both traditional worship practices as well as newer technologies such as photography and offset printing (Pinney 2004).

COLOR, AESTHETICS, AND THE OTHER

The complex history of the twentieth and early twenty-first centuries—the end of colonial rule in various parts of the world, the formation of nation-states, multiple wars, and the waves of migration that followed—blurs analytical categories of religion as private or public or belonging to the East or West, and juxtaposes more traditional forms of spirituality with modern forms of affiliation such as civil religion and nationalism (explored later in this chapter). These entanglements also make it hard to separate forms of faith that are more institutionalized and familiar to the West from those perceived as "exotic." Different examples drawn from the Western and non-Western worlds illustrate the symbolic and agentive role of color, that is, what color both *means* and *does* within a particular religion. In the examples that follow, spirituality may be broadly regarded as a force that both objectifies beliefs as colored surfaces, objects, and substances as well as the process by which a faith community incorporates the bodies of believers, literally "people of color" in many instances, via ritual and practice.

Even as color found acceptance in modern art as a form of spiritual evolution (for instance, in the work of Yves Klein as discussed previously), color as the embodiment of the Other (whether of other people or other religions) presented a cross-cultural and aesthetic problem. David Batchelor provocatively describes

a phenomenon that he terms *chromophobia* (2000: 89) wherein color was systematically marginalized, diminished, and degraded in the West, such that the absence of bright color was often construed as a mark of distinction, power, and taste. Such a differentiation of religions and colors based on associated values and regimes of power could be situated within a legacy of evolutionary thought in which visuality and knowledge were connected to a person's place on a (dematerializing) spectrum of Western progress and evolution. Against this backdrop, colonial histories of chromatic bias were embedded in notions of the exotic and primitive in which color becomes part of a visual and social hierarchy.

When Adolf Loos (1870–1933), the Austrian architect, designer, and theorist, analyzed ornament as "crime" ([1908] 1970), he was expressing a disapproval of decoration (as well as the use of color and pattern in decoration) shared by many aesthetes of the early twentieth century. For Loos, ornament could be understood in the context of the Other (the Persian who weaves and the Slovak woman who embroiders lace). As for the Self, "we have grown finer, more subtle" ([1908] 1970: 24) and ornament could no longer be made by anybody who was truly modern. The nomadic herdsman may have had to distinguish himself by colors but the modern man's "spiritual strength" (24) and individuality was to be expressed in freedom from the indiscriminate use of decoration and color. In this tribute to modern man, the examples cited by Loos could be considered essentialist at best and racist at worst. His faith in the progress of Modernism was bitterly refuted in the catastrophes of subsequent wars and genocides of peoples marked by their different religion and/or color. Indeed, one of the most poignant uses of color as religious stereotyping and discrimination was the enforced use of yellow Star of David badges by Jews in Nazi ghettos during World War II.

Hence, from the beginning of the twentieth century we can trace a relationship between the formation of the ideal modern subject, the aesthetics of color, as well as an Othering of certain colors, religions, and people. To state the obvious, many of these other religions were practiced by people with different appearances and presented both sides with unique interpersonal and sociocultural problems. While the conceptualization of the self in relation to another is a human phenomenon that occurs in all societies, a problem arose when self/other distinctions were applied in the establishment of various kinds of dehumanizing hegemonies. The politics of human relationships is thus implicated in the interaction of color and religion.

MIMESIS AND RELIGIO-COLORSCAPES

With such a complex history, the study of religion and color need not be confined to subjects under consideration within religious studies departments.

For instance, the philosopher Walter Benjamin wrote about a range of subjects that could be considered relevant including essays on art and mechanical reproduction (1968) and mimesis ([1933] 1999). Benjamin locates the capacity for mimesis in the human ability to produce similarities and the democratization of images and other art forms through technologies of reproduction—forces that impact our ideas of aura and authenticity.

Christian missionaries in different parts of the world attempted both to convert the native Other to Christianity as well as to encourage "civilized" forms of dress. These interactions often involved controlling color as a technique of controlling members. In the case of a Zionist group (the Barolong Tshidi) in South Africa, communities revitalized and established intragroup relations through a combination of colonial and modern uses of color (Comaroff 1985). Indigenous dress codes among the Tshidi did not use color as a primary distinction between adult male and female apparel in precolonial times. The Methodist dress of that time in red, black, and white was the ritual of a new establishment, combining precolonial forms and the traditional symbolic African color triad (Turner 1967: 60) with Christian associations of sin and redemption. It was also a technique of body affiliation and management as the mission introduced uniforms to differentiate converts from non-converts. The role of color is fundamental to the Zionist symbolic order, and members today wear their dress as evidence of a holy transformation with men in sparkling white robes and women in Victorian tunics. Precolonial color associations are still used by modern Tshidi, and the church's use of color is both a form of normative orthodoxy and dynamic reconstruction. Different church groups make use of the basic color triad in different quantities both as a way of contrast and to draw from a common set of signs.

As another example of the mimetic power of color, consider the role of colored goods that arrived from the 1920s onwards in Western Australia. The Western settlers mocked the aboriginal Anangu's preference for bright colors in bold combinations, evinced today in their clothing, household goods, cars, and foodstuffs (Young 2011). The Anangu used colors both for their phenomenological effects as sensuous and embodied things, and as a means of objectification of their values and beliefs (Young 2011: 357). Ancestral knowledge and events are revealed to them in material form, such as in painting, ritual, or song, and referred to as "the Dreaming." Moments when the sun appears and disappears are used for revelatory imagery in rituals with the most sacred rituals held at night and ending when the sun begins to flood the country with light. Sacred sites such as Ayers Rock/Uluru, along with neighboring Katatjuta, exhibit brilliant colors and seem to glow from within at dusk and twilight. The capacity of a sacred site to become animated in this way for a few minutes, through bright color, confirms its ancestral importance for the Anangu. The interior power of the earth as ancestral energy is manifested for

this group in objects' and people's capacity to change the color of their surface or skin. When women received printed fabric as rations from the Christian Mission at Ernabella, traditional ontologies of color were further incorporated into their clothing.

In a world of mobility, contact, and exchange, colored objects must participate in numinous relationships both as tangible entities that can be directly sensed as well as detached, circulating images. Organic ties to the land and its products are loosened as people travel and take their religio-colorscapes (either as physical objects or in their imagination) with them. New forms of technology mediate between older sources of efficacy (the sacred place, the deity figure, the pilgrimage path, the totemic animal, the magical plant, and so on) and the new, representational materials of religious use, identity, and global consumption. Today, a green T-shirt and blue skirt might symbolize that its Anangu wearer in Australia is a Christian and is celebrating renewal through water and growth. In addition, green and blue together create a shimmering effect that seems transcendental, expressing the temporal state of the community and the land. This use of bright colors is not just about the issue of perception but the agency of colors to enable people to materialize their connections both to one another and to their "chromatic country" (Young 2011: 372). Just as features of the landscape become materialized at sunset or dawn by their emanation of color, brightly colored clothing has become a way of materializing the Anangu, their relationships with each other, and ancestral presence.

In the Scottish anthropologist James Frazer's famous work *The Golden Bough* ([1901] 1960), the concept of mimesis is part of magic through the principles of similarity and contact and is invoked through the *contagion*—a thing that was once in contact with the entity and is continuing to act on it at a distance via the copy. The latter's connection with the original, that is, the relationship between the copy and the original, is one that is both metonymic and metaphorical. The power of the contagion lies in the efficacies of the metonymic "contiguous" (wherein part of, or an attribute of, something comes to stand in for the thing) as well as the metaphoric "similar" (wherein the symbolism of something may come to represent the thing). One such example of the use of sympathetic magic in the West comes from the mystical group called the Theosophical Society that developed in the early part of the twentieth century in the United States and engaged color in an embodied spiritual practice. Annie Besant (1847–1933) and Charles Leadbeater (1854–1934), both influential members of the society, clairvoyantly investigated the universe and matter through what they termed "thought-forms" and published a book of that same title (1901) in which thoughts and emotions associated with human beings were described in terms of sensations, colors, and values. For instance, one chapter in that book focused on blue, which the authors described as a color essential for spiritual pursuits. (Coincidentally, as described earlier, blue was a color that Yves Klein explored

in depth.) Further, when associated with a shape or motion, colors could be attributed to different spiritual and emotional effects and meanings.

The mimetic faculty acquires additional meanings in anthropological studies of magic and witchcraft by entering the practices and discourses of ritual, the making of magical works, and spirit possession. In magical mimesis, the copy takes power from the original as well as involving both social convention and mechanisms of abstraction. Examples include those acts of magic that require bodily substances, such as hair, nails, or blood, although a resemblance to the body is not always required. In these cases, color could be considered a "polymorphous magical substance" (Taussig 1993), mediating a transformative relationship between bodily matter, image, and action. Sensorial mimetic dramas could be in themselves healing (Romberg 2009) as part of divination, healing, and cleansing rituals as well as magical works such as those performed during consultations at the home altars of Puerto Rican *brujos* (witch healers). Such interactions promote a state of emotional openness among clients and spirits, necessary to initiate the healing process. There are several different ways in which color features in these rituals: humans dress as a particular deity spirit (*orisha*) in preparation to host/receive that spirit, ritual spaces are decorated with fabrics associated with a deity, and healers advise people to alter the color of their clothing (as well as its proximity to the body) to influence their aura and well-being. Here, the magical is associated with experiences of transformation that arise in confrontation with alterity or a compelling insight that shifts everyday orientations to the world. In an interesting example of flows between religious traditions, an anthropologist (Romberg 2009: 195) narrates her encounter with a Nuyorican (reference to Puerto Rican diaspora settled in and around New York) healer who advises her to wear certain colors to "balance" her *cakras,* that is, to manipulate the energy emanated by the different energy points in her body by adjusting the colors that surround them. Arising from an Eastern theology, the concept of *cakras* has clearly now found its way into a different religio-healing system.

RITUAL AND PERFORMANCE IN THE RELIGIOUS USE OF COLOR

One of the ways to approach a religio-colorscape is as practice and ritual work, leading to spiritual and sociocultural results. Ritual practices spatially and temporally construct an environment to produce a ritualized body as well as the social contexts in which color is mobilized as a religious substance. The French sociologist Pierre Bourdieu (1930–2002), who was a student of the phenomenological philosopher Maurice Merleau-Ponty (1908–1961), is popularly known for his concept of *habitus*, or "systems of durable, transposable dispositions" (1990: 53). Less well known than his concept of *habitus* is the

fact that Bourdieu criticized scholars of religion in general for their "propensity to treat beliefs as mental representations or as discourses," when in reality "religious belief … is above all a corporal hexis associated with a linguistic habitus" (Bourdieu in Rey 2007: 66). Subsequently, the religious studies scholar Catherine Bell explicated the relation of ritual to social practices by discussing processes of "ritualization," wherein the focus is on "a way of acting that is designed and orchestrated to distinguish and privilege what is being done in comparison to other, usually more quotidian, activities" (1992: 74). According to this definition, ritual is an activity that is set apart in some way but also emerges from bodily actions and practice. To further extend these ideas, and using insights from praxeology, bodies are turned into ritualized subjects by incorporating or disincorporating materials and other bodies (Mohan and Warnier 2017) and never act (or are acted upon) just on their own.

Against this backdrop, the study of color helps mediate between entities in religious practices that are connected (bodies and materials) but are often analytically approached as separate. For instance, the study of color in religion could move between scholarly approaches that choose to either focus on meanings or emphasize techniques. By doing so, such approaches may highlight verbalized knowledge or procedural means of learning. It is, however, the combination of these different registers of knowledge and experience that renders practices spiritually compelling. The American anthropologist Clifford Geertz (1926–2006) studied religion as a "system of symbols" (1973: 90), but these systems, including cosmologies, are also motivated by the qualities of the material world (Boivin 2009). Colors in indigenous religions are related to the availability of raw materials and the flora and fauna of an environment. For example, the spiritual power of a natural dye for fabrics may be related both to the esoteric nature of dyeing knowledge as well as the position and importance of the dyer in a community. Beliefs in the magic of indigo-dye vats exist on the island of Sumba, Indonesia, and a woman who has acquired the knowledge needed to become an indigo dyer is also considered worthy to qualify as a herbal healer and midwife (Hoskins 1989: 142). Ideas reified as the power of cloth also draw upon the alchemical and medicinal efficacy of the ingredients used, the high degree of skill required to create a functioning indigo vat and the "magical" effect of oxidation on the dyed fabric where exposure to air can seemingly miraculously transform white yarns to blue.

Faith in the spiritual power of cloth continues to be relevant to modern practices of religiosity in the Indonesian archipelago. In the former Dutch colony of Bali, archival sources from the early twentieth century illustrate how the offering of ritual textiles in traditional patterns to the deities and ancestral spirits was central to Hindu and Animist life on the island. Although carried out as a project of psychological anthropology primarily focused on child development, the research of iconic anthropologists Gregory Bateson and

Margaret Mead (1942) demonstrates how a kinesthetic approach was used to document Balinese culture. Many of the practices recorded by them are alive even if modern substances, such as chemical dyes, are now incorporated in ritual cloths. For example, the availability of cheaper dyes and synthetic threads makes it possible for Balinese to express their love of bright colors through the opulence of clothing worn for rites of passage such as toothfiling ceremonies (see Plate 4.3 and Figure 4.3). A comparison with colonial photographs shows that the ceremonies today are markedly different in the rich clothing and decoration used by all castes of Balinese society, and that color, formerly restricted to those who could afford the materials, is much more accessible (Mohan 2018: 53–79). The yellow and green colors of ceremonial clothing (Plate 4.3 and Figure 4.3) mark toothfiling as a type of puberty ritual and symbolize fertility and maturation through their reference to ripening fruits and vegetables. The use of color resonates in the yellow coconuts that store toothfilings (and are later ritually buried) and the orange of mango juice drunk to dull the pain. Toothfiling is believed to limit animalistic desires and negative traits by filing even the upper canines and four teeth inbetween and this practice, along with the colorful paraphernalia, forms a type of semiotic "bundling" (Keane 2005) of qualities and properties as they initiate transitions from youth to adulthood.

FIGURE 4.3 Initiates awaiting their turn at a toothfiling ceremony, Bali, 2016. Photograph by Urmila Mohan.

COLOR IN NEW AGE AND CIVIL RELIGIONS

With advances in the development of consciousness-altering drugs in laboratories in the twentieth century, the use of entheogens (literally: substances "generating the divine within") became a debated issue. An entheogen is any chemical substance, such as a plant or drug, used in a religious, shamanic, or spiritual context that often induces psychological or physiological changes. In indigenous religions, such substances are ingested to bring on a spiritual experience through sensory stimulation. Colors are brighter, sounds more distinct and more subtly experienced, smell and taste heightened, and touch sensitized to the finest textures (McGraw 2004). Sometimes in a higher range of dosage, an effect called *synaesthesia* occurs where the senses are crossed over and colors may be tasted or felt. Contributing to essential sacraments in a variety of ancient religious traditions, the use of such drugs became part of the temporary alliance between hippie culture, alternative spiritualities, and religions such as Hinduism in the West in the 1960s and 1970s.

An interest in experiencing or visualizing spirituality via consciousness-altering drugs in the West can be related to the rise of alternative, New Age philosophies in which practices are detached from their original contexts to become parts of new rituals. The syncretism of New Age religions enables a blurring of boundaries toward new spiritual itineraries, for example, in the use of blue-and-white evil eye objects (*matakia*) in contemporary Greece where Orthodox religious icons, evil eye beads, and New Age symbols cohabit as material objects and spaces (Roussou 2013: 82–6). These new relationships are embodied materially and spiritually in synthesized objects that renew an affinity between Orthodoxy, spirituality, and the evil eye. The affinity that results (Roussou 2015) is very much a mimetic one with the blue and white of the traditional evil eye symbol resonating in (the sale of) apotropaic blue-and-white Chinese feng shui balls and Greek icons of the Virgin and infant Christ (see Figure 4.4). The latter is a hybrid object combining the evil eye with an Orthodox icon and has only come about in very recent years. It is in the study of *how* color (e)merges or rather moves through the formation of new relationships that the beliefs behind this juxtaposition can be further researched. As one shop owner in Greece stated, "Even if they [the evil eye and Orthodoxy] had not shared any kind of relationship up to now, well, now they do" (Roussou 2015).

A form of color usage that has come into its own in the twentieth century is its role in civil religion. Earlier regimes suffused politics with religion, but the end of colonialism and the rise of new nation-states in the middle of the twentieth century meant that different kinds of religions began to realign themselves with national boundaries and struggles for freedom. Civil religion is a concept that originated in French political thought[3] and became a major

FIGURE 4.4 A popular evil eye object, Greece, 2006. Photograph by Eugenia Roussou.

topic for American sociologists since its invocation by Robert Bellah (1967). Bellah wrote the article "Civil Religion in America" arguing there was an implicit "religious dimension" to American culture, which he called "American civil religion." (For instance, African American spirituality and black churches became an important part of the civil rights movement in the United States in the 1960s.) Along with civil rights, American civil religion is evident in

the frequent references to God in public discourse and objects such as the US currency and flag. Most government events acknowledge that the United States is a nation "under God," and the US currency makes clear that it is in God that people place their highest trust.[4]

The relationship between denominational faith and a country's flag may vary, but the flag itself as a form of civil religion becomes invested with the aura and transcendental imagination of a particular nation's or people's history. The Indian flag, for instance, is based both on the symbolism of religious syncretism, with the saffron, white, and green representing Hinduism, Christianity, and Islam respectively, as well as on the nation imagined as the body of a Hindu Mother Goddess or *Bharat Mata*. Following the logic of performative color, one must see the colors/flag in action via rituals, such as flag hoisting during Independence Day celebrations, and the highly ritualized forms of territorial display that take place daily at the Wagah border crossing between India and Pakistan. In another example, in the former French colony of Madagascar, the invocation of ancestral spirits from a royal dynasty (*Tromba*) draws upon powerful symbols such as the spirits themselves as well as the national flag. Rituals use combinations of red, white, and green to create a coherence that includes national identity in which the use of white could represent spirits from all over the island (Nielssen 2012: 264). Religion in modern nations is hence entangled in a complex manner with traditional practices, diverse spiritual influences, and the politics of identity in a world of global flows.

CONCLUSION

The colors of objects and people are imagined, expressed, and manipulated through rituals and practices to access divine or transcendental powers as well as to create and sustain sociocultural norms and identities. Scholarly developments in the embodied, material study of religion over the twentieth and twenty-first centuries reveal a move away from tenets as primary sources of data and the acknowledgment of the body as a transitive register of knowledge that can apprehend and use color for spiritual purposes, however broadly conceived. And modernity, despite predictions, has not resulted in uniform secularization but a revitalization of faiths and a spread of beliefs in new forms. Modern religious practices continue to involve symbolic as well as actual physical use of (and interaction with) substances, surfaces, and products that activate chromatic, spiritual, and social efficacy.

The examples discussed in this chapter are both from groups that could be considered culturally homogenous and traditional, as well as from cultures that are the result of multiple forms of contact and borrowing either recently or over time. Indeed, in a paradigm of modernity, it would be impossible to study color in isolation from globalization and the various kinds of ruptures, mediations,

and negotiations entailed. Color in modernity is certainly complicated as it moves between various regional and national boundaries. Color in a *religious* modernity, however, is distinctive because it also moves between categories of the real and the imaginary, the physical and metaphysical, and the worldly and otherworldly, forming trajectories and relationships across various tangible and intangible registers of experience to create a modern religio-colorscape.

Body and Clothing

TRACY CASSIDY

INTRODUCTION

Historically, color in clothing was directed by the availability of dyestuffs and the colors of natural fibers, which were then predominantly managed by the dye industry as new colors or techniques for dyeing fabrics developed. By the beginning of the twentieth century, as ready-to-wear clothing became more widespread, manufacturers began to direct fashion style and color, which resulted in more diversity in color choice though still within certain constraints. By the mid-twentieth century the manufacturing industry was keen to acquire greater guidance on consumer needs and developing trends, requiring more control over color direction in order to produce more marketable goods for near future seasons. As the textile industry declined in the UK and Europe, many from the industry migrated toward the newly developing trend-forecasting sector. Armed with dyestuffs and techniques that would allow a full spectrum of colors to be applied to clothing, the forecasting sector played a key role in creating a consensus of color season-by-season, and today this essentially governs color availability on the high street.

However, as this chapter demonstrates, color is more than merely a sales tool. Color indeed has meanings that embrace individuals' preferences and aversions, and thus the meaning of and preference for a color differs from one person to another. While color is used as a means of self-expression it can also signify the essence of periods of time, resonating with the sign of the times as a reflection of socio-economic and political trends, to name but a few of the intrinsic drivers of fashion and consumer acceptance of new products/services,

ideas, attitudes, and so on. These are the very same drivers that the forecasters of today identify, analyze, and reinterpret to project into the not-too-distant future to create a new consensus of color and style for the marketing of new trends. Yet, as individuals we seek to satisfy our own ideals, often finding new ways, or reconnecting with old ways, to defy manufactured fashion trends, and thus to create our own innate aesthetic. Also, throughout much of the twentieth century and to the present day, the notion of individualism and collective style directed through street subcultures challenges such restrictions imposed by the fashion industry. Clothing is only one medium that can be used for the adornment of the body—cosmetics, body painting, and tattooing have been used to express individuality and cultural belonging for centuries around the world. The popularity of tattooing has increased more recently.

In addition to the industrial perspective, this chapter explores the personal use of color through clothing, cosmetics, and body art throughout the time period, as well as the issues that have collectively arisen as a result and how these have, or have not, been resolved to bring a rich understanding of the use of color to adorn the body in the broader context. The intervention of the color forecasting sector directing color in clothing throughout the fashion industry is an important inclusion, as is the need for self-expression and unification in the social context. Bonnie English eloquently describes the epitome of twentieth-century fashion as being "the inter-contextual relationships that exist between designer fashions, popular culture, big business, high-tech production, and the multimedia world of promotion" (2007: 1). Throughout this chapter, it is demonstrated how people and events together shape not only the cultural history of the phenomena of fashionable trends but also the impact of those movements on color.

MANUFACTURING COLOR CHOICE

The onset of the 1920s marked a turning point in the history of clothing and fashion when "industrial fashion," to use Diane Crane's (2000) term, really came into being, as ready-made garments became more commonplace in the retail sector. Part-made garments had been available for some time previously, which were finished as part of the in-store service or completed at home. Once completely ready-made garments were available off-the-peg, new fashion boutiques provided a different fashion-forward environment for the younger generation, and the ready-to-wear manufacturing industry developed in earnest. Prior to the fashions of the 1920s, the term *fashion* makes reference predominantly to the bespoke garments that were produced by the highly acclaimed fashion designers of the time.

Diane Crane (2000) reflects on the fashion system, identifying three distinctive categories from the end of World War I to the present day, namely,

couture or luxury fashion, *industrial fashion*, and *street fashion*. Street fashion refers to the styles that are recognized as part of a street culture or subculture. Luxury fashion has become an extension of couture fashion and is still very much associated with high-end designers or fashion names. Industrial fashion refers to the ready-to-wear sector that dominates today's high street and is very much supported by the media. The luxury and industry fashion sectors together shape the manufactured culture of fashion through the fashion system that has developed from the 1920s onwards to the present day. Both of these sectors impose color choices, which are reinforced through the media but mostly through the trend-forecasting sector's predetermined seasonal palettes. Subcultures or street fashion, however, allow for originality and for individuals to embrace more of their preferred colors. Invariably, street fashion makes its way into mainstream fashion through the fashion system and is taken up by a wider consumer audience.

Throughout the 1920s and into the 1930s there was an upsurge in technical innovations in the European and British dye industries to meet the challenge of supplying the growth of synthetic fiber manufacturers with suitable dyestuffs for both color and color-fastness purposes. The first bright green vat dye, known as *Caledon Jade Green*, is said to have been popular for the next fifty years following its development in 1930 by Scottish Dyes Ltd, Grangemouth, Scotland (Williams 2013: 152). Disperse dyes offered new primary colors (red, yellow, and a range of blues) as well as bright orange and purple, black, and maroon (Morris and Travis 1992).

As new colorants were developed dye manufacturers were keen for the colors to be used by the textile industry; a system to facilitate this was not, however, in place in Europe. The Textile Color Card Association (TCCA) of the United States was founded in 1914, and in 1927 Tobe Associates was established as the first color forecasting body and the company is still a leader in this sector (Cassidy and Cassidy 2012: 161). As well as new developments in the dye industry there were also developments in the fiber industry, particularly in the manmade sector where the main objective was to invent a synthetic silk-like thread. The artificial silks, such as rayon and acetate, bore bright colors extremely well (Breward 1995: 186) so that manufacturers of hosiery included pink as well as tan stockings in their stock lists. The idea of influencing people to make color choices became associated with broader developments such as greater social and economic independence for women in some countries.

The 1920s is renowned for the music of its time and for the general changing of tastes in aesthetic and artistic expression. Jazz provided the sounds and Art Deco a vibrant chromatic backdrop for the mood of liberation in the Western world. Figure 5.1 shows a typical bodice worn by "Flapper" girls during the Jazz Age.

FIGURE 5.1 Example of an original flapper bodice, 1920s. Photograph by Tracy D. Cassidy.

As the entertainment industry developed, movie stars became influential and were often clothed by couture designers. Music continued to influence the younger generations. For example, the zoot suit became an iconic fashion statement of Black American jazz, with its bright colors, used as a symbol of pride in the early 1940s as a "subculture gesture" (English 2007: 79), and is one of the earliest examples of street fashion and culture in the twentieth century. The bright colors were used to attract attention to the African American youths who wore them to establish their identity and ethnicity in the new modern world.

DESIGNING COLOR CHOICE

Designers and creatives from the art world throughout the 1930s contributed to the styling of nations and to their prescribed color choices. Fashion designers such as Coco Chanel and Elsa Schiaparelli imparted their personal preferences through their designs. While Vionnet worked extensively with neutral colors, she imposed her favored colors of terra-cotta and deep green on her fashion followers (Mendes and De La Haye 1999: 94). Jeanne Lanvin went as far as establishing her own dye house, developing her own color schemes, and even her own shades of color including her signature *Lanvin Blue*. Artists including Sonia Delaunay, who influenced fashion textiles and color inspirations through her use of strong colors, and Alex Brodovitch, who was a graphic designer first and foremost, explored textile design. The painter and printmaker Georges Braque, costume designer Vertés Marcel, and artist and fashion illustrator Christian Bérard, also known as Bébé, contributed to the design of color for the masses (English 2007: 43; Williams 2013: 157). Delaunay's bright colors contrasted with the popular color schemes that were more compatible with the modernist-minimalist design influence of this time, which favored black, white, grays, and beige (Mendes and De La Haye 1999: 66). The discovery of Tutankhamun's tomb in 1922 influenced the use of blues and gold in design (Franklin et al. 2012: 233) as events in an otherwise outside world became drivers of style or at least key sources of design and color inspiration.

USING COLOR TO BEAUTIFY THE BODY

Beautifying the body can be described as not only the most ancient practice to adorn the body but also the "most direct expression of human activity" employed globally and throughout history (Camphausen 1997: 1). As hemlines rose, legs were exposed and emphasized not only by the use of colored stockings but also through suntan. The 1920s, dubbed by some as the suntan era (Franklin et al. 2012: 222), experienced a rise in the popularity of sunbathing, foreign travel, and transatlantic cruises (Baudot 1999: 63). Coloring the skin naturally became fashionable. For those without the financial means to travel to popular destinations such as the French Riviera, red food coloring could be added to skin cream to achieve the desired aesthetic. Cosmetics, considered to be brazen in previous decades, in general also gained popularity, adding color to the eyes, cheeks, and lips particularly of the younger generations as statements of personal identity.

Jennifer Craik regards the use of cosmetics as passive and trivial behavior due to their non-permanency in direct contrast to other forms of body decoration such as tattooing (Craik 2000: 153). By the 1930s cosmetics had become a staple product in a woman's daily beauty regime, so much so that women were actively seeking information, hints, and tips on how to make the most of their makeup

products. The company Max Factor capitalized on this movement by investing in the development of different product types such as their water-soluble "pancake" introduced in 1938, which helped to revolutionize the cosmetics industry (161) and firmly embedded the application of color to exposed skin as normal practice amongst women. At around the same time designers reinforced the presence and importance of cosmetics in the color movement. For example, Elsa Schiaparelli introduced *shocking pink*, considered at that time to be quite outrageous and only for the most daring. Actresses and Hollywood also led the way for the cosmetics industry as they displayed new ways of applying color as well as making new shades popular. Consumers made reference to this new generation of celebrity in their own use of color in cosmetics and in fashion. Despite rationing during World War II the sales of cosmetics continued to grow—between 1940 and 1946 sales in the United States were reported to have risen by 65 percent (161). By the late 1940s deep red lipsticks were very much on trend (Mendes and De La Haye 1999: 154).

FASHION EQUALITY

Fashion magazines had long since supported the female fashion consumer, providing information, patterns, and inspirations. In 1931 Arnold Gingrich introduced the *Apparel Arts* magazine, aimed principally at the trade—manufacturers, wholesalers, and retailers—in order to promote the fashion concept to the male consumer market. In 1933 Gingrich introduced *Esquire* for male consumers, giving similar inspiration and advice on design and color. This is reported to have coincided with the rise in popularity of ready-to-wear in the United States in the newly forming menswear sector (English 2007: 65). From this point forward men have played an equally important part in decisions made about the use of color in clothing design and have also contributed strongly to the direction of style adoption on the street and engagement in subcultures. For example, undergraduate students studying at Oxford University in the 1920s began to rebel against the ban on knickerbockers for sport by wearing the loose-style trouser, which became known as *Oxford Bags*. The more usual colors for trousers were the conservative colors navy, gray, black, cream, and beige; some, however, made a bolder statement with lavender and pale green. Through media coverage the trend spread across the Atlantic to the Ivy League colleges in the United States (Mendes and De La Haye 1999: 70).

THE INFLUENCE OF FURTHER TECHNICAL DEVELOPMENTS

Following their recovery after World War II, the dyeing and manufacturing industries reaffirmed their strong influence on color choices for the mass market. The main focus in technical developments throughout the 1950s was very much

on yarn development including spinning technology, which impacted on further developments in knit and weave. This in turn induced rapid improvements in the garment manufacturing sector. Fabric types, particularly those made of manmade (synthetic) fibers, gained importance (Baudot 1999: 141), not only in the fashion context but also impacting on the changing lifestyles of women in particular as they juggled work and home commitments. Color gained recognition by the industry as a powerful sales tool and also with high street retailers, especially boutiques, which began to capitalize on seasonal color preferences. By the late 1960s Eric Paxton Danger (1968) further enforced the importance of color as a sales tool through his publication *Using Color to Sell*. Danger's interest in color began when he was approached for color advice by a leading paint company. He realized that little guidance existed on color for marketing and sales professionals, and this instigated a lifelong study. He became Managing Director of a color consultancy, Economic Color Trends Ltd., that specialized in environmental design, marketing, and packaging. Danger developed a strong connection with color consultant and theorist Faber Birren, who, as President of American Color Trends Inc., New York, had gained international standing as an authority on color and also advised the US Government on color matters. Together they enforced the importance of color as a business tool. Danger published in excess of seventy articles on color marketing and was a member of the British Colour Council (BCC). The BCC, as well as other publications, created sets of British Colour Codes for a range of industries including textiles between 1931 and 1974 (Blaszczyk 2017: 191–225).

DESIGNERS CONTINUE TO INFLUENCE COLOR IN DESIGN

New fashion colors for the 1950s such as turquoise, ocher, and mauve are now considered to be the signature colors of this decade under the influence of Spanish designer Balenciaga who had used these colors in his own color schemes (English 2007: 59). This trend demonstrated the continuing influence of the high-end designers. Similarly, in the 1970s Calvin Klein's signature color was marketed as brown, as he favored earth tones and neutral colors (Mendes and De La Haye 1999: 205). However, just as in the 1920s, new designers with fresh ideas entered the design scene, for example, Mary Quant whose first collection used clashing bright colors, which became very popular with youth generations (English 2007: 83). Like Quant, designer Barbara Hulanicki sold her own designs in her London boutique in the 1960s and 1970s. Through the Biba store, Hulanicki developed her signature colors—sludgy blues, plums, and pinks—and also popularized dark eye shadow cosmetics through the *Dark Biba* makeup range (Mendes and De La Haye 1999: 217).

The use of blocks of color, which were employed in fashion design in the 1960s, is an appropriation of a concept taught in the Bauhaus School of

Design in Germany during the 1920s. Yves Saint Laurent was particularly interested in popular cultures, declaring that this was a great influence on his designs. He observed young people on the street for inspiration (English 2007: 88). This method of design research continues today as standard practice and demonstrates the important role that street fashion and subcultures play in the direction of style and color. By the 1960s the diversity of lifestyles, however, influenced a much wider range of color, design, and style, which represented a break from the more traditional single trend or single fashion style at any one time that was evident during the first half of the twentieth century (Baudot 1999: 186). Thereafter, concurrent trends have become the norm, and the range of subcultures has grown significantly since the postwar years.

THE INFLUENCE OF FAIRGROUNDS AND POP ART

By the postwar years, artists all around the Western world reconnected with folk traditions and with folk art as a means of self-expression and decoration (Figure 5.2). Bright and somewhat garish colors became popular. Folk art flourished on English narrow boats, American showboat paddle steamers, and gypsy caravans (Hillier 1990: 123). Similar artwork began to gain favor as body art. Tattooing, once popular in China and Japan, gained some degree of popularity in the Western world during Victorian times as many of the Chinese and Japanese tattoo artists migrated to the United States and Europe. At that time circus performers in particular would set themselves apart from the mass population, using tattoos to affirm their quirkiness and artistry as eccentric entertainers. The most typical colors used were predominantly bright primary colors or just indigo.

This tradition, which already had a long history, was adopted by the fairground workers of the twentieth century. Fairgrounds regained popularity in the 1950s as a source of pleasure, with mechanized rides including carousels. Waltzers (flat, rotating rides) and dodgem cars were decorated to epitomize the tattooed circus bodies and folk art designs of previous times. With this, fairground workers used similar colors and designs to decorate their bodies. Traveling fairgrounds are viewed as an important influence on popular art and to this day still use Art Deco designs and Renaissance scrollwork (Lewery 1991: 25). Indeed, Lewery emphasizes synergies between the youth generation of the postwar years, the pop music industry, and the fairground as an important mix, declaring the waltzer entrance steps to be the natural home for rock and roll (26). Popular music was indeed a key ingredient of the fun fair, and it was used to attract the younger generations. Regulars to the fairgrounds included Teddy Boys and Rockers, who were particularly instrumental in popularizing tattooing on a street level in the mid-twentieth century (Camphausen 1997: 10–11). Tattooing continued to

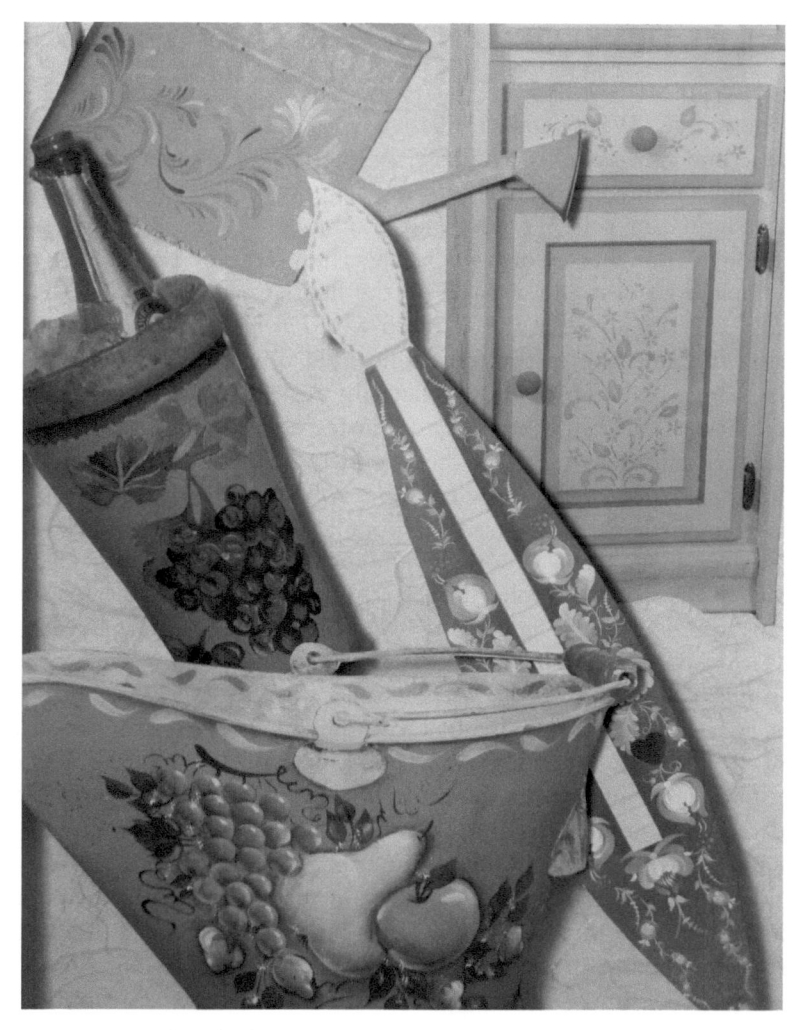

FIGURE 5.2 Examples of folk art on everyday objects. Photograph by Tracy D. Cassidy.

grow in popularity throughout the 1960s, 1970s, and 1980s as more subcultures developed and engaged with the tattooing movement. Hippies, Hell's Angels, and punks in particular used tattoos as a symbolic form of expression as part of their rebellion against the social norms (11). While colored tattoos symbolized rebellion, they were also a celebration of the body, the self, and life (Camphausen 1997: 23; English 2007: 2). In this context body color was a form of individual expression as well as a means of forging links between subcultural beliefs through a defined aesthetic.

RETAIL DEVELOPMENTS, POPULAR ICONS, AND THE YOUTH GENERATION

Throughout the 1950s and 1960s cheaper fabrics made fashion more affordable and more readily available. As the fashion system in the Western world became firmly established with the support of the fashion media, color played a significant role. Trendsetting boutiques and the inclusion of color photography in the wealth of fashion magazines (Baudot 1999: 186) ensured the dominance of on-trend apparel on the high streets of US and UK towns and cities, and equally so in the Western world at large. Younger generations once again became one of the most influential drivers of aesthetic style and lifestyle change and were by now financially reasonably well off. Interests in music had changed from the big band and tea dance band formats that were popular during the early half of the twentieth century as the electric guitar made its appearance and the new rock and roll era began in earnest. Films of the 1950s in particular influenced the popularity of blue jeans. English notes actors such as Gene Autry, known as the "Singing Cowboy," and the singer/actor Roy Rogers in their roles in westerns as being responsible for bringing blue jeans to the screens (English 2007: 67). It is, however, more likely to have been Marlon Brando in *The Wild One* (1953) and, probably more so, James Dean in *East of Eden* and *Rebel Without a Cause* (both 1955) who made jeans and black leather jackets synonymous with the youth rebel culture of that time (Baudot 1999: 124). According to Diane Crane, popular culture is a means for constantly changing and refining social phenomena; while identities can be formed through the artifacts that become associated with a movement these may acquire new meanings in different periods (Crane 2000: 172). Color can be seen to be related to this both as a part of the overall aesthetic and also as an independent element of design. Television, film, and music often become catalysts for embedding style, design, color, and lifestyle attributes, while also influencing subcultural trends and the construction of personal identities (Kidd 2002: 109).

Probably one of the most influential events in the history of the twentieth century is the moon landing in 1969 (Hillier 1990: 123). Materials, color, form, and just about every aspect of design for every type of product made reference to space and space travel at this time. High-end fashion designers were also influenced by the event. For example, Courrèges was greatly inspired by astronauts' suits and spacecraft, which were reflected through his use of white and silver, colors he thought signified youth and optimism (Mendes and De La Haye 1999: 166). Space travel also influenced TV programs, such as *Lost in Space* (1965–8), as well as songs, such as David Bowie's *Space Oddity* (1969) and Elton John's *Rocket Man* (1972). Silver and metallic colors were highly popularized during the 1970s, particularly through Glam Rock bands,

or Glitter Rock as it was also called, both in the outfits worn by the bands and also through the use of heavy makeup. The bands featured on music programs, such as *Top of the Pops* (1964–2006) in the UK.

Cosmetics were later used by other pop band cultures including punk rockers, the New Romantics and Goths (Polhemus 2004: 27). The use of cosmetics, according to Ted Polhemus, radiates meaning through both the style of the application and through the selection of color (30). Punks favored black for their attire with outrageous and unnatural colors for their hair creating a sharp, attention-grabbing contrast as a mark of their rebellious nature and beliefs. The New Romantics used mostly black and white in their dress often accented with bold colors such as red, with strong colors for cosmetics to reflect their edgy personalities. Goths, of course, also favored black both for attire and makeup—eyes and lips—against often quite a stark white facial foundation, to reflect a more sinister and mysterious look. This extreme use of cosmetics was, however, mainly used by the youth generation who were attracted to that sinister perception of the subculture rather than by those who embraced the more spiritual lifestyle of those they perceived to be "true Goths" (as opposed to those they called the "Weekend Goths").

The ancient henna plant and its use in body decoration is revered for protection, good luck, and for material and spiritual health. It has long been used for wedding and rites of passage ceremonies (Fabins 1998: 17). The use of henna was once again popularized by pop artist Madonna in the 1990s and has become a popular form of body art by music festivalgoers. Polhemus recognizes the connotations of spiritual significance, which he states the Western world rarely embraces (Polhemus 2004: 33), or at least is rarely willing to demonstrate in such an obvious visual form of expression.

POPULAR LIFESTYLE MOVEMENTS

The 1970s and 1980s revivalist era, the forerunner of the vintage movement that is purported to have begun in the 1990s and remains popular today, is a return to 1920s, 1930s, and even 1940s styles (English 2007: 59). Hillier identified this as being the nostalgia craze, what we now refer to as *retro*, which was even evident in the late 1960s (Hillier 1990: 206). The decorative arts are a key design feature of this return to the Arts and Crafts concept. The handmade and handcrafted items also became synonymous with 1970s street style (English 2007: 96). The hippie movement of the time used this style as a metaphor for healthy living and saving the planet. This may be viewed as the onset of the environmental Green movement of today. It was also the hippies who instigated the use and desire for secondhand and vintage clothing, which they wore with pride, as it reinforced their desire for a simplistic lifestyle that was considered to be kind on the environment. They embraced color, favoring

bizarre combinations that accentuated their lifestyle of using anything to hand. The look was brought into mainstream fashion with gypsy skirts, vest-type tops, T-shirts, and knitwear. The appearance of the subsequent merchandise in high street stores mimicked that disorganized free-style existence to the point of devastation for the fashion industry in the UK. Riots of color made high street stores resemble jumble sales to which order, streamlining, and simplification was needed to restore harmony. This linked to the minimalist movement now directed once again by the design community, in both fashion and in the home and work environments, including in-store design. The movement demanded a reduction of everything including color. Achromatics became the sign of the times.

THE COLOR CONSENSUS

During the 1960s and into the early 1970s in the UK, parts of Europe, and in the United States, the textile industry declined as a new sector of the industry began to grow: the trend-forecasting sector—largely due to the migration of some shrewd textile experts. The trend sector had made its appearance during the 1920s and 1930s, possibly beginning in the United States, at least in its modern-day format. The sector developed through initial agencies that established color consultants to advise fashion and textile companies regarding color direction. Color forecasting today is a fundamental part of the larger fashion forecasting or trend prediction sector. The role of the forecaster is to accurately forecast color and other design elements for fashion-related products that consumers will purchase in the near future. As more agencies were established it became important to diversify, and consequently many offered inspirations to companies beyond the fashion and textiles sector, such as the automobile industry. In widening the customer base, color-trend information has become more generalized and therefore less market focused and even further removed from personal tastes and preferences.

Color forecasters operate mostly from the major global fashion cities providing seasonal color stories comprising a limited number of colors per season. The color palettes are sold as part of a trend prediction package at regular intervals throughout the year (see Plate 5.1). Originally palettes were devised for the spring/summer and autumn/winter seasons. Today some, however, update their palettes on a more regular basis, particularly those operating online. The information is used mostly by designers and buyers who are responsible for making color decisions for their company's product ranges. Originally the color forecasting sector enabled the textile industry to anticipate the requirements of the garment manufacturers, and for the garment manufacturers to respond to the needs of retailers, aiding the establishment of the fashion industry as it is today.

In 1931 the British Colour Council (BCC) was formed and played a key role in the development of seasonal color palettes in the UK (Cassidy and Cassidy 2012: 161). However, over a decade later the UK industry still faced difficulties in providing the most appropriate colors. This may have been due to the organization's focus on providing standardization for color as opposed to forecasts. To help alleviate this, a group of manufacturers formed the London Model House Group in 1947 (Burns and Bryant 1997) to coordinate a structure for the industry to use by introducing stock seasonally into the growing retailing sector. Manufacturers were then able to work to deadlines on heavier weight clothing for autumn/winter collections and similarly on lighter weight garments for spring/summer.

More color and fashion trend consultancies have been established since the 1970s, many of which now have a global presence such as Promostyl and the International Color Association (ICA). The fashion and textile industry uses trend information to inspire some of their color decisions in order to create products that are considered to be on trend. The process purports to involve an accurate evaluation of the current mood to project into the near future (Brannon 2000). This is coupled with a color data collection process that is analyzed and interpreted to anticipate change (Perna 1987). The seasonal color stories are promoted throughout the industry, in particular through trade fairs. The promotion of "color stories" is considered to be important to instigate high street sales through a consensus on color. It is the competitiveness of the fashion and textile industry that drives the apparent need for trend prediction information. While forecasters, like designers, frequently incorporate inspirations from street style and subcultures into their color ranges, personal color preferences still tend not to be taken into account (Diane and Cassidy 2005).

CONTEMPORARY TATTOO CULTURES

By the 1960s tattoos were popular amongst the college-educated middle class, and in particular, among art school graduates. Many were inspired by popular culture and emerging street styles. The color palette became less limited and a greater number of women became tattoo artists (Polhemus 2004: 47). *Juxtapoz* is a West Coast art and culture magazine established in the United States in 1994 (Groebner 2008: 9). On its website, *Juxtapoz* markets itself as being the "contemporary underground art bible" (Juxtapoz n.d.). *Juxtapoz* artists have gained popularity, bringing their artwork into mainstream fashion. Some artists such as Julie Becker (Los Angeles) also uses her tattoo art on fabrics (Groebner 2008: 14). For the tattoo (*tat*) artists, it would appear that their artwork is more about using their artistic flare and talent as a means of self-expression, rather than aiding their clients to find their own artistic identity. Many of the *Juxtapoz* artists have a clearly defined signature style and artistic preferences that their

FIGURE 5.3 A monotone tattoo. Photograph by Tracy D. Cassidy.

clients buy into just the same as fashion followers buy into the signature styles of leading designers. For example, tattoo artist Eli Quinters (New York) draws inspiration from Mexican folk art and also from advertising and vignettes, particularly those from the early twentieth century. Prison tattoos, which have distinctive meanings such as the empty clock face symbolic of serving time or cobwebs representing long periods of time in prison, are another form of inspiration. The most popular color is a deep indigo blue (Groebner 2008: 142).

Today tattoos have found favor with a number of subcultures, including those who engage with the vintage movement. Tattoos have become more

mainstream, popularized to such an extent through social media that they are now recognized as part of popular culture. The purpose has perhaps become quite simply to use the body as a canvas for artistic expression. While the color range is still somewhat limited, there are enough basic colors to cater to the preferences of most individuals. While colors were generally based on bright and sharp primary and secondary colors, in recent decades some favor a softer palette with the inclusion of pinks, soft lilacs, and soft oranges that make the tattoos appear more like pieces of artwork rather than the more comic-strip or fairground appearance of earlier tattoos (see Plate 5.2 and Figure 5.3).

COLOR STYLE ANALYSIS AND IMAGE BUILDING

Since the late 1970s and early 1980s there has been a growth of color and style analysis, and image building, through which the number of color and style consultants has grown in the Western world, as well as becoming evident in the East in more recent times. While this specialist service sector appears to be growing in popularity and many systems are available—several of which can be located and interacted with online, such as "The Colourflair System" and "The Australian Image Company"—there are still only a small number of companies or key figureheads driving this industry sector. These include the works of Mary Spillane of the "Color Me Beautiful Organization" and two image consultants and authors, Barbara Jacques and Angela Wright. Since Barbara Jacques has passed away, her daughter and granddaughter continue her work to educate the general public about how to make the most of color in clothing and in cosmetics. Similarly, as media consumers in general are becoming far better educated in recognizing colors (and styles) that work best for them as individuals, they are more sensitized to their own personal preferences. This may be due to the increasing number of publications in this area that help the reader to understand and analyze their own coloring. Mary Spillane strongly advocates the importance of color in fashion and personal image, as expressed when she was interviewed by *Drapers Record* to promote color analysis as a selling tool for fashion retailers ("How to be a Successful Retailer" 1998). Outlining the issues, she referred to a womenswear retailer who considered that color trend forecasters created problems for retailers since their emphasis on current trends often excluded colors sought by their potential customers.

Almost twenty years after this article was published, the sector is, however, no further forward; the fashion industry still relies heavily on colors promoted through trend forecasts, and individuals still have color preferences that are often not reflected in those trend colors (Cassidy and Cassidy 2012). Whether consumers really know what suits them or whether they have strong preferences for colors and styles they believe suit them, the fashion industry could benefit greatly from consumer preference data. Regardless of fashion trends, people

in general have a sense of, or preference for, colors and styles that they feel comfortable in both physically and psychologically. In the same *Drapers Record* article the advantages of image consultancy were also deliberated. One image consultant, for example, claimed to have knowledge of her clients' loyalty to retailers that offer fashion in color ranges that meet their requirements. She added that knowledge of color analysis can assist the retailer in fine-tuning their product offering to avoid stocking colors that will not sell ("How to be a Successful Retailer" 1998). Whether retailers and other fashion personnel within the industry endorse the use or potential use of color analysis or not, the fact remains that it is evident that consumers are more aware and better educated about color. Whether consumers are motivated by the knowledge or awareness of those colors and styles that suit them best or about their own personal tastes and preferences in fashion, the fashion consumer in general is becoming more discerning and more demanding on the industry to get color right for them.

Angela Wright's color system uses four fundamental palettes each named after one of the four seasons. This method is also typical of the color forecasters. The spring palette comprises colors that are warm and light, known as *tints*, in which the key aspect is clarity. The summer palette comprises colors that are cool, known as *tones*, in which the key aspect is subtlety. The autumn palette has warm, intense, and lively shades. The winter palette comprises very strong primaries, including white and black, or spectrum colors with strong contrasts and also some of the strong tints and shades; these are very powerful colors. It is said that personal skin, hair, and eye colorings are also synonymous with these four basic color palettes. Angela Wright, a specialist in color psychology, has recognized the harmony between colors that belong to the same season or family and has built a consultancy business on this basis giving advice to many sectors of commerce on color combinations for interiors—offices, retail stores, and so on—as well as for product packaging, in addition to educating the general public regarding clothing (Wright 1998).

The image company Color Me Beautiful also uses the four seasons as the basis for their color analysis system. Mary Spillane claims that feedback from more than two thousand of their image consultants has been instrumental in the refinement of their system. The original four types were based upon the undertones of hues, otherwise referred to as the *color temperature*, that is, warm or cool, and also on *value*, which is the lightness or darkness of the color. Light colors, or tints, have white added, and shades have black added. Using the Color Notation System devised by Albert Munsell, Color Me Beautiful now uses a system of twelve types incorporating *chroma*, otherwise known as saturation or clarity. This third dimension takes into account how clear (pure) a color is or how muted (tonal, with added gray) it is (Spillane 1995; Henderson and Henshaw 2014).

Barbara Jacques declared that everyone can wear any colors if only they understand how to wear them, stating that it is essentially the individual's color personality—how one's own body absorbs, transmits, and reflects light energy—that is the critical aspect to understand (Jacques 1994). She also recognized the importance of undertone, clarity, and intensity; she claimed the latter to be the most important aspect of any analysis or design. Jacques initiated her tonal concept in the 1950s, which is based upon twelve color wheels or types. These twelve types are not the same as the twelve types developed by Color Me Beautiful; the methodology behind Jacques's model is not, however, clearly stated. While the personal color analysis and consultancy sector has grown since the 1990s and has some influence over the colors some people wear, the impact is not significantly high. The sector is likely to have developed due to the rise of the opinion that fashion was no longer something to be *slavishly* followed as it had been throughout the twentieth century (Baudot 1999: 318), making way for the expression of more individuality for the new millennium.

NOSTALGIA AND SUBCULTURES

The change in the UK, Europe, and US economic climates during the 1990s has been suggested by many as the catalyst for the vintage trend that began a new cycle of interest in all things nostalgic that is still going strong today (Walden 2010). Other factors relate to the change in attitudes of the general public toward secondhand products, and "Green" issues such as eco-sustainability. The movement also appears to be a response to contemporary fast fashion and throw-away cultures (Palmer and Clark 2005). In sourcing vintage clothing individuals can once again express themselves through the use of color and style that relates to their own personalities, preferences, and cultural interests. While the vintage movement began as a trend among a subset of the general population it has now become synonymous with lifestyle changes and a renewed value of products that are generally viewed as being of a higher quality than modern-day products, or valued for their individuality and rarity that cannot be realized in mass-produced items. Palmer, however, perceives vintage as having moved from a subculture to a mass culture due to its acceptance by, and with the engagement of, a much larger body of people (Palmer 2005: 197).

There are a number of other subcultures, such as *Lolita* and *Steam Punk*, that have emerged during the time of the vintage movement and have traveled across the globe to make their mark on some cities more than others (see Figure 5.4). The origins of these examples are evidently rooted in previous subcultures, as are the influences and inspirations that have helped to define modern-day subcultures. For example, Lolita's origins appear to have been inspired by

FIGURE 5.4 Example of the steampunk look. Photograph by Tracy D. Cassidy.

Nabokov's infamous novel (1955), which was adapted for film in 1962 and 1997. The subculture developed in Japan in the 1980s and migrated to other countries including the UK. Lolita was born out of the trend for nostalgia in Japan at that time and can be viewed as having been adopted in other countries at a time when nostalgia was also in favor there. Not only does Lolita wear a certain style of clothing, but her clothing also displays very particular

mannerisms and behavior (Kang and Cassidy 2015). The style of clothing is based on the look of the Victorian doll typical of Western countries, employing lace, frills, and ribbons in the doll's dress. However, further mini-subcultures developed from this original concept, allowing individuals to develop their own sense of style within the key signature style (Winge 2008: 47).

Although Lolitas are generally young women, they appear and act like young girls, and this reinforces their desire for cuteness, innocence, and elegance (Gagné 2007). The clothing makes use of dominant colors: black for *Kuro Lolita*, otherwise called Kurololi; and white for *Shiro Lolita*, otherwise called Shirololi. Kuro Lolita and Shiro Lolita are often presented next to each other, which to the onlooker further emphasizes their visual differences. *Ama Lolita* (which means "sweet") involves a preference for pastel colors and soft tones or bold reds and blacks (Winge 2008). *Gothic Lolita* became a very common subgenre using makeup to add further drama to their more sinister look (Nguyen 2008: 9). The Goth aesthetic has reinvented itself many times throughout the latter part of the twentieth and early twenty-first century, as has punk. *Punk Lolita* makes use of leather, zips, and chains just as punk rockers did in the 1970s (Kawamura 2006).

Steampunk is another modern-day reinvention of punk, whose origins can be traced back to the 1970s in relation to the fantasy/science fiction literature of that time. The subculture holds dear the concept of alternate histories spiraling out from the Victorian age of steam power. Over time, the culture has come to be supported by film, the gaming industry, music, fantasy literature, and fashion (Robb 2012). Inspiring artifacts have now found their way into the mainstream largely through websites such as eBay but also craft sites such as Etsy. The trend links to upcycling, which is a newly coined term for making something new from something old. Steampunk fashion for women is not so dissimilar to that of Lolita in that both take their inspirations from the Victorian era, though steampunk is often less cute-looking in its aesthetic. References to aviation or to explorers are often featured. The most typical colors used are black, white, and neutrals, which may be associated with sepia photography, while contrasting with flashes of striking colors for effect (Grymm 2011). Like many subcultures, self-expression and sometimes also fantasy appear to be the drivers of interest and engagement. Color both in attire and its use on the body are used in combination with style to create a look that somehow has a language of its own, with which it expresses its meanings to individuals inside and outside the subculture. Similarly, subculture styles and colors that extend into popular culture, as well as manufactured trends that have been discussed throughout the chapter directed by designers, artists, and industry for the purpose of selling products to the nations also speak volumes about personalities, beliefs, and values, but only to those who are listening.

CONCLUSION

This chapter has explored color in relation to the adornment of the body through clothing and cosmetics in order to discover how people and events shape the cultural history of color from the 1920s to the present day. It has brought together the mechanisms of an industry where color is used as a powerful driver of sales with the popular interests of the people for whom those colors were intended. It demonstrates that industry may influence those who wish to follow a consensus of color, but essentially we are the driving force behind the colors that we prefer to wear; and that as individuals and as collaborators we determine the visual expression of the meaning of those colors. While we pause to reflect on almost a century of color, new subcultures, movements, and pop cultures are emerging, and without a doubt, the fashion industry will continue to try to impose color choices upon us. The popularity of colors may go around in cycles or be recycled, but their meanings are determined by and belong to those who choose to adopt them.

Language and Psychology

GALINA V. PARAMEI AND DAVID L. BIMLER

INTRODUCTION

Colors, as percepts, or qualia, are a product of human psychology as well as physiology and genetics, and are closely linked to language. We are obliged by the requirements of cognitive economy and of effective communication to partition the gamut of all possible colors into a manageable number of color categories, and to label each category with a term, such as *red*. Color terms, categories, and the boundaries that demarcate categories are shared across the speakers of a language, but not as identical copies, so that each speaker has their own personal variant of the collective structure.

This creates possibilities for diachronic color language *changes*, where speakers of a language collectively replace older terms with new ones, for reasons that remain obscure. In particular, a notable aspect in the last century, across many languages, has been a trend toward greater descriptive refinement—necessarily involving the acquisition of new terms. This trend, and the cultural forces driving it, is one theme of this chapter.

As with other linguistic domains (where possible), one can define color names in terms of their objective referents, or denotata—a range of color gamut samples (compare Bloomfield 1935: 140). However, there is more to color conversation than specifying paint shades and the denotative function of color terms. The meaning of a color term cannot be reduced to the range of physical hues it encompasses, for color terms also carry connotations: they have affective values, reflect cultural conventions, and serve as social markers.

A second feature of the modern era is an interest in this affective role of colors and color terms, and in particular, color preferences. Research into color preferences is largely a phenomenon of the last hundred years (for example, Guilford 1934). Like the increase in linguistic, descriptive refinement, this can be traced to modern technologies of production, which severed the connections between manufactured artifacts, their constituent materials, and their surface appearance. The color of a given artifact is now arbitrary rather than determined by its materials, creating choices for purchasers that became a vehicle for self-definition and self-expression. It is now practical—and even expected—for individuals to have "favorite colors," and color preferences abstracted from any specific context.

COLOR NAMING AND CATEGORIZATION: CHANGE OF THE PARADIGM

Compared to other linguistic domains, the semantic and conceptual field of color is clearly demarcated. In contrast to more abstract domains, it also has identifiable referents—standardized color chips, such as comprise Munsell charts, and more generally, color stimuli whose hue, brightness/lightness, and saturation can be specified in photometric terms (for example, CIExyY, CIELUV, CIELAB, and so on).[1] The possibility of validating the "color word" by its specific referents opened at the beginning of the twentieth century—due to progress in both technology and color vision science. As a result, the color domain gained favor among researchers interested in straddling linguistics and color psychophysics, in order to tackle the mechanisms of the development of mental constructs and the driving forces of the construct lexicalization, as well as those investigating cross-cultural differences.

Until the late 1960s, standardized collections of color stimuli were largely the domain of anthropological linguists. Conceptually, the relativist view was dominant, that is, the Sapir-Whorf hypothesis or linguistic relativity hypothesis (LRH). Leonard Bloomfield expressed it clearly and influentially:

> Physicists view the color-spectrum as a continuous scale of light-waves of different lengths [...] but languages mark off different parts of this scale quite arbitrarily and without precise limits, in the meanings of such color-names as *violet, blue, green, yellow, orange, red*, and the color-names of different languages do not embrace the same gradations.
>
> (1935: 140)

Linguists turned to color vocabularies in different languages to demonstrate that divisions of the color continuum are arbitrary, such that the only universally true generalizations to be drawn are trivial or tautological (Saunders and van Brakel 1997).

The pendulum-swing change in the paradigm came with the seminal work of Brent Berlin and Paul Kay ([1969] 1991), whose universalist view posits panhuman basic color categories (BCCs), recurring and evolving from a minimum of two to a maximum of eleven (in industrialized societies), in a partially fixed order across languages. The authors introduced four main criteria of basicness and four subsidiary criteria (Berlin and Kay [1969] 1991: 6–7).

Berlin and Kay's predecessor, Eric H. Lenneberg (Brown and Lenneberg 1954), had already introduced the notion of basic color terms (BCTs) as a working assumption, if not so well defined. Lenneberg and collaborators also introduced the "Munsell palette" array of color chips to map the denotata of (basic) color terms. Berlin and Kay extended this by examining internal gradation within color categories: a BCC encompasses a "best exemplar," or category focus, but also other colors that are less representative of the color concept in question. In operational terms, both the focus and the outer boundary of a color category are important.

BASIC COLOR TERMS

Any attempt to address "descriptive refinement" requires a distinction between "basic" color terms and their underlying BCCs, and all others. BCTs are the "core vocabulary" of color language and psychology, the first-level system of chromatic analysis we use for an initial description of any object in the visual environment. It follows that (almost) everyone knows and uses each BCT in their language, and there is general consensus on what region of the color gamut it covers. There are tests to apply to the color terms of a language to ascertain whether they are basic or non-basic (Biggam 2012: 21–43). Color terms can also be assessed with regard to their *relative basicness* in a language, that is, their position on a continuum ranging from low to high cognitive salience (Kerttula 2002).

BCTs contrast with non-BCTs, which offer more fine-grained specificity (for example, *cinnabar* denotes a narrower range of colors than *red*), but not everyone applies them to the same narrower range, limiting their usefulness in communication. Some high-salience non-BCTs may become BCTs in the future.

Linguistic anthropologists, psychologists, and historians specializing in a given language have several options for quantifying the prominence of its color terms. Specifically, terms can be rated by their cognitive salience for the average speaker, or the reaction times required to evoke them, or the extent of their denotata. Written corpora for the language, if available, can yield measures of each term's usage, and also its morphological, generative properties. *Salience* singles out a term's position within the productive

vocabularies of the language's speakers—measured by the proportion of speakers who use it spontaneously and by how easily each speaker accesses it. The outcome of these diverse measures is generally a quantitative gap, with BCTs on one side and non-basics on the other (Davies and Corbett 1994; Sutrop 2001).

Once the scope of comparison is limited to BCTs, a substantial degree of overlap is found between the category schemata of languages around the world (Kay and Regier 2003). Which is to say that translation of color discourse is imperfect but possible: despite the continuous nature of the color gamut, languages do tend to divide it into mutually recognizable chunks and "carve Nature at the same joints." The overlap of the BCCs between languages tends to deteriorate, however, closer to their boundaries (Regier et al. 2005; Bimler 2007).

This presents a choice between focusing on the panhuman universal features of color vocabularies and categorization, where languages generally agree; or on their departures from the universal trends, on linguistic differences. The latter, linguistic relativity perspective entails the possibility that when two category schemas differ (for example, in the existence or the location in color space of the boundary between two adjacent categories) the divergence is accompanied by subtle differences between speakers of the languages, in their perceptions or the conceptual structure—as the LRH predicts. The former perspective, universalism, downplays the possibility of linguistic differences.

The universalist view is closely identified with the empirical research program that started with Berlin and Kay ([1969] 1991). The B-K paradigm is strongly evolutionary and historical-developmental, viewing the degree of chromatic refinement available in a language as a property that develops over time, following predictable sequences, or trajectories. A single broad "grue" term, applicable to both blue and green objects, might be replaced by separate terms that recognize the blue/green distinction.

Since the 1969 publication the original model has been revised and elaborated by the authors and their collaborators, with a special regard to sequences of BCT emergence (Kay and Maffi 1999). The revision was based on extensive data collected as part of the World Color Survey (WCS; Kay et al. 2009) and the Mesoamerican Color Survey (MacLaury 1997). The latest version—now named the Universals and Evolution (UE) model—contains five pathways of color term acquisition (Kay et al. 2009: 31).

Crucially, the original B-K sequences culminated in an upper limit of eleven BCTs. However, Berlin and Kay ([1969] 1991) were not doctrinaire on the limit, and noted the possibility of more than eleven BCTs in Russian, with two "blue" terms, *sinij* and *goluboj*, and Hungarian, with two "red" terms, *piros* and *vörös*.

THE BERLIN-KAY UNIVERSALISM MODEL: EXPLANATORY SCHEMES

Several explanatory schemes have been proposed to account for the formation of the BCCs (for reviews, see Bimler 2005; Lindsey and Brown 2014a; Witzel 2019). In one line of reasoning, BCCs are a universal innate representation because they have a biological basis, or inherited visual-system "hardwiring." Paul Kay and Chad K. McDaniel (1978) suggested that the structure of BCCs is anchored to privileged color sensations, and that Ewald Hering's six elemental colors—red, green, blue, yellow, black, and white—are manifestations of the corresponding color-opponent processes. In contrast, more recently Youping Xiao and colleagues (2011) have suggested that biological constraint is limited to the fundamental distinction between "warm" and "cool" color categories, which arises from the sign of the "red" (L-) and "green" (M-) cone difference signal in the ascending visual pathway.

A contrasting approach is that color categories are internalized by observers through a process of linguistic (cultural) transmission, requiring the structure of BCCs to converge upon an efficiency of communication, to account for the cross-language agreement. In this vein Stephen C. Levinson (2000) argues that BCCs are built around the reference points that are specific to the language/ culture and may not necessarily be related to the Hering elemental sensations.

Finally, the optimality hypothesis explains color categorization by characteristics of color perception implying an interaction of perceptual and cognitive factors. According to the Interpoint-Distance Model put forward by Kimberly A. Jameson and Roy G. D'Andrade (1997; also Jameson 2005), the BCC structure reflects a partition of color space, as a way of meaningful information coding of the visible color gamut. Hence, in the development of the BCT inventory, color categories are added so that they maximize color differences between adjacent categories and minimize color differences within the new contiguous categories. The pressure-to-optimality was supported in a similarity-prediction task: the eleven BCCs perform better than other, random systems of categories (Griffin 2006; see Figure 6.1 and Plate 6.1).

Using a computational simulation based on the optimality criterion, while probing up to six primary BCCs, Terry Regier, Paul Kay, and Naveen Khetarpal (2007) arrived at a solution resembling Berlin and Kay's trajectory for BCC/BCT evolution. However, the simulation for ten and eleven BCCs failed to reproduce the empirically obtained data; Yasmina Jraissati and Igor Douven (2017) interpret this failure as evidence that the optimality criterion is not the only organizing principle. Language common ancestry (Bimler 2007); social interaction in color categorization (Steels and Belpaeme 2005; Xu et al. 2013); the distribution of color in the environment (Yendrikhovskij 2001); and interaction between cultural needs and environmental factors

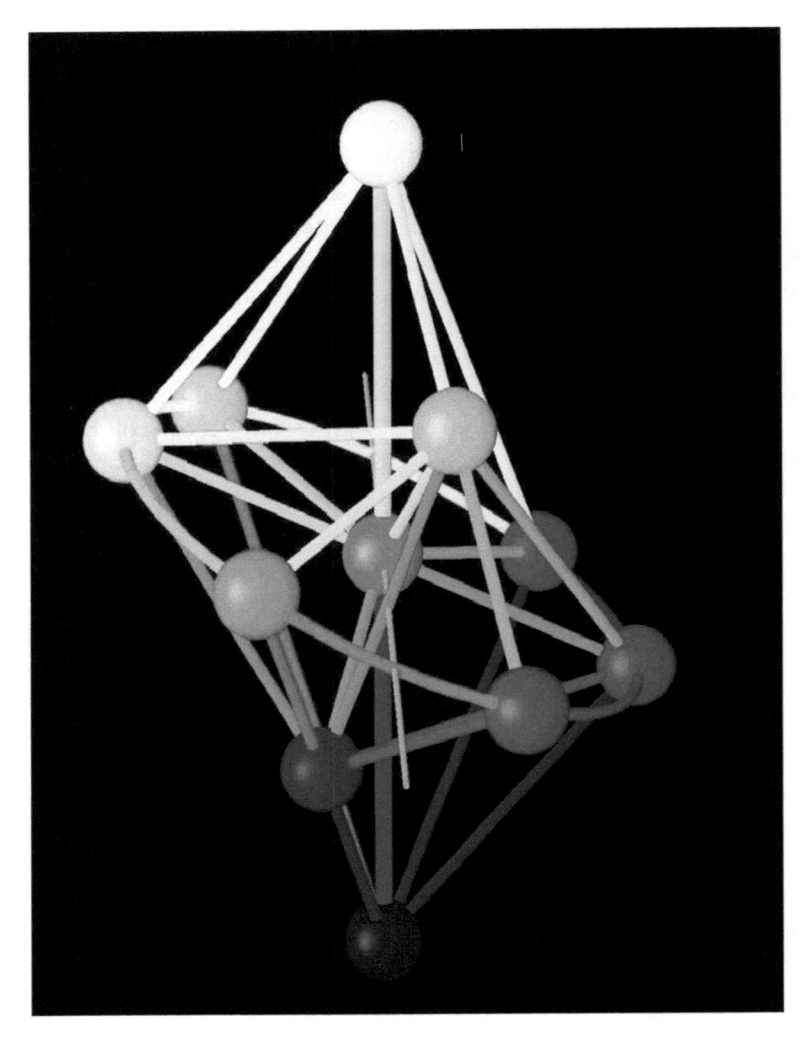

FIGURE 6.1 The psychological structure of the eleven basic color terms. *Source:* Figure 1 from Griffin (2006). With permission.

(Regier et al. 2016)—all are considered to play a role in determining the BCC structure.

THE WORLD COLOR SURVEY AND
THE UNIVERSALISM–RELATIVISM DEBATE

In the decades following the 1969 publication, the universalist view gathered widespread support but also endured vigorous criticisms from proponents of the relativist view. The debate was productive in the abundance of research

it inspired, aimed at validating or disproving the universal model. The last two decades witnessed the reconciliation of the two extreme theoretical views within the framework of the weak relativity hypothesis: this acknowledges that perceptual, linguistic, social, and pragmatic factors all play a role in the cognitive processing of color (Dedrick 1998; Roberson 2005; Roberson et al. 2005; Davidoff 2015).

Since some languages seemed to contradict the universality constraints (for example, Himba in northern Namibia, see Roberson et al. 2005), the World Color Survey (Kay et al. 2009) was undertaken in the 1970s to assess BCCs in 110 non-written languages. Detailed analyses of WCS data provide convincing evidence that (1) across languages, category best examples, or focal colors, of BCCs cluster around certain points in perceptual color space (Kay and Regier 2003), and these privileged points tend to locate near, although not always at, those colors named in English as *red, yellow, green, blue, purple, brown, orange, pink, black, white,* and *gray* (Regier et al. 2005), and (2) category boundaries of BCTs may vary between individual languages, with color category boundaries being well predicted from labelings of the foci (Regier et al. 2005). The WCS data provide examples of languages exhibiting the same number of categories, while disagreeing on their exact boundaries (Bimler 2007).

CHALLENGE TO THE BCT UPPER LIMIT TENET

Weak relativism embraces one significant aspect of the B-K hypothesis—the possibility of new BCCs emerging, specific to a certain language, beyond the established eleven. The possibility of BCTs exceeding the original "ceiling" has seen recent empirical findings for several languages, as well as theoretical developments.

In the case of Russian, the BCT upper limit was challenged by converging evidence that *goluboj* (light blue) is a twelfth BCT, distinct from *sinij* ([dark] blue). This includes evidence from categorical perception tests[2] across the inter-category boundary—the level of lightness separating *goluboj* shades from darker *sinij* shades—as the LRH predicts. The distinction also extends to the connotative, affective qualities of *goluboj* and *sinij* shades (reviewed by Paramei 2005). Such findings serve as a reminder of the influence of language upon cognition and perception.

Scrutiny spread to the status of "light blue" (or "sky blue") terms in Slavonic languages related to Russian (Ukrainian, Belarusian, Polish) or influenced by Russian due to geopolitical factors, for example, Lithuanian and Udmurt (Bimler and Uuskula 2018). Further, there is evidence for a lexical partition of the "blue" region in circum-Mediterranean languages (Greek, Turkish, Maltese) and most notably in Italian (Figure 6.2), where *blu* is applicable to darker

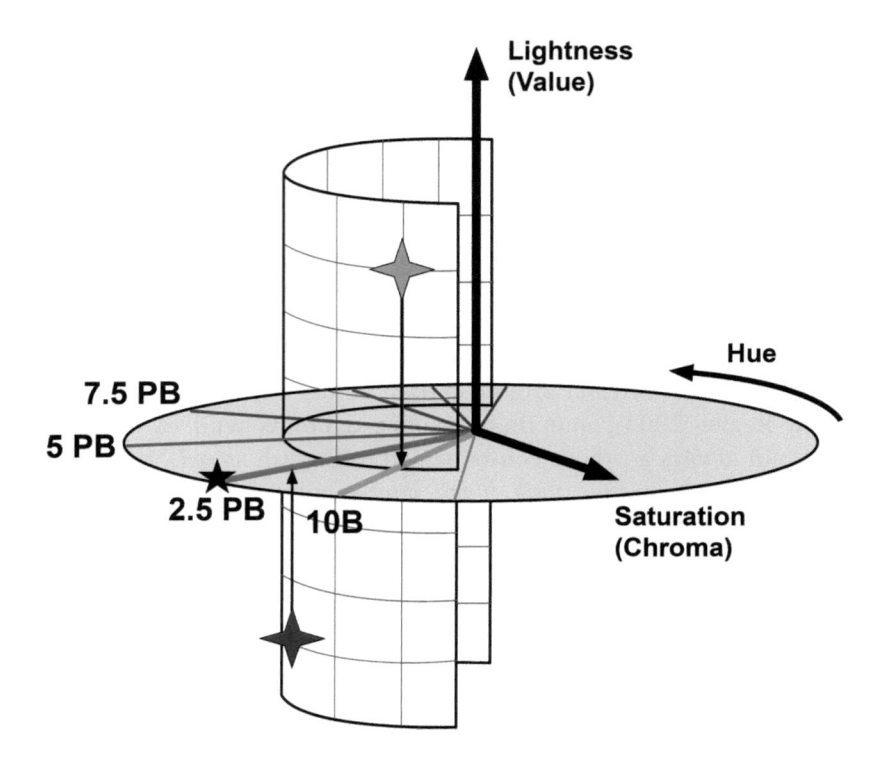

FIGURE 6.2 Empirically estimated (predominant choices of) focal colors, defined in the Munsell system, for Italian *blu* (dark gray star) and *azzurro* (light gray star), obtained in Verona (Paramei et al. 2014), compared to the focus for English *blue* (black five-pointed star). Figure design from Figure 11 in Jameson (2005: 189). Adapted with permission.

shades, while lighter shades can be *azzurro* or *celeste*, varying between regional topolects (Paramei et al. 2014; Uusküla 2014; Grossmann and D'Achille 2016).

Along with *azul*, the BCT for blue in all Spanish dialects, *celeste* is a basic-level term in Uruguayan Spanish but is non-basic in Castilian and Mexican Spanish (Lillo et al. 2018). Outside Europe, the salience of *mizu* (light blue) has increased in Japanese (Kuriki et al. 2017).

It is hard to specify a single cause that directed each community of language speakers' collective attention to "lightness" distinctions within the BLUE region of color space. Color statistics of the natural environment is potentially a strong driving factor (compare Yendrikhovskij 2001), such as the importance of sea color for Mediterranean societies. However, cultural factors are paramount: in Russian, the cognitive salience of *goluboj* was increased by its connotational, affective difference from *sinij*.

LEXICAL DIFFERENTIATION OF COLOR SPACE: HYPOTHESES AND RECENT EMPIRICAL FINDINGS

These challenges to the notion of the eleven BCT ceiling culminated in fresh inquiries into the color vocabulary of contemporary English, less dogmatic about the criteria of "basicness," while introducing the concept of the "relative basicness" of a term (Kerttula 2002): a continuum of "basicness" between the most and the least basic color terms (Lindsey and Brown 2014b). Nicole Fider and colleagues (2017) used WCS color-naming data to define a "color strength" (CS) measure of how well a term is understood within a communicating population. (CS departs from the traditional "basicness" definition by not relying on structural features of languages or color lexicons, making it insensitive to details of language morphology.) Interest turns to terms that sit close to the threshold of "basicness."

Such developments also happened to coincide with a series of large-scale online color-naming surveys (not limited to English). The distributed approach relinquishes fine control over the stimuli presented to participants but is less susceptible to the risk that the results will be skewed by idiosyncratic local usage within an unrepresentative sample. These studies (for example, Moroney 2003; Mylonas and MacDonald 2016) opened up the opportunity to examine terms that did not reach the threshold of "basic" in earlier studies but are being pushed in that direction, and may have passed it. Lexical refinement of color space can unfold along one of two ways: as the lexical partition of color space or as the emergence of a color category in the "no man's land" of color space.

Berlin and Kay ([1969] 1991) assumed that all languages partition the color gamut, even those of Stage II (which has only three BCTs), with the available BCTs at each stage between them covering all observable colors. In a "partition language," two scenarios are observed: (1) a novel BCC/BCT can emerge as a result of an "old" BCC splitting into two, or fission, or (2) a new category that straddles the boundaries of existing BCCs is inserted. Certain color-space areas are particularly prone to further lexical differentiation—the PURPLE area and the boundary of the BLUE-GREEN categories (Kerttula 2002), each illustrating one of these scenarios.

Category fission of the PURPLE area

The English BCT *purple* covers a large region of the color gamut. Lightness distinctions can be made within it, distinguishing *lilac* and *lavender*, on the one hand, from *mauve* and *violet*, on the other. Indeed, recent studies indicate that *lilac* across English variations (Mylonas and MacDonald 2016) and *lavender* in American English (Lindsey and Brown 2014b) augment the BCT inventory.

Russian subdivides the PURPLE area into at least five subcategories, observing fine distinctions between *sirenevyj* (lilac), *malinovyj* (raspberry) (the two most frequent non-BCTs), *lilovyj* (mauve), and so on, with *fioletovyj* coming closest to subsuming the others as a superordinate term, while all have distinct referential ranges and are used consistently across the population (Davies and Corbett 1994; Paramei et al. 2018).

Category insertion at the BLUE-GREEN boundary

In the case of English, Mylonas and MacDonald (2016) found that *turquoise* is in common descriptive use augmenting the modern BCT inventory. For American English, in one sample, the most common term was *teal* (Lindsey and Brown 2014b). The status of the "turquoise" terms, as non-basic but highly salient, in European languages has its own literature: for example, German *turkis* (Zollinger 1984; Jones 2013), Russian *birjuzovyj* (Paramei et al. 2018); Italian *turchino/turchese* (Grossmann and D'Achille 2016; Paggetti et al. 2016).

The emergence hypothesis

The emergence hypothesis (Levinson 2000) allows for the possibility of "non-partition" languages, which leave less salient regions of color space without any BCT. If a need arises to label such colors, names may be adopted from the environment, or vague "wild-card terms" repurposed to a specific meaning. A loose parallel in the modern era might be the recent rise of English *beige* for the hard-to-name pastel RED/ORANGE region, where no term dominated in 1987 (Boynton and Olson 1987), or the lexicalization of an area between PINK and ORANGE, termed in English *salmon/tan/peach* (Lindsey and Brown 2014b).

Intriguingly, some modern languages manifest two coexisting lexical tokens for a single BCC, with referential ranges greatly overlapping but only one of these being a BCT. One of the factors behind this phenomenon is diatopic and/or generation-related variation. For Standard French, Isabel Forbes (1979) demonstrated such diatopic variation of two terms for "brown," *brun* and *marron*. For Spanish, dictionaries usually offer *morado* as the closest equivalent to *purple*, but Julio Lillo and colleagues (2018) report that among Castilian speakers of various regiolects, *violeta* is also used as nearly synonymous with *morado*.

Another factor relates to pragmatic aspects reflecting the motivation behind the use of each one of the counterparts. This is illustrated by two Hungarian terms for "red," *piros* and *vörös*, whose usage depends on the specific referent: only *vörös* collocates with "flag" and "star" (a communist symbol) and with "spilled blood", while *piros* collocates with "blood" in the (living) human being (MacLaury et al. 1997; Wierzbicka 2006).

DRIVING FORCES OF THE LEXICAL AND CATEGORICAL REFINEMENT OF COLOR SPACE

In addition to new basic categories developing to augment the BCT inventory, a complementary phenomenon is observed in modern languages—intensive lexical differentiation of BCCs by non-basic terms, which enables communication of nuances along all three color coordinates (hue, value, or chroma). It is noteworthy that color-space areas that undergo such lexical refinement appear to be language specific, reflecting cultural and environmental influences. The dominating tendency, though, is the refinement of the "warm" part of color space, in line with Edward Gibson et al.'s (2017) hypothesis of the usefulness of color to a culture.

In English, examples of non-basic terms in the RED and PINK areas are *russet*, *raspberry*, and *rose* (Casson 1994) or, more recently, *magenta* and *fuchsia* (Lindsey and Brown 2014b). In French, these two areas are enriched by *bordeaux* (burgundy) and *saumon* (salmon), two object-derived terms with high inter-informant consensus (Claidière et al. 2008). In several Germanic languages, the last decade indicates that along with entrenched *rosa* (German, Bernese Swiss German), that is, the BCT for "pink," non-basic *pink*, an English loan denoting "hot/deep pink," became embedded (Vejdemo et al. 2015). In Italian, in comparison, nascent non-basic terms deployed in the RED and PURPLE areas are exemplified by *corallo* and *vinaccia* respectively (Paggetti et al. 2016).

The widespread trend toward an increasingly fine-grained partition of color space is a confluence between psychology, language, and cultural-economic factors. Together they encourage differentiation in color terminology by raising the level of chromatic precision under communication pressure, that is, what is needed for communication efficiency (Steels and Belpaeme 2005; Jameson and Komarova 2009; Baronchelli et al. 2015; Gibson et al. 2017).

Technology, the development of new dyeing materials allowing production of an unparalleled variety of color appearances, and trade globalization are the driving economic forces. It seems fair to say that the nature of the visual environment in contemporary urban life is "color coded": colors are used to signal an increasing density of information. This is especially evident for manufactured items—clothing, food, paints, plastics, cars, and so on—where colors are no longer bound to raw materials or the process of production but become arbitrary and conventionalized. Thus, a variety of color options for any product confronts the consumer, whose choice of one color over another sends a signal about personal identity.

One aspect of this cultural-economic pressure is the tendency to use unusual, exotic, or elaborate terms to connote brand prestige. This trend is particularly marked in the discourse of car paints (Bergh 2007), fashion (Stoeva-Holm 2007),

and advertising (Anishchanka 2013). Specific terms can find their way into general acceptance if their associations are sufficiently appealing to speakers. An example is *beige*: cognate terms rose to prominence in many European languages in the 1980s, at a time when IBM desktop computers known as *beige boxes* became a standard office fixture.

The globalization of travel, media, and trade, accentuating language contact, increases exposure to the category distinctions and hyponyms (names for subcategories of a more general class) of languages that are not one's native tongue. With regard to communication efficiency, this can be a force for cross-cultural harmonization (Xu et al. 2013). Linguistically, new color terms are originally constrained to collocations with artifacts, and later expand to include natural objects while supplanting old, semantically less precise names (Rakhilina and Paramei 2011).

It is not clear what the end-point of differentiation may be. There have been attempts to predict the optimal number of "extended basics" of color categories and their lexicalization, where optimality is defined on theoretical grounds as a result of different kinds of processes—biological constraints on color discrimination within the environment, the grouping of perceived colors (categorization), along with the lexical refinement of color space to guarantee communication success in cultural evolution (for example, Steels and Belpaeme 2005).

ACQUISITION OF COLOR CATEGORIES AND THE DEVELOPMENT OF COLOR NAMING

Studies of the prelinguistic stage of human development (that is, with infants) are helpful in judging whether color categories are innate and, in particular, whether the Hering sensations have special status in determining color category formation. Three-month-old infants are known to possess full trichromatic vision. The evidence from viewing times in a preferential-looking paradigm (Bornstein et al. 1976; Franklin and Davies 2004) supports the presence of color categories in four-month-old infants. In these studies, four categories were found: RED, GREEN, BLUE, and YELLOW. More recently, Alice Skelton and colleagues (2017) demonstrated that infants also have a fifth category: PURPLE. Crucially, though, their categorical distinctions relate not so much to the four opponent sensations reported in adults but more to the activities of the two neural subsystems involved in the early stages of color processing. That is, if infant color categories are a biologically grounded, genetically endowed "first sketch" of adults' color categories, then their structure is modified in the course of maturation (Bimler 2009; Witzel 2019).

Although young infants discriminate colors well and categorize them, and color is a salient attribute in the child's world, the acquisition of color labels

is slow: children are surprisingly late to exhibit correct and consistent color naming (Bornstein 1985; Pitchford and Mullen 2003; Roberson et al. 2004). Children may know many basic color terms at an early (preschool) age, while applying them haphazardly (for example, naming red as *blue*, *black*, and so on). Color naming becomes less erroneous with maturation, revealing an influence of perceptual similarity from the age of three and above, so that confusions involve names for adjacent color categories (Pitchford and Mullen 2003).

It appears that the acquisition of color terms precedes learning the terms' denotative meanings (the range of applicable hues), that is, the formation of corresponding color categories. A comparison of performance in color matching and color comprehension tasks of two- to seven-year-old Russian children led Zinaida M. Istomina (1963; see Paramei 2007: 79–83 for an English-language review) to conclude that preschoolers' perceptual categorization precedes their verbal categorization, and that color term comprehension leaves much room for development even after the age of seven. In addition, Istomina reported that primary BCCs are developmental forerunners, initially overextended at the expense of secondary BCCs due to the markedly slower extension of the latter.

The lag between color term production and comprehension was also demonstrated for English-speaking preschoolers (Wagner et al. 2013). Again, the authors observed overextensions of early color categories that gradually shrank as children gained experience with words. Katie Wagner, Karen Dobkins, and David Barner (2013) conjecture that children's delay between using color words as labels and their construction of preliminary meanings of these words is likely due to the problem of constructing language-specific category boundaries.

All these studies also reveal significant individual differences in the rate of color term acquisition, which traditionally are explained by the perceptual salience of color for children, as well as the child's cognitive development, learning, and experience. Marc Bornstein (1985) also suggested that a minimum age for appropriate color naming depends on the maturation and integration of specific cortical structures.

COLORS OF EMOTION

A cultural fascination with the affective aspects of color flourished in the early twentieth century, inherited from the German Romantics of the nineteenth century (notably Goethe and Runge). Artists from the late Symbolist movement and early abstractionists (Wassily Kandinsky, František Kupka, Paul Klee, and Piet Mondrian among them) assumed as a basic tenet that colors have intrinsic emotional qualities, so that a language of "rational chromatic synesthesia" could be deduced and used toward artistic goals. Elements of metaphor and synesthesia are inevitable in this area, when participants are invited (for instance) to ascribe "warmth" or "speed" to abstract color stimuli.

Psychologists were not immune from this interest, and the affective qualities of color have accrued a substantial research tradition. In operational terms, this has involved eliciting the associations that people make between color concepts or percepts, and other objects of cognition.

When color associations are used often enough, they enter a language as conventional phrases and collocations. The presence of these "crystallized metaphors" within written language corpora allow them to be used as a window into collective color cognition. Color terms seem to invite associations with affective terms: in a linguistic analysis of color term/emotion collocations within the *Bank of English* (BoE), Anders Steinvall (2007) found *red* co-occurring most frequently with *rage*, and *green* with *envy* (with twice as many co-occurrences). In addition, terms for darker colors were found in association with stronger emotions of anger and sadness.

Many studies in this tradition ask participants to locate stimuli along a series of semantic differential bipolar scales, each anchored by antithetical extremes such as "cool" to "warm," relying on a form of metaphor or mild synesthesia that allows participants to ascribe the attributes of "speed" or "strength" to abstract chromatic qualities. Factor analysis then reduces these ratings to latent factors. These studies are generally compatible with Charles E. Osgood's schema of subjective appraisal, in which three broad factors of *Evaluation*, *Potency*, and *Activity* capture affective experience (recurring across multiple semantic domains), with considerable cross-cultural generality (Osgood et al. 1975). For instance, in Tadasu Oyama, Yasumasa Tanaka, and Yoshio Chiba (1962) the Activity factor contrasted *red* stimuli (rated as excitable and warm) to *blue* (cool and calm), while a Potency factor correlated with a Munsell Value, that is, the lightness of the stimuli.

However, it is a reality of factor analysis that different selections of semantic differential scales skew the prominence and composition of the factors abstracted from them. Thus, the correspondence between studies is only approximate. Variations are especially evident among scales assigned to a putative Evaluation factor (for example, pleasant/unpleasant). Li-Chen Ou et al. (2004) could not identify any of their factors as Evaluation and argued that this should be measured separately by a *Liking* scale; instead, "Color Weight" and "Color Heat" accompanied Activity in their results (see Sato et al. 2000). None of the factors found by Xiao-Ping Gao and colleagues (2007) bore any obvious relationship to hue, for the same reason; there is a scarcity of scales that capture this quality. Lars Sivik noted the "conspicuous result, perhaps astonishing to many [...] that the color parameter *hue* had less influence on the semantic variance than the other color parameters" (Sivik 1997: 187).

More recently an international team elicited color term–emotion associations from 3,555 participants in forty-two countries (Mohr et al. 2018). Twenty affective terms were presented as a pattern of radial spokes as unipolar scales of emotion intensity (Geneva Emotion Wheel, analogous to Scherer's affect

PLATE 0.1 Jim Lambie, *Zobop (Prismatic)*, 2016, exhibited at the Galleria d'Arte Moderna, Turin, 2018. Photograph by Sarah Street.

PLATE 0.2 Tracey Emin, *I Want My Time with You*, St. Pancras station, London, 2018. Photograph by Sarah Street.

PLATE 0.3 Light painting mapping on Horzyca Theatre in Toruń, Poland, during the Bella Skyway Light Festival, 2015. Photograph by Pko. Public Domain.

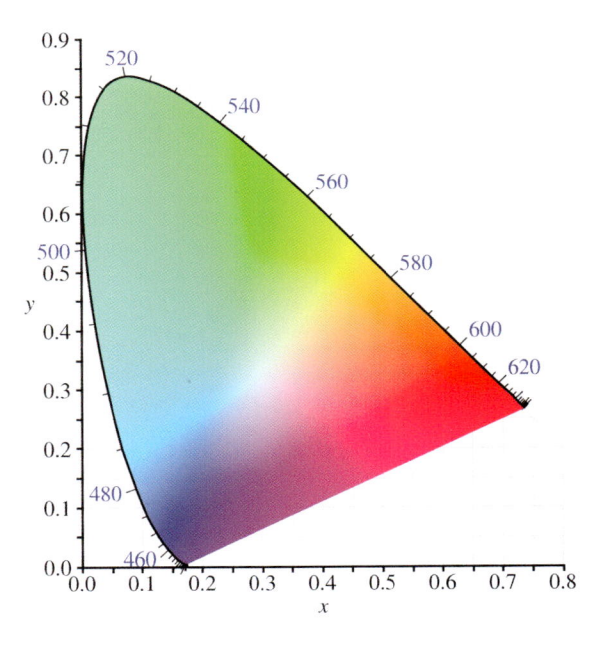

PLATE 1.1 The CIE 1931 Color Space is based on the mixture of three colored lights (represented as red, green, and blue at vertices). The location of hues is relative to one another, with wavelength information along the outer edge. Public Domain.

PLATE 1.2 The Land effect, full color.

PLATE 1.3 The Land effect, composed solely of red and gray wavelengths. The appearance of other colors, such as blues and yellows, is a product of our visual system and not in the image itself. *Source:* Edwin Land, "Experiments in Color Vision," *Scientific American*, 200(5) (1959): 84–99. With permission of Susan Olin-Vandivert.

PLATE 2.1 The *blue marble* image of the earth released by NASA in 1972. Public Domain.

PLATE 2.2 Schematic representation of Maxwell's three-colour additive process. On the left, the image is captured using three black-and-white cameras taken through red, green and blue filters. On the right the colour image is reproduced by overlapping the three captured images projected through red, green and blue filters. Image by Stephen Westland and Qianqian Pan.

PLATE 2.3 The first analogue-based COMIC recipe prediction computer, created by Davidson and Hemmendinger to enable optimization of color manufacturing. Image supplied by Society of Dyers and Colourists, Bradford, UK.

PLATE 3.1 Gay and Lesbian Holocaust Memorial, Sydney, Australia. Public Domain.

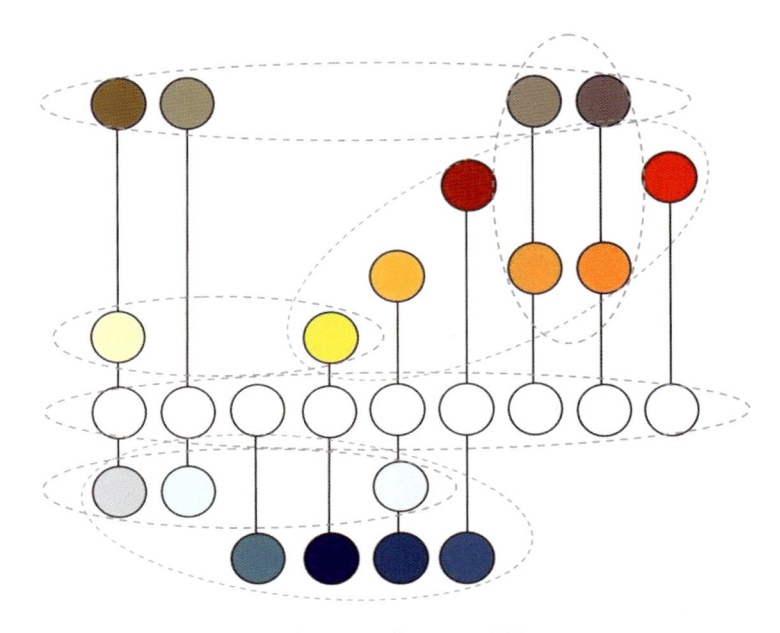

PLATE 3.2 Logo color mapping study. Image by Zena O'Connor.

PLATE 3.3 Color-contrast strategy to improve environmental visual literacy. Image by Zena O'Connor.

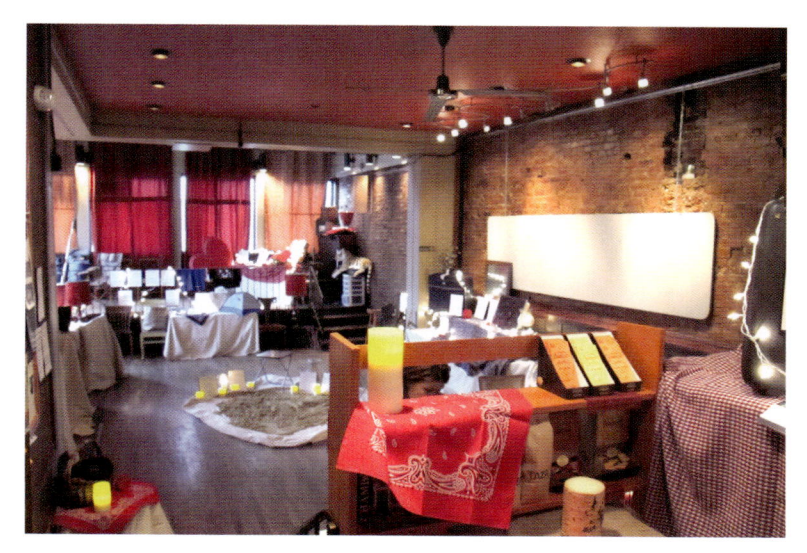

PLATE 4.1 An Evangelical meeting place designed in tones of red and brown for the celebration of Lent, USA, 2010. Photograph by James S. Bielo.

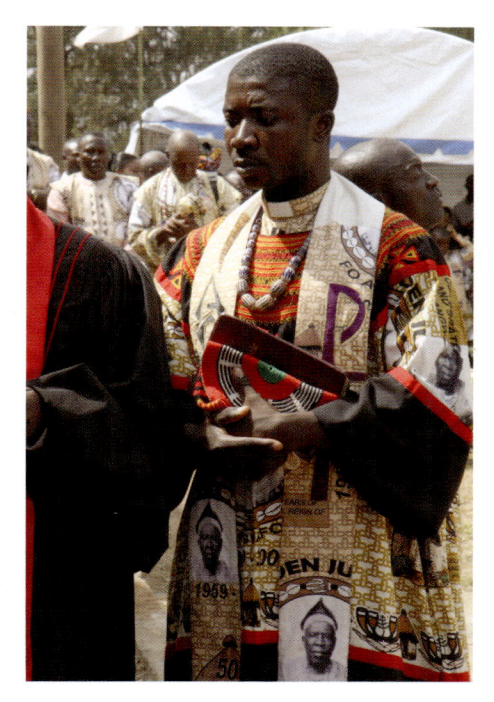

PLATE 4.2 Catholic priest at the fiftieth jubilee celebration for the king of Mankon, Cameroon, 2009. Photograph by Manuela Zips-Mairitsch.

PLATE 4.3 Initiates awaiting their turn at a toothfiling ceremony, Bali, 2016. Photograph by Urmila Mohan.

PLATE 5.1 Elements of a color trend prediction package. Photograph by Tracy D. Cassidy.

PLATE 5.2 A more contemporary colored tattoo. Photograph by Tracy D. Cassidy.

PLATE 6.1 The psychological structure of the eleven basic color terms. *Source:* Figure 1 from Griffin (2006). With permission.

PLATE 7.1 *Phantom of the Opera* (Rupert Julian, USA, 1925). DVD Milestone Ultimate Edition, 2015. Fair Use.

PLATE 7.2 *The Adventures of Prince Achmed* (Lotte Reiniger, Germany, 1926). British Film Institute DVD, 2013. Fair Use.

PLATE 7.3 *A Colour Box* (Len Lye, UK, 1935). Len Lye Foundation DVD, 2016. Fair Use.

PLATE 7.4 Jean Simmons as Kanchi in *Black Narcissus* (Michael Powell and Emeric Pressburger, UK, 1947). Criterion Collection DVD, 2010. Fair Use.

PLATE 8.1 Henri Matisse, *Plum Blossoms, Ochre Background,* Vence, 1948. Oil on canvas, 116 × 89 cm. Promised gift of Marie-Josée and Henry R. Kravis. Acc. no.: 642.2005. © 2018. The Museum of Modern Art, New York/Scala, Florence. © Succession H. Matisse/DACS 2018.

PLATE 8.2 Howard Hodgkin, *Morning,* 2015–16. Oil on wood, 50.5 × 64.8 cm. © The Estate of Howard Hodgkin. Image courtesy of Gagosian.

PLATE 9.1 Aldo Rossi's Quartier Schützenstrasse (Berlin, Germany, 1997). Photograph by Jörg Zägel. Public Domain.

PLATE 9.2 Frank Gehry's Guggenheim Museum (Bilbao, Spain, 1997). Photograph by DeAgostini via Getty Images.

PLATE 9.3 Neutelings Riedijk Architects' Netherlands Institute for Sound and Vision (Hilversum, The Netherlands, 2006). Photograph by Ben Bender. Public Domain.

PLATE 9.4 UNStudio's (Ben van Berkel) "La Defense" Offices, Almere, The Netherlands (Amsterdam, 1999–2004). Photograph by Laureen Manning. Public Domain.

PLATE 10.1 An assortment of unmarked glass reflecting the palette of common glasswares of the 1920s and 1930s. Illustrated here are three shades of pink, a pair of iridescent plates with a pale pink base, a small pitcher and juicer in greens, a cobalt sugar bowl, and two mixing bowls in the most common colors of the day for kitchenwares—white and jadite. Image by Beth Fowler.

PLATE 10.2 Mid-century glassware (from top left): amberina goblet, Vaseline hobnail water glass, large jar (possibly Blenko), Vaseline bowl, avocado relish dish, nostalgic barware. Image by Beth Fowler.

PLATE 10.3 Plastic dinnerware, like its ceramic counterparts, reflected the times in which it was produced. The dinnerplate was the maker's attempt to update colonial revival themes popularized at mid-century with later colors. American Chemical was one of several component suppliers that decided to produce and market its own line of dinnerware direct to consumers. The turquoise saucer shows the rococo asymmetry of organic Modernism. Image by Beth Fowler.

PLATE 10.4 Like other manufacturers, Dolphin made fondue pots in typical late 1960s "decorator" colors of red, yellow, orange, and avocado as well as stainless steel, which they touted as the same material used by architects Mies van der Rohe and Marcel Breuer. Detail from a Dolphin sales brochure. Photograph by Kelly F. Wright.

circumplex), to be linked with twelve color term targets displayed at the center. The results followed cross-cultural trends: red was associated with strong love and strong anger; yellow was associated with joy, whereas brown was associated with weak disgust. Culture-specific connotations were superimposed on these universal trends and showed greater similarity between related languages (for example, Polish and Serbian).

Mitsuhiko Hanada (2018) invited participants to propose affect-word associations for each of forty color stimuli, a task that can be seen as an all-or-nothing version of the graded scales in Christine Mohr and colleagues (2018). Participants were not restricted to a set of acceptable responses but were primed beforehand with a list of emotion-term suggestions. Notably, the obtained spatial solution is recognizable as a distorted version of Scherer's affect circumplex.

COLOR PREFERENCES

Color preferences can be regarded as a special case of affect. "Preference" overlaps with the related concepts of "pleasantness" or "liking." It is the target of a large body of research, too large to cover in detail, so here we only mention the most general trends.

The one recurring theme in the literature is the lack of consensus among studies. Often replicated are the early results of Joy Paul Guilford (1934), who pioneered the use of standardized (Munsell) stimuli varying in hue, tint, and chroma. Blue was the color rated most pleasant (by Nebraskan college students), followed by red and green, with least preference for yellow and orange. But the variables of color interact, and for lighter, saturated samples these two colors become more preferable, evoking associations of *Joy*, similar to recent findings for yellow and orange by Stephen E. Palmer and Karen B. Schloss (2010).

The existence of preferences and "favorite colors" has variously been explained in terms of biological mechanisms (resulting from the evolutionary value of an attraction to certain colors) and of social conventions, acquired as part of acculturation (though modified by personal factors). These perspectives respectively predict cross-cultural universals in the mean preference profile and culture-specific differences in the arbitrary conventions.

Palmer and Schloss (2010) have proposed a third alternative, emphasizing the ecological valences of different colors: people like colors associated with pleasing phenomena (for example, blues associated with clear skies) and dislike colors associated with negatively perceived objects (for example, browns associated with feces and rotten food). To the extent that ecological chromatic signals agree between environments, we can expect occupants of those environments to converge upon similar mean patterns of preference.

Gender has often been considered as a possible factor in determining preferences. Results are equivocal, with some authors highlighting gender

differences and others minimizing them. Christoph Witzel (2015) recently argued that a particular pattern of male/female preference differences is more consistent across cultures than the pattern of preferences per se. Here, as elsewhere in color-preference research, synthesis and meta-analysis are hindered by the various procedures and stimuli in use.

The emphasis on averaging preference profiles across groups—whether to highlight cross-cultural communalities or cultural specifics—has tended to understate the range of individual variation. Taking a different approach, Valérie Bonnardel and colleagues (2018) analyzed variations in color preferences in two cultures (British and Indian) to extract prototypal profiles, so that each individual's preferences could be approximated by a combination of those prototypes. The contributions of the prototypal profiles to individuals' preferences were compared between cultures and genders.

In a simple spatial model of preferences, one assumes that the most and least preferred hues are located at opposite sides of color space, so that an individual's or a group's collective pattern of preferences can be shown as a direction running from "least" to "most." Describing any color as an angle in the color plane, preference becomes a sinusoidal function of that angle. Guilford considered a more complex model that includes additional contributions (or harmonics) (Guilford 1934: 357). A second direction, for instance, defines a diametrically opposite pair of preference peaks, perpendicular to an opposite pair of preference troughs. Schloss et al. (2018) recently described a similar model with second-harmonic contributions.

Any discussion of individual versus prototypal preferences is complicated by the issue that self-ascription of preferences can be a vehicle for personal expression, or identification with a group. In this function, preferences have conventions, and these can undergo historical shifts. In this regard, there is an impressive level of agreement between Guilford's group averages and contemporary results.

FIGURATIVE USE OF COLOR TERMS

Color terms feature widely in figurative expressions, metonymies, and metaphors—where rather than designating a certain area of color space (having a denotative meaning), the color term undergoes an extension of meaning by referring to another domain than that of color (Niemeier 1998; Steinvall 2002; Philip 2011). Color terms lend themselves particularly well to these meaning extensions, since color concepts are deeply internalized in the mind of an individual language speaker, widely shared within a language community, and crucially, are highly polysemous, that is, have meanings besides their basic ones. For Gill Philip (2011), color term case studies are a window into figurative language more generally.

Color metonymies are expressions containing a color term whose concept implies the relationship of contiguity with another noncolor concept. In the framework of cognitive linguistics, Susanne Niemeier assumes a prototypical center of a color term category, from which the meaning extensions emanate in a radial network, "based on extralinguistic experiences and connotations" (Niemeier 1998: 123). Importantly, this implies that the meaning extensions of color terms are specific to the background culture; hence, as stressed by Niemeier, a frequent problem in the metonymic uses of color terms is their "intercultural translatability" (134).

Examples of cross-language disparities in the color term used in a metonymical expression are English *greenhorn*, "young, inexperienced person," versus Russian *želtorotyj junec*, (literally) "yellow-mouthed youngster"; English *out of the blue* versus Italian *di punto in bianco*, "out of the white"; or German *blau (sein)*, (literally) "to be blue," versus its French counterpart *(être) gris*, (literally) "to be gray," both with the sense of "drunken."

In many instances, however, color metonymies are strikingly similar across languages, suggesting that the relevant color–other domain associations are universal and natural (Niemeier 1998). This is the case for color metonymies related to emotional expressions (Steinvall 2007), such as *seeing red* or *in a blue mood* (see "Colors of emotion" above). Marjolijn H. Verspoor and Ágnes de Bie-Kerékjártó (2006) explored the linguistic ramifications of "blue" in four languages as a microcosm of the workings of metaphor and metonymy.

But cross-language similarities of meaning extensions can also have "conventional" bases, having spread through language contact, particularly through globalization in the westernized world—in culture, politics, or economy. In such cases the English color term is translated into its counterparts in other languages: for example, *bluestocking* (a learned woman) (Niemeier 2007); *brown shirts* (right-wing extremists, Nazis); or *yellow pages* (the business telephone directory). Another example is *green/vert* (French)/*grün* (German), where the metonymy stands for organic food and an ecological attitude in politics, the economy, and industry (Steinvall 2002: 206–9).

Also non-basic color terms, usually object-derived, are components of color metonyms (Casson 1994). As the title of his work states, in English these include *rose* and *raspberry*; Ronald W. Casson's other "conventional" non-BCTs are *scarlet, lilac, gold, cream,* and *navy*. The non-basic color terms are widely used in poetry, marketing, and advertising. Notably, in recent decades, they feature profusely in "evocative" metonymic expressions in marketing discourse (for example, *lemon zest, cappuccino beige*), intended to suggest pleasant feelings, thus motivating the shopper to buy a product (Biggam 2012: 50).

Compared to color metonymy (implying concept contiguity), color metaphors imply concept similarity. Color metaphors can be exemplified by the concept of humor with sinister or malicious undertones as *l'humour noir*

(coined by André Breton)/*black humor*/*schwarzer Humor* (German)/*umorismo nero* (Italian) (Philip 2011). Although primary BCTs dominate in figurative expressions, a few non-BCTs have become components of color metaphors, but in this function they usually draw on one domain in particular (Steinvall 2002: 215). In English, for instance, *beige* acquired the figurative meaning of "dull/uninteresting/unimaginative," while *lavender* is associated with "effeminate/homosexual" (Steinvall 2002); *amber* is an indication of approaching danger, while *peachy* implies something excellent or great (Hamilton 2016).

CONCLUSION

In the "Language" part of the chapter, we considered theoretical developments and empirical findings on color naming and color categorization in the modern age, predominantly in Germanic and Romance languages; illustrations from other languages (Russian, Hungarian, Japanese) were invoked for confirmation of the observed trends.

The central organizing framework is the Berlin and Kay ([1969] 1991) hypothesis of basic color categories, or the universalist view, and its latest revision incorporating the rich data of the World Color Survey. The counter-hypothesis that color terms are specific to each language, or the relativist view, was discussed too, as was weak relativism, the compromise between the two views currently accepted by the majority of researchers.

The chapter built on this foundation by focusing on phenomena observed in the modern age across languages and characterized by the increasing refinement of color-space categorization and of color naming. We discussed various explanatory schemes—referring either to biological, or perceptual/cognitive, or linguistic/cultural bases. Different factors that drive lexical segmentation of color space were addressed: panhuman regularities of color perception and cognition; universal factors of communication pressure; language-specific factors reflecting environmental influences, and the cultural salience of certain color categories.

In the "Psychology" part, we discussed some recent findings on the development of infant color categorization—the "first sketch" of adults' BCCs—and on regularities of color term acquisition in preschool children. Further, we addressed color preferences and mechanisms behind the observations, touching on the ecological valence theory (Palmer and Schloss 2010). One other psychological aspect is the association of colors with specific emotions: in cross-cultural studies, some associations proved to have panhuman generality. The chapter concluded by considering recurring themes in metonymic and metaphoric use of color terms, whose extended meaning is either universal and natural or specific to the background culture, causing the problem of "intercultural translatability."

CHAPTER SEVEN

Literature and the Performing Arts

NICHOLAS GASKILL, SARAH STREET, AND JOSHUA YUMIBE

INTRODUCTION

The twentieth century was a new age of color, as the aniline revolution of the previous era took full root in the increasingly globalized commodity culture that emerged after World War I. Reflecting the chromatic splendor of the time, literature, cinema, and the performing arts made color a central motif. This was the century in which so much depended on William Carlos Williams's "red wheel / barrow // glazed with rain / water" ([1923] 1970: 138); on Dorothy's ruby-red slippers that glowed in the Technicolor hues of *The Wizard of Oz* (Victor Fleming, USA, 1939); and on the psychedelic rainbows of Tom Wolfe's *Electric Kool-Aid Acid Test* (1968) that emanated from the counterculture of the 1960s. Color surged across the modern page, stage, and screen both in celebratory and also critical fashion. As Thomas Pynchon reminds us in *Gravity's Rainbow* ([1973] 2006), the synthetic hues of the modern era are also interwoven with chemical horrors—the Sarin Gas and Zyklon B that were developed in tandem with the aniline colorants at IG Farben. Relatedly, color has been a revivified marker of racial difference as well as political and aesthetic resistance: "vivid color," which in a previous era Goethe dismissed as a hallmark of savage nations, has now come to define the increasingly globalized media world of recent decades. In this chapter, we examine these various chromatic trends of the modern age and pay particular attention to the types of meanings and ways of reading color that accrued across literature, film, and the performing arts from early twentieth-century Modernism to our contemporary digital landscape.

MODERNISM AND THE LANGUAGE OF COLOR IN THE 1920S

Color, or rather a particular idea about color, played a central role in the disruption of traditional mimetic practices that unfolded across the arts in the early twentieth century. The painter Wassily Kandinsky offered an influential formulation of the modernist approach to color in his 1911 treatise on nonfigurative painting, *Concerning the Spiritual in Art*: "Color is the keyboard, the eyes are the hammers, the soul is the piano with many strings. The artist is the hand which plays, touching one key or another, to cause vibrations in the soul" (Kandinsky [first English translation, 1914] 1977: 25–6). Colors here comprise a console through which the artist activates emotional forces that pound the viewer's "soul," making a direct and immediate impression. Color is thus pried from particular objects, appearing just as itself rather than as a component of an illusionistic representation. Nonetheless, color for Kandinsky has an internal logic or "grammar" that governs its powerful effects. By employing the "language of color," abstract artists attempted to convey emotional states to their audiences without a detour through the world of material objects.

Within modernist experiments in literature, cinema, and the performing arts, the importance of these attempts to formulate a language of color lay less in their particular claims (blue as calming, red as exciting) and more in the model of aesthetic experience that they suggested. After all, no single grammar of color gained universal assent in either the sciences or the arts, and one would be hard pressed to coordinate the individual chromatic systems at work in, say, the polychromatic lights that illuminated Loïe Fuller's serpentine dance, the color tints in Ferdinand Léger and Dudley Murphy's *Ballet mécanique* (France, 1924), and the stark hues that run through Williams's poetry. As the Soviet filmmaker Sergei Eisenstein wrote, there is no single system of correspondences between colors and emotions; rather, each artist must invent the affective and symbolic meanings of colors within the confines of the work itself (1941: 111–53). What characterizes the role of color in Modernism, then, is not any specific theory of color's emotional effects but the project of using chromatic stimuli to make direct affective impressions capable of conveying qualitative feelings. In this section, we will consider how the idea of the language of color not only influenced color usage in literature, theatre, and cinema but also how it proved vital for articulating modernist impulses throughout the arts.

Modernist literature is awash in vivid colors. From Marianne Moore's "days of prismatic colour" to Gatsby's gaudy parties, from Rainer Maria Rilke's "Blue Hydrangea" (1906) to the "snotgreen sea" in James Joyce's *Ulysses* (1922), and from Willa Cather's vibrant landscapes to the mauves and lilacs in Marcel Proust's *À la recherche du temps perdu* (1913–27), the hues of modernist writing

encapsulate both the formal and narrative concerns of the period, as well as the interchanges between literature and the visual arts. As Virginia Woolf wrote, "all great writers are great colorists" (1934: 241). Occasionally critics have attempted to uncover a system governing literary hues, as in Stuart Gilbert's (1952) schema for *Ulysses* or Allan H. Pasco's (1976) "color-key" to Proust; but more often the "language of color" in literature has been treated as a technique for rendering the fleeting processes of perception and experience, in all their qualitative richness. As a vivid and evanescent sensation, on the one hand, and as a signature component of the bright modernity emerging through synthetic dyes and advertising, on the other, color proved the perfect figure for capturing the whirlwind of modern life.

In their attention to vibrant colors, modernist writers drew on the chromatic culture of their moment, which witnessed a proliferation of colorful commodities. Consumers accustomed to a limited selection of goods were suddenly confronted with blue telephones, green bathtubs, red kitchenware, and polychromatic cars. Especially in the United States, these strategies made color a sign of novelty and variety, and of global modernity itself. As the editors of *Fortune* magazine put it at the end of the decade, "color has fitted the tempo of the times," and for writers eager to capture the energies and excesses of the Jazz Age, it provided a ready tool ("Color in Industry" 1930: 88–90). For instance, F. Scott Fitzgerald's Jay Gatsby drives a yellow roadster, wears a pink suit, has a closet full of multicolored shirts, and throws parties full of "spectroscopic gaiety" and "gaudy" guests—all indications of the ambition and self-fashioning that make him such an enduring figure of the roaring twenties (Fitzgerald [1925] 2004: 49, 44).

By embracing color, modernist writers not only participated in the "new age of color" but also joined contemporaneous efforts in psychology and philosophy to investigate subjective experience and the qualities of conscious life ("The New Age of Color" 1928: 28). Françoise Meltzer traces this technique back to the Symbolist poets who elevated color above form, allowing particular hues—such as the white in Mallarmé's "Le Cygne" or the blue in his "L'Azure"—to overtake their objects and estrange language from the world of referents (Meltzer 1978: 254). These strategies undercut the materialism of the nineteenth century and so joined contemporaneous philosophical efforts to create a more expansive metaphysical framework inclusive of psychological reality (Henri Bergson, William James, Alfred North Whitehead). Given the importance of Symbolism for Stein, T.S. Eliot, Joyce, and other modernists, Meltzer's analysis can safely be extended into the twentieth century. Indeed, one could hardly find colors more exaggerated and less "secondary" than the hues of Stein's *Tender Buttons*, which she regularly presents as substantives: "a white," "a yellow," "a not torn rosewood color," a "bit of blue," "a single hurt color" (1914: 17, 12, 15, 9). Like Mallarmé, Stein turned to color to test the relation between language and

the world and to experiment with different techniques for conveying subjective feeling in words.

The task of representing perceptual experience inevitably brought writers in line with modern painters, and indeed the handling of color in literary modernism has been productively read in light of those authors' engagements with Impressionism, Cubism, and Postimpressionism. In *The Phantom Table* (2000), Ann Banfield details Woolf's use of color, triangulating her novels with Roger Fry's aesthetic theory and Bertrand Russell's philosophy to reveal color words as a locus of Woolf's attempts to capture immediate perception. She reads *Mrs. Dalloway* (1925) and *The Waves* (1931) as impressionist novels, emphasizing how they use "pure color" to capture the world of appearances, what Roger Fry called "the mysterious play of light upon matter" (1926: 40). Such impressionistic writing need not confine itself to "pure" hues, as shown in John Dos Passos's *Manhattan Transfer* (1925). Dos Passos, a painter as well as an enthusiast of Eisenstein, joined Joyce in creating hybrid words to conjure the particular hues of perception, as in this description of a New York scene: "A small bearded bandy-legged man in a derby walked up Allen Street, up the sunstriped tunnel hung with skyblue and smokedsalmon and mustardyellow quilts, littered with second hand gingerbread-colored furniture" (Dos Passos [1925] 2000: 9). These inventive color descriptions attempt to bend language toward the nuances of perception, creating a fresh vision of the city's colors.

Yet, as Fry noted in his work on Cézanne, the dissolution of the world into sensory particulars—mere red, pure green, mustard yellow—presented a new compositional problem for artists: how to arrange all of these impressions? Monet's presentation of passing perceptual moments may have succeeded in breaking down traditional modes of organizing paintings, but it did not offer an alternative method for assembling these impressions into a coherent aesthetic composition. According to Charles Altieri (1989), this problem of aesthetic construction drove both painters and poets, especially Ezra Pound, Williams, Stein, and Wallace Stevens. Paradoxically, it is precisely at this point, when the connection between literature and the visual arts is strongest, that the question of color in writing becomes vexingly complicated. Even though "painterly abstraction" in modernist poetry often assumed a colorful form—think of H.D.'s "Oread" calling the sea to "hurl your green over us" or of Williams's shards of green glass—the formalist lesson of modern painting demanded a focus on the specific media of one's art; so writers could only join visual artists by turning away from the visual to the verbal.

How then is this still about color? Here we must return to our claim that it was an *idea* about color that proved so consequential for Modernism across the arts. In particular, modernist writers used the *figure of color* to articulate their distinctive ideas about literary language. They not only created colorful descriptions and images but also imagined that their writing could be felt as

immediately as a color. Consider how Pound invokes color when explaining the principles of his writing. In "Vorticism" (1914), Pound connected his theory of the image to Kandinsky's theory of aesthetic color effects. "The image is the poet's pigment," he explained; "with that in mind you can go ahead and apply Kandinsky, you can transpose his chapter on the language of form and color and apply it to the writing of verse" (Pound 1916: 100). Pound's "image," which he illustrated with his famous short poem "In a Station of the Metro" (1913), sought to give language the immediacy of color, sought to make it something that "is real because we know it directly" (1916: 99). The image thus encapsulates the paradoxical task of modernist poetry that drove writers to the figure of color: using it as a literary device to communicate individual, qualitative experience.

The literary aesthetic that Pound formulated through color persisted in Modernism for decades—and occasionally it returned writers to color experience. In "The Man with the Blue Guitar" (1937), for instance, Stevens focuses his exploration of imagination, reality, and the nature of aesthetic mediation through the image of a blue guitar and its playful transformation of "things as they are" (1997: 135). Similarly, the latter-day modernist William H. Gass looked to blue to articulate his account of literary language in *On Being Blue* ([1976] 2014). Pitched as a "philosophical inquiry," Gass's book holds that all qualitative experiences are relationally constituted like colors and that writers, to convey such qualities, must rely on the relational complexes created by their words. Maggie Nelson takes a direct shot at this tradition in *Bluets* (2009). Like Gass, she takes blue as her central motif, but she uses it to rework the relation between writing and feeling that Modernism figures through color.

Even as the specific aesthetic concerns of writers finally pulled them more to a figure of color than to color as such, the same aesthetic trends motivated parallel experiments in theatre and film, where material colors comprised a primary medium of expression. In avant-garde circles, these literary and visual endeavors often overlapped: Kandinsky cited Maeterlinck's poetry and drama as an inspiration; the poet, painter, and designer Florine Strettheimer created colorful costumes for Stein's opera *Four Saints in Three Acts* (1934). Perhaps most strikingly of all, Beatrice Irwin performed "color poems" in theaters in New York and London, where she recited her Symbolist verses amid changing, multicolored lights. A kind of literary Loïe Fuller, Irwin combined actual hues with literary "color" in an attempt, as Richard Le Gallienne of *The Yellow Book* fame wrote, to achieve "spiritual suggestion through the mysterious medium of color" (Le Gallienne 1910). She even predicted a coming age in which a "color theater" would establish color as a channel of telepathic communication, a literal language of color (Irwin 1916).

Less obscure theatre productions also relied on color to produce their modernist effects. The impact of electrical lighting on theatre staging cannot

be overestimated. In the 1920s, it facilitated anti-realist scenic designs, from the stylized experimentation of the Ballets Russes, and the Italian Futurists' celebration of modern technology, to Oskar Schlemmer's constructivist performances at the Bauhaus. Edward Gordon Craig, a major influence on theatrical design and staging during this period, argued for the rejection of realism and historical accuracy, deploying colored lighting on mobile screens so that a scene's atmosphere could be changed simply but effectively. Such techniques led the way for the achievement of hyper-stylization through color, which was championed in the United States and Germany by Max Reinhardt, who produced stylized décor, backed by a cyclorama with lighting equipment that produced highly saturated colored effects (Brockett et al. 2010: 236). Similarly, Leopold Jessner headed Berlin's Staatstheater where a 1920 production of *Richard III* was renowned for its use of steps and colored lighting effects: "It showed the rise in Richard's power by playing scene ever higher on the flight of stairs, and as Richard became more powerful, the stage became increasingly red" (245). Such productions reflected modernist influences across the arts, with color as an expressionist technique of mood and emotion.

In film during the 1920s, color was widely applied through tinting and toning techniques that were used to denote shifting scenes and connote emotional meanings in films, as well as through experimentation in photographic color systems such as Prizmacolor and early Technicolor in the USA, and Claude Friese-Greene's Natural Colour in the UK. The decade was marked by cinema's interconnectedness with other media: colorful film performances were often accompanied by orchestras or preceded by theatrical displays so that the cinema experience was a profoundly intermedial one. The use of color could be particularly dynamic in films that used more than one process, such as *The Phantom of the Opera* (Rupert Julian, USA, 1925), which in addition to tinting and toning used two-color Technicolor and Handschiegl, a labor-intensive manual process that embellished details in particularly deep or saturated hues. The Technicolor sequence signals the arrival of the Phantom at the Bal Masqué in a particularly dramatic manner (see Plate 7.1 and Figure 7.1). Even though directors were cautious about using color for fear that it might distract audiences from a film's narrative, color's novelty persisted within a hybridized chromatic culture that nevertheless was drawn to its inherently spectacular qualities. This was particularly on display in Pathé's stencil films of the 1920s, which showcased new fashions in clothing and décor. In this sense film color was imbricated with revolutionary trends in consumer culture as embodied in the plethora of newly available colored goods for the home (Blaszczyk 2012). In all of these cases—in film, theatre, and literature—modern experimentation across media turned to the language of abstract color to produce its effects.

FIGURE 7.1 *Phantom of the Opera* (Rupert Julian, USA, 1925). DVD Milestone Ultimate Edition, 2015. Fair Use.

NATURALISM AND EXPERIMENTATION, 1930–45

Writers, filmmakers, and theatre practitioners in the 1930s and 1940s responded in various ways to the immediate legacy of modernist color. Prevailing contextual factors to some extent reigned in obtrusive experimentation, for across literature, film, and theatre there were also sustained attempts at chromatic restraint and naturalism. Still, experimentation continued, but with a different emphasis. In cinema, the arrival of sound necessitated a new engagement with color, and the rise of Technicolor was accompanied by an increasing emphasis on making color subservient to narrative as an underscoring device, rather than an obtrusive or independent aesthetic motif. Similarly, theatre practitioners deployed color as a harmonizing element of stage design, along with lighting and costume. With the onset of socialist realism in Russia an overtly propagandistic aesthetic prevailed, foregrounding boldness and line over playful nuance or chromatic fragmentation, while in literature the onset of the Depression influenced a retreat from the bright and ornamental hues of the 1920s.

John Steinbeck's *The Grapes of Wrath* (1939) opens with a play of abstract colors that presents the dampening of modernist literary colors in the writing of the 1930s at the same time that it dramatizes the onset of ecological and social

disaster. "To the red country and part of the gray country of Oklahoma, the last rains came gently, and they did not cut the scarred earth." Though the rains coax a "green cover" from the fields, soon the sun scorches the corn, fading the colors: "The surface of the earth crusted, a thin hard crust, and as the sky became pale, so the earth became pale, pink in the red country and white in the gray country" (Steinbeck 1939: 4). Steinbeck's opening paragraph captures a more general shift away from the chromatic aesthetics of the 1920s—based on self-conscious experimentation and abstraction—toward a more restrained use of color in the naturalism of the 1930s. To be sure, poets such as Stevens continued to play with the possibilities of modernist color, but on the whole literary hues were used less as figures for imaginative creation and more as signs of focused engagements with the material world, be it in the detective Philip Marlowe's gimlet-eyed attention to hue in Raymond Chandler's *The Big Sleep* (1939) or Nathanael West's satirical treatment of Hollywood's glittering surfaces in *The Day of the Locust* (1939).

TECHNICOLOR, DUFAYCOLOR, AND THE AESTHETICS OF RESTRAINT

The ascendancy of photographic and psychological realism on screen after the introduction of sound cinema privileged black-and-white cinematography. Counterintuitively this was held by many to be more realistic than any color film could attempt (Cavell 1971: 91). In addition, the introduction of sound films at the end of the 1920s created technical problems for the applied forms of color that had dominated films of the silent era. Technicolor is often remembered as garish, bold, or even tasteless. Yet nothing could be further from its application in the 1930s and 1940s when it was used for a minority of feature, short, and animated films. The domination of the relatively small color film market by Technicolor heralded a very specific application of color that coded naturalist design through generic conventions. Natalie Kalmus, head of Technicolor's Color Advisory Service, was guided by a notion of "color consciousness" as she devised aesthetic guidelines for the application of the process. She emphasized the use of harmonious design and color complements, advising filmmakers to draw on earlier theorizations of color in art and psychology, which foregrounded its impact on mood and differentiated warm from cold colors (Kalmus 1935).

Technicolor's higher expense compared with black-and-white film made producers risk-averse in its application, preferring to use color as part of a restrained palette that reduced hue contrast, as in *The Trail of the Lonesome Pine* (Henry Hathaway, USA, 1936). In this film the mise-en-scène of cabin interiors and woodland "is generally rendered in shades and tones of brown and gray. When other hues are present, they often possess a pronounced gray

undertone" (Higgins 2007: 95). Such restrained use followed an earlier phase of production that showcased a more obtrusive, saturated, and dramatic approach characterized by variety of hue as in the feature film *Becky Sharp* (Rouben Mamoulian, USA, 1935). When non-naturalistic color was deployed, such as a purple horse in *The Wizard of Oz* (Victor Fleming, USA, 1939) and a blue rose in *The Thief of Bagdad* (Ludwig Berger, Michael Powell, and Tim Whelan, UK, 1940), the striking chromatic designs were influenced by each film's generic heritage in fantasy and spectacle.

Although color was generally applied with caution, its very appearance in films during the sound era inevitably marked it as spectacle. To offset fears that obtrusive highlighting of color might distract spectators from fully engaging with a film's narrative, Technicolor's accompanying promotional rhetoric argued that color made films more realistic. Even though color films of the era subscribed to notions of restraint, this did not mean that prevailing ideological and aesthetic imperatives did not come into play. The development of makeup to be used when filming in Technicolor, for example, provoked intense debate about the correct rendering of skin tones. Indeed, it seems that the "insistence on natural skin colors was in fact deployed euphemistically to mask an insistence on whiteness as a natural state, whereby all departures from this standard were characterized as excesses, problems, or flaws" (Sinclair Dootson 2016: 107). Debates about "natural" color were also subject to nationalistic discourses, such as in France, Germany, and the UK where subtle, less assertive chromatic sensibilities than those of the USA were preferred. For instance, in Britain a photochemical process called Dufaycolor briefly rivaled Technicolor. It was known for generally soft, pale tones that presented a tasteful likeness of natural scenery in short films such as *English Harvest* (Humphrey Jennings, UK, 1937) or in the feature film *Sons of the Sea* (Maurice Elvey, UK, 1939). An advocate of this approach was Adrian Cornwell-Clyne whose influential ideas on color in narrative cinema emphasized harmony based on principles of "simplicity, area and saturation, successive contrast, subtlety and key" (Cornwell-Clyne 1951: 653–5).

In the 1940s prestigious cinematographers experimented with Technicolor in the USA. Charles Rosher's approach was "nuanced, jewel-like" in *The Yearling* (Clarence Brown, USA, 1946), which used a design based on "hot-cold contrast versus a monochrome theme, and saturated versus neutral palettes" (Cagle 2014: 45). In the UK, even though during World War II Technicolor cameras and processing dyes were in short supply, cinematographer Jack Cardiff made the most of creative opportunities for chromatic expressivity in shorts such as *This is Colour* (Jack Ellitt, UK, 1942) and the *World Windows* (UK, 1937–40) travelogues. While very few domestic color films were produced in France, critics admired the quality of British Technicolor films and the subtle, pastel-like appearance of Germany's Agfacolor (Andrew

2006: 40–9). Agfacolor was a process developed by the Nazis for propaganda documentaries, newsreels, and feature films including *Women are Better Diplomats* (Georg Jacoby, Germany, 1941) and *Münchhausen* (Josef von Báky, Germany, 1943). Agfa manufactured a photographic color reversal film in 1936 known as *Agfacolor Neu*. The single-strip stock could be used in any camera and was thus cheaper and less cumbersome than Technicolor. This method was also the basis for Eastmancolor, an American stock that similarly revolutionized color filmmaking, paving the way for its increasing domination of global sound film production during the second half of the twentieth century.

EXPERIMENTAL ANIMATION

More overtly experimental trends during this period can be observed in animated films, which were well suited to color experimentation, even within popular modes such as Disney's mid-late 1930s *Silly Symphonies* or the feature film *Fantasia* (USA, 1940). Kristian Moen argues that in the *Silly Symphonies* color is "more than a motif or embellishment: it is an aesthetic and expressive element that figures the fluidity of musicality, landscape and transformation" (2010: 386). Animators working from more overtly avant-garde traditions were similarly inspired by color to experiment with form and musicality. A key exemplar of this tradition is Mary Ellen Bute, whose short animated "color-music" films were shown in New York and beyond, often accompanying mainstream feature films. Her films typically used abstract color imagery in conjunction with popular classical music, as in *Color Rhapsodie* (Mary Ellen Bute and Ted Nemeth, USA, 1948) and *Pastorale* (Mary Ellen Bute, USA, 1950).

German animator Lotte Reiniger was renowned for her development of silhouette techniques that contrasted dark figures against vibrant colored backgrounds, most notably in *The Adventures of Prince Achmed* (Germany, 1926), one of the first animated feature films (see Plate 7.2 and Figure 7.2).

Other key animators from this period include Len Lye and Norman McLaren who worked in the UK making short, experimental films for industrial sponsors using Gasparcolor and Dufaycolor. Although these films were made for advertising purposes, they were striking for the vibrant, chromatic impact of painting directly onto celluloid, as in Lye's *A Colour Box* (UK, 1935, advertising cheaper rates for parcel post) (see Plate 7.3 and Figure 7.3) and McLaren's *Love on the Wing* (UK, 1938, advertising the airmail service). The major avant-garde filmmakers in interwar Germany, including Reiniger, Walter Ruttmann, and Oskar Fischinger, also worked with advertising producers, innovating their form in dialogue with advances in advertising theories of color (Cowan 2014: 27–54).

FIGURE 7.2 *The Adventures of Prince Achmed* (Lotte Reiniger, Germany, 1926). British Film Institute DVD, 2013. Fair Use.

FIGURE 7.3 *A Colour Box* (Len Lye, UK, 1935). Len Lye Foundation DVD, 2016. Fair Use.

THEATRE: FROM ABSTRACTION TO NATURALISM

Such limitations on the extent to which abstract practices could flourish within commercial cinema were also evident in theatre. As in film, there were practitioners who were drawn to the idea of color being part of an overall harmonious system, operating as a kind of symphony in which light and colors were deployed to underscore action and not distract the spectator from the drama, as in Louis Jouvet's staging of Corneille's *L'Illusion*, designed by Christian Bérard at the Comédie-Française in France in 1937 (Vallée 2007: 27). This approach tied set design and color to serving the play text while working toward the achievement of a theatrical dimension.

Innovative European stage design of the 1920s was influential in the United States. It inspired the "new stagecraft" as designers produced abstract designs based on geometric grids that were often devoid of color. In the 1930s the main approach was to pare down stage sets to achieve a simplified realism, as in Robert Edmond Jones's designs for ballets, operas, Broadway productions, and the Technicolor designs of *Becky Sharp*. Lee Simonson, one of the New York Theater Guild's most prolific designers during the interwar years, also reduced physical sets to absolute necessity by "using a few basic architectural forms, simple set pieces, projections, and lighting" (Brockett et al. 2010: 262). And Norman Bel Geddes's naturalistic designs, such as those in the Broadway production of *Dead End* in 1935, showcased the use of new lighting technologies, including dimmers, spotlights, direct and indirect footlights, and unified switchboards that enabled a single technician to control a show's light and color.

Another prolific designer working in the United States during this period was Jo Mielziner, who also aimed to simplify detail, using lighting strategically to focus the audience's attention on a particular section of the stage. He wrote: "This kind of designing [...] deals in form that is transparent, in space that is limited but has the illusion of infinity, in light that is ever changing in quality and color" (Mielziner quoted in Brockett et al. 2010: 265–6). This method was applied in the Martin Beck Theater production of *Winterset* in 1935 and in *Death of a Salesman* (1949) when lighting enhanced color effects as when "sunlit spring leaves" were projected by dimmers onto the set of the house, while in less optimistic times the same house was lit darkly in brownish tones. In 1941 Robert Edmond Jones published *The Dramatic Imagination* in which he marveled at how lighting could transform a scene: "As we gradually bring a scene out of the shadows, sending long rays slanting across a column, touching an outline with color, animating the scene moment by moment until it seems to breathe, our work becomes an incarnation" (Jones [1941] 2004: 36). The influence of new directions in electrical lighting technology and their impact on color was therefore experienced very profoundly in the performing arts during this period.

VIVID COLOR AND "PRIMITIVE" EXPERIENCE: FROM MODERNISM TO CONTEMPORARY PRACTICE

To understand transformations of color design from mid-century on, it is helpful to return to the roots of Modernism. A foundational influence on its rise in the early twentieth century was the racialized aesthetics of primitivism, which shaped the chromatic palette of the movement in vital ways. Pablo Picasso drew from African sculpture and masks in *Les Demoiselles d'Avignon* (1907) to pioneer a mode of cubism that emphasized fragmentation, flatness, and vivid color contrasts (Lemke 1998: 31–58). Through occult systems such as Theosophy and Mazdaznan, Eastern mysticism played a pivotal role in the color designs of early abstract artists and filmmakers such as Kandinsky, Johannes Itten, and Fischinger. The imagined primitive world beyond the West also provided a potent source of transgression for what James Clifford has called the "ethnographic surrealism" of artists and critics such as Georges Bataille, Antonin Artaud, and Luis Buñuel (Clifford 1981). With Artaud, for instance, the rich colors of Balinese theatre represent an apex of the physical density that he pursued in his own theatre of cruelty (Artaud 1994: 56).

These examples are indicative of the persistent racial association of vivid color imagery with notions of primitive experience, both of which are seen in modernist practice as being simultaneously dangerous and alluring. In what follows we examine attempts to naturalize and/or critique color meaning in relation to primitivism. Beginning briefly with interwar modernist experimentation in literature, we will then turn to the postwar period to examine the aesthetic effects of decolonization as well as the rise of 1960s countercultures on chromatic practice. Within this later period, bright and bold hues develop a dialectical relationship with alterity, becoming an emblem as well as revolutionary signifier for the subaltern. In the words of Frantz Fanon, "Colors, once restricted in number, governed by laws of traditional harmony, flood back, reflecting the effects of the revolutionary upsurge" (2005: 175). This is in part why Toni Morrison, in *Beloved* (1987), has Baby Suggs focus on color at the end of her life, both as a restorative measure and a sign of resistance. From the color of skin to the rich palettes of the mise-en-scène, we examine how bright and heavily saturated colors have thus been reappropriated, not as a naturalized emblem of global difference but as political and aesthetic resistance in an increasingly mediated era.

HARLEM RENAISSANCE

The tangled mix of attraction and repulsion that characterizes color experience in the West permeates literary representations of Harlem in the 1920s, providing a template for the resurgence of primitive color in the 1960s. In works such as Carl Van Vechten's infamous *Nigger Heaven* (1926), Nella Larsen's *Quicksand* (1928), Claude McKay's *Home to Harlem* (1928), and Zora Neale Hurston's

"How it Feels to Be Colored Me" ([1928] 1979), the trope of color draws its power from the association of vivid hues and racial blackness. In Van Vechten's novel, the flamboyant hustler known as the "Scarlet Creeper" embodies a "colorful" mode of black vitality that the novel sets against the "respectable" New Negro figures of Byron Kasson and Mary Love, who dress in sober hues and have a distanced relation to what Mary describes as the "naïve delight in glowing color—the color that exists only in cloudless, tropical climes—this warm, sexual emotion" (Van Vechten [1926] 2000: 3, 6, 89–90). The narrative celebrates this "primitive birthright"; yet in doing so it perpetuates a long-standing racist libel about black sensuality, revealing how the modernist fascination with color's emotional power drew from a widespread link between bright hues and dark bodies.

Larsen and McKay offer more nuanced presentations of the connection between color and race. In *Home to Harlem*, and again in *Banjo* (1929), McKay embraces the love of color as a sign of racial blackness, and he pits the mode of feeling activated by bright hues against the "pale" existence that he associates with "civilization." Cabarets and colorful sidewalks provide him with his favored examples: "It was a scene of blazing color," he writes of one club; "soft, barbaric, burning, savage, clashing, planless colors—all rioting together in wonderful harmony" (McKay [1928] 1987: 320). For McKay, the mix of rhythmic movement and rioting colors celebrated difference, in opposition to a colonial project that "reduced [everything] to a familiar formula" (314). However, when pitched to a reading audience only too quick to collapse a love of color into racist stereotypes, this critique is not certain to hit its mark. No one dramatized this danger better than Larsen. Throughout the course of *Quicksand*, the mixed-race protagonist Helga Crane consistently has her exquisite and "intensely personal taste" for beautiful colors repackaged as a racial trait, reinforcing the narrative's overwhelming sense that no place exists for a woman "neither white nor black" (Larsen [1928] 2006: 1).

REVOLUTIONARY COLOR

The association of color with race continued through postwar and counter-cultural contexts within the performing arts, and calls attention to the transnational flows of color theory and practice. The postcolonial context of color design that Fanon raised was a response to repressive ideas of aesthetic control: the importation and naturalization of chromophobic notions of color restraint into the colonies—which correspond racially and politically to epidermal-based hierarchies—resulted dialectically in an uptake of vivid color imagery to signify colonial liberation.

Black Narcissus, both as a novel (Godden 1939) and film (Michael Powell and Emeric Pressburger, UK, 1947), offers a useful example to begin tracking these

aesthetic changes. The story is about a religious order based in Sussex, England, which sends a group of nuns to establish a school and dispensary in Mopu, a deserted palace in the hills north of Darjeeling, India. Both novel and film present a saturated vision of the East as other, documenting the nuns' encounter with the environment and local peoples as physically and emotionally challenging. The colors are too bright, an incessant wind blows through the palace, a baby dies in the dispensary, one nun rebels, and another nun experiences a crisis of faith; the mission ultimately fails and they return to England.

The subject matter of *Black Narcissus* was intimately connected to its immediate political environment. When the novel was published in 1939, India was heading toward independence from British rule, which was achieved in 1947, the year of the film's release. The story can be read as a narrative about the decline of empire and failure of imperialism. While Godden's novel is inflected with an orientalist sensibility—India proves too exotic to be colonized safely— the film is particularly complicated in its representation of East–West relations with color providing a crucial commentary. The film's visualization of the East is intense, typified by bold colors for clothes and the natural environment (see Plate 7.4 and Figure 7.4). Yet it also implies that the exotic nature of India cannot be easily separated or safely contained. Rather, it is represented as a

FIGURE 7.4 Jean Simmons as Kanchi in *Black Narcissus* (Michael Powell and Emeric Pressburger, UK, 1947). Criterion Collection DVD, 2010. Fair Use.

remarkable, topographic structure that is alien to the nuns' experience yet strangely familiar in terms of its capacity to unleash lush memories of the past and repressed sexuality. This collapsing of binary notions of East and West serves as an apposite meditation on the complex dynamics of decolonization that equates with notions of cultural hybridity and the contested legacy of imperialism (Bhabha 1994).

A useful juxtaposition can be made with Ousmane Sembène's film *Xala* (Senegal, 1975), which is also an adaption of his novel from 1973. Both film and novel critically satirize the postcolonial, independent government of Senegal, which is evident in the film's introductory, pre-credit scene. The opening shot of the film is a close-up of a man's face, dripping with sweat as he loudly plays a djembe drum amongst a crowd celebrating independence. The camera pans down from his face, along his vivid red shirt to the drum, connecting the African drumming to the red of revolution. A cut to a young woman in traditional beads, dancing joyously to the rhythms, provides a successive contrast to the drummer's red shirt, as her head is draped in a green scarf. The rhythmic drumming and dance movements correspond with the vivid red and green palette, using color to signify the celebratory moment of Senegalese independence from colonial rule—a pictorial embodiment of Fanon's reflections on color (2005).

Color, as we have stressed in this chapter, played an instrumental role in the disruption of notions of mimetic realism. Modernist works of the early twentieth century mobilized notions relating to the language of color as a means of challenging naturalist aesthetics that favored pictorial verisimilitude. In the context of the political modernism of the 1970s (see Rodowick 1995) in which *Xala* can be situated, color was still a language but one that was informed by semiotics; it was part of the sign system of cinema. As Jean-Luc Godard famously noted in response to an interviewer's observation about the amount of blood in *Pierrot le fou* (Jean-Luc Godard, France, 1965), "Pas du sang, du rouge"—"It's not blood, it's red" (Comolli et al. 1965: 21). Such an emphasis on the nature of color as a sign, rather than as a naturally occurring thing, helps decipher the color in *Xala*. While the colors of its opening allegory correspond to particular objects—a shirt and headdress—the way in which they signify larger motifs is what is vital to note. To an extent the colors correspond to the association of vivid color with primitivism and desaturation with colonial, Western power, though the film reverses the aesthetic judgment by prioritizing vividness and liberation over the desaturated nature of economic oppression. Yet these juxtapositions are not naturalized in the scene—their performative nature as signs estrange the colors from an illusionistic realism that might otherwise equate such values with race. Instead they are foregrounded as a system of signs; not blood but red. *Xala* translates its overt attack on neocolonialism into its color design to reassess and subvert primitivist stereotypes of color meaning. The vivid, orientalist color of *Black Narcissus* becomes the revolutionary hues of the opening of *Xala*. What

is significant about the stylistic design of these works is the way in which they experiment with the signifying potentials of color to rupture associations of racial savagery with saturated hue.

Parallel to these postcolonial examples, the political radicalisms of the 1960s linked the hallucinatory or mystical experience of color to emancipatory politics. Intense, drug-induced color experiences—along with the expansive notions of selfhood, consciousness, and nature that accompanied them—indicated a mode of resistance to the status quo, be it Western liberalism or simply the buttoned-up postures of 1950s suburbia. For William S. Burroughs, color promised an immediacy that had been poisoned by Western strategies of control, from advertising and the culture industry all the way to sex and language. In *The Ticket That Exploded* ([1962/1967] 2014), Burroughs pits the "parasite" of "the Word" against the intensities of color. The former is figured through the Nova Mob, which aims at dividing human life against itself by introducing the "virus" of language; the latter is associated with the cut-up techniques deployed by both the Nova Police and Burroughs himself. "Do you need words?" Burroughs asks; "Try some other method of communication, like color flashes—a Morse code of color flashes" ([1962/1967] 2014: 165). A refrain throughout the novel's last chapters is the command to "Rub out the word," with the promise that once language has been "explod[ed]" then we will feel "the colors released" (193, 202, 153). Cancel the codes, abolish habit, and remove society's aggressive and subliminal control tactics that enter us through the virus of language: for Burroughs and many others, the revolutionary outcome of such imperatives was figured in a blast of color beyond all words.

DIASPORIC COLOR IN THE DIGITAL AGE

Revolutionary color aesthetics are also present in various diasporic traditions, as can be seen in John Akomfrah's remarkable *Last Angel of History* (UK, 1995)—a film that crosscuts several of our interests in film, literature, and the performing arts. Taking its methodology from Walter Benjamin's seminal writing on Klee's painting *Angelus Novus*, the film is an experimental documentary about Afrofuturism. The film, like Afrofuturism itself, turns to science fiction as a means of interrogating the ignored and erased atrocities of Black history— forced diaspora through the Middle Passage, slavery, and unending oppression. *Last Angel of History* provides not a straightforward historical account of Afrofuturism but instead radically intercuts interviews of theorists, writers, and musicians with historical as well as fictional footage of a futuristic "Data Thief," who "surf[s] across the internet of black culture" in search of the ruins and fragments of history.

A central aspect of the film's account of Afrofuturism is the curious juxtaposition of the musical performance practices of Sun Ra, George Clinton

of Parliament-Funkadelic, and Lee "Scratch" Perry, each of whom pioneered parallel and psychedelically colored Afrofuturist projects in their music and theatrical performances. Footage from Sun Ra's film *Space Is the Place* (John Coney, USA, 1974), for instance, features prominently in the *Last Angel of History* and helps delineate the chromatic world of Afrofuturism. In its opening, Ra and his band, the Arkestra, have departed Earth and find themselves on a new Edenic planet, where Ra, robed richly in an Egyptian-styled golden robe and headdress, wanders through lush and verdant foliage. The healing aura of the utopian space is evoked through richly saturated colors—extraterrestrial greens, purples, and golds—and through exploratory, first-person, and handheld following shots. In so doing, the film's use of color evokes what Laura Marks has theorized as the "haptic visuality" that is often used to code sensory experience in intercultural film and media that grapple with "the global flows of immigration, exile, and diaspora" (2000: xi, 1). Such haptic colors can similarly be seen in other diasporic performance traditions contemporary with Sun Ra and also associated with the Black Arts Movement, such as in Barbara Ann Teer's National Black Theater in Harlem (Smethurst 2006: 104). Drawing from West African traditions, such as Yoruba culture and fashion, Teer also crafted elaborately hued productions that connect African colors to the theater's intercultural performances and political interventions.

Last Angel of History's citation of *Space Is the Place* is only fragmentary, in keeping with the overall style of the film, but in so doing it absorbs and transforms the countercultural, color effects of Sun Ra and his contemporaries into its own aesthetic palette. Contrasting digital oranges and blues dominate many of the visuals of the *Last Angel of History*. Detailed by producer Lina Gopaul of the Black Audio Film Collective, these recorded portions of the film—as opposed to the recycled footage it weaves in—were shot in Digital Betacam, the most widespread technology used in professional digital production during the 1990s. This format allowed Akomfrah, who had rigorously planned the film's distinct color scheme in advance, to adjust the color grading in camera during filming, and then fine tune it further during postproduction (Gopaul, personal communication, September 27, 2016). The result of the film's digital grading is highly innovative in terms of color style for its time. The orange and blue juxtaposition, which sharpens each hue through simultaneous contrast, is a chromatic style that has been adopted with inescapable frequency in mainstream digital cinema over the past twenty years, since *Last Angel of History* was produced. Akomfrah's film is thus indicative of a contemporary mode of design enabled by new digital effects that looks both backwards and forwards, absorbing modernist, countercultural tendencies found in the literature, theatre, and films of the past and hybridizing them for our digital present. The vivid digital fragments that comprise *Last Angel of History* denaturalize epidermal associations of color by divorcing it from skin as

a sign of primitiveness. Instead these glowing hues are haptic shards that reflect historical ruptures and chromatic possibilities.

CONCLUSION

The promise of color in the modern age rested on the paradoxical way in which it suggested a language or code but always held something in reserve, something that threatened to unsettle any semiotic system and make space for something other. Modernist artists searched for color's "grammar," or at least claimed to, but in the end their success rested not on one-to-one correspondences of emotions and hues but on the general affective force of chromatic stimuli, deployed in theatre, film, and literature. The technological advances in lighting, dyes, film stocks, and digital effects that enabled new expressive possibilities throughout the past century supported a variety of aesthetic styles and political stances, from exuberant to restrained, repressive to revolutionary. Yet this expansiveness, far from diluting the power of modern color, only specifies it as "more a presence than a sign, more a force than a code" (Taussig 2009: 6). What this presence did and how this force was felt throughout the twentieth century varied across the media, cultures, and techniques it touched. But at all points it helped to define what it feels like to be modern.

CHAPTER EIGHT

Art

JUDITH MOTTRAM

INTRODUCTION

The starting point for this chapter, the 1920s, was a colorful period in art. Following the challenges to social mores of World War I, European artists were building on the revolutionary changes to the constructs of painting that resulted from the innovations of the late nineteenth and early twentieth centuries. A new model of teaching art was being developed at the Bauhaus and a new purpose for art, in the service of the proletariat, was emerging in the Soviet Union.

As detailed in the chapter "Art" in the previous volume of *The Cultural History of Color*, the immediately preceding period had seen color liberated from form and form liberated from color. The impressionist agenda overthrew the subservience of color to the bounding parameters of enclosing lines. Color's role as a stimulator of optical sensation in its own right was explored. Color became form, with the edge of the color area denoting shape, and dab or brushstroke mirroring the jumping of the eye from one point of attention to another. The artists working in the postimpressionist period reflected science's explorations of fundamental properties.

This chapter shows how color in art has progressed. Unlike the rhetoric of sequential revolution that formed the story of art in the mid-twentieth century, we now see something more like the twisting helix of DNA. There are parallel strands, with bridges or crossing places, where perspectives, practices, and proclivities switch back and forth, coming back into or going out of interest.

The following account identifies three approaches to color in the modern period: color as significant form, color as an expressive tool, or color as a

fundamental conceptual component of art. The period also saw the introduction of new materials and new tools to transmit color images. The digital revolution in particular has implications for color use and perception.

COLOR AS SIGNIFICANT FORM

Clive Bell's *Since Cézanne,* first published in 1922, introduces the notion of significant form. The significance of an artwork was taken to be implicit in the form of the work, with the appeal of an artwork being "essentially permanent and universal." Bell argues that knowledge of Byzantine theology or Greek myths was unnecessary to appreciate works historically associated with those periods, as their "permanent and universal, that is to say their purely aesthetic, qualities" render them "as moving and intelligible as on the day they left their makers' hands" (Bell 1922: 95). His discussion of Pierre Bonnard's work indicates how color could operate in this model. He describes the initial apprehension of a Bonnard (for example, *Coffee*, 1915) as giving,

> a sense of perplexed, delicious colour: tones of miraculous subtlety seem to be flowing into an enchanted pool and chasing one another there. From this pool emerge gradually forms which appear sometimes vaporous and sometimes tentative, but never vapid and never woolly.
>
> (Bell 1922: 100)

He articulates how Bonnard was giving the viewer something emphatically of art. It was not color aiding recognition of a representation of the real world, nor color being expressive or standing for an emotion, but color as a formal constituent of the painting. Bell said Bonnard would "never be appreciated by people who want something from art that is not art" (102). Whilst this assertion might not be proven, he was drawing attention to the idea that Bonnard's patches of color had a role in the paintings that was separate from and not dependent upon a descriptive or expressive role. Significant form, as outlined by Bell and developed by Roger Fry (Fry 1920; Schaper 1961), provides one lens to describe one of the enduring approaches to color in art in the modern period.

COLOR, EMOTION, AND EXPRESSION

During the time that Bell and Fry were writing in London, the Bauhaus was a focus for thinking about art and its teaching in Germany, and art was being pressed into the service of the proletariat in the Soviet Union. John Gage has described color as the "spearhead of non-representational art" (1995: 247) at this juncture. This was also the moment at which color was being theorized as an expressive tool. Color was seen as having a grammar, drawing on the propositions of Michel Eugène Chevreul (1855) and others. Wassily Kandinsky

saw color in painting as having a psychic power capable of causing "emotional vibration" (Kandinsky 1946: 41). He wondered whether this was a direct effect or came about because of association, but believed that color harmony rested on "the principle of corresponding vibration of the human soul" (43). Both he and Johannes Itten asserted that certain colors are emphasized by particular forms (Kaiser-Schuster 1999: 394), and questionnaires with Bauhaus colleagues were used to explore the psychological effects of the interplay of shape and color (Gage 1995: 261).

This quasi-scientific testing did not provide conclusive evidence of Kandinsky's assertions. From today's perspective, the claims and search for proof appear questionable in light of current understanding of cultural encoding. The meanings accorded to and perception of color across the world would now render the attributions of emotions to specific colors and forms untenable. Investigations into cultural relativity in color perception or naming are now the domains of more specialist enquiry. In linguistics, for example, the exploration of color vocabulary initiated by Brent Berlin and Paul Kay ([1969] 1991) has generated a considerable literature. The sort of exact linkages between color, form, and emotion suggested by Kandinsky seem naïve. He suggested that "light yellow would make a sour impression, because of its association with a lemon" and that "sharp colours sound stronger in sharp forms (for example, yellow in a triangle)" (Kandinsky 1946: 41–6). As well as challenging this expressive model of color, more recent explorations of color preference also, to some extent, challenge Bell's model of significant form. If the response to Matisse's *Plum Blossoms, Ochre Background, Vence* (1948), with its artfully arranged lemons, might be so impacted by cultural background, where does that leave the idea that artworks might be intelligible purely as a result of their aesthetic form (see Plate 8.1 and Figure 8.1)?

THE LEGACY OF THE BAUHAUS

Leaving aside the challenges of applying theoretical models with the benefit of hindsight, the key legacy of the Bauhaus in relation to color and art was through the contribution to the teaching of color. Paul Klee, Kandinsky, and Itten contributed to compulsory and optional elements of the Bauhaus program. As Kaiser-Schuster notes, "The Bauhaus did not have a single coherent doctrine on color" (1999: 399), but the impact of this period on Western art and design teaching was nevertheless significant due to the spread of its diaspora during and after World War II. Gage implicates the confusion of the approaches among the Bauhaus teachers as the stimulus for a later rejection of systematic knowledge of color (Gage 1995: 263), although a semblance of system was certainly evident in the approach taken by Joseph Albers in his work at Black Mountain College in the period 1933–56 (Betts 1999).

FIGURE 8.1 Henri Matisse, *Plum Blossoms, Ochre Background,* Vence, 1948. Oil on canvas, 116 × 89 cm. Promised gift of Marie Josée and Henry R. Kravis. Acc. no. 642.2005. © 2018. Digital image, The Museum of Modern Art, New York / Scala, Florence. © Succession H. Matisse / DACS 2018.

There are numerous references to the importance of Albers's teaching for the emergence of abstract expressionist art in the United States in the 1950s and since. Ann Temkin's discussion of Sherrie Levine notes, "Like many American artists of her generation, she studied with a teacher who had studied with Josef Albers" (Temkin 2008: 204). Williamson considers this generational influence of Albers and other Bauhaus artists on British art education through the latter part of the twentieth century (Williamson 2015: 118). Albers's emphasis on looking to really see how one color impacts upon another in proximity, or

relative to perceived transparency or overlap, gave an empirical basis for managing the formal aesthetic elements of painting. Frederick Horowitz and Brenda Danilowitz refer to "the laboratory-like simplicity of the exercises" that "made it possible to observe the smallest, subtlest events in the visual field—the precise shade of a color, the exact nature of a curve, or the character of a paper's torn edge" (2006: 75). Together with Itten's *The Art of Color* (1973), this emphasis on looking gave a greater sense of agency and practical induction to a language of art than the rigid system of Kandinsky. Several generations of aspirant artists were introduced to exercises in seeing what colors do together in the abstract, devoid of the necessity to describe objects and scenes.

COLOR AND PICTORIAL ORGANIZATION

Before looking at the direct influence on American artists of Albers's systematic color explorations, the prominence accorded to Matisse's color needs attention. This offers a different take on the expressive and the formal role of color from that of Kandinsky and the Bauhaus. In 1945, when reflecting on expressivity through color and its relationship to drawing, Matisse comments:

> At the beginning, the Russian Ballet, particularly Scheherazade by Bakst, overflowed with color. Profusion without moderation. One might have said that it had been thrown from a bucket. The result was gay because of the material itself, not as a result of any organisation [...]. An avalanche of color has no force. Color attains its full expression only when it is organised, when it corresponds to the emotional intensity of the artist.
>
> (Flam 1995: 155)

These words are interesting in respect of Matisse's use of color and that by others. For Matisse, we get an indication of his conception of the work he was doing with painting. He spoke in 1929 about trying to replace the vibrato of divisionism with "a harmony whose simplicity and honesty would have given me quieter surfaces" (Flam 1995: 84). He was trying to find a way to avoid the jumpy surface generated by the retinal sensation of viewing pointillist or divisionist paintings and to bring back a notion of forms and their contours. Instead of the eye bouncing from point to point, tracking colors of the same value as they occur in proximity to other colors, representing points of light or dark, on a surface or in space, he sought to allow the eye to dwell, to drop into a pool of a color and to feel around for its edges. Then the eye would move, either sliding across to another occurrence of that color, or following an edge or arabesque or scratch or decorative motif to drop into another color. This is why Matisse saw drawing as being inseparable from color. The boundary of the form described in color is edge. Through contrast with the adjacent area, line is formed. He describes how "when you know an object thoroughly, you

are able to encompass it with a contour that defines it entirely" (156). There is an intentionality in how color is operationalized in this approach—it does the work of the painting through asserting the form. As such, it is fulfilling the role of significant form as described by Bell and Fry and providing the foundation for the later color field painting of high modernist formalism.

A succinct account of what happens in the paintings of Matisse, or those of Albers, is given by Anton Ehrenzweig to justify Patrick Heron's claim in the 1960s that his (Heron's) work was solely dedicated to color:

> A strong shape will tend to stand out as a figure against an indistinct ground. The stronger the figure effect the weaker will be the colour interaction between figure and ground. For the same reason a strong space illusion created by perspective and other formal means such as the overlapping of shapes will also diminish the colour interaction within the picture.
>
> (Ehrenzweig 1966: 2)

Ehrenzweig goes on to describe how Heron started with soft shapes like those of Mark Rothko (for example, Rothko's *No. 10* [1950] and Heron's *Horizontal Stripe Painting: November 1957–January 1958* [1957–8]), as he felt his way to make the color work. By the time Heron painted *Purple Shape in Blue: 1964*, he had developed his capacity to strengthen shapes and "toughened his pictorial space [...]. His color has accordingly gained in strength and decisiveness" (Ehrenzweig 1966: 4).

With reference to the use of lots of colors, Matisse was distinguishing between considered and unconsidered approaches. That the Bakst scenography for *Scheherazade* was colorful is clear. Matisse's comment quoted above seems to indicate it was unorganized, but Bridget Elliott and Anthony Purdy (2007) argue convincingly that Bakst achieved a complex orchestration of color linked with expressive intent. Consideration of the merit of coloration per se is useful in relation to other artworks made throughout the modern period in art.

COLORING IN

The supremacy of line over color, which Matisse was challenging, gives a frame for thinking about other highly colored works in modern period art. In these works, the artist takes the role of "colorer." The forms are generated by drawn line or figurative recognition, and the artist uses color to distinguish parts. The color does not have the same sort of structural role as it did for Bonnard, Monet, or Matisse, or for Albers, Rothko, or Heron. The dominant role is given to structure or line. The distinction can be clearly seen in the late works of Picasso, such as the *Rape of the Sabines* (1963). This and other works in the 1984 Picasso exhibition at the Guggenheim Museum in New York (Schiff 1983) constitute a virtuoso collection of paintings where line and form are dominant, and color takes the roles of "servant."

Bernard Berenson uses this term to describe how color must be subordinate "to shape and pattern, and then of tactile values and movement" (Berenson 1948: 74). Berenson saw color as taking a commanding position only "in times of decadence" and stated "coloured artefacts have much in common with pastries or cocktails." Continuing the food analogy, Picasso had commented that color was something often added after the composition of a picture was formulated; he said he added color to his work "as you put salt in soup" (Georges-Michel 1957: 94).

There is a significant group of artists in the modern period, associated with a wide range of artistic movements, whose work might fall into the same category as the late Picasso in respect of color. They share the approach in which structure and line dominate composition. The formally stylized works of Fernand Léger, Joan Miró's paintings from the 1920s onwards, and Russian constructivism in the early part of this period all see color used within this mode. Systems of depiction building upon a partial abstraction of perceived forms, rendered primarily through drawn forms, have color operating as a symbolic referent or as a means of differentiation. The collection of Léger works at the Tate Gallery, London, UK, has paintings that generally include black and white with red, yellow, blue, and green, or with an alternative narrow palette such as green, orange, and gray for *Keys* (Léger 1928), or the dark red, yellow, orange, and green for *Leaves and Shell* (Léger 1927).

In Miró we see two main approaches: a colored ground with black, white, and colored elements ranged across the space (for example, *Painting*, 1934), or neutral, white, or black grounds (for example, *Woman and Birds at Sunrise*, 1946). The colors in the paintings at the Miró Foundation tend to include a vermilion or cadmium-type red, a blue (probably cobalt but sometimes cerulean), and a cadmium yellow. These pigments are close to those identified by O'Donoghue et al. (2006) in their analysis of another Miró work (*Groupe de Personnages*, 1938). Pigment identification is becoming a useful technique to establish the authenticity of paintings, both in respect of colors used and the date at which particular colors became available. While accurate reconstructions of materials used are now possible, studies of pigments have to date primarily focused on methodological issues and questions of restoration, conservation, and the assessment of degradation. There could, though, be other interesting questions to ask on ranges of pigments or palette subsets, such as the extent to which palette selection relates to degrees of figuration or conceptual framing.

COLOR AS COMPONENT: THE MONOCHROME AND THE POLYCHROME

From Russian Constructivism we see the emergence of another key approach to color. Kazimir Malevich made a significant shift from cubist-influenced Léger-like figures through his suprematist period to monochrome works. His first *Black*

Square painting was exhibited in the Last Exhibition of Futurist Painting 0,10, in 1915, with another three versions made between 1923 and 1932. They have been described as the hour zero of modern art (Borchardt-Hume 2014). *Black Square* was followed by Alexander Rodchenko's *Pure Red Colour, Pure Yellow Colour, Pure Blue Colour* (1921). Yve-Alain Bois recounts Rodchenko's words about this work: "I reduced painting to its logical conclusion and exhibited three canvases: red, blue and yellow. I affirmed: it's over. Basic colours. Every plane is a plane and there is to be no representation" (Rodchenko quoted in Bois 1995: 238). With these works, a monochrome dynasty of art in the modern period was initiated.

Monochrome is one aspect of a third distinct typology of color in art in the modern period—of works that are colored. The other aspect is the colorful polychrome. Such mono- or poly-coloration as a fundamental component is often associated with a strong conceptual focus to the work. The choice or absence of choice, regarding color, or random means of selecting color, is the driver. Starting with Malevich and Rodchenko, monochrome appears both in painting and sculpture. In Europe, key points are the monochromes of arte povera (an Italian art movement), Yves Klein's blue and other monochrome paintings, and monochrome sculptures such as those by Anthony Caro (for example, *Early One Morning*, 1962) and Phillip King (for example, *Tra-La-La*, 1963). In the United States, too, monochromes spanned painting and sculpture, including Ad Reindhart (*Abstract Painting No. 5*, 1962), Robert Ryman (*Ledger*, 1982), Ellsworth Kelly (*Broadway*, 1958), Robert Rauschenberg (*Untitled*, 1953), and in three dimensions by Donald Judd and James Turrell.

What characterizes these artists is the use of color as a matter of principle— that the works were in color is important, but color still has varying roles. In arte povera, for Lucio Fontana (*Spatial Concept "Waiting,"* 1960) or Piero Manzoni (*Achrome*, 1958), it was the surface or material that was foremost, and that the material's color was often neutral was secondary. For Yves Klein (*IKB 79*, 1959), his particular blue was made from ultramarine pigment in a resin binder so matte it denied the surface of the paint (Ball 2009). His focus on blue was to avoid the trivial response to differently hued monochromes in his 1955 and 1956 exhibitions: "I realized at the opening of the exhibition that the public, enslaved by visual habit, when presented with all those surfaces of different colors on the walls, reassembled them as components of polychromatic decoration" (Klein 1973 quoted in Harrison and Wood 2003: 818). To enable a focus on the intent of the monochromes, to "plunge into the sensibility of pure color, relieved from all outside contamination," Klein edited down his palette to only blue, made more intense than ever with the Rhône-Poulenc Rhodopas M binder.

In sculpture, Caro added color to deny the vestiges of any idea of truth to material, enabling forms to be not seen for what they were—color as camouflage. With the sculpture of Judd and Turrell, it gets more complicated. Judd, for example, produced many polychrome pieces alongside his monochrome works

(for example, *Untitled*, 1984). He declared his core interest as being in space not color, but he did believe color needed to move beyond the surface. In his polychrome objects, he

> especially didn't want the combinations to be harmonious, an old and implicative idea, which is the easiest to avoid, or to be inharmonious in reaction, which is harder to avoid. I wanted all of the colors to be present at once. I didn't want them to combine. I wanted a multiplicity all at once that I had not known before.
>
> (Judd 1993)

What was constant in his polychromes was the units used to build the works—spray-painted steel from the office furniture industry. The utilization of industrial components is arguably a stronger bounding concept than the placing of color. In Turrell, the color of light and the slippage between presence and illusion are key. For example, *The Skylight Series* (*Hover,* 1983, *Milk Run Sky,* 2002, *Jacob's Rain,* 2007) frames the changing color of the sky. No colored materials are used in its making but the point of the work is color and human perception. So while having in common the fact that their works are colored, Turrell nods back to color having profundity, whereas Judd gives us an endgame of color.

Before returning to monochrome painting, two further examples of colored three-dimensional works are notable. Contemporary installation works with strong polychrome color are seen in the Plexiglas ceilings and powder-coated aluminum structures of Liam Gillick (for example, *Returning to an Abandoned Planet,* 2007). In 2003, he talked of being able to specify any color he wanted, but was more interested in the choice being made by others (Mottram 2006). Bill Roberts (2013) more recently positions Gillick within a post-Fordist aesthetic, where the relay between text, image, and other media (sound, moving image, and so on) leaves color choice as procedurally fairly inconsequential. As brand signifier, Gillick's palette signals the contemporary capitalist arenas he critiques, but it would be mistaken to accrue symbolic values to them.

David Batchelor also makes multicolored three-dimensional works, often utilizing found objects and combining them with light sources, for example, *HK Fesdella* (Batchelor 2008a). He uses the colors of the city at night, with incorporated lighting almost dissolving the integrity of shape. The works are high key and polychromic. In addition to making art that is colorful, Batchelor writes about color and has edited a volume of texts from 1850 to 2007 about color. In its introduction he notes:

> The assumption that colour somehow belonged to modernism, formalism and to certain kinds of abstract art; and that as the prominence of those concerns was undermined during the 1960s and overthrown in the seventies, so the issue of colour withered away as a result.
>
> (Batchelor 2008b: 15–16)

He concludes, however, that this assumption was mistaken and that the critics who were making this linkage were overlooking art that was more or differently colored than the focus of their attentions.

SIGNIFICANT FORM, EXPRESSION, AND THE COLOR FIELD

In contrast to the colorful mono- and polychromes referred to above, Rothko and Jules Olitski presented monochromicity and restricted palettes differently. These painters can be considered in relation to the first group looked at in this chapter, working within the theoretical framing that built upon Bell's "significant form." Along with other American-based artists who emerged in the post-Second World War period, Rothko and later Olitski became known as "Color Field" painters. Seen as a logical expression of the purity or primacy of the paintings' surface, central to the ideology of the critic Clement Greenberg ([1948] 1973), the chromatically constrained canvases of Rothko comprise veils of color that sit on the surface of the paintings rather than setting up recessive space. While his use of color was seen by Greenberg as exemplifying the flatness appropriate to abstract expressionism (Greenberg [1955] 1973), Rothko himself saw his color as inherently expressive—he intended to reference sublimity and a world beyond the physical even though the critical framing was otherwise. "I'm interested only in expressing basic human emotions—tragedy, ecstasy, doom and so on," Rothko said in a conversation with Selden Rodman in 1956. He continued, if you "are moved only by their color relationships, then you miss the point!" (Rothko 2006: 119–20). Greenberg described Rothko's work, along with that of Barnett Newman and Clyfford Still, as having "a new kind of flatness, one that breathes and pulsates," and as "the product of the darkened, value-muffling warmth of color" ([1955] 1973: 226). With Rothko, as with Yves Klein, the fine line between formalist monochrome and the attribution of spirituality is notable.[1]

Olitski's works are also emphatically of and about color, whether the crisp-edged forms of the 1960s and late paintings, or his thinly sprayed veils or heavily encrusted surfaces (Olitski n.d.). This mid-century period also saw a number of painters who were more conceptually motivated engaged in monochrome or limited palette paintings: Ad Reinhardt, Barnett Newman, and Ellsworth Kelly can be seen as one cluster, and Jasper Johns and Robert Rauschenberg form another. Barbara Rose explored the use of the monochrome in the modern and postmodern period in the exhibition and book *Monochrome: From Malevich to the Present* (2006). Her account articulates the nuances of conceptual positioning around the separation of the elements of painting or sculpture.

In looking at Western art from the mid-1950s through to the 1970s, the purity of approach ascribed to the use of the monochrome in Rose's earlier

examples was present alongside very different approaches to color. There are examples of significant painters working in an idiom that builds upon the model of colorer as ascribed to Picasso, such as Jackson Pollock (for example, *Summertime 9A*, 1948). There is the lineage by which expression continues its tussle with significance of form within abstraction: through Hans Hofmann (for example, *Pompei*, 1959), Willem de Kooning (for example, *Women Singing II*, 1966), and Helen Frankenthaler (for example, *Jacob's Ladder*, 1957). With the emergence of pop art in the UK and the USA in the 1960s, we see representation reentering the conceptual landscape, with David Hockney, Andy Warhol (for example, *Flowers*, 1964), Peter Blake (for example, *Self-portrait with Badges*, 1961), and others. This is the other sort of color that Batchelor (2008b) notes that the formalist writers missed. Pop art moved color into the space of everyday life: color in film, on TV, in the supermarket, in the city. The framing of for or against figuration, for or against color, for or against commodification, is that generally associated with artistic progression within a conceptual framework.

Sitting outside this conceptual framework is the significant figure of Gerhard Richter. Working from the 1960s onwards, his practice ranged from polychromic figuration through both crisp and expressive abstraction. Within the context of abstract art, it is his color charts (for example, *180 Colours*, 1971) and his abstract polychrome works (for example, *Forest*, 2005) that are more notable, but the photo-based figurative works (for example, *Flowers*, 1993) also belong to the category of figurative polychromes that have survived the conceptual morality of mid-twentieth-century theorizing.

CHALLENGING THE CENTRALITY OF COLOR

The account of color so far has seen three core approaches in the modern period: color as significant form, color as an expressive tool, or color as a fundamental conceptual component of art. We see color playing a part in the understanding of what art is about, how it might be made, and how it might be experienced. While color's importance in art seems obvious given its pivotal role in the perception of the visual array, this centrality of color has waned again in the latter part of the twentieth century.

Art education since 1970 has been drawn increasingly into university systems and structures. An emphasis on learning through doing has remained the core pedagogic approach and artists have continued to play a significant role in teaching art at university level. Since the 1980s, however, the postmodern period has seen an increase in the emphasis given to conceptual and contextual thinking about art practice. In some countries, this has been accompanied by a decline in the practical skill-based content. Williamson's account of color pedagogy in the London art schools ends by asking "what will the lack of formal

training in colour theory mean for the transfer of colour knowledge in the contemporary era?" (2015: 131).

Color as a key differentiator has lost some visibility in the discursive practices of art. By the year 2000, the primacy given to other concerns led to what Batchelor (2000) termed "chromophobia." Rather than phobia, perhaps the shift in the type of color available may have constrained articulation through or about color? Ball speculates whether "the surplus of choice might contain the very problem: artists have lost confidence in paint because they no longer feel they understand it" (2012: 32). Is this perhaps a withdrawal from engaging with color in the light of an onslaught from it?

Color is now so present in everyday life that it has ceased to be special. Temkin's *Colour Chart* exhibition (2008), which followed Rose's (2006) survey of the monochrome, was another attempt to account for color in the art of the modern period. Temkin proposes that Western art from 1950 to the early 2000s is characterized by two distinct positions on color: work that builds upon the conceptual opportunity provided by the color chart, and work by those using chance or other conceptual parameters to select color. Both in effect reject the notion of artists as experts in color. She argues that it has become impossible for artists to engage in the expressive or scientific use of color, because of its new role as a commercial product (Temkin 2008: 16). Her assertion is that artists can now only engage with "color as store-bought rather than hand-mixed" or "color as divorced from the artist's subjective taste or decisions" (17).

Ellsworth Kelly and François Morellet were early exponents of the chance technique, with their works using many or few colors. Similar procedural determiners of a painting's parameters were used by Richter for *180 Colours* (1971), by Alighiero Boetti for his works embroidered by Afghani women (for example, *Tutto*, 1994), and by Damian Hirst for his spot paintings (for example, *Edge*, 1988). Store-bought color or color for manufacturing purposes was significant for Frank Stella (house paint and alkyd [a polyester], for example, *Hyena Stomp*, 1962), and John Chamberlain (car color, for example, *Kora*, 1963), and this practice of appropriation continues with the vinyl tape installations of Jim Lambie (for example, *Zobop*, 1999) and Angela Bulloch's re-presentations of digital color (for example, *Aluminium 4*, 2012).

Temkin comments on the "constant conversation that filled the small downtown art world" of New York, pointing out that, despite the new formats of abstract expressionist and conceptual art and color field painting, "color was virtually absent as a subject" (2008: 20). Whilst a convincing account of some colored works in art in the modern period, Temkin's model could represent a subset of the category of artworks described here as concerned with color as a fundamental component of a painting or sculpture. Despite her theoretical framing, there is still a belief that artists have a special propensity to work with color and a continuing and significant appetite for experiences with color.

AUDIENCES AND THE APPETITE FOR COLOR

Intellectual frameworks for engagement with art look for different ways to categorize, explain, or legitimize the works, but audiences continue to enjoy looking at color in art. Interest has endured in the lineage of polychrome figurative and abstract painting that continued to be made alongside the conceptual highpoints of postimpressionism, the fauves, abstract expressionism, color field painting, minimal art, pop art, and conceptual art. This is perhaps an indication that the visual and visual narrative are resilient even in the face of endgame intellectual propositions. The international market for Western art in the modern period (made by artists born since 1860) was $9.2 billion in 2015 (Artprice 2015). As Prendegast (2014) notes, this is not a reflection of an art market but of a market predominantly concerned with paintings. For example, six paintings by Matisse realized sale prices of over $15 million each through Christie's auction houses in the period between 2007 and 2012 (Christie's n.d.).

Matisse is regularly referred to as the starting point for both figurative and abstract works engaged with color in the modern period. In relation to figurative polychrome painting, we do also see artists as diverse as Edward Hopper, Max Beckmann, David Hockney, Alex Katz, and Peter Doig all utilizing particular approaches to color that draw on the steps taken by Vuillard, Bonnard, German Expressionism, and Matisse. There are instances of the "colored in," with bounding drawing lines (for example, Max Beckmann, *Quappi in Grey*, 1948), in which color gets its power from the bounding black line. Ehrenzweig's comments on color in stained glass are pertinent here. Such works can generate intensities of color because the breadth of lead, or drawn line between parts, "inhibited the excess in colour interaction" (Ehrenzweig 1966: 4), which means that the optical sensation of each area can be heightened rather than undermined by the opponency of colors in adjacent areas. There are figurative works more categorically built from color, but with distinctive palettes at the darker end of the scale (for example, Edward Hopper, *Nighthawks*, 1942) or at the lighter end (for example, Alex Katz, *Penobscot*, 1999). For Hopper and Katz, it has been the currency of their subject matter and the pathos or delicacy of expression that have been more prominent, but both build skillfully with color and tonality rather than line.

The palettes of some artists and their utilization of linear depiction or color-driven depiction have varied over the course of their careers. For example, Hockney's seminal paintings of the pop art period present structures delineated by the drawn line with color used to demarcate figurative elements (for example, *California Art Collector*, 1964). By the mid-2000s, his early digital tablet images had more colored linear elements, which shifted the role of color to a more dominant position in determining the visual outcome of

his later paintings (for example, *More Felled Trees on Woldgate*, 2008). This painter's work does give a neat example of technology influencing color use. There appears to have been a liberation arising from the ability of computer programs to enable significant colored linear elements to be composed—not that this was not possible in paint, and his oil works of the past twenty years reflect what he was able to do digitally. There may have been some liberation in respect of how to construct images resulting from the sheer practicality of generating the sort of sinuous, agile lines so easily achievable with cursor on screen in graphic interfaces.

In the last part of this modern period, we have already noted Temkin's (2008) framing of the significant number of artists generating conceptually orientated works building on Duchamp's color chart-like progression of planes in *Tu m'* (1918). In counterpoint, there have been other artists, such as Howard Hodgkin, who have become renowned for the impact of their color, working in a very different idiom. Emerging in the late pop era in the UK, Hodgkin's abstractions were built from color-saturated expressive marks that have an emphatic presence as paint, echoing back to Bell's significant form and the earlier discussion of Bonnard's patches of color. The marks building his painting also carry some sense of expression or place or memory. Overall, his palette tends to operate within a fairly defined range of saturated colors—vermilion, cobalt, viridian, black, orange, sienna, umber, and perhaps cadmium yellow—with individual works using a much narrower subset of these (for example, *In a French Restaurant*, 1977–9). Especially after 2000, we start to see two or three colors forming the core of each work, with one quite often providing an accent (for example, *Morning*, 2015–16) (see Plate 8.2 and Figure 8.2). Both the way he applies paint and his approach to the content of his works relate back to two of the ideas introduced at the start of this chapter, the expressive use of color and the significance of form. In an elegant rebuff to the sort of ideas Kandinsky promulgated in respect of what red might mean, Hodgkin is reported to have said, "great nonsense is spoken about color. Take red, he says, it is the color of sunset, of tumescence, of blood, but it is also the color of a pair of trousers" (Tóibín 2006: 50–1). Hodgkin is also a great user of green, particularly viridian or, even more, the yellow greens. Kandinsky had claimed the following for green:

> Green has a wearisome effect (passive effect) [...] the absolute green in the realm of colour can be compared to the so-called bourgeoisie; it is an immovable, self-satisfied element, limited in every sense and, in many ways, resembling a fat, healthy, immovably resting cow, capable only of eternal rumination, while dull bovine eyes gaze forth vacantly into the world.
>
> (Kandinsky 1946: 65–6)

FIGURE 8.2 Howard Hodgkin, *Morning*, 2015–16. Oil on wood, 50.5 × 64.8 cm.
© The Estate of Howard Hodgkin. Image courtesy of Gagosian.

Despite Kandinsky's attribution of particular qualities to certain colors, Hodgkin notes that color can simply reflect what is adjacent, "just as blue can be the colour of your jacket" (Tóibin 2006: 51). These very different positions on color, separated as they are by sixty years, exemplify the very different ways in which color can be thought about by two nonfigurative artists who are both seen as masters of the use of color.

Another British artist, born a year before Hodgkin, who has achieved significant critical acclaim for her work with color as well as commanding significant auction prices, is Bridget Riley. Using stripes and lozenges throughout her career, Riley's works have, like Hodgkin's, been more difficult to assimilate into the narrative structures of exhibition making. This may be related to the difficulty of securing loans to temporary exhibitions, or it may be that the works resist categorization. For both, though, I would suggest that a painting such as Riley's *Nataraja* (1993) is, like Hodgkin's *In the Shade*, a clear example of a painting that is both of and about color.

COLOR AND MATERIALITY

Coming back to the present-day context, where color is pervasive in the physical and digital environments, we need to address whether we are talking about the same thing when looking at color on an artwork or color on a digital

reproduction of that artwork. Ehrenzweig had commented on "the misleading effect of using colour slides for illustrating talks on art" (Ehrenzweig 1966: 3). So even prior to the introduction of digital color, the difference between colored light and colored stuff was recognized, which Ehrenzweig anticipated as a demoralization of "our already weak sensitivity to colour" (3). The challenge of reproducing the color of artworks in exhibition catalogs is now more widely understood. Particular challenges have been found in reproducing works by Yves Klein. Ball explains the role of the carrier for the pigment that was the key to the effect of *International Klein Blue* (Ball 2009: 281). It would only be possible to get the sensation of seeing that color if we were looking at a similarly matte surface to that realized by the particular binder, Rhodopas M60A. That absence of reflectivity is behind the blackest blacks being produced in recent years: *Vantablack* (Theocharous et al. 2014) and *SingularityBlack* (Nanolab n.d.). Such blacks are proving of interest to artists, with rights issues forming the core of press coverage to date (Voon 2017).

It is interesting to see how reflectivity, or rather its absence, is crucial for this new color development. One of the key challenges for digital rendition of color is the extent to which it gives a convincing picture of the world as we see it. Rendering metallic and pearly colors is well understood to be a challenge and there is quite a literature on how to achieve metameric matches for physical application and digital rendering. In addition, there are limitations in the color gamut that can be realized by different digital devices. So as with the ability of paintings or sculptures to make utterly convincing renditions of the real world, so there are also limitations for the digital.

It seems that realism in a digitally simulated world is almost as difficult to realize as was verisimilitude in painting. Perhaps similarly to the claim that paintings would disappear in the face of photography, it may be that painting, analog photography, and sculpture will together resist their demise in the face of digital image making due to the continuing need for artworks made of physical material to be physically encountered. The act of seeing, or visually perceiving the actual work, is required for it to be fully comprehended.

My own speculation on the increase in visibility of highly colored and colorful art is that we need to be able to discriminate quickly when searching through tiny thumbnails, and color is a useful tool for that. Our expectations for color values in respect of hue and saturation are also changing, as digital color is brighter due to its backlit nature—light shining through the screen means we are looking at a transparent not an opaque surface. As Ehrenzweig (1966) said, perhaps our ability to discriminate color is waning? Additionally, we are all empowered and tooled up to make art now. We all have our color-picker and palette on the software programs we use to edit our pictures for Facebook and Instagram. We can all be artists now.

CONCLUSION

My original expectation for this discussion about color in the modern period was that the focus would fall on the shifts in the materials used by artists. I anticipated a clear division between color as part of formalist approaches and color as a vehicle for expression. This proved not to be the case. Instead I suggest we see evidence of greater slippage between the way the perceptual is experienced by mind and body. What goes in and out of focus is the ability to wrap theory around what is felt. I consider I have made a case for reconsidering the utility of the term *colorist* as a positively valued term for artists who use color intentionally and effectively within their art, where color is a significant form. The notion of a *color-er* could be used to describe artists who use color as a second order visual differentiator, perhaps where expressivity through the drawn or through representation is common. And artists who make colored works may well locate their coloration within a strong conceptual framing, but this may subjugate the actual agency of the color on reception. Color can be central to the organization of a pictorial array, can fill the gaps between drawn structural components, and can comprise the perceptual proposition. We do now face a procedural challenge as set up by the color chart, the color picker, and the immediacy by which color can be digitally produced and reproduced. We need to be mindful of Judd's (1993) concern that color, like astronomy, "has been cursed with its own astrology." As he said, artists seem to want "a multiplicity all at once," but one that resists knowing.

Architecture and Interiors

JUAN SERRA

INTRODUCTION

"I do not understand architects! They are always afraid of using strong colors beside each other." It is noteworthy that this comment was uttered by an architect, but even more so that it was said by Adolf Loos ([1936] 2011: 63). Loos has been unfairly blamed for the rejection of color in architecture at the end of the nineteenth century, and for paving the way for the triumph of white in later modern architecture. Certainly, the architecture of the first half of the twentieth century was erroneously believed to have rejected colors other than white, and its dissemination with black-and-white photographs did not help in this regard. However, a careful study shows that color had a prominent role in the configuration of modern architecture and its influence has persisted up until today. In order to avoid a superficial understanding of color in architecture, as well as to go beyond the prevailing objection to color among some professionals, it is important to review the main architectural trends since 1920 and recognize the connections between the colors and the formal concerns in modern and postmodern buildings.[1] Such a view is expressed by Spanish architects Anna and Ricardo Bofill who state that "color should be used to underline the internal laws of the architectonic form of the building and to make them visible and artistic" (Bofill and Bofill quoted in Porter and Mikellides 1976: 49).

COLOR IN MODERN ARCHITECTURE (1920–60): PURISM, EXPRESSIONISM, AND NEOPLASTICISM

It is not easy to determine when the color white became an emblem of 1920s modern age architecture. After Philip Johnson and Henry-Russell Hitchcock

pointed out the main features of the "International Style" at an exhibition at the Museum of Modern Art (MoMA), New York, in 1932, color disappeared from the narrative of architecture for a few decades. In spite of some theorists denouncing the erroneous belief that the modern movement was just white, there was a reluctance to apply color among later generations of architects. In the years after World War II, cohorts of architecture students were taught that "proper, serious Modern architecture should have no colour except for the colours of natural materials, whites or greys—anything else was frivolous or decadent" (Pelli 1996: 27). It was even claimed that "color should be rejected to avoid distortions" (De las Casas quoted in Táboas-Veleiro 2006: 191).

The false myth of white is remarkable considering that Le Corbusier, probably the most outstanding European architect in this period and frequently incorrectly identified with whitish shades, had none of his buildings painted without colors (Cramer 1999; Serra Lluch 2010a). The Villa Savoye (Paris 1929–31) is certainly a paradigmatic example, as it is considered a white icon of modernity despite both inner spaces and outer volumes being colored. The whole ground floor was dark green to camouflage it with the background vegetation, and the rounded walls on the roof were painted pink and blue to emphasize the purism of the middle white prism supported on *pilotis* (supports that raise a building). Interiors were even more colorful, resembling one of Le Corbusier's initial purist paintings, but displayed in three dimensions. Considering that a colored model of Villa Savoye was at the MoMA exhibition in 1932 and that the curators reflected on colors in the catalog (see Hitchcock 1932), we have to agree with Mark Wigley that there existed a sort of "blindness" toward color (Wigley 1995: 424), rooted in the Ruskinian principle of material truth, fueled by historians of the modern movement, and perhaps linked to a genuine "chromophobia" in Western thinking (Batchelor 2000).

A more careful reading of the first half of the twentieth century emphasizes the importance of three contemporary color trends and leading architects: purism[2] in France with Le Corbusier, expressionism[3] in Germany with Bruno Taut, and neoplasticism[4] in the Netherlands with T.G. Rietveld. These three architects shared a common will to surpass the previous architectural paradigm, but with distinct creative solutions and different ways of understanding architectural color.

Fewer colors but not only white

The three architectural color trends aimed to limit the colors used in architecture to avoid the "color excesses" of nineteenth-century decoration. Initially, Le Corbusier was in favor of this color restriction because he did not want a wall to become "tapestry and the architect, tapestry maker," and he aimed to "eliminate the colours that one can qualify as being non-architectural," purples and greenish yellows, in general terms (Le Corbusier 1997: 95). Nevertheless,

in his later works, such as the Swiss Pavilion or the Unité d'Habitation, Le Corbusier would recover those hues avoided during the purist period.

Taut also wanted to restrict the architectural colors and rejected secondary hues (orange, violet, and green) in favor of primary ones with different brightness:

> Mixing alters the intrinsic structure of pigments, weakening their homogeneity, making them powerless to resist sun, wind, rain, and snow because their backs, so to say, have been broken. This is the reason why pure, basic pigments are the most reliable ones for exterior use. Even green, being a mixed color, has to be used with caution.
>
> (Taut [1925] 1981: 13)

However, this kind of hue restriction in Taut's architecture was not a limitation but led to the development of an extraordinary creative color freedom that went far beyond Le Corbusier's rationalism, and neoplasticists' color abstraction. Indeed, neoplastic architectural colors stand out for being the subtractive basics (red, yellow, and blue) and the neutral ones (white, black, and gray). Intriguingly, these "essential" color provisions in neoplasticism can be linked to the notion of primitivism that encouraged others to use white (Besset 1993).

Color reinforces the composition of the forms

Color in modern architecture was provided in a manner consistent with the composition of form and space, in order to strengthen the idea on which the whole formal conception of a building relied, particularly in purism and neoplasticism. Colors were intrinsically linked with the conception of a building's form, as distinct from the more superfluous provisions associated with classical decoration. This does not, however, suggest that modern architects always decided the colors during the ideation phase, a common misunderstanding, but that they carefully considered their color decisions. For example, Le Corbusier decided to paint the *brise-soleils* (structures that deflect sunlight) of the Unité d'Habitation (Marseille, 1947) once they were already built, to mitigate execution errors:

> During the busiest period of construction there was never a false step, not an ugly wall, not a blemish, not a dead space [...]. With the exception of two liberties taken by a careless engineer, producing a disfigurement for anyone to see who can discover the cause: windows outside the regulating proportion and cast concrete squares of a different module [...]. Such off-hand behaviour of numbers in the midst of the Modulor's harmonies was, to me, so distressing that, near exasperation, I hit upon the idea of exterior polychromy. But a polychromy so dazzling that the mind was forcibly detached from the dissonances, carried away in the irresistible torrent of

major colour sensations. But for these faults, the exterior of the Marseilles Unité might, perhaps, not have been multi-coloured.

(Le Corbusier [1955] 2000: 233)

Le Corbusier's color in architecture evolved considerably from his initial purist period to his expressive developments after World War II, and sometimes incongruences exist between his own writings and buildings. Possibly the most important text in order to understand Le Corbusier's architectural color thinking during the purist period is "Polychromie Architecturale," probably dated to between late 1931 and early 1933 but not published until 1997 (de Heer 2009). At this time, he was designing some color charts named "color keyboards" for the Salubra Wallpaper Company. In this text, Le Corbusier (1997) describes how color in architecture may modify the space, classify objects, and act upon our feelings.

Blue and red constitute a basic pair of opponent colors for Le Corbusier and symbolize a contrast that goes beyond the pure optics and reaches psychological, associative, and architectural issues:

Red (and its brown, orange, etc. combinations) fixes the wall, affirms its exact position, its dimension, its presence. Moreover, to blue are attached subjective sensations, of softness, calm, of water-landscape, sea, or sky. To red are attached sensations of force, of violence. Blue acts on the body as a calmative, red as a stimulant. One is rest; the other is action.

(Le Corbusier 1997: 115)

It should be noted that this duality between red and blue, in terms of light–shadow, warmth–freshness, happiness–serenity, joy–melancholy, violence–sadness, is a literal translation of Goethe's *Zur Farbenlehre* (1810), and his pair of opposite colors, yellow–blue. Other symbolic connotations are common in Le Corbusier's architecture, so that green may sometimes represent nature, red a wall, or blue the sky. This explains the presence of green colors in the ground or roofs of some villas, to reinforce the idea of the natural vegetal ground plan or the roof gardens.

It is important to emphasize that one of the fundamental principles that governed Le Corbusier's polychromy was his desire to submit architecture to an accurate compositional order, so that the colors expressed a hierarchy, which informed the understanding of architecture. Le Corbusier carried out many color operations with shaping intentions: to limit the dimensions of the geometry, separate one volume from another, correct dimensional errors, increase the perception of spaciousness, and so on. Nevertheless, he was reluctant to break the spatial box in a neoplasticist manner, displaying the colors solely to introduce a certain tension in the space, to achieve what Fernand Léger called the "elastic rectangle" ([1952] 1990: 92).

Neoplasticist architecture is at the other extreme regarding the use of color to create tension in space. At Schroeder's House (Utrecht, 1924), T.G. Rietveld arranged color to break the enclosure of the space and dissolve the boundaries between interior and exterior (see Figure 9.1). Color thus frees the components of the spatial box, which is no longer a closed prism but an encounter between independent planes and edges. The different parts of the shape are independent both visually and physically with moving elements like walls and furniture that emphasize the dynamism of the interior. The arrangement of elementary colors accentuates the identity of every singular element and is coherent with the use of elementary shapes (planes and edges). Neoplatonic philosopher M.J.H. Schoenmaekers endowed three principal colors with a metaphysical sense: "Yellow is the movement of the ray (vertical) ... blue is the contrasting color to yellow (horizontal firmament) ... red is the mating of yellow and blue" (Schoenmaekers 1915, quoted in Frampton 1992: 143).

FIGURE 9.1 T.G. Rietveld's use of color at Schröder House (Utrecht, 1923). Photograph by A.J. van der Wal. Courtesy of the Rijksdienst voor het Cultureel Erfgoed. Public Domain.

Expressionism in Germany was less concerned with this connection between color and form. When Bruno Taut was town councilor in Magdeburg, he permitted different color compositions on preexisting historic façades in the city center, which definitively weakened the visual understanding of their shapes, as they could be taken as mere canvases.

Color promotes cultural change

The desire to promote cultural change in society is a fundamental idea of modern architecture. It is an ethical conception that transcends the various aesthetic assumptions and is transferred to color composition. This sociocultural change reaffirmed itself in opposition to the academic architecture of the nineteenth century, which was criticized both "for its lack of color" and "for using color" (Caivano 2006: 356). Both the use of stark colors and full-color provisions share a common ethical background: the rejection of the past. Hence, the false iconic idea of purist architecture as white can be explained as a way to distill the form from its superimpositions, since the buildings were never completely white.

Bruno Taut believed that it was the bold color compositions that would predict the arrival of a new era, such as in his Glass Pavilion for the exhibition of the Deutscher Werkbund (Cologne, 1914) (see Figure 9.2). This building

FIGURE 9.2 Bruno Taut's Glass Pavilion in the Deutscher Werkbund exhibition (Cologne, 1914). Public Domain.

summarizes the utopian ideals expressed by author Paul Scheerbart in *Glass Architecture* (1914), as well as the prophetic advent of a new culture advocated by Adolf Behne. Taut (1925) assured everyone that color was the starting point of a new style before form was refined. For him, color was able to shed light on the shadows, which should be understood not only in a metaphorical sense but also in a plastic one. Color was able to "illuminate" a new society and a new architecture to come. During this period, many German architects took an apparent ideological stance in favor of color. In 1919, an "Aufruf zum farbigen Bauen" (appeal for colorful buildings) was published in the journal *Die Bauwelt,* and signed by architects such as Walter Gropius, Hans Scharoun, and Taut. In a few years, the journal *Die farbige Stadt* (The Colorful City) was published, some urban color plans were carried out, and exhibitions held, such as *Farbe und Raum* (Color and Space; Berlin, 1925).

Neoplasticists, on the other hand, had fewer social concerns, as J.J.P. Oud contended: "I abandoned it [the development of neoplasticism] and began to move in another direction: a healthy, broad, universal social architecture could never come from this, i.e. from so abstract an aesthetic" (Oud, quoted in Benevolo 1977: 411). Nevertheless, their artistic convictions were sometimes in part influenced by the writings of Wassily Kandinsky, who conceived of color as "a power which directly influences the soul. Colour is the keyboard, the eyes are the hammers, the soul is the piano with many strings. The artist is the hand which plays, touching one key or another, to cause vibrations in the soul" ([1914] 1977: 25).

Anti-decorative colors

Regardless of the different color dispositions between purism, expressionism, and neoplasticism, they shared the aim of avoiding the use of color in a decorative way. To achieve that, they developed several strategies: the imitation of materials and nature was abandoned in favor of "material truth," figuration was abandoned in favor of abstraction, and color became intellectualized to prevent arbitrary or capricious rules.

Neoplasticists accomplished this goal by robbing color of any emotional content, understanding it as an abstract matter that could be organized according to rational principles (Ramírez-Luque 2007: 354). They were not interested in the representation of the sensual experience, or in how colors might have a stimulating or concentrating effect on the nerves such as Taut expressed regarding his Glass Pavilion (1919). They imagined the artist as a scientist in his laboratory, intellectually analyzing form and color. This separation from nature is achieved by reducing architecture to the essentials.

Purism, on the other hand, abandoned decoration by looking for common, invariable, universal rules: "The work should not be accidental, exceptional,

impressionistic, inorganic, contestatory, picturesque, but on the contrary general, static, expressive of what is constant" (Ozenfant and Jeanneret [Le Corbusier] [1918] 2001: 165). Salubra color keyboards by Le Corbusier perfectly illustrate this intention to control the colors to be used and their combinations. This attempt to rationalize and control the color variables is comparable to the system of proportions of *The Modulor*[5] (Le Corbusier 1948 and [1955] 2000), and research has been conducted to identify possible underlying rules (Serra et al. 2016).

Taut also evolved from expressive toward functional color provisions in his last period. With regard to his own house in Berlin-Dahlewitz (1927), he stated that "the purely aesthetic ... is here no more than the outcome of what is practical" (Taut 1927: 32, quoted in Pehnt 1975: 88). The architect thus ends up rationalizing the color composition and brandishing functional arguments to support his formal decisions.

Flat colors without gradations

Modern architects usually observed the principle of a color spread over a whole architectural element (wall, floor, pillar, and so on) without any variation in hue, value, or chroma. This principle of "flat colors" was shared by Le Corbusier, Rietveld, and Taut. In fact, architects Henry-Russell Hitchcock and Philip Johnson proposed it as belonging to one of the aesthetic principles (architecture as volume rather than mass) of the "International Style" of architecture, considering that "it is also important that the surface remain a plane without convexities and concavities. Otherwise the effect becomes picturesque and the sense of equal tension in all directions is destroyed" (Hitchcock and Johnson [1932] 1995: 65–6). To be more precise, it should be noted that sometimes there is a change in colors within a single architectural element like a wall, but it occurs abruptly, with no gradation between colors, or rather with a black border. For example, in the interiors of the neoplasticist Café Aubette, Van Doesburg provided different shades on the same wall but separated them with a black line, as Mondrian did in his paintings, so transitions are clearly marked.

There were, however, exceptions. The Italian architect Piero Bottoni claimed to use gradation of colors in his manifesto *Chromatismi Architettonici* (1927). While modern color conceptions were still being discussed, Bottoni argued that color gradations in lightness were able to modify the sense of weight of a façade by virtually moving the perception of the center of gravity. In the 1920s, this interesting approach was controversial as it challenged the idea of flat-constructive color and opened the possibility of an unjustifiable color that could distort the form rather than reinforce it (Serra Lluch et al. 2009).

COLOR IN POSTMODERN ARCHITECTURE (1960–2000): UTOPIAS, NEORATIONALISM, POSTMODERN FIGURATION, AND DECONSTRUCTION

After World War II, the architectural principles of the modern movement spread throughout the Western world, both in academic and professional circles. The 1950s were years of big city plans based on urban zoning and historical amnesia, which reshaped some historic European city centers. In the late 1960s, some critical opinions started to defend an alternative architecture, although as yet there was still no typical postmodern architecture. In *The Language of Post-Modern Architecture* ([1977] 1991), Charles Jencks dated the birth of postmodern architecture back to 1972, when the Pruitt-Igoe blocks in St. Louis, Missouri, were dynamited. These blocks had earned an award from the American Institute of Architects but turned out to be uninhabitable only twenty years after they were built because of their depersonalized design. It would be an exaggeration to blame the architecture for the social problems, but modern architects had associated new buildings with a considerable increase of virtues and positive feelings (Ramírez 1996), so this was in many respects a spectacular failure. In any case, 1972 cannot be understood as a definitive boundary between the modern age and postmodernism because other influential ideological, economic, and political factors contributed to the shift.

Technological and ecological utopian colors (1960s)

At the 9th Congrès Internationaux d'Architecture Moderne (CIAM) Conference (Aix-en-Provence, 1953), opinions contrary to the modern doctrine began to be obvious, such as the functional separation between dwelling, work, recreation, and transport in urban planning. It was in the 1960s, however, that these ideas were translated into specific utopian architectural ideas, which proposed complex technical and formal designs in opposition to their predecessors' simple rational forms. Nevertheless, they shared with the modern movement the same trust in architecture as a force for social change. Many of these utopian designs were never built but became influential icons for further developments.

Some of the utopian color proposals were linked with *ecological* activism and introduced green gardening to color buildings, as well as less rigid color conceptions. Here Friedensreich Hundertwasser and Ian McHarg stand out, in particular the latter's manifesto *Design With Nature* ([1969] 1992). Other utopians, such as Yona Friedman, Archigram, or Kiyonori Kikutake, trusted a prodigious *technological* development, with architectures that were mainly colored in a functional manner.

In *Mouldiness Manifesto Against Rationalism in Architecture* (1958), Hundertwasser, who was politically committed to environmentalism, advocated self-constructions that opposed the coldness associated with modern housing: "We

must at last put a stop to having people move into their quarters like chickens and rabbits into their coops." Trying to avoid the orthogonality and purity of modern architecture, Hundertwasser designed a large number of façades with curves, bright colors, and vegetation on balconies and roofs. His chromatic arrangements can be described as *naïve*: they are spontaneous, instinctive, and distant from any color theory, although interiors somehow recall Art Nouveau and surrealism.

Technological utopians, on the other hand, were confident in the construction of megastructures: buildings were conceived of as big artifacts with a highly complex technical level inspired by science-fiction spacecraft. Some examples are the Arcology by Italian-American Paolo Soleri, Friedmann's mobile architectures, Kikutake's super-dense towers, and Schoffer Nicolas's light and mobile structures. Some of these ideas were actually built, for instance Kikutake's modular towers in concrete, some others were adapted, but all of them were influential in later developments, particularly those architectures imagined in the drawings of the British group Archigram. All these architects seemed slightly more interested in the visual glamor of the machine than in social or environmental issues.

The building that probably best expresses the idea of technological utopias is the Centre (Georges) Pompidou, National Museum of Modern Art, in Paris designed by the architects Richard Rogers and Renzo Piano (see Figure 9.3). The building is literally understood as a "machine for living" like Le Corbusier's, but shows its own gears, with complex structures full of pipes and cables both inside and outside, resembling Archigram's drawings. Rogers stated: "We believe that buildings are machines, as did the modern architectural pioneers" (Rogers 1976: 60), while distancing himself from the rigidity of modern color.

The color composition of the Centre Pompidou is a consequence of its internal working: blue for the air conditioning tubes, green for the water pipes, yellow for the electric lines, red for the elevators, white for the underground air ventilation tubes, and so on. Piano and Rogers moved away from subjective assessments and based their color decisions on three aspects: the use of colors with conventional coded meanings, the disposition of durable colors against fading, and the incorporation of a rhythm attending to the scale of the building. Despite this rationality, Rogers admitted that the selection of the colors was also a personal and subjective choice that aimed to give some joy to the building: "We have always consciously designed with color because of our interest in what Renzo and I call 'happy buildings'—buildings that people react to" (Rogers 1976: 61).

Later utopian colors

High-tech architecture during the 1980s was greatly influenced by the technological utopias of the 1960s and inherits the same paucity of color. For example, Norman Foster displays color like Piano and Rogers did, sharing a

FIGURE 9.3 Richard Rogers and Renzo Piano's The National Center for Art and Culture George Pompidou (Paris, France, 1977). Photograph by Serge DE SAZO/ Gamma-Rapho via Getty Images.

common high-tech aesthetic of plain colors. Those megastructures imagined by the technological utopians, like small cities in just one building, with versatile and modular architectural pieces, have also survived today in the work of architects such as MVRDV and Rem Koolhaas. Unlike the chromatic scarcity shown in the 1960s, later megastructures have featured significant colors, which can help to identify the individual parts and functions that make up the whole building.

The ecological utopian trends of the 1960s, with prominent examples such as the Habitat in Montreal (Moshe Safdie, 1967) and the Espai Verd in Valencia (Antonio Cortés, Spain, 1973), are probably the source of contemporary greenery in buildings. Architecture covered with vegetation can be found in many places, such as the Tower Flower of the Jardins de Saussure by Edouard François (Schindler 2007). Also significant is the presence of green walls, such as in the Museum at Quai Branly in Paris, and in One Central Park in Sydney, both by the architect Jean Nouvel.

Rationalism survives: Monumentalism with natural colors and white (1970s)

In the late 1960s and during the 1970s, a group of architects wanted to correct the excess of rationalism of the modern movement. There were different chromatic trends but one common idea: to use color in a monumental sense.

White was widely displayed as an emblem together with the use of natural materials as having a resemblance to classical architecture.

In the United States, "The New York Five architects" stood out: Peter Eisenman, Michael Graves, Charles Gwathmey, John Hedjuk, and Richard Meier. The press nicknamed them *The Whites* because of their passion for this color. It is clearly expressed in Meier's Pritzker Acceptance Speech: "For me, white is the most wonderful color because within it you can see all the colors of the rainbow [...]. It is against a white surface that one best appreciates the play of light and shadow, solids and voids" (Meier 1984). The almost verbatim reference to Le Corbusier's famous sentence "architecture [is] the masterly, correct and magnificent play of masses brought together in light" ([1923] 1986: 37) shows the influence he had on The Whites. However, they were blind to Le Corbusier's purist colors in favor of white, a regular feature in the revision of the modern movement, as noted previously in this chapter. The Whites felt that they were the heirs of the modern pioneers, and not creators who were struggling to impose a radical language on a hostile world as did the Utopians. These North American architects paid attention to Europe, both to the whiteness of the modern movement, as in Peter Eisenman's interest in Terragni's Casa del Fascio in Como (Italy), and to ancient Roman architecture, as in Richard Meier's Getty Center, which was built in sumptuous Italian marble after his visit to Hadrian's Villa (Gössel and Leuthäuser 2001).

In Europe, the architectural debate was led by the Italian group Tendenza, with architects such as Manfredo Tafuri, Aldo Rossi, and Giorgio Grassi. Tendenza tried to match the order and the clarity of the modern movement together with the lifestyles of a long secular tradition. They tried to distill the typological forms of historic architecture, to reduce them to their most essential parts (Bozal-Fernández 1996: 384). In accordance with this idea, their color composition pursues this essentialism by using uncoated materials (marble, brick, concrete, copper, and others) and connecting with the image of a timeless monumental architecture.

An exemplary case of architecture in this period is the San Cataldo Cemetery in Modena, designed by Aldo Rossi. It embodies architecture conceived as an unfinished and solemn civic monument with obvious references to classicism and a great formal simplicity (Moneo 1992: 46). In this cemetery, uncoated materials such as concrete coexist with coated materials such as a Pompeian red plaster, giving the impression of an antique ruin. It resembles an unfinished village with plenty of echoes from the past, like an uncompleted monument for the dead. Rossi maintained his interest in color and historical architectures until the end of his career, as is well illustrated by his posthumous work in the Quartier Schützenstrasse in Berlin—a reinterpretation of the Palazzo Farnese (Antonio de Sangallo, Rome, 1516) (see Plate 9.1 and Figure 9.4).

FIGURE 9.4 Aldo Rossi's Quartier Schützenstrasse (Berlin, Germany, 1997).
Photograph by Jörg Zägel. Public Domain.

Later neorationalist colors

The tradition of rationalism and later brutalism can still be seen today in architecture that discards any color apart from white or uncoated materials. It represents an attempt to prioritize the clear vision of the form, to prevent any possible misunderstanding because of color. This is the case with Spanish rationalist architecture (for example, Josep Antoni Coderch, Josep Lluís Sert, Miguel Fisac) and with the subsequent minimalism movement, which reached its peak during the 1990s (for example, Alberto Campo Baeza). Portuguese architects associated with the Porto school also belong to this tradition, for example, Fernando Tavora, Souto de Moura, and Alvaro Siza, who have a predilection for the purity of white, and therefore have rarely mixed it with other colors. When this abstract architecture displays other shades, these are borrowed from a physical or historical context, following in some way a color reduction to the essentials as well as the sense of monumentality, which was common to Italian neorationalists. Other examples are some works by the Spanish architect Rafael Moneo and by the Portuguese Alvaro Siza. Swiss architecture is also linked to the simplicity of neorationalist forms to a certain extent but with a broader, fruitful experimentation with material finishing, as is evident in the works of Gigon and Guyer, who have been labeled "multi-color minimalists" (Wang 2000).

Color and pop culture: Figuration and meaning (1980s)

Architects who identified with North American pop architecture and the ideas formulated by Robert Venturi and Denise Scott Brown started using colors in a figurative and meaningful manner during the 1980s. Beginning with their analysis of American main streets with a large number of advertisements, Venturi and Scott Brown wanted to recover the artistic and communicative effects of buildings by opposing the simple and "clean" solutions of the functional school. They also wanted to challenge the unity between the external appearance of architecture and its inner structure, a paradigmatic assumption of the modern movement (Gössel and Leuthäuser 2001). A new figuration emerged that freely used the repertoire of classical architecture, thus creating what Juan Antonio Ramírez has described as an "ironic classicism," or a "pompous and sometimes hilarious monumentality" (Ramírez 1996: 431). Among the most influential American pop architects in this period were the previously mentioned Venturi and Scott Brown, and John Rauch. They renounced the use of façades to inform about the inner formal composition and they spread colors freely, like a wrapping paper, sometimes with figurative patterns or letters in color (Riedijk 2009). A good example of this is the colorful tapestry in the form of flower-print porcelain-enamelled steel panels used to clad the façade of a Best Products catalog showroom (Langhorne, Pennsylvania 1979).

American pop architecture emphasized two important compositional resources: scale distortion and decontextualization. Buildings included common architectural elements but of an unusual size, or placed in a disconcerting context, so the meaning of the building was distorted. Colors were used in very basic primary hues and fully saturated, associating themselves with everyday consumer goods and their images in advertisements. In short, color in figurative postmodernity was a key aspect of bringing the ambition of "high architecture" closer to the public. James Stirling, for instance, describes his *Neue Staatsgalerie* as an attempt to be monumental, and at the same time informal and accessible:

> Colorful elements counteract the possibly overwhelming appearance of a monumental stone quarry [...]. Internally, the green rubber flooring, as [an] alternative to the more normal highly polished stone which is usual in Germany, reminds us that museums today are places of popular entertainment.
>
> (Stirling 1985)

On the other hand, during the 1980s in Europe there was a noticeable development of ambitious color plans featured in urban areas. France was fully involved in this colorful fervor; the *villes nouvelles* in the suburbs of the main cities were colorfully designed in order to provide interest and personality to such housing estates (Lenclos 2009). Some color interventions in this period were carried out by France and Michel Cler (Schindler 2012), Emille Aillaud near Paris, and the muralist Fabio Rieti, who specialized in trompe l'oeil.

In common with France, Portugal faced a difficult social period that required the construction of massive social housing developments in Lisbon and Porto. Both cities opposed the architectural positions of the previous fascist regime, but represent two different ways of understanding architecture, which became evident in the exhibition After Modernity (Lisbon, 1984). Porto's architects decided not to participate in this exhibition, which showed different buildings that rejected the seriousness and the messianic spirit of the modern movement. These buildings emphasized other values such as pleasure and novelty in the use of colors and materials. Lisbon's architects, among them Tomas Taveira, Julio Teles Grilo, and Antonio Tomás de Eça Leal, were influenced by American postmodernity, pop, and historicism (Siza 1987: 23–7). The colors in some of Tomas Taveira's buildings are understood as a deliberate provocation, with bold and contrasting color compositions expressing a socially progressive attitude.

Despite this color excitement in the European urban landscape during the 1980s, the interiors were often characterized by soft and light colors that were considered sophisticated and elegant. This is a common characteristic of American pop architecture, which was combined with the colorful presence of the buildings in wide-open urban areas. Commercial signs and colored lights were used together with much more intimately scaled interior spaces with low-saturated, uncoated material colors (Hess 2010). Painted colors in Europe and commercial signs in North America represent two different color solutions aiming for the same goal: bringing architecture closer to the people.

Later pop colors

During the 1980s, color was seen as a useful means of recovering the connection between buildings and their inhabitants, for creating a distance from the abstract and theoretical positions of modernity. Color had a key role in making architecture significant for inhabitants, but it was associated with the new mass-media codes rather than with the local culture's color tradition. As a consequence, many color compositions in this period could be better understood from a social point of view rather than in connection with the landscape or the shape of the building itself.

British architect William Alsop can be thought of as a contemporary heir to these pop color trends. He is not interested in architectural theories and building interpretations, and uses color in a completely intuitive and personal way to give joy to the city and arouse people's interest:

> I can introduce color into the buildings ... and I find that people respond to these places very well ... and often there are too many places like graves ... I am very popular with people, and sometimes they ask me how do you do that, and I do not really want to know ... that is what I do and the color is just something natural, it is not a conscious decision, it just emerged.
>
> (Alsop interviewed in Serra Lluch 2010b: 197)

Alsop's use of colors has sometimes been viewed as controversial, provocative, and excessive, but his strategy succeeds in connecting architecture with citizens.

Color of deconstruction and new technologies (1990s)

In 1988, Philip Johnson and Mark Wigley organized the exhibition Deconstructivist Architecture at the MoMA in New York. There they showed the designs of some architects who were working in a different way to the predominant postmodern trends, with broken shapes, full of intersections and corners. The exhibition was coincident with the rise of post-structuralist philosophy and the so-called "postmodern doubt," which rejected universal and authoritarian explanations of reality in favor of discontinuous, provisional, and fragmentary theories (Montaner 1999). To a certain extent, architects had by then already lost faith in the great utopian visions of modernity and focused instead on novel solutions for color and design with the help of new technologies. Some architects associated with deconstructivism are, among others, Frank O. Gehry, Daniel Libeskind, and Eric Owen Moss in the United States; Zaha Hadid, Enric Miralles, Benedetta Tagliabue, and the architectural studio Coop Himmelb(l)au in Europe.

Despite the supposed connection with post-structuralist philosophy, many deconstructivist architects mimicked the colors and shapes of some avant-garde trends, such as German Expressionism or Russian Constructivism, which had received comparatively little attention in twentieth-century architectural historiography. Deconstructivist architect Zaha Hadid, for instance, kept close to Russian Constructivist colors by using white, gray, and black backgrounds in her drawings and adding a few saturated colors to emphasize elements.

Deconstructivist architectural colors are also the consequence of different technical innovations; on the one hand there are new building materials with unexpected finishes (titanium, anodized copper, silk-screen printing, color glass improvements, lighting, and so on), while on the other hand there are computer-aided color design processes. Without special computer software for designing airplanes, Gehry's Guggenheim Museum in Bilbao would not have been possible, for instance (see Plate 9.2 and Figure 9.5). Technical innovations offer new possibilities for color complexity, both with regard to its chromatic nature and to its formal composition.

The Vitra Fire Station was probably the first outstanding built project by Zaha Hadid, when she was already admired for her paintings with fragmented geometries. Early sketches of Vitra show the architect's attempts to reconcile the lines of the land, the nearby streets, and the movement of people using the building in order to shape this fire station in a very personal way, which some authors have labeled as "Kufic Suprematism" (González-Cobelo and Hadid 2001). *Suprematism* refers to its formal resemblance to the abstract art of Russian avant-garde, and *Kufic* indicates its similarity to the oldest Arabic calligraphy.

FIGURE 9.5 Frank O. Gehry's Guggenheim Museum (Bilbao, Spain, 1997). Photograph by DeAgostini via Getty Images.

This fire station aims to represent "frozen motion" and to express the usual tension of firefighters, who remain alert with "the potential to explode into action at any moment" (Binet et al. 2000: 109–10). At the same time, Hadid wanted the building to be "transparent without using a transparent material, but concrete" and attempted to "lightweight a heavy mass" (Hadid and Futagawa 1995: 75). Regarding the colors, initial sketches had green, blue, orange, and gray shades inside, but finally Hadid decided to leave the concrete unpainted. The reconciliation of contradictory concepts such as abstract–contextual, frozen–movement, colored–plain materials is a key aspect for understanding colors and finishing in deconstructivist architecture in general. Color and material try to be both something and its opposite at the same time, which we understand as a search for *versatility* (Serra Lluch 2013).

Later deconstructed colors

The most important novelty in architectural color composition during the 1990s was the improvement of new coloring technologies, both in building materials and in computer-aided designing methods. Artists and architects tried to exhaust the color possibilities of materials and their shaping, thus reaching complex results.

During the 1990s, some deconstructivist architects chose monochromatic colors for their buildings, which were clad with new outstanding materials (such as titanium) that suggested a kind of color containment in a chaotic shaping. Some buildings, for instance those designed by Frank Gehry, have evolved toward extended color palettes such as in the Experience Music Project (Seattle, 2000), which features a fusion of a deep red, blue, gold, silver, and shimmering "purple haze" metal. Gehry's intention here was to evoke Jimi Hendrix's smashed guitars (Kirkpatrick 2000).

There are many contemporary architects who emphasize the importance of the coloring process, assuming a kind of random result that is a consequence of new computer methods for creating designs. Architects Enric Miralles and Benedetta Tagliabue (EMBT) represent such an approach in their design of the roof of Santa Caterina's Market in Barcelona (2005), where they displayed traditional modernist colored glazed tiles, but also explored the possibilities of digital image processing. Colors were obtained from the image of a grocery stall following a digital treatment to reduce the original color ranges. Some other examples, though not formally linked to deconstructivism but representing the use of digital color processes, are the Pharmacological Research Laboratories in Biberach (Sauerbruch Hutton, Berlin, 2002) and the Contemporary Art Museum in León (Tuñón and Mansilla, 2004).

In other projects, as in the Netherlands Institute for Sound and Vision (Neutelings Riedijk Architects, Rotterdam, 2006) (see Plate 9.3 and Figure 9.6), both the building materials and the designing process were new. Special

FIGURE 9.6 Neutelings Riedijk Architects' Netherlands Institute for Sound and Vision (Hilversum, The Netherlands, 2006). Photograph by Ben Bender. Public Domain.

software was used to transfer selected film scenes onto the façades by burning three different pigments into the glass at the same time as it was melted into the molds. The interiors have underground corridors painted in a highly saturated orange that seems to come virtually forward, together with gray-stone and metallic cladding that shimmers when natural light comes through the colored glass of the façade. The global effect of the color is somehow evanescent.

Some architects, such as Rem Koolhaas, consider our color preferences to be influenced by technology (Koolhaas et al. 2001). Koolhaas describes our contemporary experience of physical reality as overstimulated, heightened through technology. Accordingly, the chromatic intensity in contemporary architecture could be viewed as the response to an aspiration of approximating a building's image to the one presented by digital technology. One good example is the Hageneiland dwellings in The Hague by Dutch architecture firm MVRDV (1997–2001), in which houses in different monochromatic colors, including the roofs, look like a literal translation of an image rendered by a computer. Another example is the increasing presence of phosphorescent colors that shine as if they were seen on a digital device like the greenish-yellow escalators in Koolhaas Public Library in Seattle (OMA, 2004).

Common features in contemporary color design are the consequence of those improvements in technology that started in the 1990s and were pushed forward thanks to deconstructivism. The use of specific drawing software, the possibilities of digital image processing, and the artificiality of the colors seen on the computer screen, together with the ambiguity, disorder, and deliberate contradictions in deconstructivist architecture, form the roots of *versatile* colors, typical of the twenty-first century.

COLOR IN CONTEMPORARY ARCHITECTURE (2000–): VERSATILE AND IMMATERIAL COLORS

Color tendencies during the modern period (purism, expressionism, and neoplasticism), together with those in the postmodern period (utopias, neorationalism, postmodern figuration, and deconstruction), provide the background for understanding contemporary color in architecture and interiors. Thus, the high-tech and ecological color trends of today go back to a mix of traditions from the 1960s and onwards. During the first two decades of the twenty-first century, color has been serving as a useful resource for expressing *versatility*, the wish to adapt to different situations, which is an aspiration inherited from the beginnings of the modern period. This color versatility is based on different possibilities for change: the transformation of the colors of buildings that change their visual aspect; color fragmentation that affects the sense of unity; color movement which implies a change in position; and the search for novelty with new color procedures and technologies.

Color *transformation* may be achieved through changes in the light source, incorporating reflections, using transformable materials, or as a consequence of the observer's limitations, to name but a few possibilities. New artificial lighting systems can transform the colors of architecture, and it is not difficult to find neutral surfaces on which many changing colors are projected, for example, the Allianz Arena Stadium in Munich (Herzog & de Meuron, 2005) and the Burj Al Arab Hotel in Dubai (Mark Major and Tom Wright, 1994–9). Moreover, there are materials that incorporate reflections from, for example, glass, mirrors, and satin-finished surfaces, which continuously transform their visual impact because a fugitive color, coming from an ever-changing reality, is superimposed on their inherent color. The reflection integrates whatever is outside the building with its surface, creating an impression of it being immaterial, as in the Vieux Port Events Pavilion in Marseille (Foster and Partners, 2013). There are also a large number of new transformable materials that change their color in different situations. This is the case with iridescent foils that make the façades shimmer in all the colors of the rainbow, as in the "La Defense" Offices in Almere, The Netherlands (UNStudio, 2004) (see Plate 9.4 and Figure 9.7), and with the phosphorescent paint which transforms its color under ultraviolet lighting in interiors such as the staircase of the Medialab-Prado in Madrid (Langarita-Navarro Arquitectos, 2013). Some buildings appear to transform their colors as a consequence of the observer's limitations, when neither light conditions nor the object has changed. This happens when the color composition is complex

FIGURE 9.7 UNStudio's (Ben van Berkel) "La Defense" Offices, Almere, The Netherlands (Amsterdam, 1999–2004). Photograph by Lauren Manning. Public Domain.

and difficult to apprehend, so the building as a whole seems unstable. This is true of architectures that use a very large number of small colored fragments with non-evident compositional order, such as the Sedus high-bay warehouse in Dogern, Germany (Sauerbruch Hutton, 2003).

Color may alter architecture's unity and result in its *fragmentation*. To seek fragmentation means rejecting the idea of the architectural project as a unified whole and instead understanding it as something dispersed and contradictory. Fragmented architecture usually has complex color dispositions that reinforce the idea of a hybrid reality in which the separate origin of its components can be traced, as in the Silodam Building in Amsterdam (MVRDV, 2002). This design process requires expressive mechanisms such as *collage* or *panography* (assembling an image from several overlapping photographs), a legacy from some of the twentieth-century artistic trends (cubism, Dadaism, surrealism, and others). Color goes through a double fragmentation process whereby it is disassociated from the structural aspect of the building (fragmentation between structure and finish as in many high-tech buildings), while at the same time emphasizing the breakdown, dispersion, or conflict between the parts (fragmented composition systems as in deconstruction). Thus, fragmentation seems to be the expression of freedom against monolithic interpretations of reality.

The interest in expressing *movement* in the arts has its roots in the early avant-garde period, but contemporary architecture is also concerned to do this, either with static colors that suggest movement, or with colors that actually do move. Movement in architecture has traditionally been understood in a musical sense: the color movement is the rhythm, the distribution of silences and accents visually perceived. Color allows the introduction of this rhythm in architecture, which breaks the static monotony with a particular cadenza. A good example of this kind of ambition is the T4 terminal of Barajas Airport, Madrid (R. Rogers and Lamela, 2006), where the rainbow color range gives movement to an extremely extensive and monotonous succession of identical structural supports.

In contemporary architecture and interiors, on the other hand, there are many colors that do move, mainly thanks to new artificial lighting technologies, as mentioned above, from simple lighting changes to media surfaces that contain dynamic text, graphics, or images. Moreover, such media-surfaces can leave the color design unfinished and open to the observer's interaction. Looking at the different methods of displaying content, some authors distinguish between "mechanical facades, projection facades, rear projection facades, illuminated facades, window raster animation, display facades, and voxel facade systems" (Haeusler 2009: 12). A good example of a media façade is the surface of the Kunsthaus Graz, Austria, which works like a large screen (Spacelab Cook-Fournier [Peter Cook and Colin Fournier], Graz, 2003).

Color *novelty,* or change in technology and coloration procedures, involves experimentation with every possible technological and expressive method. This has almost been an obsession since the early twentieth century to express the spirit of the new era. Computer-aided color has greatly expanded creative potential, and has influenced both the nature and composition of color. "Color in the real world looks increasingly unreal, drained. Color in virtual space is luminous, therefore irresistible" (Koolhaas et al. 2001: 12). As a consequence, the nature of color seems to evolve from the material to the immaterial, from pigmented color to colored light.

The pursuit of versatility and the four concepts discussed above—transformation, fragmentation, movement, and novelty—help to explain the ways in which colors are being conceived and arranged in contemporary architecture and interiors. To achieve versatility in buildings means to renounce permanence, to understand life as being contingent on chance, ever-changing, constantly evolving. Thus, durability no longer refers to everlasting objects, but rather to those that always try to reinvent themselves and stay updated. Nowadays, architecture seems to be caught up in this excitement of constant renewal, urged to deny its very self and become something new. It should be emphasized that this versatility is not only the consequence of an artistic attitude and a change in the understanding of the discipline, but also the effect of new plastic resources: building materials and design tools. Technological improvements have definitively helped to express versatility.

Nevertheless, the future of color in architecture should focus not only on the versatility of an isolated building but also on the relationships between color and the environment, something that is frequently overlooked. Perhaps in this way, certain auto-referential contemporary color arrangements could be overcome, as well as the predicament of certain buildings that are understood to be isolated objects or out-of-context artifacts. Interior color design has the pending matter of considering people's reactions to the environment, thus transferring some interesting scientific findings obtained in experimental conditions to practical day-to-day architecture. Undoubtedly, the future of color in architecture and interiors includes many challenges.

CONCLUSION

The architecture of the modern movement, which developed in the first half of the twentieth century, has been largely identified with the color white. However, there were interesting architectural color trends linked to some avant-garde movements in Europe, particularly purism, neoplasticism, and expressionism. Five characteristics of these modern architectural colors have been pointed out: (1) there were fewer colors used than in the nineteenth century but not only white, (2) colors were used to reinforce the composition of the forms, (3) color

was used with the aim of stimulating cultural change, (4) color for the sake of decoration was avoided, and (5) only flat colors without gradations were displayed.

In the second half of the twentieth century, four architectural color trends have been identified in what is often called the postmodern period: (1) colors were linked to technological and ecological utopias, (2) there was a search for monumentality with natural materials and white in rationalist architecture, (3) the recovery of figuration and meaning took place using pop colors, and (4) the colors of deconstruction and new technologies arrived. All four trends have influenced the use of color in the architecture of the twenty-first century, in which it is characterized by versatility and immateriality.

Artifacts

KELLY F. WRIGHT

INTRODUCTION

Among the deprivations suffered by millions during World War I, albeit a relatively trivial one, was decorative color. On the eve of the "Great War" Germany had been one of the world's largest purveyors of dyestuffs and colorants; those industries had in fact helped to fill the country's war chest. By the end of the nineteenth century European chemists had formulated a range of colorants so complete as to include acid and "hot" colors; all the options were there for the twentieth-century designer and artist to create. Formal declarations of war from Germany's Allied opponents allowed those countries to help themselves to German industrial patents as a supposed exigency of war, an opportunity that jump-started the United States' chemical industry. The first years of the postwar era saw ardent research into the development of new technologies and media to contain the wealth of colors available, and the subsequent reintroduction of more vibrant color into the decorative arts. For the rest of the twentieth century, except for wartime rationing, it would be considerations of taste, not problems with access, that would dictate color's use. This chapter outlines major developments in design conventions, practices, and styles in America and Europe as they were reflected in consumer goods, synthetic products, dinnerware, glass, and furniture. It traces how the dominant colors used in the twentieth century often reflected social and political trends as well as cultural mores.

ART DECO, INDUSTRIAL, AND CONSUMER GOODS IN THE 1920S

The early 1920s palette in the decorative arts and home furnishings was still largely influenced by the Arts and Crafts movement's deep moss greens, yellow ochers, and striated browns of varnished woods. The Art Deco movement that began in the middle of the decade, however, borrowed liberally from the dazzling colors of the sets and costumes of the Ballets Russes to compose a more spring-like palette of lavenders, violets, and deep purples; emerald, jade, and grass greens; rose pink; golden yellow; and magenta, all of which quickly made their way into Western decorative arts. Art Deco color schemes relied on jagged and geometric compositions of bright colors juxtaposed against themselves, black, white, and midnight blue, typically embellished by metallics. Art Deco employed the power of orange—a color generally avoided by the Victorians—in an unprecedented way. The stark and brilliant contrast of orange with green was a well-loved combination in the era: jewelers set jade cabochons against coral stones, lapis, and platinum; teal-and-orange friezes circumscribed Egyptian Revival façades. Orange backdrops highlighted set designs; orange suns warmed beaches in travel posters; orange inlays enlivened jewelry boxes. The color came to embody Modernism itself. Even manufacturers of agricultural machinery were not immune to its charm. In the late 1920s the American firm Allis-Chalmers retired the dull green pre-war color of their tractors, replacing it with *Persian orange*, a color supposedly inspired by the factory owner's drive past a field of blooming poppies.

By the 1920s automobiles were dramatically changing industrialized societies, and in the United States their ubiquity affected every facet of life. The last American president to ride to his inaugural by horse-drawn coach was Woodrow Wilson in 1912; by the end of World War I automobiles had blessed American society with oil trusts, traffic jams, and fatal accidents everywhere, but none of this diminished Americans' love for them. Automakers bent on distinguishing their cars relied increasingly on color to do it. Initially vehicles in this period drew from a conservative range of dark and serviceable colors—navy, brown, forest green, maroon, and black. Despite the lore surrounding Henry Ford's obstinate adherence to black finishes—including a remark attributed to him that Americans could purchase the Model T in any color they wanted as long as it was black—even the Ford Motor Company introduced colors into this line in the 1920s when their once near monopoly on sales to the middle class lost market share to competitors. By 1927, however, the company suspended production of the Model T and launched the Model A, the first car to be emblazoned with the blue oval Ford logo. More high-end makers began in the 1920s to offer creamier colors, such as beige and tan, in two-tone combinations.

The 1920s saw the powerful American economy dedicate itself to the production of a huge array of consumer items. The Art Deco movement's emphasis on streamlined forms and new, exuberant colors launched redesigns in refrigerators, stoves, washers, mixers, clocks, jewelry, coffeemakers, and more, at price points focused on multiple sectors of the buying public. Light-colored enamel stoves made a dramatic and refreshing change from the old cast-iron wood stove of the nineteenth century whose proper maintenance included regular blackening. The new electric refrigerator that replaced the old wooden icebox was first sold in the 1920s; its white surface, rounded shape, and Art Deco linear detailing lightened kitchens everywhere in the industrialized world. Blenders and mixers gleamed in heavy chrome plate that literally mirrored the era's emphasis on metallic finishes. When purchasers could not afford these shiny new articles, the system obliged by extending easy credit, whether or not buyers were likely to repay the loans. Magazines with color advertisements and movies shown in grand palaces fueled much of this consumption.

In *Babbitt* (1922), novelist Sinclair Lewis's scathing portrayal of American consumption, the author describes his eponymous protagonist's pride in the glowing green phosphorescent dial of the alarm clock that awakened him every morning, a "rich" and modern device that Babbitt believed gave him the same elevated social standing as "cord tires" (Lewis 1922: 13). Babbitt's clock was a social marker as much as his motor car, his wife's hand-painted china, or his house's red terra-cotta tiled roof. As critical as it was, Lewis's account of Babbitt's idiosyncratic fetishism did not factor in the terrible cost of this addition of ghostly color to the clock. Women working in factories painted these dials with radium-226, licking their brushes frequently to maintain the fine point their work required and even using the dangerous substance on themselves as eyeshadow.

Sinclair Lewis may have won a Nobel prize for literature in part for his ridicule of American materialism, but few of his readers were taking this message to heart. Corporate research and development departments worked overtime to create new substances that were both beautiful and useful, and many of these permitted the molding, twisting, knitting, dusting, and bending of color into new forms, such as glowing alarm clocks. Demand for objects fabricated with these fresh materials grew through the decade, making it worth the while of manufacturers to extend the effort, despite the threats from carcinogens and other health and environmental issues associated with their production.

Phenolic resins, created by blending phenol and formaldehyde, offered an entirely new medium for embellishing with color. The trade name for one of these synthetic resins, *Bakelite*, has come to be used as a kind of shorthand for the plastics developed in the period between the wars. Bakelite accommodated itself to warm colors of solid amber, red, and brown, and tortoiseshell effects in various colorways, but could also be made in blues and greens. It was molded

into colorful clocks, radios, jewelry, telephones, cigarette lighters and cases, makeup compacts, vanity sets, brushes and combs, purses, utensil handles, toys, and poker chips, though it began its life unglamorously as an ordinary electrical insulator. The thermosetting property making Bakelite invulnerable to heat damage has guaranteed the survival of many pieces into the twenty-first century, and today genuine Bakelite objects are avidly sought by collectors worldwide who use a variety of techniques to determine their authenticity. *Celluloid* was an older plastic that revolutionized the early film industry and decorative arts. Naturally clear, celluloid was fashioned into the very same kinds of articles as Bakelite throughout the 1920s and 1930s in many colors, especially a creamy white. It was on celluloid that the first movies were filmed and hand tinted, but its fragility has mitigated its longevity. Most celluloid production stopped around 1940, but ping-pong balls are still made of it (National Museum of American History n.d.).

More traditional materials still embodied the colorways of Art Deco, if not the excitement of the "Jazz Age." Several varieties of decorative glass, first developed in the nineteenth century, remained or even grew in popularity through the 1920s. "Custard" glass was, as its name implies, a creamy yellowish color. "Jadite" was a light green tending toward blue, with some translucence, to which Americans particularly gravitated. "Uranium" or "Vaseline" glass was perhaps the most distinctive of all the glassware colors. In normal light Vaseline glass appears a pale, somewhat opalescent yellowish green, somewhat like petroleum jelly. Under black light the uranium incorporated in the glass-making process causes the glass to glow an intense lime green. This color's fabrication was suspended in the United States when uranium was regulated during World War II, but production continued after the war using depleted uranium.

The British pottery industry met that country's demand for affordable china and stoneware in Art Deco's trademark colors and abstract patterns. Dubbed "Bizarre," Clarice Cliff's first line as a ceramics designer in Stoke-on-Trent, UK, created a sensation among consumers with its large fields of streaky hand-painted green, orange, and black enamels separated by radiating or intersecting lines of black, green, or brown. Cliff continued her success with other boldly colored patterns evocative of the age—painterly crocuses in bright blue, red, and purple; sunbursts in solid jonquil, orange, and black. In the next decade her "My Garden" line added more diluted color in the 1930s palette to embossed ceramic blanks, and her work continued in a similar vein until 1940 when the British government banned the manufacture of colored china during World War II. Amateur china painting continued its popularity in this era.

The stunning "Jazz" punch bowls produced by Ohio's Cowan Pottery at the end of the 1920s captured the zeitgeist of a dynamic era at the end of its life span. They originated from an anonymous commission that turned out to be from Eleanor Roosevelt, the commission was a gift for her husband Franklin.

Potter Viktor Schreckengost, who later became one of the best known industrial designers of the twentieth century, chose a deep Egyptian faience blue for his overglaze, and his audacious design executed in black celebrated the New York skyline, the music blaring from nightclubs everywhere, and alcohol while Prohibition was still in effect. Sealed forever under glossy, electric cyan, these symbols of the Jazz Age look as fresh and decadent today as they did when the era came crashing down. The color next associated with this point in history is, in fact, much more funereal.

DESIGN TRENDS DURING THE GREAT DEPRESSION

"Black Tuesday"—October 29, 1929—and the Great Depression that followed brought with them worldwide economic misery, but as is often the case in periods of social stress, it also inspired tremendous resourcefulness and creativity in the decorative arts. Governments, manufacturers, and individuals rightly perceived that color can serve as a palliative in a time of suffering, and in their own ways ensured that the backdrop to all that misery would be visually stimulating. In the United States, President Franklin D. Roosevelt's "New Deal," a package of economic reforms enacted over the course of the decade, engaged with color in a variety of ways. The Index of American Design, a program of the Works Progress Administration (WPA), the New Deal's largest agency, was charged with archiving the country's material culture, including its colors. Like the other programs of the WPA that married the dignity of labor to the sublimity of art, the Federal Art Project (FAP) allowed out-of-work artists to travel the country creating public art murals and sculpture, paintings, posters, graphic work, and photographs. The administrators of the Index of American Design employed commercial artists to render in watercolors the furniture, textiles, musical instruments, decorative arts, and toys they collected state by state. They intended to publish and distribute this catalog of objects to public educational institutions as both a record of American aesthetic achievement and as a resource for future artists. Retooling for World War II caused the suspension of such programs, and the watercolors quietly retired to their permanent archives at the National Gallery of Art in Washington, DC.

The automakers who survived the first years of the Great Depression modestly expanded the options from which customers could choose by adding white and red and a wider variety of shades of traditional vehicle finishes. Others were much more liberal in their offerings. The World's Fair that opened in Chicago in 1933 celebrated the city's centennial with the theme of "A Century of Progress," a showcase of innovation in technology. "Science Finds, Industry Applies, Man Adapts" was a logical motto for Progressives reared on the doctrine that science can engineer a better society. Organizers innovated the fair itself by creating a multicolored "rainbow city" of buildings in contrast to the patrician

White City at the World's Columbian Exhibition forty years before it. Chicago-based retailer Sears, Roebuck and Company sponsored a quilt competition at the fair with a grand prize of $1,200, a fortune for most people during the Great Depression. Judges reviewed more than 25,000 entries before awarding the three top prizes to beautifully made but highly conventional piecework and appliqué quilts, despite the entirely avant-garde offerings of many of the consignors. The conservatism of these judges clashed with the brilliant range of colors, from pastels to primaries to acids, displayed in American quilt styles of the 1930s, one of the greatest eras of quilt production.

Some of the most cheerful colors of the Great Depression were seen in glass and ceramic artifacts. "Vitrolite" was a pigmented glass product designed for architectural applications that was made in many colors in the Art Deco palette including jade, pale blues and pinks, robin's egg blue, violet, black and white, and marbleized or "agate" finishes of various hues (Benton et al. 2003: 119). Vitrolite and its competitor products gave a sleek appearance to store marquees and building façades, daily reinforcing the color vocabulary of Art Deco. Marketed for its easily sanitized surface, this colorful glass also covered kitchen tables, counters, and other surfaces where cleanliness is important. The fragility of the product has ensured that few objects made with it have survived.

In the 1930s American consumers' tastes in decorative glass shifted from opaque to clear. The many different varieties manufactured in that period, mostly in the Ohio River Valley, can be broken down into two levels of refinement—"Elegant" or "Art," and "Depression." As its name suggests, elegant glass, produced by companies such as Orrefors, Steuben, and Lalique, received more manufacturing steps and polishing than more cheaply made glass, and often had a high lead content. Pressed glass, commonly called Depression glass, represented the bulk of the decorative glasswares produced in the period. It was machine pressed into a mold, and often left with bubbles, seams, and rough edges. Depression glass came in many colors, most of them pastels in various shades of pink, amber, and green from light yellow to an opaque blueish shade (see Plate 10.1). There was also cobalt, iridescent, and a white called "Monax." American manufacturers such as Libbey, Anchor Hocking, Hazel-Atlas, and others, produced these molded glass patterns with widely varying degrees of elaboration in their relief for dinner settings as well as cake plates, measuring cups, mixing bowls, cocktail shakers, toothpick holders, and as bases for rotary mixers and choppers. Depression glass was a great democratizer of color. Cereal companies, detergent manufacturers, and other companies whose product packaging could accommodate their size inserted pieces of this colorful glassware inside as premiums, which is why these pieces are sometimes referred to as "oatmeal glass."

In 1936, the Homer Laughlin China Company of West Virginia launched "Fiesta," frequently called "Fiestaware," whose streamlined forms glazed in a

single color were interrupted only by subtle concentric rings molded into the clay. Among the most colorful and iconic objects of the twentieth century, the original Fiesta line came in a cobalt blue, chrome yellow, clear orange, light yellow green, "Old Ivory," and a bold red made from uranium oxide. Two years later the company added a turquoise shade. Fiesta was the first dinner service whose colors could be mixed and matched, and the company encouraged artistry in their arrangements. In its colors, form, and flexibility, Fiesta defined Modernism for consumers.

Appliance manufacturers of the 1930s drew their colors for the most part from the same palette as pressed glassmakers, not Fiesta. Refrigerators remained white, but the most popular combination for stoves, based on the large numbers that survive today, seems to have been cream and a pale (jadite) green. In the United States, the Hamilton Beach milkshake mixer in the same creamy green took up its position on restaurant, diner, and malt shop counters everywhere in the 1930s, where its twenty-first-century replicants reside today. Jadite was undoubtedly the most common color for kitchen artifacts in the period. Today it is still easy to find these green juicers, spice mills, reamers, graters, sifters, mixing bowls, counter scales, cake stands, and wooden utensils with handles painted in this color so closely associated with the 1930s.

Neither the category of mild-mannered colors to which jadite belonged, nor the primary colors of Fiesta, accounted for all colors in the decorative arts in the decade before World War II. The craze for "tiki" culture that began in Hollywood at the end of Prohibition and that soon permeated American popular culture and beyond, introduced a tropical palette to domestic artifacts. American and European movies set in Hawaii and Polynesia in the 1930s inspired an interest in an ersatz culture of imagination, a fuddled mix of elements from several oceanic and exotic cultures combined with homegrown objects that lent themselves to escapist wanderlust. Clear, hot secondary colors including orchid pink, magenta, turquoise, lime green, and chartreuse provided the colorways for travel posters, strings of "Chinese" lanterns, monstrous "screaming tiki" *mai tai* cups, ukulele-playing hula dancers, ceramic pink flamingos, barkcloth curtains printed with palm fronds, and lamps whose colorful painted leather and fiberglass shades were upheld by smiling buddhas and scimitar-wielding Arabian figures. Servicemen returning from the South Seas after World War II, Bing Crosby's and Bob Hope's "Road" series of movies, the publication of Thor Heyerdahl's *Kon Tiki* in 1948, and Hawaii's statehood in 1959 perpetuated an interest in tiki through mid-century. Even high-end designers and artists embraced this exoticism: Henri Matisse, for example, designed a tapestry in the late 1940s called "Polynesie—La Mer" in cobalt and turquoise blocks with white fish and algae superimposed over them (Jackson 1991: 91). Tiki culture has been resuscitated many times since and is enjoying its own kitsch revival in the late 2010s.

In the 1930s, tin toys captured the technologies and reinforced the gender roles of the eras of their production. Inspired by the advent of richly colored chromolithographic printing in the late nineteenth century, tin, "tin litho," or "penny" toys were manufactured in Germany and the United States in the second half of the nineteenth century, soon to be followed by the UK and France. Germany continued to dominate this industry until after World War I when the United States took the lead. The toys' inexpensive construction and cheap and cheerful finishes ensured their survival through the hard times of the 1930s. Most of these toys included a winding key and made some kind of movement and often noise, like chattering teeth or a monkey that banged cymbals together. Cars, planes, streetcars, speedboats, shiny tractors, and Charlie Chaplin were all popular subjects in the 1920s and 1930s. Marketed to boys, litho cranes miniaturized the enormous real cranes urban children saw as the American skyline grew taller; for girls, toymakers offered tin nannies pushing baby carriages and similarly domestic subjects. Like the chromolithographic process that facilitated their decoration, tin toys typically enhanced naturalistic colors with the brighter reds, yellows, greens, and blues children loved. Rationing of tin suspended US tin toy production during World War II; after the war their manufacture, now based on themes popularized by television—cowboys and horses, spaceships, muscle cars (high-performance cars)—shifted to Japan.

Perhaps the single most colorful object of the 1930s was the jukebox. Jukeboxes offered everything someone wanting to escape the angst of the Great Depression could want: colored lights, music, playful movement in the levers and works, and the promise of a fun time. Jukeboxes of the 1920s and 1930s show a clear predominance of red, orange, and yellow glass panels (akin to the colorways most frequently found in Bakelite plastics), but no clarity of aesthetic provenance. With such a new device, industrial designers struggled to find the appropriate decoration, much as late nineteenth-century architects had done to find the proper grammar of ornament for skyscrapers. Jukebox designers therefore took sanctuary in derivative designs that harked back as far as the Renaissance Revival of the mid-nineteenth century. The Wurlitzer Victory jukebox marketed just following World War I featured a geometric inlaid wooden cabinet surmounted by three glass reverse-painted panels of brass instruments in gold, a central decorative panel of stylized feathers arranged in a "V," and heavy bracketed Italianate feet in an eclectic composition that overall strikes the viewer as Victorian in sensibility. On either side of the cabinet were lighted panels depicting a Colonial Revival-inspired man and woman. The woman wears a loosely styled rococo hooped skirt in Deco colors of pink, bright green, and yellow, but hemmed above the knees from which her long legs protrude; her powdered wig and heavy eyeshadow were clearly inspired by colonial figures as portrayed in silent

films of the era. Her male counterpart wears tights and an Elizabethan collar, and both figures are superimposed against bright red and French blue Art Deco backgrounds. Such eccentric devices seduced Americans with their bright colors and found acceptance in a transitional time in which more conservative values intersected daily with the forces of Modernism.

A Seeburg Symphonola of the 1930s displays a similar artistic synthesis. Its chrome-yellow rounded glass panel across the top and bright red glass flanking the sides spoke directly to Art Deco, while its wooden cabinet with rounded shoulders reflected Art Moderne's streamlining. Centered on this Symphonola were insets of mottled green-and-blue slag glass popular during the earlier Arts and Crafts period. In the 1950s jukeboxes transitioned from the curvaceous wooden appliances they had been in the 1930s and 1940s to boxier metal forms heavily laden with chrome and illuminated by a wildly colorful palette of electric blue, pink, violet, and yellow lights. Some featured a clear glass panel for viewing the interior movement of vinyl albums in an array of colors as they were selected and played.

DECORATIVE ARTS, DESIGN, AND CROSS-FERTILIZATION IN THE POSTWAR ERA

Rationing during World War II inspired several movements in the postwar period that rejected wartime's austerity and limited palette. One of the fastest regenerations of the late 1940s was in the decorative arts and design. The *New Look* revisited the late nineteenth century's obsession with the female hourglass form, and that form, now newly sleek and geometric, appeared everywhere from coffeemakers to light fixtures. Italy's *Ricostruzione* turned out truly innovative work through a system of small artisan shops, while Sweden and Denmark employed sophisticated international marketing for their furniture and silver. Finland's relative isolation did not prevent its designs from winning international awards and attracting the attention of consumers far beyond the country's borders. The Scandinavian Modern aesthetic characterized much of the innovative production emerging from northern Europe. The Italians' use of color was perhaps the most exuberant while the Scandinavians' tended to be derivative of their folk traditions. Glassmakers in Czechoslovakia, initially stifled by the regime change of 1948, managed to see design trends beyond the Iron Curtain while creating new forms of fine art glass. In the UK the hum emanating from textile mills printing millions of yards of modernist fabric reminded the world of the roots of the Industrial Revolution. Across the Atlantic Americans' amped up economy, which just a few years before had supplied the bulk of the Allies' armaments, returned to the frenzied production of consumer goods on an even greater scale (see Plate 10.2).

In the postwar era, the spilling over of colors from the fine into the applied arts suggested the permeability of those fields; it became difficult at times to perceive—happily, one could argue—distinctions among high, industrial, and popular design. Cross-fertilization occurred everywhere, and first came to the attention of many commentators through the observance of the influence of Pablo Picasso's ceramics. In 1955 *The Studio* magazine reviewed the work of several British potters who were inspired by Picasso's designs, noting its "Gay, amusing, and colorful" effects, and it may in fact have been domestic artifacts that drove general acceptance of abstract expressionism by the end of the 1950s (Jackson 1991: 9–10). The movement's random blocks of color, unpredictability of line, more rococo asymmetrical forms than the streamlined Modernism of the 1930s, and color field painting all launched redesigns in the most mundane of domestic goods everywhere. The Bauhaus school and artist Alexander Calder's organic abstracted sculptures of primary colored metal and black painted wire strongly influenced the mid-century modern designer's reliance on clear, loud colors discretely separated by black and clean white. Technology cooperated by offering titanium dioxide—a safe white pigment that finally forced into retirement the warmer white shades and dangerous properties of white lead—that quickly became an indispensable element of the modern palette. In home furnishings these primaries coexisted with a more subtle range of sometimes muddied pastels that are equally evocative of the era.

The ceramic work of industrial designers Eva Zeisel and Russel Wright provide convenient cases in point. Hungarian-born potter Zeisel called herself "a maker of things," as opposed to a designer who innovated for commercial returns (Zeisel 2001). Nevertheless, while working at the Red Wing Pottery in Minnesota in 1947 she developed a highly successful, novel line of dinnerware called "Town and Country," a service in several soft, toned colors that could also be mixed and matched. The salt and pepper shakers of this line are well known for their organic forms of rounded, almost interlocking shapes evocative of Henry Moore sculpture, that Zeisel said were modeled on her and her daughter.

Another industrial designer from Ohio, Russel Wright, was trained as a fine artist but went on to create the widest-selling ceramic dinnerware in history. In 1937 he designed the internationally acclaimed dinnerware "American Modern" that Ohio pottery Steubenville put into production by 1939. American Modern is a glazed earthenware of biomorphic forms unadorned by anything but color. The original service came in six: "Seafoam blue," "Coral," "Grey," "White," "Bean Brown" (a red umber), and a soft chartreuse. Color offerings expanded over the next decades to include the clear and mottled glazes of "Glacier Blue," "Seafoam Green," "Cedar Green" (a grayish, sage green), "Steubenville Blue" (an icy blue), "Black Chutney" (a mottled brown), and "Cantaloupe" (an

orange yellow). The following decade Wright followed American Modern with "Casual China" for the Iroquois China Company, another line of mix-and-match service. Fiesta also added "Chartreuse," "Grey," "Rose," and "Forest Green" in the early 1950s, and "Medium Green" at the end of the decade. In more conservative homes English-made printed transferware remained popular, particularly in blue or red on white, and together these ultra-modern and traditional forms and colors summarize the decorative ambivalence of the mid-century modern home.

THE IMPACT OF THE COLD WAR AND 1950S TRENDS

By 1949 both the United States and the Soviet Union had nuclear weapons, and domestic decor was not immune to the influence of the Cold War. Colored and metallic rockets, asteroids, spaceships, and other motifs evoking the atomic age and space race appeared on decorative arts and furnishings throughout the 1950s and 1960s. Light fixtures evoked the shape of the Soviet satellite, Sputnik, and George Nelson designed the "Atom" clock, a gray round clock face circled by radiating spikes with ball finials in the same color, for the Howard Miller Clock Company. Many imitations of the clock followed, most in metallic finishes. Franciscan Ware of California unveiled the "Starburst" line of dinnerware in the mid-1950s. The pattern featured discs of subdued teal and chartreuse of various sizes, with thin black lines arranged in a loose star that referenced the atom's structure, all scattered randomly across a cream-colored body highlighted with gold flecks. The medium for Starburst was *malanite*, a proprietary material composed of rock, not clay, which the company hailed as a great technological achievement in the ceramics industry. Despite this new material and ultra-trendy pattern, Starburst's atomic-themed decoration came from a century-old technology—decalcomania (a technique of transferring prints to pottery and other materials). Lamps and fixtures of this period were typically finished in brushed aluminum or pierced copper that cast pinpoints of light in a starburst effect. Though they never existed outside of popular culture, the red phones that supposedly occupied the desks of the sitting American presidents and Soviet premiers symbolized the Cold War world's tenuous security and circumstantial proximity to nuclear Armageddon. The strange centrality of housewares to the Cold War rivalry between the USA and the USSR had first become obvious in the so-called "kitchen debate" at the American National Exhibition in Moscow in 1959. At this event Vice-President Richard Nixon and Soviet Premier Nikita Khrushchev argued the merits of American versus Soviet design and quality, and by extension, capitalist versus communist societies, as they examined a sparkling model kitchen loaded with appliances installed by General Electric. The chauvinist exchange was recorded on Ampex color videotape, a new technology that figured in the debate itself when Nixon

touted the invention and pointed out that what it recorded would be easily played back for the American people, whereas Khrushchev expressed his view, later disproven by national broadcasts in the USA, that American viewers would never hear their animated discussion.

Common colors for decorative objects in the early 1950s included pink and charcoal, pale to butter yellow, beige, tan, and turquoise, along with brushed copper and stainless steel. Some kitchens were still white, but dark linoleum backsplashes and colorful terrazzo floors commonly highlighted white, copper, and sometimes red flour canisters and tea-kettles, chrome Sunbeam and KitchenAid mixers, and bright red and yellow stepstools and fixtures. In early 1950s USA, in keeping with the sexist traditionalism that had sent women home from the factories after 1945, manufacturers and designers pushed pastel-colored china and gadgets as supposedly more adapted to feminine tastes and capabilities. Women who just a year before had welded and riveted the nation's destroyers now set their tables with Franciscan Ceramics' delicately colored "Oasis" line of china featuring a starburst figure over an impressionistic black grid inspired by the Bauhaus style. The speckles and drips of color of Jackson Pollock and other abstract expressionists may have inspired the flecks in these china patterns and reinvigorated an interest in terrazzo finishes. A centuries-old technology, terrazzo was a common treatment for floors in the 1920s, and by mid-century, professionally manufactured and homemade versions of varicolored terrazzo could be found in floors and countertops, as well as everything from small jardinieres and birdbaths to large architectural planters and benches.

Through the 1950s, appliances made in pink were still lining counter-tops, and dirty pink dishes sat in pink sinks. The color also made a surprising appearance on Cadillac Fleetwoods in the 1950s. The 1954 model was the beneficiary of superstar promotion when Elvis Presley purchased one in pink with whitewall tires and a white roof in 1955. When it was destroyed by a fire the same year he commissioned another in a new version of pink, which the bodyshop named "Elvis rose." Ford included pink in its standard line of colors at the time, but after Elvis bought his "Caddy" other manufacturers introduced their own versions of pink. For the next three decades pink Cadillacs made their way into American popular culture as song, album, and film titles, and, one could argue, as a pseudonym for a particular view of American culture. At once a paean to the consumer-driven lifestyle of the 1950s, the pink Cadillac also represented the notion, if somewhat illusory, of the unlimited freedom car travel offered. Such images jibed with the times. A byproduct of the Federal Highway Act of 1956, which was implemented to facilitate the strategic decentralization of densely populated American cities in an age of intercontinental ballistic missiles, was to encourage freeform trips on the open

road for much less weighty reasons. The *pink* Cadillac's allure—specifically—transcended generations and racial lines. In the 1980s Bruce Springsteen composed a song called "Pink Cadillac," and Aretha Franklin sang about a "Freeway of Love," in which she drove a pink Cadillac in both the lyrics and the music video. In the 1960s the cosmetics firm Mary Kay reinforced the car's standing as an American icon by inaugurating what became the long-standing practice of gifting leases of pink Cadillacs as compensatory perquisites to their top-earning salespeople.

Pink's most prominent rival for domestic artifacts in the 1950s was yellow. Reviews of both the Chicago furniture market and International Housewares Show in New York in 1956 described a decided trend toward yellow in the objects shown there. Yellow pillows, ottomans, and glittery laminate end tables joined other furnishings in the 1950s range of teals, coral pink, orange, a hue somewhere between Kelly and olive green, chartreuse, light aqua, beige, and cream. These typically sat on a foundation of tweedy or sculpted loop nylon and wool pile carpets in a range of practical, muted teals, mustards, oranges, and grays, and every conceivable iteration of tan from tints of dusty pink to jaundiced yellow, all of which managed somehow to look exactly like the same shade of brown shortly after their installation.

By the decade's end housewares and furnishings reflected an expanded range of colors that drew from both abstract expressionism and the early 1950s palette, combining white with pale and chrome yellow, light pink, black, and red. All appliance companies continued to offer white as their basic color while some made it a feature. At the end of the 1950s the Corning Glass Company introduced their massively popular cornflower pattern featuring three blue blossoms and sprigs of blue leaves on a clean white body of Pyroceram, a heat resistant glass-ceramic that could go directly from refrigerator to oven. Pyrex also sold several lines of white-bodied heat-resistant mixing bowls and serving pieces whose colors closely followed the trends of the day. Even more popular were their very colorful lines of solid-colored bowls and casseroles, the most recognizable of which was the now highly collectible set of graduated bowls in bright red, blue, yellow, and green the company had first issued in 1946. Many designers of cookware and even stemware (drinkware with stems) in this period drew their inspiration from Scandinavian and Pennsylvania Dutch folk designs, and American Colonial Revival themes, relying heavily on red, white, black, turquoise, and pink, of course, for their coloration (see Plate 10.3).

While televisions were prized objects in the mid-century home, they themselves were bland and awkward pieces of furniture. In centrally heated homes increasingly less likely to have a fireplace, a television took the place of the hearth as the centerpiece of the living room to which eyes must quite

literally be focused. Electronics manufacturers attempted to beguile consumers into thinking televisions were legitimately attractive pieces of furniture by housing their glass screens in modern, rectilinear encasements, their speakers covered in a weird, almost metallic grill cloth that was intended to coordinate with the cabinet color but that even on brand-new televisions looked old and dirty. The television's fancy wood veneer and later abominable wood-grained plastic surface required a new kind of garniture reflective of twentieth-century interests. American public schools and women's auxiliaries were teaching Japanese-style floral arranging, then popular on the other side of the Atlantic as well, and television tops provided the perfect exhibition space for cream-colored spider chrysanthemums, white and yellow calla lilies, green bamboo sprigs, and tomato-red anthuriums slung in shallow ceramic bowls. Family photos, chinoiserie and tiki statuary, and atomic-themed lamps also took their places on either side of rabbit-ear antennae.

The owners of sprawling ranch houses in suburban communities across the United States wanted more telephones in more rooms. In 1956 Western Electric ran an advertisement with a bright red desk phone and the caption "Because you love color ..." with a list of the colors of phones they offered that year: red, blue, yellow, green, gray, ivory, black, brown, and beige (Figure 10.1). In the next few years, they announced that they were making other communications products in colors for their parent company, as well as a new line of colorful "Princess" telephones. An advertisement in 1960 asserted: "The trend in telephones is definitely to color—in both home and office—to complement any decor, or for just the sheer fun of it," and that two-thirds of all new phones they would make that year would be in color. Of all colored phone rentals, baby blue represented 27 percent, tan 22 percent, bright pink 12 percent, ivory 11 percent, chrome yellow and olive tied at 7 percent, gray 5 percent; and bright red came up last at 4 percent of the market (Click Americana n.d.-b).

Another Western Electric advertisement showed a white desk model phone being showered with pellets of color in discrete streams, which the copy described as the "jewels" that the company used "to give striking color to your ultra-modern Bell telephone." The Bell System promoted these new lines so heavily because color was profitable, and because the company was on the cusp of spinning off specific operations as their own subsidiaries: Western Electric, its manufacturing and supply division; Bell Laboratories, its research and development portion; and Bell Operating Companies, the service provider. The vivid colors of falling pellets and the colorful phones themselves gave the company a visually stimulating opportunity to explain to customers an otherwise dull corporate agenda—the need for this Ganesh-like, once monopolistic public utility to divest itself of extra appendages.

For information about color telephones
and special purpose telephones, call your
Bell telephone company business office.

because you love

COLOR... **Western Electric** makes Bell telephones in color ... red, blue, yellow, green, gray, ivory, brown, beige as well as black.

Because you want other kinds of telephones — with illuminated dials, spring cords, volume controls and other special devices — we make them, too. And we manufacture the complex central office equipment needed to make all these telephones work.

You see, as the manufacturing unit of the Bell System it's our job to produce the things needed by your Bell telephone company to give you the more attractive, more convenient telephone service you want.

FIGURE 10.1 Western Electric's advertisement "Because you love color ..." featured a bright red desk phone. The color stood out against the white background and harmonized with the bright red background of the Western Electric logotype. Advertisement in *Life*, December 19, 1955, vol. 39, no. 25, p. 101.

SHIFTING COLOR TRENDS IN THE 1960S
AND BEYOND

Advertising in the 1960s broke with the emphasis on conformity to convention of the 1950s, stressed individuality, and reflected both trends in color and pseudo-scientific approaches to color psychology. Sales literature of the 1960s disparaged the monotony of the all-white scheme and encouraged a certain adventurousness in design, emphasizing that colorful kitchens had the power to determine a woman's mood, an interesting assertion in an age when huge numbers of homemakers abused Valium (Click Americana n.d.-a). Such arguments drew from psychological rationales of color use and appropriateness circulated by theorists such as Faber Birren, the most serious of which were geared for institutional applications. The publication of *The Feminine Mystique* (Friedan 1963) and the women's liberation movement merely prodded advertisers to market housewares to women more aggressively. The Amana Corporation advertised panels in 329 colorful designs to cover their refrigerators and dishwashers, but the great irony in covering these appliances with visually exciting panels was to make them "invisible" (Figure 10.2).

American objects of the late 1960s and early 1970s are easily recognized for their autumnal colors of chocolate brown, burnt orange, olive, and ocher gold. Corning introduced *Corell*, a line of dinnerware made of three layers of sandwiched glass, and the color of "Butterfly Gold," its first pattern released in 1970, resembled the "harvest gold" of appliances and other objects in the period. In the 1970s covered casseroles from the French line of enameled cookware, Le Creuset, appeared in kitchens throughout Europe and the United States, meeting the obsession of Western people everywhere to fit an entire meal into one dish. Le Creuset's signature color, an intense orange shade called "Flame," was inspired by the molten iron the company used to cast their products. Flame, and the other deep enamel colors the company produced, coordinated with the colored sinks and other appliances being sold at the same time. American Standard capitalized on another successful brand by naming their new line of enameled sinks "Fiesta," offering them in six colors: two shades of green—a yellow green and a dark olive—bright orange, jonquil and pale yellows, and an orange red. Their competitor, Kohler, sold very similar shades. These same colors also tipped the ends of the long, wooden-handled forks that both Europeans and Americans dipped into molten cheese during the fondue fad of the 1950s and 1960s, when these utensils matched in intensity and range the colors of the furnishings around them (see Plate 10.4 and Figure 10.3).

Popular decorative motifs in this period included owls, mushrooms, and happy faces; daisies, sunflowers—single-petaled flowers rendered in freeform and imperfect shapes—that replaced the full, naturalistic cabbage roses of

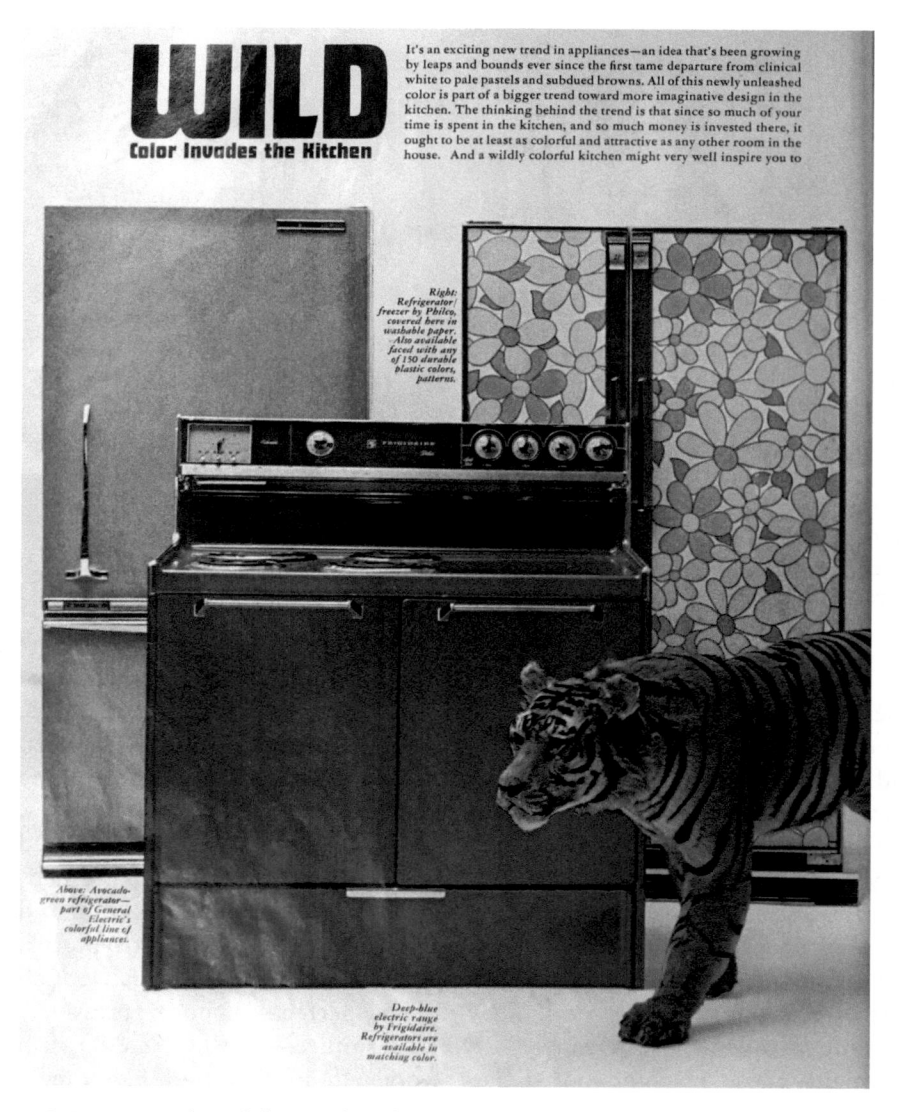

FIGURE 10.2 The solid avocado refrigerator on the left and the patterned one in gold, orange, and avocado on the right were among the appliance colors "unleashed" on eager consumers in the late 1960s and 1970s. *Ladies' Home Journal*. Photograph by Kelly F. Wright.

FIGURE 10.3 Like other manufacturers, Dolphin made fondue pots in typical late 1960s "decorator" colors of red, yellow, orange, and avocado as well as stainless, which they touted as the same material used by architects Mies van der Rohe and Marcel Breuer. Detail from a Dolphin sales brochure. Photograph by Kelly F. Wright.

the Victorian age and the geometric, conventionalized flowers of Art Deco. These figures perched and sprouted on everything from kitchen canisters, handbags, draperies and vinyl wallpapers, muumuus (Hawaiian loose dresses) and kaftans, enameled pins, latch-hook rugs, and cookie jars, all in the same heavy-handed palette of olives, avocados, yellow greens, sun golds, oranges, and umbers in a suffocating color conspiracy that today is usually remembered only with derision. Low credenzas and music cabinets fronted by patterned-glass doors in bottle colors of amber and olive; orange shag carpeting and Scandinavian "rya" rugs and wool hangings in bold expressionist patterns; and china and chunky, leprous ceramic lamps in these same colors were all part of the look in this period. They meshed perfectly if not oppressively with the so-called "Mediterranean" style of furniture—a bastardized Spanish colonial—whose machine-milled dark woods in imitation of hand-hewn Spanish oak were always unconvincing in their historicism, especially when they were fabricated with plastic. The artifact of this period that seems to have had the most lasting effect on world culture may be the chrome yellow "Have-a-Happy-Day" face, which, one could easily argue, was the first emoticon.

The color palette of the late 1960s and 1970s is one that is easily recognized but whose hegemony is not so easily explained. "Harvest" golds and burnt orange did capture the mood in the United States in perhaps the most uncertain times since the worldwide depression of the 1930s. Ironically, President Jimmy

Carter's "Crisis of Confidence" speech in 1979 cited the emotional vacuity of American materialism as a symptom, if not cause, of the country's malaise in the face of a crippling oil embargo, a decade of stagflation, and serious environmental and social problems. The spectrum of colors available in the 1950s—from pastels to primaries—may have tempted manufacturers into experimenting with consumers' responses to a unique selection of saturated secondary and tertiary colors. The conservation movement of the same period stressed a return to more "natural" colors produced from the earth, and while the many greens of the period might fit that requirement there is nothing particularly organic about burnt orange. In addition, only a relatively few zealots made such a commitment to using natural materials; commercial manufacturers simply made new colors in what was by then the old way—in the laboratory. In this period color options were becoming more and more institutionalized, suggested if not dictated by corporate color consultants who do not seem to have concerned themselves with the aesthetic satisfaction these colorways may have withheld from consumers. Finally, these colors may have been part of a campaign of planned obsolescence, as this heavy-handed palette almost guaranteed manufacturers new sales when customers inevitably tired of living in a mushroom-dotted, autumnal forest year-round. No matter which of these theories, if any, explains this palette, after 1980 manufacturers shunned these colors for the rest of the century. The standard offerings of most appliance manufacturers since have been white, black, and stainless steel.

Coinciding with these color shifts in the late 1960s was the psychedelic movement's palette taken straight from the local head shop. Swirling, radiating electric colors complemented both the flower power and acid rock subcultures. These movements' emphasis on a bohemian existence did not lend itself to material accumulation, and so relatively few objects outside of clothing can be directly attributed to this period by their coloration. Despite the lyrics' contention, no one lived in a yellow submarine, although it, and its enemies, the Blue Meanies, were well known to everyone who saw the 1968 eponymous Beatles' film *Yellow Submarine*. There are, however, some tactile objects closely associated with the psychedelic palette. Ephemera of this period are one example: posters, flyers, and album covers with psychedelic colors are easy to find today. The Volkswagen van perfectly reflected the hippie movement's vagabond, communal ways, especially when the van was graffitied in psychedelic colors.

Like the VW van, the lava lamp brilliantly evoked the zeitgeist of the late 1960s counterculture. The lamp's mechanics blended two heated liquids with no affinity for one another—a water-based liquid in one color suspended in a wax-based liquid in a contrasting color. The molten blobs in intense purple,

blue, red, green, and gold slid over one another up and down through a rocket-shaped glass housing on the earliest models, with a metal cap resembling a detonator. The lamp's shell came in several finishes including brass, brushed stainless, and enamels in red or black. Also known as the "Astro lamp," the lava lamp's shape and colors blended a fascination with the possibilities of space travel with the earth-bound trips afforded by hallucinogenic drugs. Produced by a Chicago-based company from a British engineer's design, the lamp's first public appearance was at an international trade show in Brussels in 1965. Its role in Western popular culture is just as slippery as its liquid colors. The manufacturer promoted the lamp as a serious piece of furniture, even introducing an executive version, but today such lamps are more likely to remind a middle-aged person of a stoner's bedroom than a corporate office. The craze for lava lamps died out about the same time as disco in the late 1970s, but in 2020 new lava lamps are still being sold.

ELECTRONIC OBJECTS AND COLOR

With so many electronics produced in black, color in electronic objects is not an obvious category of research. But the popularity of color in objects was fundamental to one of the most important corporate turnarounds of the century. In the late 1990s, on the precipice of filing for bankruptcy, the board of Apple rehired its former CEO and one of its founders, Steve Jobs. Jobs took their computers in bold new directions, both internally with a revamped operating system, and externally through the use of color in their housing. The first model of Apple's power Macintosh G3, a tower nicknamed "Beige," had been sold in a neutral, blonde plastic housing common to the Windows computers to which Apple was losing market share.

The next generation Apple introduced at the turn of the 2000s featured a distinctly modernized translucent cyan plastic enclosure fronting a white tower with built-in handle and the Apple logo in the same blue on the sides. The company marketed these as the first made-to-order computers, but this model is no doubt best remembered for its unique coloration. Even more memorable was the Apple iMac G3—the first all-in-one computer that came in a range of thirteen bright colors (512 pixels 2013). The 233–700 MHz desktop model's colored case sat on a white plastic base and came with a two-tone matching mouse. The shade the company chose to kick off this line was "Bondi," a translucent blueish green designed to evoke the waters of Bondi Bay outside of Sydney, Australia. This line of computers reversed the fortunes of Apple and redirected computing in general. The iMac G3 came in several other translucent colors: "Graphite," "Sage," "Snow," "Indigo," and "Ruby." "Flower power," a nod to the 1960s, was patterned in atmospheric blues, purple, pink, and yellow, and

"Blue Dalmatian" was blueish green with white polka dots. Apple sold a more satin-finished solid plastic housing in "Grape," "Strawberry," "Tangerine," "Blueberry," and "Lime." The next spectacular introduction from Jobs's Apple came in 1999—the Apple iBook laptop computer (the "Clamshell"). The Clamshell paired white with the customer's choice of color on the exterior with an all-white interior and keyboard. Even Windows users could recite the Clamshell's five iconic colors by name, having seen them being used in what seemed like every television show of the early 2000s that featured characters under thirty. The model came in two blues—"Indigo" and "Blueberry"—as well as "Tangerine" and "Graphite." Customers desperate for "Key Lime" had to order directly from Apple. Apple's use of color indoctrinated young people worldwide into lifelong brand loyalty.

While the addition of color to computer hardware dramatically enhanced one company's economic viability in the early 2000s, the more significant relationship between color and computers comes in the form of the color monitor, from which an infinite number of colors can be constructed and viewed. The internet to which these monitors connect us has proven to be the greatest democratizer of color in history. As physical artifacts are daily degraded by the passage of time, jeopardized by the atrophy of museum funding, and physically assaulted by ideologues, the refuge which cyberspace offers images of these objects, and the monitors that exhibit them, may someday legitimately lay claim to the title of the world's greatest museum.

CONCLUSION

This chapter has shown how colorful artifacts come in and out of fashion for social, political, and commercial reasons, and how they have both driven and reflected tastes throughout the twentieth century. The history of the Crayola crayon, first marketed in 1903, testifies to these truths. At the height of the civil rights movement in 1963, Binney and Smith, Crayola's parent company, renamed its pink "Flesh" color "Peach" in response to charges of racism; in the 1990s "Indian Red" drew similar complaints and an official name-change to "Chestnut." The millions in free publicity Crayola exploits when it "retires" old colors and launches new ones suggests the kind of exceptional brand equity engendered by their product's century-long history of providing both lasting color and temporary domestic tranquility when kids sit down to color quietly. Companies such as Crayola change their color offerings to reinvigorate product lines as new colorants become available, as consumers' preferences and social norms fluctuate, and as arbiters of fashion dictate. The modern age has supplied both abundant colors and marketing data for so long that observers should be able to trace a color's popularity career, or its life span in a given population,

over a specific time frame, much as archeologists do. Decorative color's profitability, indeed its necessity for the happiness of humanity, has ensured that there will be no end to its invention.

In the late nineteenth century the great discovery in the chemical industry, one sought for nearly a century, was an artificial indigo. At the dawn of the twenty-first century the new great blue is YInMn, a sumptuously deep pigment that, like many of its color forebears, emanated from a laboratory accident. YInMn is the first inorganic blue to be produced since the discovery of pure alumina-based cobalt in 1802, and like cobalt and indigo it will make its way into and onto a vast number of colorful artifacts until its future successor has been found. In 2017 "Bluetiful"—made from YInMn—became the newest color in the Crayola Crayon box when the company retired "Dandelion," a cheerful golden yellow. The name "Bluetiful" was chosen as democratically as any product identity in the modern age—from suggestions submitted by lovers of colorful things living all over the world.

NOTES

Chapter 1

1. These were not only the two theories in play at the time; see Boring 1942: 210–16.
2. For histories of the CoC, see Jones 1953; and Johnston 2001.
3. See T. Crane 2000.
4. The inverted spectrum thought experiment goes back at least to the seventeenth century, but it took on a new significance at the turn of the twentieth century; see Daston and Galison 2007; and Adams and Browning 2020.
5. For a summary, see Byrne 2016.
6. Much later in the century Dennett (1988) used a similar thought experiment to a similar end.
7. For a useful history of these studies, see Jacobs 2014.
8. See Hurvich and Jameson 1957.
9. Hurvich and Jameson mention several notable two-stage precursors to their own account. But earlier theories did not provide Hurvich and Jameson's psychophysical and physiological evidence.
10. For prominent examples, see Blake and Sekuler 1985: 181; Goldstein 1989: 140; Backhaus and Menzel 1992: 28; and Palmer 1999: 95.
11. For discussion of Wittgenstein's work on color, see Westphal 1987.
12. Hilbert here drew upon the work of the computationalist Laurence Maloney, who argued that "what we call color corresponds to an objective property of physical surfaces" (Maloney 1984: 119).
13. Nassau (1983) is a useful overview of the fifteen different causes of color experience.
14. Hilbert's later work with Alex Byrne discusses these other sorts of colors in detail. See Byrne and Hilbert 2003.
15. Adams (2015) offers an account of how dispositionalism came to seem to be common sense among one group of philosophers from this time.
16. Hardin (1992) offers his own response to this question.
17. Broackes (1992) explores this possibility.
18. The most famous such experiment is Crane and Piantanida 1983.
19. Prominent examples include Hardin and Maffi 1997; Backhaus et al. 1998; and Mausfeld and Heyer 2003.

20. For skepticism in this regard, see Adams and Hansen 2020.
21. We would like to thank David Hilbert, C.L. Hardin, and Evan Thompson for discussing their contributions to the debates discussed in this chapter with us, and Jay Elliott, Adam Gies, Nathaniel Hansen, Daniel Harris, Joseph Lemelin, Chauncey Maher, Eliot Michaelson, and James Trybendis for providing us with helpful comments on draft versions of this chapter.

Chapter 4

1. The uniqueness of IKB does not derive from the ultramarine pigment but rather from the matte, synthetic resin binder in which the color is suspended, allowing the pigment to maintain as much of its original quality and intensity of color as possible. For more about the role and effects of IKB in art in the modern period, see Judith Mottram's chapter in this volume.
2. Personal communication with Rebecca Ann Moody, September 6, 2017.
3. The phrase "civil religion" was first discussed extensively by Jean-Jacques Rousseau in his 1762 treatise *The Social Contract*.
4. "In God We Trust" is the official motto of the United States, adopted in 1956. It first appeared on US coins in 1864 and has appeared on paper currency since 1957.

Chapter 6

1. The acronyms indicate alternative color appearance models developed by the International Commission on Illumination (Commission Internationale de l'Éclarage, CIE). The models represent subjective similarities between color stimuli in geometric terms and are optimized for alternative colorimetric aspects: specifically, the illuminant and the color-stimulus mode—surface colors (those of light-reflecting objects, including printed paper or cloth) versus on-screen self-luminous colors without context. For details of the color spaces and the differences between them, see Fairchild 2013.
2. In categorical perception (CP), the dissimilarity between a pair of stimuli is reduced if the pairs lie within a single category and are labeled with the same BCT; subjective dissimilarity is increased if the stimuli straddle a category boundary. For detailed discussions of CP in the color cognition domain, see Davidoff 2015; Witzel 2019.

Chapter 8

1. See Mohan, this volume, for a further discussion of the spiritualized and ritualized dimensions of blue.

Chapter 9

1. The present text builds partly on previous articles in which the color composition features in modern, postmodern, and contemporary architecture were studied, see Serra et al. 2012; Serra Lluch 2013; and Serra and Codoñer 2014.
2. Purism was an artistic movement created by Le Corbusier and A. Ozenfant in France in 1918, inspired by the beauty of machines and the harmony of classical numerical proportions. It was an abstract and rational art that avoided the accidental or expressive, and tried to capture the eternal and invariant.
3. Expressionism was an artistic movement that emerged in the early twentieth century. It pursues the free manifestation of the emotion of the artist and a personal vision of the world, beyond the analytical understanding of reality.

4. Neoplasticism was an artistic movement that emerged in the Netherlands in 1917 encouraged by T.V. Doesburg and P. Mondrian. It aimed to be more abstract than cubism by reducing shapes to orthogonal surfaces, straight lines, and primary colors. Neoplasticists explicitly renounced classical symmetry and instead achieved balance of forms through asymmetrical compositions.
5. The Modulor is a system of numerical proportions for architectural elements based on the golden ratio and on the measures of an ideal person developed by Le Corbusier.

BIBLIOGRAPHY

Adams, Zed. 2015. *On the Genealogy of Color: A Case Study in Historicized Conceptual Analysis*. New York: Routledge.

Adams, Zed, and Jake Browning. 2020. "How Colour Qualia Became a Problem." *Journal of Consciousness Studies*, 27(5–6): 14–25.

Adams, Zed, and Nat Hansen. 2020. "The Myth of the Common-Sense Conception of Color." In Teresa Marques and Åsa Wikforss (eds.), *Shifting Concepts: The Philosophy and Psychology of Conceptual Variability*. Oxford: Oxford University Press.

Aftalion, Fred. 2001. *A History of the International Chemical Industry*. Philadelphia: Chemical Heritage Foundation.

Albers, Joseph. 1950–76. "Homages to the Square." Joseph and Anni Albers Foundation. Available online: http://www.albersfoundation.org/art/josef-albers/paintings/homages-to-the-square/index/ (accessed August 31, 2017).

Albers, Josef. 1963. *The Interaction of Color*. New Haven, CT: Yale University Press.

Altieri, Charles. 1989. *Painterly Abstraction in Modernist American Poetry*. Cambridge: Cambridge University Press.

Andrew, Dudley. 2006. "The Post-War Struggle for Colour." In Angela Dalle Vacche and Brian Price (eds.), *Color: The Film Reader*. New York: Routledge.

Anishchanka, Alena. 2013. "Seeing it in Color: A Usage-Based Perspective on Color-Naming in Advertising." PhD thesis, University of Leuven.

Appadurai, Arjun. 1996. *Modernity at Large: Cultural Dimensions of Globalization*. Minneapolis: University of Minnesota Press.

Arcagni, Simone. 2010. "Media Architectures and Urban Screens as New Media: Forms, Places and Spectatorship." In Pietro Zennaro (ed.), *Color and Light in Architecture: International Conference, 11–12 November 2010: Proceedings*. Venice: Università Iuav.

Arrarte-Grau, Malvina. 2016. "Color Pollution." In Ming Ronnier Luo (ed.), *Encyclopedia of Color Science and Technology*. New York: Springer.

Artaud, Antonin. 1994. *The Theater and Its Double*. Translated by Mary Caroline Richards. New York: Grove Press.

Artprice. 2015. *The Art Market in 2015*. St-Romain-au-Mt-d'Or, France: Artprice. Available online: https://imgpublic.artprice.com/pdf/rama2016_en.pdf (accessed August 28, 2017).

Asad, Talal. 2003. *Formations of the Secular: Christianity, Islam, Modernity*. Stanford, CA: Stanford University Press.

Aslam, Mubeen M. 2006. "Are You Selling the Right Color?" *Journal of Marketing Communications*, 12(1): 15–30.

Assmann, Jan. 1996. "Translating Gods: Religion as a Factor of Cultural (Un)Translatability." In Sanford Budick and Wolfgang Iser (eds.), *The Translatability of Cultures: Figurations of the Space Between*. Stanford, CA: Stanford University Press.

Atkinson, Diane. 2018. *Rise Up Women! The Remarkable Lives of the Suffragettes*. London: Bloomsbury.

Ayer, Alfred Jules. 1968. *The Origins of Pragmatism*. London: MacMillan.

Backhaus, Werner, and Randolf Menzel. 1992. "Conclusions from Color Vision in Insects." *Behavioral Brain Sciences*, 15(1): 28–30.

Backhaus, Werner, John Simon Werner, and Reinhold Kleigl, eds. 1998. *Color Vision: Perspectives from Different Disciplines*. Berlin: Walter de Gruyter.

Ball, Philip. 2009. *Bright Earth: The Invention of Colour*. London: Vintage Books.

Ball, Philip. 2012. "The Invention of Colour." In Frédéric Ogée and Maurice Géracht (eds.), "Definitions of Color/de la Couleur," special issue of *Interfaces—image, texte, language*, 33: 1–32.

Banfield, Ann. 2000. *The Phantom Table: Woolf, Fry, Russell and the Epistemology of Modernism*. Cambridge: Cambridge University Press.

Baronchelli, Andera, Vittorio Loretto, and Andrea Puglisi. 2015. "Individual Biases, Cultural Evolution, and the Statistical Nature of Language Universals: The Case of Colour Naming Systems." *PLoS ONE*, 10(5): e0125019. https://doi.org/10.1371/journal.pone.0125019.

Barragán, Luis. 1980. [Video] "The Pritzker Architecture Prize: Ceremony Acceptance Speech." Available online: https://www.pritzkerprize.com/sites/default/files/inline-files/1980_Acceptance_Speech.pdf (accessed May 14, 2018).

Batchelor, David. 2000. *Chromophobia*. London: Reaction Books.

Batchelor, David. 2008a. *HK Fesdella*. British Council Collection. Available online: http://visualarts.britishcouncil.org/collection/artists/batchelor-david-1955/object/hk-fesdella-batchelor-2008-pcommissioned-work (accessed August 31, 2017).

Batchelor, David. 2008b. "Introduction: On Colour and Colours." In David Batchelor (ed.), *Colour: Documents of Contemporary Art*. London: Whitechapel Art Gallery.

Batchelor, David. 2014. *The Luminous and the Grey*. London: Reaktion Books.

Bateson, Gregory, and Margaret Mead. 1942. *Balinese Character: A Photographic Analysis*. New York: New York Academy of Sciences.

Baudot, François. 1999. *A Century of Fashion*. London: Thames and Hudson.

Beaumont, Peter, and Amanda Holpuch. 2018. "How *The Handmaid's Tale* Inspired the New Protest Outfit of Choice." *The Guardian*, August 4: 3.

Beckmann, Max. 1948. *Quappi in Grey*. Private Collection, New York. Exhibited in Max Beckmann in New York, Metropolitan Museum of Art, NY. Available online: http://www.metmuseum.org/exhibitions/objects?exhibitionId=168a91df-f8bd-4804-bfb3-7e995fbff2c4#!?perPage=20&offset=20 (accessed August 30, 2017).

Bell, Catherine. 1992. *Ritual Theory, Ritual Practice*. Oxford: Oxford University Press.

Bell, Clive. 1922. *Since Cezanne*. London: Chatto and Windus.

Bellah, Robert N. 1967. "Civil Religion in America" *Dædalus*, 96(1): 1–21.

Bellah, Robert N. 1970. *Beyond Belief: Essays on Religion in a Post-Traditionalist World*. Berkeley: University of California Press.

Benevolo, Leonardo. 1977. *History of Modern Architecture*, vol. 2, *The Modern Movement*. Cambridge, MA: MIT Press.

Benjamin, Walter. [1933] 1999. "On the Mimetic Faculty." In Michael W. Jennings, Howard Eiland, and Gary Smith (eds.), *Selected Writings, 1926–1934*. Translated by Rodney Livingstone and others. Cambridge, MA: Belknap Press.

Benjamin, Walter. 1968. *Illuminations*. Edited by Hannah Arendt. Translated by Harry Zohn. New York: Harcourt, Brace and World.

Benton, Charlotte, Tim Benton, and Ghislaine Wood. 2003. *Art Deco, 1910–39*. London: V&A Publications.

Berenson, Bernard. 1948. *Aesthetics and History in the Visual Arts*. New York: Pantheon Books.

Bergh, Gunnar. 2007. "The Semiosis of Swedish Car Color Names: Descriptive and Amplifying Functions." In Robert. E. MacLaury, Galina V. Paramei, and Don Dedrick (eds.), *Anthropology of Color: Interdisciplinary Multilevel Modeling*. Amsterdam: John Benjamins.

Berlin, Brent, and Paul Kay. [1969] 1991. *Basic Color Terms: Their Universality and Evolution*. Berkeley: University of California Press.

Besant, Annie, and Charles Webster Leadbeater. 1901. *Thought-forms*. London: Theosophical Publishing Society.

Besset, Maurice. 1993. *La couleur et l'architecture dans les années 1920*. Lausanne: École Polytechnique Fédérale de Lausanne.

Betts, Paul. 1999. "Black Mountain College, NC." In Jeannine Fiedler and Pater Feierabend (eds.), *Bauhaus*. Cologne: Könemann.

Bhabha, Homi K. 1994. *The Location of Culture*. London: Routledge.

Bielo, James S. 2011. *Emerging Evangelicals: Faith, Modernity, and the Desire for Authenticity*. New York: New York University Press.

Bielo, James S. 2018. *Ark Encounter: The Making of a Creationist Theme Park*. New York: New York University Press.

Biggam, Carole P. 2012. *The Semantics of Colour: A Historical Approach*. Cambridge: Cambridge University Press.

Bimler, David. 2005. "Are Color Categories Innate or Internalized? Hypotheses and Implications." *Journal of Cognition and Culture*, 5(3): 265–92.

Bimler, David. 2007. "From Color Naming to a Language Space: An Analysis of Data from the World Color Survey." *Journal of Cognition and Culture*, 7(3): 173–99.

Bimler, David. 2009. "Linguistic and Perceptual Categories in Colour Vision: A Critical Review." *Journal of Cognitive Science*, 10(1): 53–95.

Bimler, David, and Mari Uusküla. 2018. "Individual Variations in Color-Concept Space Replicate Across Languages." *Journal of the Optical Society of America A*, 35(4): B184–91.

Binet, Hélène, Zaha Hadid, and Lars Müller. 2000. *Architecture of Zaha Hadid in Photographs by Hélène Binet*. Baden: Lars Müller Publishers.

Blake, Peter. 1961. *Self-portrait with Badges*. Tate Collection. Available online: http://www.tate.org.uk/art/artworks/blake-self-portrait-with-badges-t02406 (accessed August 31, 2017).

Blake, Randolph, and Robert Sekuler. 1985. *Perception*. New York: McGraw-Hill.

Blaszczyk, Regina Lee. 2012. *The Color Revolution*. Cambridge, MA: MIT Press.

Blaszczyk, Regina Lee. 2017. "The Color Schemers: American Color Practice in Britain, 1920s–1960s." In Regina Lee Blaszczyk and Uwe Spiekermann (eds.), *Bright Modernity: Color, Commerce, and Consumer Culture*. Basingstoke: Palgrave Macmillan.

Block, Ned. 1980. "Are Absent Qualia Impossible?" *Philosophical Review*, 89(2): 257–74.

Bloomfield, Leonard. 1935. *Language*. London: Cox and Wyman.

Boetti, Alighiero. 1994. *Tutto*. Available online: https://collection.mmk.art/en/nc/werkdetailseite/?werk=1997/247 (accessed July 21, 2020).

Bois, Yve-Alain. 1995. *Painting as Model*. Cambridge, MA: October Books.

Boivin, Nicole. 2009. "Grasping the Elusive and Unknowable: Material Culture in Ritual Practice." *Material Religion*, 5(3): 266–87.

Bonnard, Pierre. 1915. *Coffee*. Tate Collection. Available online: http://www.tate.org.uk/art/artworks/bonnard-coffee-n05414 (accessed August 31, 2017).

Bonnardel, Valérie, Sucharita Beniwal, Nijoo Dubey, Mayukhini Pande, and David Bimler. 2018. "Gender Difference in Color Preference across Cultures: An Archetypal Pattern Modulated by a Female Cultural Stereotype." *Color Research and Application*, 43(2): 209–23.

Borchardt-Hume, Achim. 2014. *Malevich*. London: Tate Publishing.

Boring, Edwin G. 1942. *Sensation and Perception in the History of Experimental Psychology*. New York: Appleton-Century-Crofts.

Bornstein, Marc H. 1985. "On the Development of Color Naming in Young Children: Data and Theory." *Brain and Language*, 26(1): 73–93.

Bornstein, Marc. H., William Kessen, and Sally Weiskopf. 1976. "The Categories of Hue in Infants." *Science*, 191(4223): 201–2.

Bottoni, Piero. 1927. "Cromatismi architettonici." *Architettura e Artti Decorative*, 6(1–2): 80–5.

Bourdieu, Pierre. 1990. *The Logic of Practice*. Stanford, CA: Stanford University Press.

Boynton, Robert M., and Conrad X. Olson. 1987. "Locating Basic Colors in the OSA Space." *Color Research and Application*, 12(2): 94–105.

Bozal-Fernández, Valeriano. 1996. *Historia de las ideas estéticas y de las teorías artísticas contemporáneas*. Madrid: Visor.

Brannon, Evelyn L. 2000. *Fashion Forecasting*. New York: Fairchild.

Brevda, William. 2011. *Signs of the Signs: The Literary Lights of Incandescence and Neon*. Lanham, MD: Bucknell University Press.

Breward, Christopher. 1995. *The Culture of Fashion: A New History of Fashionable Dress*. Manchester: Manchester University Press.

Broackes, Justin. 1992. "The Autonomy of Colour." In David Charles and Kathleen Lennon (eds.), *Reduction, Explanation, and Realism*. Oxford: Oxford University Press.

Broad, C.D. 1923. *Scientific Thought: A Philosophical Analysis of Some of its Fundamental Concepts*. London: Kegan Paul, Trubner & Co.

Brockett, Oscar G., Margaret Mitchel, and Linda Hardberger. 2010. *Making the Scene: A History of Stage Design and Technology in Europe and the United States*, San Antonio, TX: Tobin Theatre Arts Fund.

Brown, Roger W., and Eric H. Lenneberg. 1954. "A Study in Language and Cognition." *Journal of Abnormal and Social Psychology*, 49(3): 454–62.

Bulloch, Angela. 2012. *Aluminium 4*. Tate Collection. Available online: http://www.tate.org.uk/art/artworks/bulloch-aluminium-4-t13848 (accessed August 31, 2017).

Burns, Leslie Davis, and Nancy O. Bryant. 1997. *The Business of Fashion*. New York: Fairchild.

Burroughs, William S. [1962/1967] 2014. *The Ticket That Exploded: The Restored Text*. Edited by Oliver Harris. London: Penguin.

Buse, Peter. 2008. "Surely Fades Away: Polariod Photography and the Contradictions of Cultural Value." *Photographies*, 1(2): 221–38.

Buse, Peter. 2010. "Polaroid into Digital: Technology, Cultural Form, and the Social Practices of Snapshot Photography." *Continuum: Journal of Media & Cultural Studies*, 24(2): 215–30.

Byrne, Alex. 2016. "Inverted Qualia." In Edward N. Zalta (ed.), *The Stanford Encyclopedia of Philosophy Archive*. Winter 2016 edn. Available online: https://plato.stanford.edu/archives/win2016/entries/qualia-inverted/ (accessed June 16, 2020).

Byrne, Alex, and David R. Hilbert. 2003. "Color Realism and Color Science." *Behavioral and Brain Sciences*, 26(1): 3–21.

Cagle, Chris. 2014. "Classical Hollywood, 1928–46." In Patrick Keating (ed.), *Cinematography*. London: I.B. Tauris.

Caivano, José Luis. 2006. "Research on Color in Architecture and Environmental Design: Brief History, Current Developments, and Possible Future." *Color Research and Application*, 31(4): 350–63.

Camphausen, Rufus C. 1997. *Return of the Tribal: A Celebration of Body Adornment*. Rochester, VT: Park Street Press.

Cardiff, Jack. 1996. *Magic Hour*. London: Faber and Faber.

Caro, Anthony. 1962. *Early One Morning*. Tate Collection. Available online: http://www.tate.org.uk/art/artworks/caro-early-one-morning-t00805 (accessed August 30, 2017).

Cassidy, Tracy Diane, and Tom Cassidy. 2012. "Color Forecasting: Seasonal Colors." In Marilyn DeLong and Barbara Martinson (eds.), *Color and Design*. London: Berg.

Casson, Ronald W. 1994. "Russet, Rose and Raspberry: The Development of English Secondary Color terms." *Linguistic Anthropology*, 4(1): 5–22.

Cavell, Stanley. 1971. *The World Viewed*, Cambridge, MA: Harvard University Press.

Chalmers, David J. 1996. *The Conscious Mind*. Oxford: Oxford University Press.

Chamberlain, John. 1963. *Kora*. Tate Collection. Available online: http://www.tate.org.uk/art/artworks/chamberlain-kora-t01094 (accessed August 30, 2017).

Chandler, Raymond. 1939. *The Big Sleep*. New York: Alfred A. Knopf.

Chermayeff, Serge, and Christopher Alexander. 1963. *Community and Privacy: Toward a New Architecture of Humanism*. Garden City, NY: Doubleday.

Chevreul, Michel Eugène. 1855. *The Principles of Harmony and Contrast of Colours, and their Applications to the Arts*. 2nd edn. London: Longman, Brown, Green, and Longmans.

Christie's. n.d. *Past Results*. Available online: http://artist.christies.com/Henri-Matisse–34505.aspx (accessed August 30, 2017).

Claidière, Nicolas, Yasmina Jraissati, and Coralie Chevallie. 2008. "A Colour Sorting Task Reveals the Limits of the Universalist/Relativist Dichotomy: Colour Categories Can Be Both Language Specific and Perceptual." *Journal of Cognition and Culture*, 8(3): 211–33.

Clark, Robin J.H., Christopher J. Cooksey, Marcus A.M. Daniels, and Robert Withnall. 1993. "Indigo, Woad, and Tyrian Purple: Important Vat Dyes from Antiquity to the Present." *Endeavour*, 17(4): 191–9.

Click Americana. n.d.-a. *Crazy, Colorful Retro Kitchens from the '60s, with Bright & Bold Decorator Appliances*. Available online: https://clickamericana.com/topics/home-garden/wild-color-invades-kitchen-decorator-appliances-1960s (accessed May 10, 2019).

Click Americana. n.d.-b. *Newest Telephones—in 9 Different Colors! (1960)*. Available online: https://clickamericana.com/eras/1960s/the-newest-telephones-in-9-different-colors-1960 (accessed May 10, 2019).

Clifford, James. 1981. "On Ethnographic Surrealism." *Comparative Studies in Society and History*, 23(4): 539–64.

Color Association of the United States (CAUS). 2009. *Color Association of the United States*. Available online: http://www.colorassociation.com/ (accessed November 30, 2016).

"Color in Industry." 1930. *Fortune*, February: 85–94.

Color Marketing Group (CMG). 2006. *Color Marketing Group Report: The Profit of Color*. Alexandria,VA: CMG.

Comaroff, Jean. 1985. *Body of Power, Spirit of Resistance: The Culture and History of a South African People*. Chicago: University of Chicago Press.

Comolli, Jean-Louis, Michel Delahaye, Jean-André Fieschi, and Gérard Guégan. 1965. "Parlons de 'Pierrot': Nouvel entretien avec Jean-Luc Godard." *Cahiers Du Cinéma*, 171(October): 18–34.

Conrad, Peter. 2011. "Neon: 100 Years of the Greatest Light Show on Earth." *The Observer*, August 28. Available online: https://www.theguardian.com/artanddesign/2011/aug/28/100-years-of-neon (accessed September 21, 2018).

Cornwell-Clyne, Adrian. 1951. *Color Cinematography*. 3rd edn. London: Chapman & Hall.

Cowan, Michael. 2014. *Walter Ruttmann and the Cinema of Multiplicity*. Amsterdam: Amsterdam University Press.

Craik, Jennifer. 2000. *The Face of Fashion: Cultural Studies in Fashion*. London: Routledge.

Cramer, Ned. 1999. "It Was Never White, Anyway (Despite his Reputation as the Godfather of White Architecture, Le Corbusier Developed Complex Ideas about Color)." *Architecture*, 88(2): 88–91.

Crane, Diane. 2000. *Fashion and its Social Agenda: Class, Gender and Identity in Clothing*. Chicago: University of Chicago Press.

Crane, Hewitt D., and Thomas P. Piantanida. 1983. "On Seeing Reddish Green and Yellowish Blue." *Science*, 221: 1078–80.

Crane, Tim. 2000. "The Origins of Qualia." In Tim Crane and Sarah Patterson (eds.), *The History of the Mind-Body Problem*. New York: Routledge.

Crawford, Elizabeth. 1999. *The Women's Suffrage Movement: A Reference Guide 1866–1928*. London: Routledge.

Csoba DeHass, Medeia. 2007. "Daily Negotiation of Traditions in a Russian Orthodox Sugpiaq Village in Alaska." *Ethnology*, 46(3): 205–16.

Csordas, Thomas J. 1994. *The Sacred Self: A Cultural Phenomenology of Charismatic Healing*. Berkeley: University of California Press.

Csordas, Thomas J. 1997. *Language, Charisma, and Creativity: The Ritual Life of a Religious Movement*. Berkeley: University of California Press.

Csordas, Thomas J. 2009. *Transnational Transcendence: Essays on Religion and Globalization*. Berkeley: University of California Press.

Danger, Eric Paxton. 1968. *Using Color to Sell*. Farnham: Gower.

Daston, Lorraine, and Peter Galison. 2007. *Objectivity*. New York: Zone Press.

Daukantas, Patricia. 2010. "A Short History of Laser Light Shows." *OPN Optics and Photonics News*, May: 42–7.

Davidoff, Jules. 2015. "Color Categorization Across Cultures." In Andrew J. Elliot, Mark D. Fairchild, and Anna Franklin (eds.), *Handbook of Color Psychology*. Cambridge: Cambridge University Press.

Davidson, Hugh R., Henry Hemmendinger, and J.L. Richard Landry Jr. 1963. "A System of Instrumental Colour Control for the Textile Industry." *Coloration Technology*, 79(12): 577–90.

Davies, Ian R.L., and Greville G. Corbett. 1994. "A Statistical Approach to Determining Basic Color Terms: An Account of Xhosa." *Journal of Linguistic Anthropology*, 4(2): 175–93.

Davis, Kristina. 2017. "Neon Light Fetish: Neon Art and Signification of Sex Work." *Visual Culture and Gender*, 12. Available online: http://vcg.emitto.net/index.php/vcg/article/view/107 (accessed June 26, 2018).

de Heer, Jan. 2009. *The Architectonic Colour: Polychromy in the Purist Architecture of Le Corbusier*. Rotterdam: 010 Publishers.

Dedrick, Don. 1998. *Naming the Rainbow: Colour Language, Colour Science, and Culture*. Dordrecht: Kluwer.

Deleuze, Gilles. 1989. *Cinema 2: The Time-Image*. Translated by Hugh Tomlinson and Robert Galeta. Minneapolis: University of Minnesota Press.

Dennett, Daniel C. 1988. "Quining Qualia." In Anthony J. Marcel and Edoardo Bisiach (eds.), *Consciousness in Contemporary Science*. Oxford: Oxford University Press.

Diane, Tracy, and Tom Cassidy. 2005. *Color Forecasting*. Oxford: Blackwell.

Dos Passos, John. [1925] 2000. *Manhattan Transfer*. New York: Mariner, Houghton Mifflin.

Duchamp, Marcel. 1918. *Tu m'*. Collection Yale University Art Gallery. Available online: http://artgallery.yale.edu/collections/objects/50128 (accessed August 30, 2017).

Dwyer, Rachel. 2004. "International Hinduism: The Swaminarayan Sect." In Knut Jacobsen and Pratap Kumar (eds.), *South Asians in the Diaspora: Histories and Religious Traditions*. Leiden: Brill.

Ehrenzweig, Anton. 1966. *Colour & Space: Comments on the ATC Exhibition, 1966, Goldsmiths College School of Art*. London: Goldsmiths College.

Eisenstein, Sergei. 1941. *The Film Sense*. Translated by Jay Leyda. London: Faber and Faber.

Elliott, Bridget, and Anthony Purdy. 2007. "(Re-)Dressing French Modernism: Décor, Costume and the Decorative in an Interarts Perspective." In Astradur Eysteinsson and Vivian Liska (eds.), *Modernism*. Amsterdam: John Benjamins.

English, Bonnie. 2007. *A Cultural History of the Twentieth Century: From Catwalk to the Sidewalk*. London: Berg.

Eskilson, Stephen. 2002. "Color and Consumption." *Design Issues*, 18(2): 17–29.

Evans, David. 2016. "Ian McGuire, The North Water: 'Subtle as a Harpoon in the Head, but Totally Gripping' [book review]." *The Independent*, February 9. Available online: https://www.independent.co.uk/arts-entertainment/books/reviews/ian-mcguire-the-north-water-subtle-as-a-harpoon-in-the-head-but-totally-gripping-book-review-a6856011.html (accessed February 10, 2017).

Evans, Ralph. 1974. *The Perception of Color*. New York: Wiley.

Fabins, Carine. 1998. *Mehndi: Art of Henna Body Painting*. New York: Three Rivers Press.

Fairchild, Mark D. 2013. *Color Appearance Models*. Hoboken, NJ: Wiley.

Fanon, Frantz. 2005. *The Wretched of the Earth*. Translated by Richard Philcox. Repr. edn. New York: Grove Press.

Farmer, Richard. 2018. "Supplemental Income: British Newspaper Colour Supplements in the 1960s." *Media History*. https://doi.org/10.1080/13688804.2018.1481372.

Feasley, Florence G., and Elnora W. Stuart. 1987. "Magazine Advertising: Layout and Design; 1932–1982." *Journal of Advertising*, 16(2): 20–5.

Fider, Nicole, Louis Narens, Kimberley A. Jameson, and Natalia L. Komarova. 2017. "Quantitative Approach for Defining Basic Color Terms and Color Category Best Exemplars." *Journal of the Optical Society of America A*, 34(8): 1285–1300.

Fitzgerald, F. Scott. 1925. *The Great Gatsby*. New York: Charles Scribner's Sons.

Fitzgerald, F. Scott. [1925] 2004. *The Great Gatsby*. New York: Scribner.

Flam, Jack. 1995. *Matisse on Art*. Berkeley: University of California Press.

Follin, Frances. 2017. "An Optical View of History." In Penelope Sexton and Frances Follin (eds.), *Seurat to Riley: The Art of Perception* [exhibition catalog]. Kineton: Compton Verney Art Gallery.

Fontana, Lucio. 1960. *Spatial Concept "Waiting."* Tate Collection. Available online: http://www.tate.org.uk/art/artworks/fontana-spatial-concept-waiting-t00694 (accessed August 28, 2017).

Forbes, Isabel. 1979. "The Terms *Brun* and *Marron* in Modern Standard French." *Journal of Linguistics*, 15(2): 295–305.

Ford, Henry, and Samuel Crowther. 1922, *My Life and Work*. Garden City, NY: Doubleday, Page.

Foster, Norman. 1976. "On the Use of Color in Buildings." In Tom Porter and Byron Mikellides (eds.), *Color for Architecture*. London: Studio Vista.

Foster + Partners. n.d. *Renault Distribution Centre*. Available online: http://www.fosterandpartners.com/projects/ (accessed February 10, 2017).

Frampton, Kenneth. 1992, *Modern Architecture: A Critical History*. 3rd edn. London: Thames and Hudson.

Frankenthaler, Helen. 1957. *Jacob's Ladder*. Collection MOMA NY. Available online: https://www.moma.org/collection/works/78722?locale=en (accessed August 31, 2017).

Franklin, Anna, and Ian R.L. Davies. 2004. "New Evidence for Infant Colour Categories." *British Journal of Developmental Psychology*, 22(3): 349–77.

Franklin, Caryn, et al. 2012. *Fashion: The Ultimate Book of Costume and Style*. London: Dorling Kindersley.

Frazer, James George. [1901] 1960. *The Golden Bough: A Study in Magic and Religion*. New York: Macmillan.

Friedan, Betty. 1963. *The Feminine Mystique*. New York: W.W. Norton.

Fry, Roger. 1920. *Vision and Design*. London: Chatto and Windus. (2nd edn., 1981, Oxford University Press, with Introduction and notes by J.B. Bullen.)

Fry, Roger. 1926. *Transformations*. London: Chatto and Windus.

Gage, John. 1995. *Colour and Culture: Practice and Meaning from Antiquity to Abstraction*. London: Thames and Hudson.

Gage, John. 2000. *Color and Meaning: Art, Science and Symbolism*. London: Thames and Hudson.

Gagné, Isaac. 2007. *Urban Princess: Performance and Women's Language in Japan's Gothic/Lolita Subculture*. London: Yale University Press.

Gao, Xiao-Ping, John H. Xin, Tetsuya Sato, Aran Hansuebsai, Marcello Scalzo, Kanji Kajiwara, Shing-Sheng Guan, J. Valldeperas, Manuel José Lis, and Monica Billger. 2007. "Analysis of Cross-Cultural Color Emotion." *Color Research and Application*, 32(3): 223–9.

Gardner, Carl. 2006. "The Use and Misuse of Coloured Light in the Urban Environment." *Optics and Laser Technology*, 38(4): 366–76.

Gass, William H. [1976] 2014. *On Being Blue: A Philosophical Inquiry*. New York: New York Review of Books.

Gay and Lesbian Holocaust Memorial (GLHM). n.d. "Gay and Lesbian Holocaust Memorial, Darlinghurst, Sydney." Available online: https://www.cityartsydney.com.au/artwork/gay-lesbian-holocaust-memorial/ (accessed April 10, 2016).

Geertz, Clifford. 1973. *The Interpretation of Cultures*. New York: Basic Books.

Georges-Michel, Michel. 1957. *From Renoir to Picasso: Artists in Action*. Boston: Houghton Mifflin.

Gibson, Edward, Richard Futrell, Julian Jara-Ettinger, Kyle Mahowald, Leon Bergen, Sivaloges waran Ratnasingam, Mitchell Gibson, Steven T. Piantadosi, and Bevil R. Conway. 2017. "Color Naming Across Languages Reflects Color Use." *Proceedings of the National Academy of Sciences of the U.S.A.*, 114(40): 10785–90.

Gibson, James J. 1979. *The Ecological Approach to Visual Perception*. Boston: Houghton Mifflin.

Gilbert, Stuart. 1952. *James Joyce's* Ulysses: *A Study*. 2nd edn. London: Faber and Faber.

Gillick, Liam. 2007. *Returning to an Abandoned Planet*. Tate Collection. Available online: http://www.tate.org.uk/art/artworks/gillick-returning-to-an-abandoned-plant-t12428 (accessed August 31, 2017).

Glaberson, William. 1993. "The Media Business: Newspapers' Adoption of Color Nearly Complete." *The New York Times*, May 31. Available online: https://www.nytimes.com/1993/05/31/business/the-media-business-newspapers-adoption-of-color-nearly-complete.html (accessed December 18, 2018).

Godden, Rumer. 1939. *Black Narcissus*. New York: Little Brown Co.

Gössel, Peter, and Gabriele Leuthäuser. 2001. *Arquitectura del siglo XX*. Cologne: Taschen.

Goethe, Johann W. von. 1810. *Zur Farbenlehre* (Theory of Colors). Tübingen: Cotta.

Goldstein, E. Bruce. 1989. *Sensation and Perception*. Belmont: Wadsworth.

González-Cobelo, J.L., and Zaha Hadid. 2001. "El paisaje como planta 1996–2001" (Landscape as a Plan 1996–2001). *El Croquis*, 103.

Greenberg, Clement. [1948] 1973. "The Crisis of the Easel Picture." In Clement Greenberg (ed.), *Art and Culture*. London: Thames and Hudson.

Greenberg, Clement. [1955] 1973. "American-Type Painting." In Clement Greenberg (ed.), *Art and Culture*. London: Thames and Hudson.

Griffin, Lewis D. 2006. "Optimality of the Basic Colour Categories for Classification." *Journal of the Royal Society Interface*, 3(6): 71–85.

Grisard, Dominique. 2017. "'Real Men Wear Pink'? A Gender History of Color." In Regina Lee Blaszczyk and Uwe Spiekermann (eds.), *Bright Modernity: Color, Commerce, and Consumer Culture*. Cham: Springer Nature/Palgrave Macmillan.

Groebner, Kim, des. 2008. *Juxtapoz Tattoo*. Berkeley, CA: Gingko Press.

Grossmann, Maria, and Paolo D'Achille. 2016. "Italian Colour Terms in the BLUE Area: Synchrony and Diachrony." In João P. Silvestre, Esperança Cardeira, and Alina Villalva (eds.), *Colour and Colour Naming: Crosslinguistic Approaches*. Lisbon: Universidade de Aveiro.

Grymm, Dr. 2011. *1000 Steampunk Creations: Neo Victorian Fashion, Gear and Art.* Beverley, MA: Quarry Books.

Guilford, Joy Paul. 1934. "The Affective Value of Color as a Function of Hue, Tint, and Chroma." *Journal of Experimental Psychology*, 17(3): 342–70.

Hackett, Stephen. 2016. "All 13 Colors of iMac." [blog] *512 pixels*, May 5. Available online: https://512pixels.net/2016/05/all-13-colors/ (accessed May 10, 2019).

Hadid, Zaha, and Yoshio Futagawa. 1995. *Zaha M. Hadid.* Tokyo: A.D.A. Edita.

Haeusler, M. Hank. 2009. *Media Facades: History, Technology, Content.* Ludwigsburg: Avedition.

Hamilton, Rachael L. 2016. "Colour in English: From Metonymy to Metaphor." PhD thesis, University of Glasgow.

Hanada, Mitsuhiko. 2018. "Correspondence Analysis of Color-Emotion Associations." *Color Research and Application*, 43(2): 224–37.

Hardin, Clyde. L. 1988. *Color for Philosophers.* New York: Hackett.

Hardin, Clyde L. 1992. "The Virtues of Illusion." *Philosophical Studies*, 68(3): 371–82.

Hardin, Clyde L. 2005. "Explaining Basic Color Categories." *Cross-Cultural Research*, 39(1): 72–87.

Hardin, Clyde L., and Luisa Maffi, eds. 1997. *Color Categories in Thought and Language.* Cambridge: Cambridge University Press.

Harrison, Charles, and Paul Wood, eds. 2003. *Art in Theory 1900–2000: An Anthology of Changing Ideas.* New edn. Oxford: Blackwell.

Haugeland, John. 1997. *Mind Design II.* Cambridge, MA: MIT Press.

Henderson, Veronique, and Pat Henshaw. 2014. *Color Me Beautiful: Expert Guidance to Help You Feel Confident and Look Great.* London: Hamlyn.

Hering, Ewald. [1905] 1964. *Outlines of a Theory of the Light Sense.* Translated by Leo M. Hurvich and Dorothea Jameson. Cambridge, MA: Harvard University Press.

Heron, Patrick. 1957–8. *Horizontal Stripe Painting: November 1957–January 1958.* Tate Collection. Available online: http://www.tate.org.uk/art/artworks/heron-horizontal-stripe-painting-november-1957-january-1958-t01541 (accessed August 28, 2017).

Heron, Patrick. 1964. *Purple Shape in Blue: 1964.* Tate Collection. Available online: http://www.tate.org.uk/art/artworks/heron-purple-shape-in-blue-1964-t00711 (accessed August 28, 2017).

Herzog & de Meuron. n.d. *Projects, 205 Allianz Arena.* Available online: https://www.herzogdemeuron.com/index/projects/complete-works/201-225/205-allianz-arena.html (accessed February 10, 2017).

Hess, Alan. 2010. "Colorful Landmarks: How Color Shaped Public Space in 1950s Suburbia." In Gareth Doherty (ed.), *New Geographies 3: Urbanisms of Color.* Cambridge, MA: Harvard Graduate School of Design.

Higgins, Scott. 2007. *Harnessing the Technicolor Rainbow: Color Design in the 1930s.* Austin: University of Texas Press.

Hilbert, David. 1987. *Color and Color Perception.* Cambridge: Cambridge University Press.

Hillier, Bevis. 1990. *The Style of the Century 1900–1980.* London: Herbert Press.

Hirst, Damian. 1988. *Edge.* Available online: http://www.damienhirst.com/edge (accessed August 28, 2017).

Hitchcock, Henry-Russell. 1932. "Le Corbusier." In *Modern Architecture: International Exhibition, New York, Feb. 10 to March 23, 1932, Museum of Modern Art.*

New York: Museum of Modern Art. Available online: https://www.moma.org/documents/moma_catalogue_2044_300061855.pdf (accessed June 11, 2018).

Hitchcock, Henry-Russell, and Philip Johnson. [1932] 1995. *The International Style.* New York: W.W. Norton.

Hockney, David. 1964. *California Art Collector.* Available online: http://www.davidhockney.co/works/paintings/60s (accessed August 30, 2017).

Hockney, David. 2008. *More Felled Trees on Woldgate.* Available online: http://www.davidhockney.co/works/paintings/00s (accessed August 30, 2017).

Hodgkin, Howard. 1977–9. *In a French Restaurant.* Available online: https://howard-hodgkin.com (accessed August 30, 2017).

Hodgkin, Howard. 2015–16. *In the Shade.* Available online: https://howard-hodgkin.com (accessed August 30, 2017).

Hofmann, Hans. 1959. *Pompeii.* Tate Collection. Available online: http://www.tate.org.uk/art/artworks/hofmann-pompeii-t03256 (accessed August 31, 2017).

Holme, Ian. 2006. "Sir William Henry Perkin: A Review of his Life, Work and Legacy." *Coloration Technology*, 122(5): 235–51.

Homomonument. 2013. *Homomonument—Since 1987.* Available online: http://homomonument.nl/ (accessed April 10, 2014).

Hopper, Edward. 1942. *Nighthawks.* Collection Art Institute of Chicago. Available online: http://www.artic.edu/aic/collections/artwork/111628 (accessed August 30, 2017).

Horowitz, Frederick A., and Brenda Danilowitz. 2006. *Josef Albers: To Open Eyes: The Bauhaus, Black Mountain College and Yale.* New York: Phaidon.

Hoskins, Janet. 1989. "Why do Ladies Sing the Blues?." In Annette B. Weiner and Jane Schneider (eds.), *Cloth and Human Experience.* Washington, DC: Smithsonian Institution Press.

"How to be a Successful Retailer: Colouring Customers." 1998. *Drapers Record*, July(23): i–ii.

Hughes, Jessica. 2015. "Immaterial Religion—Yves Klein's *Ex-voto to St Rita of Cascia*." [blog] *Material Religions*, January 7. Available online: https://jugaad.pub/immaterial-religion-yves-kleins-ex-voto-to-st-rita-of-cascia/ (accessed May 2, 2018).

Hundertwasser, Friedensreich. 1958/1959/1964. *Mouldiness Manifesto Against Rationalism in Architecture.* Orignally read by Friedensreich Hundertwasser at Seckau Abbey, Styria, July 4, 1958, with addenda 1959 and 1964. Available online: http://www.hundertwasser.at/english/texts/philo_verschimmelungsmanifest.php (accessed December 19, 2017).

Hurston, Zora Neale. [1928] 1979. "How it Feels to Be Colored Me." In Alice Walker (ed.), *I Love Myself When I Am Laughing … and Then Again When I Am Looking Mean and Impressive: A Zora Neale Hurston Reader*, introduced by Mary Helen Washington. New York: Feminist Press.

Hurvich, Leo. 1981. *Color Vision.* Sunderland, MA: Sinauer Associates.

Hurvich, Leo, and Dorothea Jameson. 1957. "An Opponent-Process Theory of Color Vision." *Psychological Review*, 64(6 pt. 1): 384–404.

Hynes, Nikki. 2008. "Color and Meaning in Corporate Logos: An Empirical Study." *Brand Management*, 16(8): 545–55.

Imagine. 2017. [Documentary] "Margaret Atwood: You Have Been Warned." BBC One, August 28.

International Color Consortium (ICC). 2018. "About ICC." Available online: http://www.color.org/abouticc.xalter (accessed March 16, 2018).

International Women's Day (IWD). 2017. "International Women's Day." Available online: https://www.internationalwomensday.com/ (accessed June 16, 2020).

Irwin, Beatrice. 1916. *The New Science of Color*. London: William Rider and Son.

Isenstadt, Sandy, Margaret Maile Petty, and Dietrich Neumann, eds. 2015. *Cities of Light: Two Centuries of Urban Illumination*. London: Routledge.

Istomina, Zinaida M. 1963. "Perception and Naming of Color in Early Childhood." *Soviet Psychology and Psychiatry*, 1(2): 37–45.

Itten, Johannes. 1973. *The Art of Color: The Subjective Experience and Objective Rationale of Color*. New York: Van Nostrand Reinhold.

Jackson, Frank. 1982. "Epiphenomenal Qualia." *Philosophical Quarterly*, 32: 127–36.

Jackson, Lesley. 1991. *The New Look: Design in the Fifties*. London: Thames and Hudson.

Jacobs, Gerald. 2014. "The Discovery of Spectral Opponency in Visual Systems." *Journal of the History of the Neurosciences*, 23: 287–314.

Jacques, Barbara. 1994. *The Complete Color, Style and Image Book*. London: Harper Collins.

Jakle, John A. 2001. *City Lights: Illuminating the American Night*. Baltimore: Johns Hopkins University Press.

Jameson, Kimberly A. 2005. "Why GRUE? An Interpoint-Distance Model Analysis of Composite Color Categories." *Cross-Cultural Research*, 39(2): 159–204.

Jameson, Kimberly A., and Roy G. D'Andrade. 1997. "It's Not Really Red, Green, Yellow, Blue: An Inquiry into Cognitive Color Space." In Clyde L. Hardin and Luisa Maffi (eds.), *Color Categories in Thought and Language*. Cambridge: Cambridge University Press.

Jameson, Kimberly A., and Natalia L. Komarova. 2009. "Evolutionary Models of Color Categorization, II: Realistic Observer Models and Population Heterogeneity." *Journal of the Optical Society of America A*, 26(6): 1424–36.

Jarvis, Chase. 2009. *The Best Camera is the One That's With You: iPhone Photography*. Berkeley, CA: New Riders.

Jencks, Charles. [1977] 1991. *The Language of Post-Modern Architecture*. New York: Rizzoli.

Johnston, Sean. F. 2001. *A History of Light and Colour Measurement: Science in the Shadows*. Bristol: Institute of Physics.

Jones, Loyd A., ed. 1953. *The Science of Color*. New York: Crowell.

Jones, Owen. [1856] 1982. *The Grammar of Ornament*. Facsimile edn. New York: Van Nostrand Reinhold.

Jones, Robert Edmund. [1941] 2004. *The Dramatic Imagination: Reflections and Speculations on the Art of the Theatre*. New York: Routledge.

Jones, William J. 2013. *German Colour Terms: A Study in Their Historical Evolution from Earliest Times to the Present*. Amsterdam: John Benjamins.

Jraissati, Yasmina, and Igor Douven. 2017. "Does Optimal Partitioning of Color Space Account for Universal Color Categorization?" *PLoS ONE*, 12(6): e0178083. https://doi.org/10.1371/journal.pone.0178083.

Judd, Donald. 1984. *Untitled*. Collection Museum Wiesbaden, Lafrenz Collection, Hamburg. Available online: http://juddfoundation.org/artist/art/ (accessed August 28, 2017).

Judd, Donald. 1993. "Some Aspects of Color in General and Red and Black in Particular." In *Donald Judd Essays*. Available online: http://s3.amazonaws.com/juddfoundation.org/wp-content/uploads/2016/04/12120632/SomeAspectsOfColor_Writings_DonaldJudd.pdf (accessed August 7, 2017).

Juxtapoz. n.d. "Home." Available online: https://www.juxtapoz.com/ (accessed June 17, 2020).

Kaiser-Schuster, Britta. 1999. "Teaching Colour at the Bauhaus." In Jeannine Fiedler and Peter Feierabend (eds.), *Bauhaus*. Cologne: Könemann.

Kalmus, Natalie. 1935. "Color Consciousness." *Journal of the Society of Motion Picture Engineers*, August 1935: 139–47.

Kandinsky, Wassily. [1914] 1977. *Concerning the Spiritual in Art*. Translated by M.T.H. Sadler. New York: Dover.

Kandinsky, Wassily. 1946. *On the Spiritual in Art*. Digitized by the Solomon R. Guggenheim Library and Archives. Available online: https://archive.org/details/onspiritualinart00kand (accessed August 18, 2017).

Kang, Zi Young, and Tracy D. Cassidy. 2015. "Lolita Fashion: A Trans-Global Subculture." *Fashion, Style and Popular Culture*, 2(3): 371–84.

Katz, Alex. 1999. *Penobscot*. Collection Tate/National Galleries of Scotland. Available online: http://www.tate.org.uk/art/artworks/katz-penobscot-ar00015 (accessed August 30, 2017).

Katz, David. 1935. *The World of Colour*. Translated by R.B. MacLeod and C.W. Fox. London: Kegan Paul, Trench, and Trübner.

Kawamura, Yuniya. 2006. "Japanese Teens as Producers of Street Fashion." *Current Sociology*, 54(5): 784–801.

Kay, Paul, and Luisa Maffi 1999. "Color Appearance and the Emergence and Evolution of Basic Color Lexicons." *American Anthropologist*, 101(4): 743–60.

Kay, Paul, and Chad K. McDaniel. 1978. "The Linguistic Significance of the Meanings of Basic Color Terms." *Language*, 54(3): 610–46.

Kay, Paul, and Terry Regier 2003. "Resolving the Question of Color Naming Universals." *Proceedings of the National Academy of Sciences of the U.S.A.*, 100(15): 9085–9.

Kay, Paul, Brent Berlin, Luisa Maffi, William R. Merrifield, and Richard Cook. 2009. *The World Color Survey*. Stanford, CA: CSLI Publications. Data available online: http://www.icsi.berkeley.edu/wcs/data.html (accessed June 16, 2020).

Kay-Williams, Susan. 2013. *The Story of Colour in Textiles*. London: Bloomsbury.

Keane, Webb. 2005. "Signs are Not the Garb of Meaning: On the Social Analysis of Material Things." In Daniel Miller (ed.), *Materiality*. Durham, NC: Duke University Press.

Kelly, Ellsworth. 1958. *Broadway*. Tate Collection. Available online: http://www.tate.org.uk/art/artworks/kelly-broadway-t00511 (accessed August 31, 2017).

Kennedy, Maev. 2018. "Tracey Emin Sends a Message of Love to the Rest of Europe via St Pancras." *The Guardian*, April 10. Available online: https://www.theguardian.com/artanddesign/2018/apr/10/tracey-emin-sends-a-message-of-love-to-europe-via-st-pancras (accessed November 8, 2018).

Kerouac, Jack. 1957. *On the Road*. New York: Viking Press.

Kerttula, Seija. 2002. *English Colour Terms: Etymology, Chronology, and Relative Basicness*. Helsinki: Société Néophilologique de Helsinki.

Kidd, Warren. 2002. *Culture and Identity*. New York: Palgrave.

King, Phillip. 1963. *Tra-La-La*. Tate Collection. Available online: http://www.tate.org.uk/art/artworks/king-tra-la-la-t01206 (accessed August 30, 2017).

Kirkpatrick, David. 2000. "Are You Experienced?." *Fortune*, 142(3): 387–92.

Klein, Yves, 1959. *IKB 79*. Tate Collection. Available online: http://www.tate.org.uk/art/artworks/klein-ikb-79-t01513 (accessed December 23, 2017).

Klein, Yves. 1973. *The Evolution of Art towards the Immaterial*. London: Gimpel Fils.

Kobo, Ousman. 2012. *Unveiling Modernity in Twentieth-Century West African Islamic Reforms*. Leiden: Brill.

Koolhaas, Rem, Norman Foster, Gerhard Mack, and Alessandro Mendini. 2001. *Colours*. Basel: Birkhaüser.

Kooning, Willem de. 1966. *Women Singing II*. Tate Collection. Available online: http://www.tate.org.uk/art/artworks/kooning-women-singing-ii-t01178 (accessed August 31, 2017).

Kotler, Philip. 2011. *Marketing Management*. 14th edn. New York: Prentice-Hall.

Kövecses, Zoltán, and Günter Radden. 1998. "Metonymy: Developing a Cognitive Linguistic View." *Cognitive Linguistics*, 9(1): 37–78.

Kuriki, Ichiro, Ryan Lange, Yumiko Muto, Angela M. Brown, Kazuho Fukuda, Rumi Tokunaga, Delwin T. Lindsey, Keiji Uchikawa, and Satoshi Shiori. 2017. "The Modern Japanese Color Lexicon." *Journal of Vision*, 17(3): 1–18. https://doi.org/10.1167/17.3.1.

Kwiet, Konrad. 2017. *Research Notes*. Sydney: Sydney Jewish Museum.

Lambie, Jim. 1999. *Zobop*. Tate Collection. Available online: http://www.tate.org.uk/art/artworks/lambie-zobop-t12236 (accessed August 31, 2017).

Larsen, Nella. [1928] 2006. *Quicksand*. Mineola, NY: Dover.

Le Corbusier. [1923] 1986. *Towards a New Architecture*. Translated by Frederick Etchells. New York: Dover Publications.

Le Corbusier. [1955] 2000. *Modulor 2*. Basel: Birkhäuser.

Le Corbusier. 1997. "Polychromie Architecturale." In Arthur Rüegg (ed.), *Le Corbusiers Farbenklaviaturen von 1931 und 1959* (Le Corbusier's Color Keyboards from 1931 and 1959 / Les Claviers de couleurs de Le Corbusier de 1931 et de 1959). Basel: Birkhäuser.

Le Gallienne, Richard. 1910. "Miss Irwin's 'Color Poems.'" *New York Times*, November 26.

Léger, Fernand. 1927. *Leaves and Shell*. Tate Collection. Available online: http://www.tate.org.uk/art/artworks/leger-leaves-and-shell-n05907 (accessed August 31, 2017).

Léger, Fernand. 1928. *Keys (composition)*. Tate Collection. Available online: http://www.tate.org.uk/art/artworks/leger-keys-composition-n05990 (accessed August 31, 2017).

Léger, Fernand. [1952] 1990. *Nuevas concepciones del espacio*. Barcelona: GG.

Lemke, Sieglinde. 1998. *Primitivist Modernism: Black Culture and the Origins of Transatlantic Modernism*. Oxford: Oxford University Press.

Lenclos, Jean-Philippe. 2009. "The Geography of Color." In Tom Porter and Byron Mikellides (eds.), *Color for Architecture Today*. London: Taylor and Francis.

Levinson, Stephen C. 2000. "Yélî Dnye and the Theory of Basic Color Terms." *Journal of Linguistic Anthropology*, 10(1): 3–55.

Lewery, Adrian J. 1991. *Popular Art: Past and Present*. London: David & Charles.

Lewis, Sinclair. 1922. *Babbitt*. New York. Harcourt, Brace.

Lillo, Julio, Lilia R. Prado-León, Fernando González Perilli, Anna Melnikova, Leticia Álvaro, José Collado, and Humberto Moreira. 2018. "Spanish Basic Color Categories Are 11 or 12 Depending on the Dialect." In Lindsay W. MacDonald, Carole P. Biggam, and Galina V. Paramei (eds.), *Progress in Colour Studies: Cognition, Language and Beyond*. Amsterdam: John Benjamins.

Lindsey, Delwin T., and Angela M. Brown. 2014a. "Color Appearance, Language, and Neural Coding." In John S. Werner and Leo M. Chalupa (eds.), *The New Visual Neurosciences*. Cambridge, MA: MIT Press.

Lindsey, Delwin T., and Angela M. Brown. 2014b. "The Color Lexicon of American English." *Journal of Vision*, 14(2): 17,1–25. https://doi.org/10.1167/14.2.17.

Loos, Adolf. [1908] 1970. "Ornament and Crime." In Ulrich Conrads (ed.), *Programs and Manifestoes on 20th Century Architecture*. Cambridge, MA: MIT Press.

Loos, Claire Beck. [1936] 2011. *Adolf Loos: A Private Portrait*. Los Angeles: DoppelHouse Press.

MacLaury, Robert E. 1997. *Color and Cognition in Mesoamerica: Constructing Categories as Vantages*. Austin: University of Texas Press.

MacLaury, Robert E., Judit Almási, and Zoltan Kövecses. 1997. "Hungarian *Piros* and *Vörös*: Color from Points of View." *Semiotica*, 114(1–2): 67–81.

Malevich, Kazimir. 1915. *Black Square*. Collection Tretyakov Gallery, Moscow. Available online: https://www.hermitagemuseum.org/ (accessed August 31, 2017).

Maloney, Laurence T. 1984. "Computational Approaches to Color Constancy." PhD thesis, Stanford University.

Manzoni, Piero. 1958. *Achrome*. Tate Collection. Available online: http://www.tate.org.uk/art/artworks/manzoni-achrome-t01871 (accessed August 31, 2017).

Marchand, Roland. 1986. *Advertising the American Dream: Making Way for Modernity, 1920–1940*. Berkeley: University of California Press.

Marks, Laura U. 2000. *The Skin of the Film: Intercultural Cinema, Embodiment, and the Senses*. Durham, NC: Duke University Press.

Matisse, Henri. 1946. *Still Life: Interior with Venetian Red*. Musées Royaux des Beaux-Arts de Belgique. Available online: https://www.fine-arts-museum.be/fr/la-collection/henri-matisse-nature-morte-interieur-rouge-de-venise?letter=m&artist=matisse-henri-1 (accessed August 31, 2017).

Mausfeld, Rainer, and Dieter Heyer (eds.). 2003. *Colour Perception: Mind and the Physical World*. Oxford: Oxford University Press.

Mayorov, Nikolai. 2012. "Soviet Colours." *Studies in Russian and Soviet Cinema*, 6(2): 241–55.

McGraw, John J. 2004. *Brain and Belief: An Exploration of the Human Soul*. Del Mar, CA: Aegis Press.

McGrayne, Sharon Bertsch. 2001. *Prometheans in the Lab: Chemistry and the Making of the Modern World*. New York: McGraw-Hill.

McGuire, Ian. 2016. *The North Water*. London: Picador.

McHarg, Ian L. [1969] 1992. *Design with Nature*. New York: Wiley.

McKay, Claude. [1928] 1987. *Home to Harlem*. Boston: Northeastern University Press.

McKay, Claude. [1929] 1970. *Banjo*. New York: Harvest Books.

Meier, Richard. 1984. *The Pritzker Architecture Prize: Ceremony Acceptance Speech*. Online video. Available online: https://www.pritzkerprize.com/laureates/1984 (accessed December 18, 2017).

Meltzer, Françoise. 1978. "Color as Cognition in Symbolist Verse." *Critical Inquiry*, 5(2): 253–73.

Mendes, Valerie, and Amy De La Haye. 1999. *Twentieth Century Fashion*. London: Thames and Hudson.

Meyer, Birgit, David Morgan, Crispin Paine, and S. Brent Plate. 2010. "The Origin and Mission of Material Religion." *Religion*, 40(3): 207–11.

Milner, Andrew. 2004. "Darker Cities: Urban Dystopia and Science Fiction Cinema." *International Journal of Cultural Studies*, 7(3): 259–79.

Miró, Joan. 1934. *Painting*. Fundació Joan Miró, Barcelona. Available online: https://www.fmirobcn.org/en/colection/catalog-works/5399/p-em-painting-em-p (accessed August 31, 2017).

Miró, Joan. 1938. *Group of Figures (Groupe de Personnages)*. Los Angeles County Museum. Available online: http://collections.lacma.org/node/207362 (accessed August 31, 2017).

Miró, Joan. 1946. *Woman and Birds at Sunrise*. Fundació Joan Miró, Barcelona. Available online: https://www.fmirobcn.org/en/colection/catalog-works/19880/p-woman-and-birds-at-sunrise-p (accessed August 31, 2017).

Moen, Kristian. 2010. "'The Miracle of the Century': Sergei Eisenstein, Élie Faure and Colour in the *Silly Symphonies*." *Screen*, 51(40): 383–9.

Mohan, Urmila. 2018. *Fabricating Power with Balinese Textiles*. Chicago: University of Chicago Press

Mohan, Urmila, and Jean-Pierre Warnier. 2017. "Editorial. Marching the Devotional Subject: The Bodily-and-Material Cultures of Religion." *Journal of Material Culture*, 22(4): 369–84.

Mohr, Christine, Domicele Jonauskaite, Elise S. Dan-Glauser, Mari Uusküla, and Nele Dael. 2018. "Unifying Research on Colour and Emotion: Time for a Cross-Cultural Survey on Emotion Associations to Colour Terms." In Lindsay W. MacDonald, Carole P. Biggam, and Galina V. Paramei (eds.), *Progress in Colour Studies: Cognition, Language and Beyond*. Amsterdam: John Benjamins.

Moneo, Rafael. 1992. "Aldo Rossi: Autobiografía Científica." In Ezio Bonfanti and Alberto Ferlenga (eds.), *Aldo Rossi*. Barcelona: Ediciones del Serbal.

Montaner, Josep Maria. 1999. *Arquitectura y crítica*. Barcelona: Gustavo Gili.

Moore, George Edward. 1903. *Principia ethica*. Cambridge: Cambridge University Press.

Morgan, David. 1998. *Visual Piety: A History and Theory of Popular Religious Images*. Berkeley: University of California Press.

Moritz, William. 1995. "Musique de la couleur—cinéma intégral." In Nicole Brenez and Miles McKane (eds.), *Poétique de la couleur: anthologie*. Paris: Auditorium du Louvre. Available online: http://www.centerforvisualmusic.org/WMCM_IC.htm (accessed June 16, 2020).

Moritz, William. 2006–2013. *Oskar Fischinger Biography*. Available online: http://www.centerforvisualmusic.org/Fischinger/OFBio.htm (accessed June 16, 2020).

Morne, Ruben. 1998. *Neon & ljusskyltar: en handbook* (Neon and Electric Signs: A Handbook). Stockholm: Svensk byggtjänst.

Moroney, Nathan. 2003. "Unconstrained Web-Based Color Naming Experiment." In Reiner Eschbach and Gabriel G. Marcu (eds.), *Proceedings of SPIE 5008, Color Imaging VIII: Processing, Hardcopy, and Applications*. Santa Clara, CA: IS&T.

Morris, Peter J.T., and Anthony S. Travis. 1992. "A History of the International Dyestuff Industry." *American Dyestuff Reporter*, 81(November): 59–195.

Morrison, Toni. 1987. *Beloved*. New York: Vintage.

Morrow, Phyllis. 1984. "It is Time for Drumming: A Summary of Recent Research on Yup'ik Ceremonialism." *Études Inuit Studies*, 8: 113–40.

Mottram, Judith. 2006. "Contemporary Artists and Colour: Meaning, Organisation and Understanding." *Journal of Optics and Laser Technology*, 38(4–6): 405–16.

Munsell, Albert Henry, and Thomas Maitland Cleland. 1921. *A Grammar of Color; Arrangements of Strathmore Papers in a Variety of Printed Color Combinations According to the Munsell Color System*. Mittineague, MA: Strathmore Paper Company. Available online: https://archive.org/details/gri_c00033125006531145 (accessed June 16, 2020).

Murmann, Johann Peter. 2002. "Chemical Industries after 1850." In Joel Mokyr (ed.), *Oxford Encyclopaedia of Economic History*. Oxford: Oxford University Press.

Mylonas, Dimitris, and Lindsay MacDonald. 2016. "Augmenting Basic Colour Terms in English." *Color Research and Application*, 41(1): 32–42.

Nanolab. n.d. "SINGULARITY™ Black." Available online: http://www.nano-lab.com/optical-black-coatings.html (accessed August 31, 2017).

Nareid, H. 1988. "A Review of the Lippmann Colour Process." *Journal of Photographic Science*, 36(4): 140–7.

Nassau, Kurt. 1983. *The Physics and Chemistry of Color: The Fifteen Causes of Color*. New York: Wiley.

National Museum of American History. n.d. *Ping-Pong Ball*. Available online: https://americanhistory.si.edu/collections/search/object/nmah_1121041 (accessed May 10, 2019).

Nelson, Maggie. 2009. *Bluets*. Seattle: Wave Books.

"The New Age of Color." 1928. *The Saturday Evening Post*, January 21.

Newhall, Sidney M., and Josephine G. Brennan, eds. 1949. *Comparative List of Color Terms: A Report of the Inter-Society Color Council*. Washington, DC: Inter-Society Color Council.

Nguyen, Michelle. 2008. "Gothic and Lolita History." *Gothic and Lolita Bible*, 1(February): 8–9.

Nielssen, Hilde. 2012. *Ritual Imagination: A Study of Tromba Possession among the Betsimisaraka in Eastern Madagascar*. Leiden: Brill.

Niemeier, Susanne. 1998. "Colourless Green Ideas Metonymise Furiously." In Friedrich Ungerer (ed.), *Kognitive Lexikologie und Syntax*. Rostock: Universität Rostock.

Niemeier, Susanne. 2007. "From Blue Stockings to Blue Movies." In Martina Plümacher and Peter Holz (eds.), *Speaking of Colors and Odors*. Amsterdam: John Benjamins.

O'Connor, Zena. 2011. "Logo Color and Differentiation: A New Application of Environmental Color Mapping." *Color Research and Application*, 36(1): 55–60.

O'Donoghue, Elma, Ashley M. Johnson, Joy Mazurek, Frank Preusser, Michael Schilling, and Marc S. Walton. 2006. "Dictated by Media: Conservation and Technical Analysis of a 1938 Joan Miró Canvas Painting." *Studies in Conservation*, 51(suppl. 2): 62–8.

Olins, Wally. 1989. *Corporate Identity: Making Business Strategy Visible through Design*. New York: Thames and Hudson.

Olitski, Jules. n.d. *Paintings: 1950s, 1960s, 1970s, 1980s, 1990s, 2000s*. Available online: https://www.olitski.com/paintings (accessed August 28, 2017).

Osgood, Charles E., William H. May, and Murray S. Miron. 1975. *Cross-Cultural Universals of Affective Meaning*. Urbana: University of Illinois Press.

Ostwald, Wilhelm. 1916. "Die Farbenfibel" (The Color Primer). Cited in Gage 2000.

Ott, Brian L., and Diane Marie Keeling. 2011. "Cinema and Choric Connection: *Lost in Translation* as Sensual Experience." *Quarterly Journal of Speech*, 97(4): 363–86.

Ou, Li-Chen, Ronnier Luo, Andrée Woodcock, and Angela Wright. 2004. "A Study of Colour Emotion and Colour Preference. Part I: Colour Emotions for Single Colours." *Color Research and Application*, 29(3): 232–40.

Oyama, Tadasu, Yasumasa Tanaka, and Yoshio Chiba. 1962. "Affective Dimensions of Colors: A Cross-Cultural Study." *Japanese Psychological Research*, 4(2): 78–91.

Ozenfant, Amédée, and Charles-Edouard Jeanneret [Le Corbusier]. [1918] 2001. "After Cubism." In Carol S. Eliel (ed.), *L'esprit nouveau: Purism in Paris, 1918–1925*. Los Angeles: Los Angeles County Museum of Art in association with Harry N. Abrams.

Paggetti, Giulia, Gloria Menegaz, and Galina V. Paramei. 2016. "Color Naming in Italian Language." *Color Research and Application*, 41(4): 402–15.

Palmer, Alexandra. 2005. "Vintage Whores & Vintage Virgins, Second Hand Fashion in the Twenty-First Century." In Alexandra Palmer and Hazel Clark (eds.), *Old Clothes New Looks, Second Hand Fashion*. Oxford: Berg.

Palmer, Alexandra, and Hazel Clark, eds. 2005. *Old Clothes New Looks, Second Hand Fashion*. Oxford: Berg.

Palmer, Stephen E. 1999. *Vision Science: Photons to Phenomenology*. Cambridge, MA: MIT Press.

Palmer, Stephen E., and Karen B. Schloss. 2010. "An Ecological Valence Theory of Human Color Preference." *Proceedings of the National Academy of Sciences of the U.S.A.*, 107(19): 8877–82.

Paramei, Galina V. 2005. "Singing the Russian Blues: An Argument for Culturally Basic Color Terms." *Cross-Cultural Research*, 39(1): 10–38.

Paramei, Galina V. 2007. "Russian 'Blues': Controversies of Basicness." In Robert E. MacLaury, Galina V. Paramei, and Don Dedrick (eds.), *Anthropology of Color: Interdisciplinary Multilevel Modeling*. Amsterdam: John Benjamins.

Paramei, Galina V., Mauro D'Orsi, and Gloria Menegaz. 2014. "'Italian Blues:' A Challenge to the Universal Inventory of Basic Colour Terms." *Journal of the International Colour Association*, 13: 27–35.

Paramei, Galina V., Yulia A. Griber, and Dimitris Mylonas. 2018. "An Online Color Naming Experiment in Russian Using Munsell Color Samples." *Color Research and Application*, 43(3): 358–74.

Pasco, Allan H. 1976. *The Color-Keys to Á la recherche du temps perdu*. Geneva: Librarie Droz.

Pehnt, Wolfgang. 1975. *Expressionist Architecture*. London: Thames and Hudson.

Pelli, César. 1996. "Designing with Colour." *Architectural Design*, 120: 26–9.

Perna, Rita. 1987. *Fashion Forecasting*. New York: Fairchilds.

Perry, Ralph Barton. 1912. "A Realistic Theory of Independence." In Edwin Holt (ed.), *The New Realism: Cooperative Studies in Philosophy*. New York: Macmillan.

Petty, Margaret Maile. 2017. "Glamour Pink: The Marketing of Residential Electric Lighting in the Age of Color, 1920s–1950s." In Regina Lee Blaszczyk and Uwe Spiekermann (eds.), *Bright Modernity: Color, Commerce, and Consumer Culture*. Cham: Springer Nature/Palgrave Macmillan.

Philip, Gill. 2011. *Colouring Meaning: Collocation and Connotation in Figurative Language*. Amsterdam: John Benjamins.

Physical Society. 1948. *Report on Colour Terminology*. London: Physical Society.

Picasso, Pablo. 1963. *Rape of the Sabines*. Boston Museum of Fine Arts. Available online: http://www.mfa.org/collections/object/rape-of-the-sabine-women-33864 (accessed August 28, 2017).

Pinney, Christopher. 2004. *"Photos of the Gods": The Printed Image and Political Struggle in India*. London: Reaktion Books.

Pitchford, Nicola J., and Kathy T. Mullen. 2003. "The Development of Conceptual Colour Categories in Pre-school Children: Influence of Perceptual Categorisation." *Visual Cognition*, 10(1): 51–77.

Poincaré, Henri. 1907. *The Value of Science*. Translated by G.B. Halsted. New York: Science Press.

Polhemus, Ted. 2004. *Hot Bodies Cool Styles: New Technologies in Self-Adornment*. London: Thames and Hudson.

Pollay, Richard W. 1985. "The Subsiding Sizzle: A Descriptive History of Print Advertising, 1900–1980." *Journal of Marketing*, 49: 24–37.

Pollock, Jackson. 1948. *Summertime 9A*. Tate Collection. Available online: http://www.tate.org.uk/art/artists/jackson-pollock-1785 (accessed August 31, 2017).

Porter, Tom. 1997. "Environmental Color Mapping." *Urban Design International*, 2(1): 23–31.

Porter, Tom, and Byron Mikellides (eds.). 1976. *Colour for Architecture*. London: Studio Vista.

Pound, Ezra. 1916. *Gaudier-Brzeska: A Memoir by Ezra Pound*. London: John Lane, the Bodley Head.

Prendergast, Canice. 2014. *The Market for Contemporary Art*. University of Chicago Booth School of Business. Available online: http://faculty.chicagobooth.edu/canice.prendergast/research/MarketContemporaryArt.pdf (accessed August 28, 2017).

Pucci, Emilio. 2017. "About Emilio Pucci." Available online: http://home.emiliopucci.com/about-emilio-pucci (accessed February 10, 2017).

Pynchon, Thomas. [1973] 2006. *Gravity's Rainbow*.New York: Penguin.

Rakhilina, Ekaterina V., and Galina V. Paramei. 2011. "Colour Terms: Evolution via Expansion of Taxonomic Constraints." In Carole P. Biggam, Carole A. Hough, Christian J. Kay, and David R. Simmons (eds.), *New Directions in Colour Studies*. Amsterdam: John Benjamins.

Ramírez, Juan Antonio. 1992. *Arte y arquitectura en la época del capitalismo triunfante*. Madrid: Visor.

Ramírez, Juan Antonio. 1996. "Aprendiendo de la arquitectura postmoderna." In Valeriano Bozal Fernández (ed.), *Historia de las ideas estéticas y de las teorías artísticas contemporáneas*, vol. 2. Madrid: Visor.

Ramírez-Luque, María Isabel. 2007. "Mucho más que una cuestión de piel: la experiencia del color en la arquitectura contemporánea." In Diego Romero de Solís, Inmaculada Murcia Serrano, and Jorge López Lloret (eds.), *Variaciones sobre el color*. Seville: Universidad de Sevilla.

Rapoport, Amos. 1982. *The Meaning of the Built Environment*. London: Sage.

Rauschenberg, Robert. 1953. *Untitled*. Collection MOMA NY. Available online: https://www.moma.org/collection/works/79709?locale=en (accessed August 27, 2017).

Regier, Terry, Alexandra Carstensen, and Charles Kemp. 2016. "Languages Support Efficient Communication about the Environment: Words for Snow Revisited." *PLoS ONE*, 11(4): e0151138. https://doi.org/10.1371/journal.pone.0151138.

Regier, Terry, Paul Kay, and Richard S. Cook. 2005. "Universal Foci and Varying Boundaries in Linguistic Color Categories." In Bruno G. Bara, Lawrence Barsalou, and Monica Bucciarelli (eds.), *Proceedings of the 27th Annual Conference of the Cognitive Science Society*. Mahwah, NJ: Lawrence Erlbaum.

Regier, Terry, Paul Kay, and Naveen Khetarpal. 2007. "Color Naming Reflects Optimal Partitions of Color Space." *Proceedings of the National Academy of Sciences of the U.S.A.*, 104(4): 1436–41.

Reichenbach, Hans. 1938. *Experience and Prediction*. Chicago: Phoenix Books.

Renn, Melissa. 2017. "*Life* in Color: *Life* Magazine and the Color Reproduction of Works of Art." In Regina Lee Blaszczyk and Uwe Spiekermann (eds.), *Bright Modernity: Color, Commerce, and Consumer Culture*. Cham: Springer Nature/ Palgrave Macmillan.

Rey, Terry. 2007. *Bourdieu on Religion: Imposing Faith and Legitimacy*. New York: Routledge.

Rheinhardt, Ad. 1962. *Abstract Painting No. 5*. Collection Tate. Available online: http://www.tate.org.uk/art/artworks/reinhardt-abstract-painting-no-5-t01582 (accessed August 30, 2017).

Ribbat, Christoph. 2013. *Flickering Light: A History of Neon*. London: Reaktion Books.

Richter, Gerhard. 1971. *180 Colours*. Available online: https://www.gerhard-richter. com/en/ (accessed August 30, 2017).

Richter, Gerhard. 1993. *Flowers*. Collection of The Art Institute of Chicago. Available online: https://www.gerhard-richter.com/en/ (accessed August 30, 2017).

Richter, Gerhard. 2005. *Forest*. Collection Museum of Modern Art, NY. Available online: https://www.gerhard-richter.com/en/ (accessed August 30, 2017).

Riedijk, Michiel. 2009. "Giant Blue Shirt at the Gasoline Station." In Susanne Komossa, Kees Rouw, and Joost Hillen (eds.), *Color in Contemporary Architecture*. Amsterdam: SUN Publishers.

Riley, Bridget. 1993. *Nataraja*. Available online: http://www.tate.org.uk/art/artworks/ riley-nataraja-t06859 (accessed August 30, 2017).

Robb, Brian J. 2012. *Steam Punk: An Illustrated History of Fantastical Fiction, Fanciful Film and Other Victorian Visions*. London: Aurum Press.

Roberson, Debi. 2005. "Color Categories are Culturally Diverse in Cognition as Well as in Language." *Cross-Cultural Research*, 39(1): 56–71.

Roberson, Debi, Jules B. Davidoff, Ian R.L. Davies, and Lori R. Shapiro. 2004. "The Development of Color Categories in Two Languages: A Longitudinal Study." *Journal of Experimental Psychology: General*, 133(4): 554–71.

Roberson, Debi, Jules B. Davidoff, Ian R.L. Davies, and Lori R. Shapiro. 2005. "Color Categories: Evidence for the Cultural Relativity Hypothesis." *Cognitive Psychology*, 50(4): 378–411.

Roberts, Bill. 2013. "Burnout: Liam Gillick's Post-Fordist Aesthetics." *Art History*, 36(1): 180–205.

Rodchenko, Alexander. 1921. *Pure Red Colour, Pure Yellow Colour, Pure Blue Colour*. Collection A. Rodchenko and V. Stepanova Archive, Moscow.

Rodowick, David N. 1995. *The Crisis of Political Modernism: Criticism and Ideology in Contemporary Film Criticism*. Berkeley: University of California Press.

Rogers, Richard. 1976. "The Colour Approach of Piano and Rogers." In Tom Porter and Byron Mikellides (eds.), *Colour for Architecture*. London: Studio Vista.

Romberg, Raquel. 2009. *Healing Dramas: Divination and Magic in Modern Puerto Rico*. Austin: University of Texas Press.

Rorke, Margaret Hayden. 1931. "The Work of the Textile Color Card Association." *Journal of the Optical Society of America*, 21(10): 651–3.

Rose, Barbara. 2006. *Monochrome: From Malevich to the Present*. Berkeley: University of California Press.

Rosler, Martha. 2004. *Decoys and Disruptions: Selected Writings, 1975–2001*. Cambridge, MA: MIT Press.

Rothko, Mark. 1950. *No. 10*. Collection MOMA NY. Available online: http://www.markrothko.org (accessed August 30, 2017).

Rothko, Mark. 2006. "Notes from a Conversation with Selden Rodman, 1956." In Miguel López-Remiro (ed.), *Writings on Art: Mark Rothko*. London: Yale University Press.

Roussou, Eugenia. 2013. "The New Age of Greek Orthodoxy: Pluralizing Religiosity in Everyday Practice." In Jose Mapril and Ruy Blanes (eds.), *The Best of All Gods: Sites and Politics of Religious Diversity in Southern Europe*. Leiden: Brill.

Roussou, Eugenia. 2015. "The Material Culture of the Evil Eye: Merging Orthodoxy and New Age Spirituality in Greece." [blog] *Material Religions*, May. Available online: http://materialreligions.blogspot.com/2015/05/the-material-culture-of-evil-eye.html (accessed May 2, 2018).

Rudisill, Richard. 1971. *Mirror Image: The Influence of the Daguerreotype on American Society*. Albuquerque: University of New Mexico Press.

Russell, Bertrand. 1912. *The Problems of Philosophy*. New York: Henry Holt.

Ryman, Robert. 1982. *Ledger*. Tate Collection. Available online: http://www.tate.org.uk/art/artworks/ryman-ledger-t03550 (accessed August 30, 2017).

Samkanashvili, Maia. 2013. "Use of Symbols and Colors in *The Great Gatsby* by F. Scott Fitzgerald." *Journal of Education*, 2(1): 31–9.

Sato, Tetsuya, Kanji Kajiwara, Hiroshi Hoshino, and Taeko Nakamura. 2000. "Quantitative Evaluation and Categorising of Human Emotion Induced by Colour." *Advances in Colour Science and Technology*, 3: 53–9.

Saunders, Barbara A.C., and Jaap van Brakel. 1997. "Are There Nontrivial Constraints on Colour Categorization?." *Behavioral and Brain Sciences*, 20(2): 167–79.

Schaper, Eva. 1961. "Significant Form." *British Journal of Aesthetics*, 1(2): 33–43. https://doi.org/10.1093/bjaesthetics/1.2.33.

Schiff, Gert. 1983. *Picasso: The Last Years, 1963–1973*. New York: George Braziller.

Schindler, Verena M. 2007. "Why is Green More and More Used as a Colour for Buildings to Create a Harmonic Chromatic Environment?" In *Procedings of the International Conference on Colour Harmony*. Budapest: Hungarian National Colour Committee.

Schindler, Verena M. 2012. "'Polychrome Environments' at the Centre Pompidou in Paris: The Work of France and Michel Cler, Architect-Colour Consultants." *Óbuda University e-Bulletin*, 3(1): 325–37. Available online: http://uni-obuda.hu/e-bulletin/VMSchindler_3.pdf (accessed December 18, 2017).

Schloss, Karen B., Laurent Lessard, Chris Racey, and Anya C. Hurlbert. 2018. "Modeling Color Preference Using Color Space Metrics." *Vision Research*, 151: 99–116.

Schneider, Daniel J. 1970. "Color Symbolism in *The Great Gatsby*". In Henry Dan Piper (ed.), *Fitzgerald's The Great Gatsby: The Novel, the Critics, the Background*. London: Scribner.

Schneider, Jane. 2006. "Cloth and Clothing." In Christopher Tilley, Webb Keane, Susanne Küchler, Michael Rowlands, and Patricia Spyer (eds.), *Handbook of Material Culture*. London: Sage.

Schoenmaekers, Mathieu H.J. 1915. *Het niewe Wereldbeeld*. Bussum: Van Dishoeck. Available online: http://www.dbnl.org/tekst/scho003nieu01_01/colofon.php (accessed June 16, 2020).

Sellars, Wilfred. 1963. *Science, Perception and Reality*. Atascadero, CA: Ridgewood Press.

Serra, Juan, and Ángela García Codoñer. 2014. "Color Composition in Postmodern Western Architecture." *Color Research and Application*, 39(4): 399–412.

Serra, Juan, Ángel García, Jorge Llopis, and Ana Torres. 2012. "Color Composition Features in Modern Architecture." *Color Research and Application*, 37(2): 126–33.

Serra, Juan, Jorge Llopis, Ana Torres, and Manuel Jiménez. 2016. "Color Combination Criteria in Le Corbusier's Purist Architecture Based on Salubra *claviers* from 1931." *Color Research and Application*, 41(1): 85–100.

Serra Lluch, Juan. 2010a. "The Myth of the Colour White in the Modern Movement." *Disegnare idee immagini*, 41: 66–77.

Serra Lluch, Juan. 2010b. "Projects Born by Colours: An Interview with British Architect William Alsop." *EGA Expresión Gráfica Arquitectónica*, 15(1): 196–7.

Serra Lluch, Juan. 2013. "The Versatility of Color in Contemporary Architecture." *Color Research and Application*, 38(5): 344–55.

Serra Lluch, Juan, Ángela García Codoñer, and Jorge Llopis Verdú. 2009. "Aportaciones al colorido de la modernidad 'Made in Italy': Piero Bottoni y la gradación cromática que nunca fue." *EGA Revista de Expresión Gráfica Arquitectónica*, 14: 180–7.

Seth, Radhika. 2017. "How *The Handmaid's Tale* Conquered the Catwalk," *Vogue*, October 28. Available online: https://www.vogue.co.uk/gallery/the-handmaids-tale-catwalk-trend (accessed November 8, 2018).

Shaw-Miller, Simon. 2013. *Eye hEar: The Visual in Music*. London: Routledge.

Sinclair Dootson, Kirsty. 2016. "'The Hollywood Powder Puff War': Technicolor Cosmetics in the 1930s." *Film History*, 28(1): 107–31.

Singer, Edgar. A. 1917. "On Sensibility." *Journal of Philosphy, Psychology and Scientific Method*, 14(13): 337–50.

Sivik, Lars. 1997. "Color Systems for Cognitive Research." In Clyde L. Hardin and Luisa Maffi (eds.), *Color Categories in Thought and Language*. Cambridge: Cambridge University Press.

Siza, Álvaro, Hestnes Ferreira, Luiz Cunha, Manuel Vicente, and Tomás Taveira. 1987. *Tendencias de la arquitectura portuguesa: Obras de Álvaro Siza, Hestnes Ferreira, Luiz Cunha, Manuel Vicente, Tomás Taveira: exposición itinerante*. Barcelona: Collegi d'Arquitectes de Catalunya.

Skard, Sigmund. 1946. "The Use of Color in Literature: A Survey of Research." *Proceedings of the American Philological Society*, 90(3): 163–249.

Skelton, Alice E., Gemma Catchpole, Joshua T. Abbott, Jenny M. Bosten, and Anna Franklin. 2017. "Biological Origins of Color Categorization." *Proceedings of the National Academy of Sciences of the U.S.A.*, 114(21): 5545–50.

Smethurst, James. 2006. *The Black Arts Movement: Literary Nationalism in the 1960s and 1970s*. Chapel Hill: University of North Carolina Press.

Solovyova, Inna. 2006. "The Theatre of Socialist Realism." In Robert Leach and Victor Borovsky (eds.), *A History of Russian Theatre*. Cambridge: Cambridge University Press.

Spillane, Mary. 1995. *The Complete Style Guide From the Color Me Beautiful Organisation*. London: Piatkus.

Squire, Michael. 2009. *Image and Text in Graeco-Roman Antiquity*. Cambridge: Cambridge University Press.

Steels, Luc, and Tony Belpaeme. 2005. "Coordinating Perceptually Grounded Categories Through Language: A Case Study for Colour." *Behavioral and Brain Sciences*, 28(4): 469–89.

Stein, Gertrude. 1914. *Tender Buttons*. New York: Claire Marie.

Stein, Sally. 1991. "The Rhetoric of the Colorful and the Colorless: American Photography and Material Culture Between the Wars." PhD thesis, Yale University.

Steinbeck, John. 1939. *The Grapes of Wrath*. New York: Sun Dial Press.

Steinvall, Anders. 2002. "English Colour Terms in Context." PhD thesis, Umeå University.

Steinvall, Anders. 2007. "Colors and Emotions in English." In Robert. E. MacLaury, Galina V. Paramei, and Don Dedrick (eds.), *Anthropology of Color: Interdisciplinary Multilevel Modeling*. Amsterdam: John Benjamins.

Stella, Frank. 1962. *Hyena Stomp*. Tate Collection. Available online: http://www.tate.org.uk/art/artworks/stella-hyena-stomp-t00730 (accessed August 31, 2017).

Stevens, Wallace. 1997. "The Man with the Blue Guitar." In *Wallace Stevens: Collected Poetry and Prose*. New York: Library of America.

Stirling, James. 1985. "The Monumentally Informal." [Audio] Part of *Revisiting Postmodernism: A Digital Archive of Talks Held at the Architectural League [of New York]*. Available online: https://archleague.org/article/james-stirling-the-monumentally-informal-fpo/ (accessed December 18, 2017).

Stoeva-Holm, Dessislava. 2007. "Color Terms in Fashion." In Robert. E. MacLaury, Galina V. Paramei, and Don Dedrick (eds.), *Anthropology of Color: Interdisciplinary Multilevel Modeling*. Amsterdam: John Benjamins.

Stout, George. 1899. *Manual of Psychology*. London: W.B. Clive.

Street, Sarah. 2005. *Black Narcissus*. London: I.B. Tauris.

Street, Sarah. 2012. *Colour Films in Britain: The Negotiation of Innovation, 1900–1955*. London: British Film Institute/Palgrave Macmillan.

Sutrop, Urmas. 2001. "List Task and a Cognitive Salience Index." *Field Methods*, 13(3): 263–76.

"The Symbolism of the Color Red in *The Handmaid's Tale*." 2017. *Vanity Fair*, May. Available online: https://www.vanityfair.com/hollywood/2017/05/the-symbolism-of-the-color-red-in-the-handmaids-tale (accessed June 18, 2018).

Táboas-Veleiro, Teresa. 2006. *El color en arquitectura*. La Coruña: Ediciós do Castro.

Taussig, Michael. 1993. *Mimesis and Alterity: A Particular History of the Senses*. London: Routledge.

Taussig, Michael. 2009. *What Color is the Sacred?* Chicago: University of Chicago Press.

Taut, Bruno. 1919. "Beobachtungen über Farbenwirkungen aus meiner Praxis." *Die Bauwelt*, 10(38): 12–13.

Taut, Bruno. [1925] 1981. "Rebirth of Color." In Martina Düttmann, Friedrich Schmuck, and Johannes Uhl (eds.), *Color in Townscape*. London: Architectural Press.

Taut, Bruno. 1927. *Ein Wohnhaus*. Stuttgart: Franck'sche Verlagshandlung.

Temkin, Ann. 2008. *Colour Chart: Reinventing Colour, 1950 to Today*. New York: Museum of Modern Art.

Theocharous, Evangelos, Christopher J. Chunnilall, Ryan Mole, David Gibbs, Nigel Fox, Naigui Shang, Guy Howlett, Ben Jensen, Rosie Taylor, Juan R. Reveles,

Oliver B. Harris, and Naseer Ahmed. 2014. "The Partial Space Qualification of a Vertically Aligned Carbon Nanotube Coating on Aluminium Substrates for EO Applications." *Optics Express*, 22(6): 7290–307. http://dx.doi.org/10.1364/OE.22.007290.

Thompson, Evan. 1995. *Colour Vision: A Study in Cognitive Science and the Philosophy of Perception*. London: Routledge.

Thompson, Evan. 2003. *Colour Vision*. New York: Routledge.

Thompson, Kirsten Moana. 2014. "Animating Ephemeral Surfaces: Transparency, Translucency and Disney's World of Color." *Refractory: A Journal of Entertainment Media*, 24. Available online: https://refractory-journal.com/thompson/ (accessed August 24, 2018).

Thompson, Kirsten Moana. 2018. "Rainbow Ravine: Colour and Animated Advertising in Times Square." In Giovanna Fossati, Victoria Jackson, Bregt Lameris, Elif Rongen-Kaynakçi, Sarah Street, and Joshua Yumibe (eds.), *The Colour Fantastic: Chromatic Worlds of Silent Cinema*. Amsterdam: Amsterdam University Press.

Timby, Kim. 2015. "Look at those Lollipops! Integrating Color into News Pictures." In Jason E. Hill and Vanessa R. Schwartz (eds.), *Getting the Picture: The Visual Culture of the News*. London: Bloomsbury.

Tóibin, Colm. 2006. "Howard Hodgkin." In Enrique Juncosa (ed.), *Writers on Howard Hodgkin*. Dublin: Irish Museum of Modern Art/Tate Publishing.

Tordoff, Maurice. 1984. *The Servant of Colour: A History of the Society of Dyers and Colourists 1884–1984*. Bradford: Society of Dyers and Colourists.

Troland, Leonard. 1922. "Report of Committee on Colorimetry for 1920–21." *Journal of the Optical Society of America and Review of Scientific Measurements*, 6(6): 527–96.

Turner, Victor Witter. 1967. *The Forest of Symbols: Aspects of Ndembu Ritual*. Ithaca, NY: Cornell University Press.

Turrell, James. 1983. *Hover*. Available online: http://jamesturrell.com/work/type/skylight-series/ (accessed August 28, 2017).

Turrell, James. 2002. *Milk Run Sky*. Available online: http://jamesturrell.com/work/type/skylight-series/ (accessed August 28, 2017).

Turrell, James. 2007. *Jacob's Rain*. Available online: http://jamesturrell.com/work/type/skylight-series/ (accessed August 28, 2017).

Tye, Michael. 2015. "*Qualia*." In Edward Zalta (ed.), *Stanford Encyclopedia of Philosophy*. 2015 edn. Available online: http://plato.stanford.edu/archives/fall2015/entries/qualia/ (accessed June 16, 2020).

Uberoi, J.P.S. 1978. *Science and Culture*. Delhi: Oxford University Press.

United States Holocaust Memorial Museum. 2012. "Classification System in Nazi Concentration Camps." Available online: http://www.ushmm.org/wlc/en/article.php?ModuleId=10005378 (accessed January 5, 2013).

Uusküla, Mari. 2014. "Linguistic Categorization of Blue in Standard Italian." In Wendy Anderson, Carole P. Biggam, Carole A. Hough, and Christian J. Kay (eds.), *Colour Studies: A Broad Spectrum*. Amsterdam: John Benjamins.

Vallée, Ariane. 2007. "From Sketch to Set: Draughtmanship and Stage Design in the Work of Christian Bérard for the Classical Theatre 1936–47." MA thesis, University of Oslo.

Van Vechten, Carl. [1926] 2000. *Nigger Heaven*. Urbana: University of Illinois Press.

Vejdemo, Susanne, Carsten Levisen, Cornelia van Scherpenberg, Þórhalla Guðmundsdóttir Beck, Åshild Næss, Martina Zimmerman, Linnaea Stockall, and

Matthew Whelpton. 2015. "Two Kinds of Pink: Development and Difference in Germanic Color Semantics." *Language Sciences*, 49(5): 19–34.

Venturi, Robert, Denise Scott Brown, and Steven Izenour. [1972] 1977. *Learning from Las Vegas*. 2nd edn. Cambridge, MA: MIT Press.

Verspoor, Marjolijn H., and Ágnes de Bie-Kerékjártó. 2006. "Colorful Bits of Experience: From Bluestocking to Blue Movie." *English Studies*, 87(1): 78–98.

Voon, Claire. 2017. "Meet Singularity Black, the Blackest Paint on the Market." *Hyperallergic* Newsletter. Available online: https://hyperallergic.com/395360/meet-singularity-black-the-blackest-paint-on-the-market/ (accessed August 21, 2017.)

Wagner, Katie, Karen Dobkins, and David Barner. 2013. "Slow Mapping: Color Word Learning as a Gradual Inductive Process." *Cognition*, 127(3): 307–17.

Walden, Celia. 2010. "The Midi Skirt is Back, But Are You a Betty or a Joan?" *The Telegraph*, October 27. Available online: http://fashion.telegraph.co.uk/news-features/TMG8089101/The-midi-skirt-is-back-but-are-you-a-Betty-or-a-Joan.html (accessed June 16, 2020).

Wang, Wilfried. 2000. "Minimalismo multicolor: observaciones sobre la arquitectura de Gigon y Guyer." *El Croquis*, 102: 24–35.

Warhol, Andy. 1964. *Flowers*. Collection MOMA NY. Available online: https://www.moma.org/collection/works/71491?locale=en (accessed August 31, 2017).

West, Nathanael. 1939. *The Day of the Locust*. New York: Random House.

Westphal, Jonathan. 1987. *Colour: Some Philosophical Problems from Wittgenstein*. Oxford: Basil Blackwell.

Wierzbicka, Anna. 2006. "The Semantics of Colour: A New Paradigm." In Carole. P. Biggam and Christian. J. Kay (eds.), *Progress in Colour Studies*, vol. 1, *Language and Culture*. Amsterdam: John Benjamins.

Wigley, Mark. 1995. *White Walls, Designer Dresses: The Fashioning of Modern Architecture*. Cambridge, MA: MIT Press.

Williams, Susan Kay. 2013. *The Story of Color in Textiles*. London: Bloomsbury.

Williams, William Carlos. 1970. *Illuminations*. New York: New Directions Publishing.

Williamson, Beth. 2015. "Colour Pedagogy in the Post-Coldstream Art School." In Nigel Llewelyn (ed.), *The London Art Schools*. London: Tate Publishing.

Winge, T. 2008. "Undressing and Dressing Loli: A Search for the Identity of the Japanese Lolita." *Mechademia*, 3: 47–64.

Winship, Janice. 1987. *Inside Women's Magazines*. New York: Unwin Hyman.

Wittgenstein, Ludwig. 1977. *Remarks on Colour*. Oxford: Blackwell.

Witzel, Christoph. 2015. "Commentary: An Experimental Study on Gender and Cultural Differences in Hue Preference." *Frontiers in Psychology*, 6: 1840. https://doi.org/10.3389/fpsyg.2015.01840.

Witzel, Christoph. 2019. "Misconceptions about Colour Categories." *Review of Philosophy and Psychology*, 10: 499–540. https://doi.org/10.1007/s13164-018-0404-5.

Wolfe, Tom. 1982. *From Bauhaus to our House*. London: Jonathan Cape.

Woolf, Virginia. 1934. *Walter Sickert: A Conversation*. London: Hogarth Press.

Wright, Angela. 1998. *The Beginner's Guide to Colour Psychology*. London: Kyle Cathie.

Wuebbles, Donald J. 2012. "Celebrating the 'Blue Marble.'" *EOS: Transactions of the American Geophysical Union*, 93(49): 509–20.

Xiao, Youping, Christopher Kavanau, Lauren Bertin, and Ehud Kaplan. 2011. "The Biological Basis of a Universal Constraint on Color Naming: Cone Contrasts and

the Two-Way Categorization of Colors." *PLoS ONE*, 6(9): e24994. https://doi.org/10.1371/journal.pone.0024994.

Xu, Jing, Mike Dowman, and Thomas L. Griffith. 2013. "Cultural Transmission Results in Convergence Towards Colour Term Universals." *Proceedings of the Royal Society B*, 280: 20123073. https://doi.org/10.1098/rspb.2012.3073.

Yendrikhovskij, Sergej N. 2001. "A Computational Model of Color Categorization." *Color Research and Application*, 26(S1): S235–S238.

Young, Diana. 2011. "Mutable Things: Colours as Material Practice in the Northwest of South Australia." *Journal of the Royal Anthropological Institute*, 17(2): 356–76.

Zeisel, Eva. 2001. *The Playful Search for Beauty*. [Video] TED Talk, February. Available online: https://www.ted.com/talks/eva_zeisel_the_playful_search_for_beauty?language=en (accessed May 13, 2019).

Zielinska-Dabkowska, Karolina M. 2016. "Night in a Big City: Light Festivals as a Creative Medium Used at Night and their Impact on the Authority, Significance and Prestige of a City." In Tomasz Domański (ed.), *The Role of Cultural Institutions and Events in the Marketing of Cities and Regions*. Łódź: Łódź University Press.

Zollinger, Heinrich. 1984. "Why Just Turquoise? Remarks on the Evolution of Color Terms." *Psychological Research*, 46(4): 403–9.

CONTRIBUTORS

Zed Adams is Associate Professor of Philosophy at the New School, New York City, USA.

David L. Bimler is a perceptual psychologist with a PhD in mathematical psychology from Massey University, New Zealand.

Jacob Browning is Berggruen/TWCF Research Fellow at NYU Center for Data Science, New York, and Visiting Scientist at MIT Brain and Cognitive Science Department, Cambridge, MA, USA.

Tracy Diane Cassidy is a trained knitwear designer and Reader in Fashion and Textiles at the University of Huddersfield, UK.

Nicholas Gaskill is Associate Professor of American Literature at the University of Oxford and Tutorial Fellow at Oriel College, UK.

Urmila Mohan is an anthropologist of material culture and religion with a focus on textiles, praxis, and embodiment. She is currently adjunct faculty at New York University, USA.

Judith Mottram is Professor of Visual Arts and Director of the Lancaster Institute for the Contemporary Arts at Lancaster University, UK.

Zena O'Connor is an independent research consultant, content creator, and author with Design Research Associates, Australia.

Qianqian Pan is currently Research Fellow in color science and image processing at the University of Leeds, UK.

Galina Paramei is Professor of Psychology at Liverpool Hope University, UK.

Juan Serra is Professor of Architectural Graphic Expression at the School of Architecture of the Universitat Politècnica de València, Spain.

Anders Steinvall is Associate Professor of English Linguistics at the Department of Language Studies, Umeå University, Sweden.

Sarah Street is Professor of Film at the University of Bristol, UK. In 2019 she was awarded the Turner Medal by the Colour Group (GB).

Stephen Westland is Professor of Color Science and Technology at the University of Leeds, UK.

Kelly F. Wright earned her doctorate at the University of Cincinnati, USA, where she teaches American history. She also consults with museums and served on an advisory panel in early photography for the Smithsonian.

Joshua Yumibe is Professor and Director of Film Studies at Michigan State University, USA.

INDEX

Note: Page locators in *italic* refer to figures.

Abbott, Tony 60–1
aboriginal peoples 88–9
additive color mixing 48, 50, 51, 54
The Adventures of Prince Achmed 144, *145*
advertising
 animated films 144, *145*
 and color in 1960s 212
 colored light in 10–13
 in print media 3–6
 Silk Cut 61–2
Afrofuturism 151–3
After Modernity exhibition 187
Agfacolor 51, 143–4
Akomfrah, John 151–3
Albers, Joseph 157–9
Alexander, Christopher 17
Allianz Arena, Munich 64, 192
Aloisio, Ricky 75, *75*
Alsop, William 187–8
Amélie 69–70
American Beauty 69
Anangu 88–9
Anderson, Wes 70
animated films 144–5, *145*
anthraquinone 42, 44
Apple 216–17
Archigram 182
architecture 173–95
 1920–1960 173–80

1960–2000 181–91
2000 onwards 191–4
anti-decorative colors 179–80
brand color in 64
color and pop 186
color novelty 194
color promoting cultural change 178–9
color reinforcing composition of forms
 175–8
color transformation 192–3
color versatility 189, 191, 194
deconstructivist 188–91
expressionism 175, 178–9, 180, 220
 n.3 ch.9
figuration 186
flat colors without gradations 180
fragmentation 193
monumentalism 183–5
movement 193
neoplasticism 175, 177, 179, 180, 221
 n.4
neorationalist colors 185
not only white 174–5
postmodern 181–91
power and identity 64–7
purism 174–5, 175–6, 179–80, 220 n.2
 ch.9
utopian colors 181–3
white 65, 174, 183–5

art 155–71
 audiences and appetite for color 167–9
 Bauhaus legacy 157–9
 challenging centrality of color 165–6
 color and materiality 169–70
 color and pictorial organization 159–60
 color as significant form 156
 color, emotion and expression 156–7
 coloring in 160–1, 167
 education 165–6
 market 167
 monochrome and polychrome 161–4
 significant form, expression and color
 field 164–5
 writers' engagement with 138–9
Art Deco movement 198–201, 202
Artaud, Antonin 147
artifacts 197–218
 1960s and beyond 212–16
 Art Deco 198–201, 202
 Cold War and 1950s' trends 207–211
 cross-fertilization 206
 electronic objects 216–17
 Great Depression 201–204
 postwar 205–207
artificial
 colored light 10–18
 silk 43–4, 99
automobile colors 198, 201, 208–209
autonomy of color 26–30
Ayer, A.J. 27

Babbitt 199
Bakelite 199–200
Bakst, Léon 159, 160
Bali 91–2
Barajas Airport 193
Barolong Tshidi 88
Barragán, Luis 66
basic color categories (BCCs) 119, 120,
 126, 129
 explanatory schemes 121–2
 lexical differentiation by non-basic
 terms 127–8
 new 125
 World Color Survey 123
basic color terms (BCTs) 119–20, 121,
 123, 125, 126
 challenge to upper limit tenet 123–4

new categories 125, 126
 psychological structure 121, 122
Batchelor, David 7, 9, 19, 79, 83, 86,
 163–4, 165, 166, 174
Battleship Potemkin 69
Bauhaus 103–104, 156, 157–9, 206, 208
Bay, Signe 76
Bégout, Bruce 15
beige 126, 128, 134, 216
Bell, Clive 156
Bellah, Robert 94
Benjamin, Walter 88, 151
Berlin, Brent 119, 120, 121, 125, 134, 157
Biba 103
Birren, Faber 103, 212
black
 color metaphors 133–4
 Ford motor cars 198
 Islamic dress 84–5
 "Jazz" punch bowls 201
 Vantablack and SingularityBlack 170
Black Narcissus 148–50, 149
Black Square 161–2
Blade Runner 16
Block, Ned 28
Bloomfield, Leonard 117, 118
blue
 basic color terms (BCTs) 123–4
 color metonyms 133
 color preferences 131
 connotations 59, 63
 to convey power and identity 68
 emotions 130
 IBM logo 62–3
 indigo 42, 91
 International Klein Blue (IKB) 83, 162,
 170, 220 n.1 ch.4
 "Jazz" punch bowls 201
 jeans 106
 Lanvin blue 101
 Le Corbusier on red and 176
 marble image of Earth 46, 47
 metaphysical sense 177
 Modernism, aesthetics and 139
 neckties 60–1
 and orange juxtaposition in digital
 cinema 152
 political color 59, 60–1
 religio-colorscapes 89

turquoise 126
and white of evil eye symbol 93, *94*
YInMn 218
body
 color to beautify 101–102
 henna decoration 107
 tattoos 104–105, 109–111
Bonnard, Pierre 156
Bottoni, Piero 180
Bourdieu, Pierre 90–1
branding 61–4, 127–8
British Colour Council (BCC) 103, 109
brown 126, 131, 198, 212
Burroughs, William S. 151
Bute, Mary Ellen 144

Cadillacs 208–209
Café Aubette 180
cakras 90
Calder, Alexander 206
Cardiff, Jack 9, 143
Carter, Jimmy 214–15
categorical perception 123, 220 n.2 ch.6
Catholic
 Charismatic Renewal 83–4
 stole 84, *85*
celluloid 200
cellulose acetate 43–4
Centre (Georges) Pompidou 182, *183*
ceramics 200–201, 206–207
 (*see also* dinner services)
Chazelle, Damien 70–1
chemical industry 40–3, 197, 218
Chermayeff, Serge 17
children, color-coding for 6–7
Christianity, color and 80–2, *82*, 83–4, *85*,
 88, 89
chromophobia 7, 87, 166
CIAM (Congrès Internationaux
 d'Architecture Moderne) Conference
 1953 181
CIE (International Commission on
 Illumination) 23, 24, 26, 53, 54, 55,
 220 n.1 ch.6
CIELAB 55
cinema (*see* movie industry)
civil religions 93–5
Claude, Georges 11
Cliff, Clarice 200

Clifford, James 147
Clinton, Hillary 59–60
clocks 199, 207
clothing
 Barolong Tshidi dress codes 88
 fairground influences 104
 fashion designers 72–4, 99, 100, 101,
 103–104, 106
 lifestyle movements 107–108
 men's fashion 102
 nostalgia and subcultures 113–15
 Pathé films showcasing new fashions in
 140
 popular icons and youth culture
 106–107
 ready-to-wear 98–100
 religious 83–6
 retail developments 106
 style analysis and image building
 111–13
 technical developments 99, 102–103
coal-tar products 40
Coen, Joel and Ethan 70
Cold War and 1950s' trends in artifacts
 207–211
collage 193
colonial
 histories of chromatic bias 87, 148
 liberation 148–51
 revival themes 204–205, 209
 use of color 88
color associations 7, 14–15, 130
 across languages 133–4
 in architecture 176
 with emotions 130–1, 133, 157, 212
 with race 148, 150–1
 with sociopolitical groups 73
 (*see also* symbolism, color)
color constancy 24
color consultancy 24, 103, 108, 111–13, 160
color experts 6, 9–10, 166
color forecasting 72, 97, 98, 99, 108–109,
 111–12
color management 53
color novelty 194
color preferences 103, 109, 111, 118,
 131–2, 191
color recipe prediction 55
color transformation 192–3

color versatility 189, 191, 194
The Color Index 43
COMIC (COlorant MIxture Computer) 55
Committee on Colorimetry (CoC) 23–6
computational objectivists 34–5
computer-aided color 188, 189, 194
computer hardware 216–17
Congrès Internationaux d'Architecture
 Moderne (CIAM) Conference 1953
 181
constancy, color 34
consultants, color 24, 103, 108, 111–13, 160
consumerism 3, 137, 140, 199
contagion 89
Coppola, Sophia 16
Corning Glass Company 209, 212
cosmetics 101–102, 103, 107
Cowan Pottery 200–201
Crabtree, Ane 2
Crayola crayons 217, 218
cultural context and color 62

daguerreotypes 46–7
Danger, Eric Paxton 103
Death of a Salesman 146
deconstructivist architecture 188–91
decorative arts and design 107, 198, 201,
 203
 postwar 205–207
decorative motifs 212, 214
defining color, color science and problem
 of 22–6
Delaunay, Sonia 101
Deleuze, Gilles 2
depression glass 202
diasporic color in digital age 151–3
digital images
 movie industry 9, 51–2, 70, 151–3
 photography and 46–52
 volume of 52–3, 56
digital reproduction of color 20, 169–70
dinner services 209
 American Modern 206
 Casual China 207
 Corell 212
 Fiestaware 202–203, 207
 Oasis 208
 Starburst 207
 Town and Country 206

Disney 18–19, 51, 144
disperse dyes 44–5, 99
dispositionalism 35–6
Doesburg, Theo van 180
Dos Passos, John 138
drugs 93, 151
Dufaycolor 143, 144
dyestuffs 1–3, 40–6, 91, 99, 135, 197, 218

Earth, image of 46, 47
Eastman Kodak 47, 48, 49–50, 51–2, 55
Eastmancolor 51, 144
ecological relationists 36–7
ecological utopias 181–2, 183
Ehrenzweig, Anton 167, 170
Eisenstein, Sergei 69, 136
electronic objects 216–17
emancipatory politics and color 151
emergence hypothesis 126
Emilio Pucci 72, 73
Emin, Tracey 17
emotion and color 129–31, 133, 136,
 156–7, 212
Enric Miralles and Benedetta Tagliabue
 (EMBT) 190
entheogens 93
environmental
 pollution 41
 visual literacy 65, 65
Evangelical Christians 81, 82
Evans, Ralph 26
evil eye symbol 93, 94
exotic culture, embracing of 203
Experience Music Project 190
experimentation with color 7–10
experts, color 6, 9–10, 166
Expressionism 175, 178–9, 180, 220 n.3
 ch.9

façades
 colors 64, 65, 66, 178, 180, 182, 184,
 186, 188
 contemporary 190–1, 192, 193
fairground influences 104
Fanon, Frantz 147, 148, 150
fashion designers 72–4, 99, 100, 101,
 103–104, 106
Faulkner, William 14
FedEx 63

festivals of light and music 18–19
Fiestaware 202–203, 207
film, camera 48, 50
films (*see* movie industry)
Fitzgerald, F. Scott 67–8, 137
flags 95
Flam, Jack 159
flat colors 180
Flavin, Dan 16–17
foils, iridescent 192, *192*
folk art 104, *105*
Follin Frances 8
fondue sets 212, *214*
Ford Motor Company 3, 198
forecasting, color 6, 72, 97, 98, 99,
 108–109, 111–12
Foster, Norman 64, 66, 182–3, 192
Fox, Holly 76
fragmentation 193
Frazer, James 89
Fry, Roger 138, 156
functionalism 28
furnishings 198, 205, 206, 207, 209–210,
 212, 214

Gass, William H. 139
Gay and Lesbian Holocaust Memorial 58,
 59
Geertz, Clifford 91
Gehry, Frank 188, *189*, 190
gender
 color preferences and 131–2
 identity and color 1–3, 6
Gestalt school 24, *25*
Gibson, J.J. 33
Gillick, Liam 163
Gingrich, Arnold 102
The Girl on a Motorcycle 9
glass 200, 202, 205
 Pyrex 209
Glass Pavilion, Deutscher Werkbund
 exhibition 178–9, *178*
Godard, Jean-Luc 150
Godden, Rumer 148–9
gold 101, 133, 152
 artifacts 198, 212, *213*, 214
 to convey power and identity 67–8
Goths 107
The Grapes of Wrath 141–2

Great Depression 141–2, 201–204
The Great Gatsby 67–8, 137
green
 Art Deco use of 198
 of Balinese ceremonial clothing 92
 branding 64
 color metonyms 133
 color preferences 131
 connotations 7
 to convey power and identity 68, 69–70
 decorative motifs 214
 emotions 130
 jadite kitchen artifacts 203
 Kandinsky on 168
 in Le Corbusier's architecture 176
 religio-colorscapes 89
 revolutionary 150
 symbol of hope 7
 turquoise 126
 vat dyes 99
 walls 183
 women's rights movement 60
Greenberg, Clement 164
Grenfell Tower 7
Griffin, Lewis 121, *122*
Guggenheim Museum 188, *189*
Guild, John 54–5

habitus 90–1
Hadid, Zaha 188–9
The Hague 191
The Handmaid's Tale 1–3
Hardin, C.L. 33, 34, 35–6, 37
Harlem renaissance 147–8
Hellmholtz-Hering debate 22–3, 31
Helmholtz, Hermann von 22, 23, 31, 54
henna 107
Hering, Ewald 22–3, 24, 31, 121
Heron, Patrick 160
Hilbert, David 34–5
Hinduism 86, 95
hippies *105*, 107–108, 215
Hockney, David 8, 167–8
Hodgkin, Howard 168–9, *169*, 170
housing developments 181–2, 186–7
Hulanicki, Barbara 103
Hundertwasser, Friedensreich
 181–2
Hurvich, Leo 31, 33

IBM 62–3
Index of American Design 201
India 66, 95, 149–50
indigo 41–2, 91
Indonesia 91–2
industrial designers 201–202, 204,
 206–207, 208
infants 128–9
Instagram 71, 74–7
interiors 6
 1950s artifacts and 207–211
 1960s and 1970s artifacts and 212–14
 1970s artifacts and 215
 color in architecture and 174, 177, 180,
 187–8, 191, 192, 194
 Pathé films showcasing new fashions in
 140
 postwar artifacts and 205–207
 public buildings and identity 66–7
International Color Consortium (ICC) 55
International Commission on Illumination
 (CIE) 23, 24, 26, 53, 54, 55, 220
 n.1 ch.6
International Klein Blue (IKB) 83, 162,
 170, 220 n.1 ch.4
internet 52–3, 55–6, 217
inverted spectrum thought experiment 28,
 29, 37
Irwin, Beatrice 139
Islamic dress 84–6

Jackson, Frank 29
Jacques, Barbara 111, 113
Jameson, Dorothea 31
Jazz Age 99, 100, 100, 137, 200–201
Jeunet, Jean-Pierre 69–70
Jews 58, 87
Jobs, Steve 73–4, 216
Jones, L.A. 25
Jones, Robert Edmond 146
Judd, Donald 162–3, 171
jukeboxes 204–205
Juxtapox 109–110

Kalmus, Natalie 142
Kandinsky, Wassily 136, 139, 156–7, 168,
 179
Kanzisa Triangle 24, 25
Katz, Alex 167

Katz, David 24
Kay, Paul 119, 120, 121, 123, 125, 134,
 157
Kerouac, Jack 68
Khrushchev, Nikita 207–208
Kinemacolor 50, 51
kitchen appliances 199, 203, 207–208,
 209, 212, 213
 since 1980 215
"kitchen debate" 207–208
Klein, Yves 82–3, 162, 170
knowledge argument 29–30
Koolhaas, Rem 191, 194
"Kufic Suprematism" 188

"La Defense" Offices, Almere 192, 192
La La Land 70–1, 71
Lambie, Jim 8–9, 166
Land, Edwin 31–2, 49
language of color 117–18
 acquisition of color naming and
 categorization 118–19
 basic color terms (BCTs) 119–20
 blue-green boundary 126
 challenge to BCT upper limit tenet
 123–4
 emergence hypothesis 126
 explanatory schemes for BCCs 121–2
 lexical and categorical refinement of
 color space 127–8
 lexical differentiation of color space
 125–6
 purple BCTs 125–6
 universalism–relativism debate 122–3
 World Color Survey 120, 123
Lanvin, Jeanne 101
Larsen, Nella 147, 148
Las Vegas 15
laser shows 19
Last Angel of History 151–3
lava lamps 215–16
Le Blon, Jacob Christoph 54
Le Corbusier 65, 174–5, 175–6, 180, 184
Le Creuset 212
Leblanc process 41
Leconte, Patrice 70
LEDs 8, 17, 66
Léger, Fernand 136, 161, 176
Lenneberg, Eric H. 119

Lewis, Sinclair 199
L'Homme du Train 70
lifestyle movements 107–108, 113
light
 artificial, colored 10–18
 festivals 18–19
 installations 8–9
 pollution 17–18
lighting
 home interiors 6
 theatre 139–40, 141, 146
 transforming colors of architecture
 192–3
Lilly Pulitzer 72–3
linguistic relativity hypothesis (LRH) 118,
 120, 123
Lippmann, Gabriel 47
Lisbon 187
literature
 Depression and retreat from bright
 colors 141–2
 Harlem renaissance 147–8
 Modernism and language of color in
 1920s 136–9
 power and identity 67–9
 revolutionary color 151
liturgical colors 81, 84
logo color mapping study 62, *63*
logos 61, 62–3
Lolita subculture 113–15
Loos, Adolf 87, 173
Lost in Translation 16
luxury fashion 99, 100
Lye, Len 144, *145*

magazines 3–6, 102, 106, 199
magic 89–90
malanite 207
Malevich, Kazimir 161–2
management, color 53
Manhattan Transfer 138
Mankon, celebration for King of 84, *85*
marketing 61–4, 103, 127–8, 133
Mary Magdalene 2
Matisse, Henri 157, *158*, 159–60, 167, 203
mauveine 41
Maxwell, James Clerk 47–8
McCann, John 32
McGuire, Ian 68–9

McKay, Claude 147, 148
McLaren, Norman 144
measurement of color 52–6
media façades 193
Meier, Richard 184
Meltzer, Françoise 137
Mendes, Sam 69
men's fashion 102
metallic colors 106, 170, 188, 190, 191,
 198, 199, 207
metamerism 34, 53
metaphors, color 15, 89, 129, 130, 133–4
metonymies 15, 89, 133
Mielziner, Jo 146
mimesis 88–90
minimalism 108, 185
Mirbach, Hannah 76, 77
Miró, Joan 161
The Modulor 180, 221 n.5
monitors, color 217
monochrome art 161–2, 164
monumentalism 183–5
moon landing 106
Moonrise Kingdom 70, *71*
Moore, G.E. 27
Morning 2015–16 168, *169*
Mossis, Mel 12
movement in architecture 193
movie industry
 1920s' coloring techniques 140
 diasporic color in digital age 151–3
 experimental animation 144–5
 introduction of sound 141, 142, 143
 popular culture and 106
 power, identity and color 69–71
 revolutionary color aesthetics 148–51
 technical developments 9, 50–2, 142–4
music influences on fashion 99–100, 104,
 106–107
MVRDV 183, 191, 193

naming and categorizing of color 118–19
 young children's 128–9
natural dyes 42, 91
naturalism
 chromatic restraint and 142–3
 experimentation and 141–2
 in theatre design 146
Nazis 58, 87, 133, 144

neckties 60–1
neon light 10–17, *11*
neoplasticism 175, 177, 179, 180, 221 n.4
neorationalist colors 185
Netherlands Institute for Sound and Vision 190–1, *190*
neurophysiological objectivists 35–6
Neutelings Riedijk Architects 190–1, *190*
New Age religion 93
New Deal 201
New Romantics 107
Nixon, Richard 207–208
non-basic color terms 119, 126, 127–8, 133, 134
The North Water 68–9
Nouvel, Jean 66, 183
novelty, color 194
nylon 45

O Brother, Where Art Thou? 70, 71
Olitski, Jules 164
On Being Blue 139
On the Road 68
opponent processing theory 22–3, 31, 35, 36
optimality hypothesis 121
orange
 Art Deco use of 198
 and blue juxtaposition in digital cinema 152
 color preferences 131
 decorative motifs 214
 in late 1960s and 1970s 212, 214, 215
 Le Creuset 212
 lexicalization of area between pink/red and 126
ornament 87
Orthodox religious icons 93, *94*

panography 193
perception
 Gibson's account of 33
 of illumination 24
performing arts (*see* theatre)
The Phantom of the Opera (1925) 140, *141*
philosophy and science 8–9, 21–38
 autonomy of color 26–30
 defining color 22–6
 developments in second half of 20th century 30–3

rise of empirically informed work in philosophy 33–7
phosphorescent paint 191, 192, 199
photography 4–6
 and digital imaging 46–52
 Polaroid cameras 31–2, 49
physicalism 29
Piano, Renzo 182, *183*
Picasso, Pablo 147, 160–1, 206
pigment identification 161
pink 6–7
 1950s artifacts 208
 Cadillacs 208–209
 lexicalization of area between orange and 126
 non-basic terms 127
 triangle 58–9, *59*
Pink Floyd 19
Plum Blossoms, Ochre Background 157, *158*
poets 137, 138, 139, 142
Poincaré, Henri 28
Polaroid cameras 31–2, 49
politics 58–61
pollution
 environmental 41
 light 17–18
polychrome
 architecture 175–6
 art 162–4, 165
 branding 64
polyester 44–5
pop art 165, 167, 168
pop culture 104–105, 106, 107, 186
Porto school 185, 187
postcolonial color 148–51
postmodern architecture 181–91
Pound, Ezra 139
power and identity 7, 57–78
 architecture 64–7
 branding and marketing 61–4
 cinema 69–71
 fashion design 72–4
 literature 67–9
 politics 58–61
 social media 71, 74–7
preferences, color 103, 109, 111, 118, 131–2, 191
Primitivism 147, 150, 175

print media 3–6, 102, 106, 109
Pruitt-Igoe 181
psychedelic color palette 73, 215
psychology of color 24–6, 33
 acquisition of color categories 128–9
 color preferences 131–2
 emotion 129–31, 133, 136, 156–7, 212
punch bowls 200–201
punks 107, 115
purism 174–5, 175–6, 179–80, 220 n.2
 ch.9
purple
 branding 61–2
 categories and terms 125–6, 127
 mauveine 41
 women's rights movement 60
Pyrex 209

qualia 26–30
Quartier Schützenstrasse, Berlin 184, 185
quilts 202

race and color 7, 135, 147–8, 150–1
Ramsay, William 11
reactive dyes 45–6
red
 clothing 2, 14
 color preferences 131
 connotations 14, 15, 59, 69, 150
 to convey power and identity in films
 69–70, 150
 emotions 130, 131, 133
 The Handmaid's Tale 1–3
 Hodgkin on 168
 Le Corbusier on blue and 176
 -light district 14
 metaphysical sense 177
 neon lights 14, 15
 political color 58, 59
 religious celebrations 81, 82, 82
 religious dress 88
 semiotics of 150
 telephones 207, 210, 211
 terms for 126, 127
reflectance profiles 32, 33, 34–5, 53
refrigerators 199, 203, 212, 213
Reichenbach, Hans 29–30
Reiniger, Lotte 144, 145
religion 81–96

aesthetics and Othering of color 86–7
civil 93–5
color as religious portability and change
 80–6
mimesis and religio-colorscapes 79, 80,
 87–90
New Age 93
practices in West 81–3
religious clothing 83–6
ritual and 90–2
Renault 64
revolutionary color 148–51
Richard III 140
Richter, Gerhard 165, 166
Rietveld, T.G. 177, 177
Riley, Bridget 8, 169
Rita of Cascia, Saint 83
Rodchenko, Alexander 162
Rogers, Richard 182, 183, 193
Rose, Barbara 164, 166
Rosler, Martha 5–6
Rossi, Aldo 184, 185
Rothko, Mark 160, 164
Russell, Bertrand 27

Saint Laurent, Yves 104
Salubra "color keyboards" 176, 180
San Cataldo Cemetery 184
Sapir-Whorf hypothesis 118
Sasson, Steve 49
Scandinavian design 205
Schindler's List 69, 71
Schoenmaekers, M.J.H. 177
Schroeder's House 177, 177
science (see philosophy and science)
Scott Brown, Denise 186
Scott, Ridley 16
sculpture 162–4
"secular spiritualism" 82–3
Sellars, Wilfrid 37
Sembène, Ousmane 7, 150–1
semiotics 150
Silk Cut 61–2
silver 67–8, 106
(see also metallic colors)
Simonson, Lee 146
sinks 208, 212
skin color in Technicolor 143
Smith, George Albert 50

social media 71, 74–7
Society of Dyers and Colourists (SDC) 43
sodium carbonate 40–1
solarization 9
Space is the Place 152
space travel 46, 47, 106, 207
Spanish rationalist architecture 185
Spielberg, Steven 69
Spillane, Mary 111, 112
Spotify 63–4
the Standard Observer 55
"starring" 82
Steampunk *114*, 115
Stein, Gertrude 137–8, 139
Stein, Sally 4, *5*
Steinbeck, John 141–2
Stevens, Wallace 139
Stirling, James 186
Stout. G.F. 26–7
stoves 199, 203, *213*
street fashion 99, 100, 102, 104
the structure preservation problem 35–6
style analysis and image building 111–13
subcultures 99, 100, 102, 104–105, 106,
 113–15
subtractive color mixing 48, 50–1
sulfuric acid 40, 41
Sun Ra 152
suntans 101
surveys, online color-naming 125
symbolism, color 2, 7
 branding and cross-cultural 62
 The Handmaid's Tale 2
 in literature 67–9
 in movies 69–71
 political 58–9
Symbolist poets 137, 139
synthetic dyes 40–6, 99, 135

tattoos 104–105, 109–111, *110*
Taut, Bruno 175, 178–9, *178*, 180
Taveira, Tomas 187
technical education 42–3
Technicolor 50–1, 140, 141, 142–3
technological utopias 182–3
technology
 color measurement 52–6
 deconstructivist architecture and new
 188–91

dyestuffs and new textiles 40–6, 99,
 102–103
experimentation, color and new 7–10,
 194
photography and digital imaging 46–52
Polaroid camera invention 31–2
and trade 39–56
telephones 207, 210, *211*
televisions 209–210
Temkin, Ann 83, 158, 166
Tendenza 184
Tender Buttons 137–8
terrazzo floors 208
Textile Color Card Association (TCCA)
 72, 99
textiles
 spiritual power of 91–2
 technical developments 43–4, 45, 99,
 102–103
theatre 141, 146
 lighting 139–40, 141, 146
Thebaut, Olivia 76
Theosophical Society 89
Thompson, Evan 36–7
Thomson, Kirsten Moana 12, 19
three-color additive process 47–8
The Ticket That Exploded 151
"tiki" culture 203
Times Square, New York 12, *13*
titanium dioxide 206
toothfiling 92, *92*
toys, tin 204
The Trail of the Lonesome Pine 142–3
transformation, color 192–3
Travers, Morris 11
trichromatic theory 22, 31
tristimulus values 54–5
turquoise 126
Turrell, James 163

Unité d'Habitation 175–6
universalism–relativism debate 122–3
universals and evolution model (UE) model
 120
UNStudio 192, *192*
utopias 181–3

vat dyes 42, 44, 99
Vechten, Carl van 147, 148

Venturi, Robert 186
versatility, color 189, 191, 194
Villa Savoye 174
vintage movement 107–108, 113
Vitra Fire Station 188–9
Vitrolite 202
"vivid color" 7, 135, 136–7, 147, 148–50

Walt Disney 18–19, 51, 144
Watkinson, Colin 2
weak relativity hypothesis 123
West, Liz 8
white
 Apple computers 216, 217
 architecture 65, 174, 183–5
 and blue of evil eye symbol 93, *94*
 connotations 60
 to convey power and identity 68
 kitchens and appliances 199, 203, 208,
 209, 212, 215
 monumentalism 183–5
 political color 60
 titanium dioxide pigment 206
 women's rights movement 60
The Whites 184
Wittgenstein, Ludwig 33–4
women's rights movement 60
Wong, Liam 76
Woolf, Virginia 137, 138

World Color Survey 120, 123
World's Fair, Chicago 201–202
Wright, Angela 112
Wright, Russel 206–207
Wright, William David 54–5
Wrigley 12, *13*

Xala 7, 150–1

yellow
 1950s artifacts 209
 Art Deco 198, 200
 Balinese ceremonial clothing 92
 branding 64
 color metonyms 133
 color preferences 131
 to convey power and identity 67–8
 emotions 131, 157
 Have-A-Happy-Day face 214
 metaphysical sense 177
 Star of David armband 58, 87
YInMn 218
youth culture 106–107
Yupik 82

Zeisel, Eva 206
Zobop 8–9
Zones of Immaterial Pictorial Sensibility
 83